Studying Film

Also in the *Studying* series

Studying Film

Nathan Abrams

Ian Bell

Jan Udris

Second edition

BLOOMSBURY ACADEMIC

First published in 2001 by Hodder Arnold

This edition published in 2010 by:

Bloomsbury Academic

An imprint of Bloomsbury Publishing Plc
36 Soho Square, London W1D 3QY, UK
and
175 Fifth Avenue, New York, NY 10010, USA

CIP records for this book are available from the British Library and
the Library of Congress.

ISBN (paperback) 978-0-34098-446-8
ISBN (ebook) 978-1-84960-334-8

This book is produced using paper that is made from wood grown in managed,
sustainable forests.
It is natural, renewable and recyclable. The logging and manufacturing processes
conform to the environmental regulations of the country of origin.

Printed and bound in Great Britain by the MPG Books Group, Bodmin, Cornwall.

www.bloomsburyacademic.com

Contents

Preface

The field of Film Studies is already large but is still growing in popularity. An increasing number of colleges and universities have adopted film as an area of degree study. Numerous courses are devoted to the study of aspects of film, film theory and film history, and many disciplines are also actively integrating the use of film, among them Media Studies, English, Historical Studies, American Studies and Cultural Studies, to name just a few.

But do we need yet another book on Film Studies? While there are any number of academic texts covering many different areas of Film Studies, there are relatively few textbooks which explain basic concepts in a lucid manner suitable for students at the very beginning of their tertiary studies. This new, updated and revised version of *Studying Film* provides an alternative core text with breadth of coverage and depth of analysis. Since its first publication the text has proved to be a useful tool for undergraduate students both in Film Studies and cognate degree courses. It has also assisted both lecturers in Film Studies and those with a general interest in film alike, providing additional information for those wishing to learn more.

Acknowledgements

We would like to thank the many people who in various ways have helped in the development and completion of this book. They include family and friends, colleagues and students, readers, Fiona Cairns, Lee Ann Tutton, Emily Salz and the team at Bloomsbury Academic. Their contributions range from patience and understanding to help and advice. We would also like to thank Kobal and the BFI for permission to reproduce film stills and Hatier for permission to reproduce the image of Plato's cave.

List of illustrations and tables

Illustrations

Tables

Introduction

Why study film? Shouldn't films be enjoyed rather than studied? Doesn't studying films destroy their entertainment value? Arguably film was the major art form and entertainment of the twentieth century and shows no sign of giving up this status in the twenty-first. Most of us have been watching films since childhood and have consequently developed an informal literacy in the language, grammar and syntax of film. Studying film can help to formalize and deepen this informal cineliteracy, as well as broadening the medium's entertainment value. The increasing popularity of academic and specialist film journals, as well as of TV programmes and documentaries about the making of films, indicates this. Studying film can also develop an understanding of production techniques, how films communicate meaning, how we as audiences both respond to films and influence the types of films made, and how the industry functions in terms of ownership, control, finance, marketing and exhibition.

How to study film? Film can be studied within three key but interrelated areas: industry, text and audiences. Films can be regarded as an integral part of the global media industry and thus are central to the economic activities of an increasingly concentrated range of multinational conglomerates. Films can also be studied as cultural products, texts that carry particular values and beliefs which are open to a number of different interpretations. They can powerfully affect or influence us, their audience, while satisfying our desires.

The field of Film Studies is already large but is still growing in popularity. An increasing number of colleges and universities have adopted film as an area of degree study. Numerous courses are devoted to the study of aspects of film, film theory and film history and many disciplines are also actively integrating the use

of film, such as Media Studies, English, Historical Studies, American Studies and Cultural Studies, to name just a few. The launch of Foundation Degrees in moving image production also creates a need for such a book to supplement vocational studies with a theoretical understanding of contexts and techniques. *Studying Film* is aimed at students taking such courses. It will also assist both lecturers and those with a general interest in film alike, providing additional information for those wishing to learn more.

Studying Film aims to aid systematic study of cinema and film based on the key concepts, terms and issues that have informed Film Studies and film criticism. It focuses on how cinema functions as an institution for the production and distribution of social knowledge and entertainment, the very specific ways in which film images and sounds generate meaning, and the relationship between audiences and cinema as institution, as films, as texts. Although most attention will be paid to dominant forms of popular cinema – particularly that called Hollywood – alternative or less 'popular' cinemas will also be addressed. Consequently, *Studying Film* aims to cover a broad spectrum of topics within Film Studies from a range of perspectives; hence the inclusion of other areas of cinema outside the United States, in particular British cinema. Although this coverage is neither comprehensive nor exhaustive of the huge range of film movements that exist, it will indicate some of the alternatives to mainstream US cinema. In doing all this, each chapter provides case studies, summaries, suggestions for further reading and viewing, as well as exercises, some of which are questions for discussion but others of which may be suitable for essay work. A supplementary website, a glossary and an index are supplied. As a result, this textbook provides an invaluable resource for the student and lecturer alike.

Studying Film aims to stimulate appreciation, enjoyment and understanding of a wide range of different types of film, together with an awareness of the nature of cinema as a medium, art form, and social and economic institution. It aims to encourage an understanding of the nature of personal responses to film and to deploy the critical languages that have been developed to analyse the ways in which films and spectators construct meaning. It will provide a critical and informed sense of the contexts in which films are and have been produced, disseminated and consumed, within both mainstream and alternative cinema. It aims to instil a thorough knowledge of the critical and technical terms used in film production and practice. Finally, it will develop a critically informed sense of the history and development of film conventions, both mainstream and alternative.

//

Structure of the book

The book is divided into three main sections covering Cinema as Institution, Film as Text and Movies and Audiences.

Part 1 (Cinema as institution) examines cinema in relation to the social context within which it operates, in particular the interaction between the cinema as an industry and the audience. It considers the determining factors behind film form, paying particular attention to the industrial and economic basis of commercial cinema, particularly its business and profit motives. Its principal focus is Hollywood, but not to the exclusion of other cinemas. The section also explores other forms of cinema outside the United States that have been vital to the development of film. It looks at the range of different cultural and institutional contexts in which films exist and seeks to understand the different, sometimes explicitly oppositional forms of film associated with them.

Part 2 (Film as text) provides an introduction to the basic terms of visual communication and perception as well as to the technical terms specific to cinema. In doing so, it begins to analyse how images and sounds produce and communicate meaning. Conventions, techniques and formats used in the writing of screenplays are also investigated.

Part 3 (Movies and audiences) examines the major critical approaches towards understanding film and aims to discover the complex relationship between film as text, cinema as institution, and the audience. The chequered history of theories about how individual spectators 'read' films is also considered.

A note on one or two conventions and other choices about usage which we have adopted for this text. English language titles are given first (except where the meaning of the foreign title should be evident), as well as the original titles in most cases; directors and dates are given for most films. We have decided to use the word 'film' to refer both to individual films and to the celluloid, the material of the original medium. The term 'movie' is used sparingly, principally in reference to particularly US contexts. The Glossary explains many of the key terms.

What is the future for Film Studies? Although there is an emerging discipline, 'Screen Studies' – the objects of which include TV, games and gaming, new media and whatever happens on a monitor screen, as well as film itself –, Film Studies has remained relevant and informs the new Screen Studies. To be sure, rapid changes in production and projection technologies and viewing contexts are now evident, and these are addressed at a number of points in this volume.

Part **1**

Cinema as institution

Chapter 1

Early cinema

When film emerged in 1895 as a new form of communication, there was little idea of what its future might hold. It was unclear how it might be used, what its purpose should be and how people would react to it. In effect, film production was an experiment. Audiences were certainly amazed by the new phenomenon but film-makers wondered how long its novelty value would last. We now know, of course, that film has become a global industry. Cinema is a central part of our lives and over time a range of conventions have developed for making films. This chapter looks at how cinema began, what its characteristics were and how conventions gradually developed. The main focus is on film form in early cinema, with film production placed in context through reference to the developing industry and audience trends of the time.

The industry

Inventions are rarely realized in isolation. Developments in the recording and projection of moving images were being pursued in several countries at the

same time, but just as important were the inventions that pre-dated cinema. The means to view moving images had been developed by 1834 by William Horner with the zoetrope, but the images were a series of drawings which mimicked the various stages of motion of a moving object, typically someone running. The ability to produce images that recorded the natural world was realized in 1827 by Joseph Niépce with the invention of photography. Cinema was the result of bringing together techniques for showing moving images and the technology of recording aspects of the real world (see Chapter 10 on film technology).

Camera and projection systems

In 1893 Thomas Edison unveiled his Kinetoscope moving image system, as developed by W. K. L. Dickson. Edison is also believed to have built the first film studio (called the 'Black Maria'), with sections in the roof to let in light and with the whole building revolving in order to be able to follow the sun. Edison's method of screening films only catered for individual viewers, though, and as such was not a projection system. Other equipment designs were developed in 1896 in Britain and the United States, but it is Auguste and Louis Lumière who are regarded as having produced the first widely used successful camera and projection system in 1895, the *cinématographe* (see Fig. 1.1).

It is also the Lumière brothers who are usually credited with having made the first films in 1895 and with having held the first public screening on 28 December of that year, at the Grand Café in Paris. In fact Max Skladanovsky had screened a film on 1 November of the same year in Germany, but his contribution to developing film technology is often forgotten; his camera/projection system was cumbersome and impractical and developed no further, leaving the Lumières to perfect their system. Other camera and projection designs were also experimented with in other countries around the same time.

Europe

Cinema may have been dominated by the United States for most of the twentieth century, but the early years belonged to Europe. US cinema was outstripped by the film output of France, England, Denmark and Italy, and it was only during the First World War that the United States began to dominate the international film industry (see Chapter 2). Production companies such as Nordisk from Denmark, Cines from Italy and Cecil Hepworth's company in England produced and exported many films but France's Pathé Frères and Gaumont led the field. By 1905 Pathé Frères was already vertically integrated, but their control of production, distribution and exhibition was soon to be mirrored by companies in the United States.

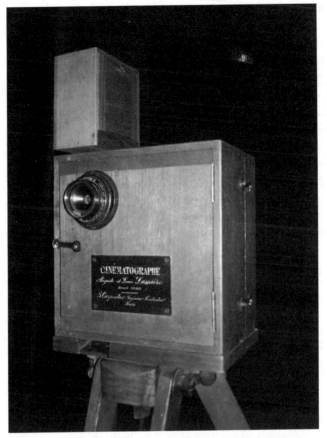

Figure 1.1 The first camera and projection system: the *cinématographe*

The United States

By 1900, the three key companies in the United States were American Muto-
scope and Biograph, Vitagraph and Edison's company. They had a large domestic
market to satisfy, though that market was at the time also being fed by European
film companies. In the United States the battle was soon on for supremacy
within the industry. The Edison company took legal action to prevent other US
companies from using cameras and projectors for which Edison claimed the
patents. American Mutoscope and Biograph used a different type of camera,
however, and they battled with Edison for control of the industry. Both forced
other companies to pay for the right to use their equipment designs.

The MPPC

The rivalry between Edison's company and American Mutoscope and Biograph
continued until 1908, when the two companies formed the Motion Picture

Patents Company. The new company also included Vitagraph, Essanay, Kalem, Lubin and Selig, all of whom had to pay the two main companies for continued use of patented designs. Although the MPPC aimed to reduce the number of foreign films coming into the country to enable US producers to expand their own share of the market, a deal was struck which allowed Pathé and the Méliès company to join. Screenings of foreign films declined in the United States as a result of the increasing power of the MPPC but European cinema continued to dominate the rest of the world.

The MPPC ensured that fees were paid by production companies using its camera designs, by distribution companies dealing with its films, and by theatres showing its films and using its projection systems. Thus the MPPC soon became an oligopoly; its small number of companies controlled the emerging US film industry. The stranglehold on the industry was tightened further when Eastman Kodak signed an exclusive deal with the MPPC for supply and use of film stock.

The independents

Nonetheless, a thriving independent sector managed to grow within the United States, prompting the MPPC to respond by forming the General Film Company to release exclusively all MPPC films. However, 1912 saw the beginning of the end for the MPPC when a court ruling rejected its claim to exclusive rights to the camera and projection equipment designs. The final blow for the MPPC came three years later in 1915, when it was declared to be undermining competition within the industry and was required to cease its restrictive practices.

The independent companies were now in a strong position: their main competitor was weak and the fact that they had not previously been tied into a rigid production structure meant they were more flexible. They made early moves towards producing feature films instead of short one-reelers and many companies, realizing that the most profitable part of the industry was exhibition, reorganized accordingly. Many of these 'independents' in turn became vertically integrated themselves and developed the same monopolistic practices as the MPPC had before them. By 1915, the origins of companies such as Paramount, Fox, Universal, MGM and Warner existed, all of which were to become the core of the studio system during the 1930s and 1940s (see Chapter 2). Initially the US film industry had been mainly based on the East Coast and in Chicago, but by 1915 the majority of companies had relocated to the Los Angeles area, which included a district called Hollywood. The weather was more suitable for location shooting – filming was much easier with reliable sunshine – and a greater variety of landscapes was available.

The European film industry had also developed monopolistic practices. In France, Pathé Frères and Gaumont dominated, while in Britain most films were exhibited by the Gaumont-British company and the Associated British Pictures Corporation. With the start of the First World War in 1914, however, the film

industry in Europe was severely disrupted. The next few years saw the United States establish itself as the dominant international power in the cinema.

> ### Exercise 1.1
> What are the key differences between the characteristics of the early US film industry and those of the Hollywood studio system?

//////////////////////////

The audience

The beginnings of cinema were characterized by uncertainty, as several camera and projection systems existed and film techniques were little more than experimental. It did not take long, however, for those concerned to realize that there was a potentially huge audience for the new form of communication. Cinema audiences were perhaps initially more interested in what the technology could do than in how it was used, since moving images were such a novelty – they could surprise and shock, they could provide a spectacle rather than tell stories. Nonetheless, the possibilities for film as entertainment were soon realized.

Exhibition

The first cinema was opened in France in 1897 by the Lumière brothers, while the first US cinema did not open until 1902. Early cinemas were basic, often consisting of nothing more than a screen, a projector, a piano and several rows of chairs. Initial doubts about the viability of public screenings of films soon disappeared and by 1905 the United States had approximately 1,000 cinemas, a figure which had risen to 5,000 by 1908. One of the early cinema chains was Loew's Theatres, renamed Loews in 1969 and incorporated into AMC Theatres in 2005. The industry continued to expand and by 1910 weekly cinema attendances numbered 26 million, a figure which almost doubled over the next five years to reach 49 million by 1915. Cinema building continued apace, led by entrepreneurs such as S.L. Rothafel.

Cinemas in the UK were similarly basic and initially had little more than rows of benches surrounding a primitive projector. The Cinematograph Act of 1909 changed this with its requirements of fireproofing, separation of the projection box from the auditorium and the installation of fire exits and toilets. The worst halls closed down and many theatres were converted into cinemas, with 3,500 in existence in the UK by 1915. However, many cinemas closed down during the First World War.

In the USA prior to 1905, films tended to be shown wherever facilities existed for entertaining the general public: thus theatres, music halls, vaudeville houses and even funfairs were regularly used. It was common for vaudeville shows to begin and

end with short films, but this practice was soon reversed in cinemas where it became common for a vaudeville act to perform while reels were being changed. By 1905 purpose-built venues had become the norm, and these early exhibition theatres were referred to as nickelodeons rather than cinemas, the cost of admission typically being a nickel. Nickelodeons were relatively small and had minimal facilities; they provided cheap entertainment and were well suited to their audience, which tended to be working-class. Films provided popular entertainment just as music halls and circuses had done previously, while classical concerts and plays at the theatre tended to be more expensive and remained a middle-class leisure activity.

Entertainment

Initially most films were non-fiction. Film's ability to record movement in the real world was sufficiently impressive for it to be entertaining and when films were unable to record actual events, the events were often re-staged to provide a representation of what had happened – typically of a news item of interest to the public. Re-enactments of historic moments were also frequently made and actuality films, especially travelogues, were popular. Fiction films soon became common, though, and proved to be very popular with audiences, who came to look for entertainment and escapism in addition to the information and novelty they were used to. The fiction narratives were usually simple and frequently took the form of comedies. The lack of sound in a film was often compensated for by a piano performance or the use of a gramophone, and actors sometimes spoke dialogue behind the screen to match the actions in the film. Sound effects were similarly added.

Until about 1905, production companies tended to sell copies of their films to exhibitors, which meant that films had to be screened repeatedly for the initial investment to be recouped. When the practice of renting films replaced that of purchasing them, exhibitors were able to show a greater variety of productions. Audience interest grew again with the arrival of feature films around 1910, which were usually between four and six reels long (sixty to ninety minutes) and were often released as serials, with titles like *The Perils of Pauline*, one reel per week. Serials were in effect a transition between one-reelers and full feature films.

Stars

Audiences were thus initially attracted to the cinema by the novelty of experiencing moving images, and soon after by the provision of entertaining stories on film. A further attraction was added by the rise of film stars when audiences began to identify particular actors and admire their performances. By 1909 two stars were already established: Florence Lawrence the 'Biograph Girl' and Florence Turner the 'Vitagraph Girl'. Whereas previously audiences tended to identify films by the production company name, increasingly stars helped to sell films, and film posters came to highlight the featured star. By 1915, stars were regularly pulling

in the crowds. Theda Bara was signed to the Fox company as their studio star and Charlie Chaplin became known as the loveable tramp with bowler hat and cane.

Censorship

Some sections of society were nevertheless expressing concern at the rise of cinema as a new form of entertainment. Many felt that cinema was a powerful form of communication and believed it was likely to have an effect upon the audience. At a basic level this was illustrated by claims that audiences momentarily believed a train hurtling towards them on a cinema screen was actually about to hit them, but the real concern was with the portrayal of crime, violence and romance on screen. Concerned US citizens claimed that nickelodeons were likely to become breeding grounds for criminality, violent behaviour and loose morals. There was also a fear from sections of the establishment that film could be used as political propaganda to create social unrest (see Chapter 11 on cinema, audiences and society). However, governments themselves soon turned to using film as propaganda with the onset of the First World War.

The developing film industry was aware of growing concern and acted to halt legislation being passed by government. In the United States the major production companies co-operated with an organization calling itself The National Board of Censorship, which was set up in 1909. Wanting to seem responsible, film companies submitted films for preview before releasing them. The production of more serious films – based on literary classics, Shakespeare and religious stories – helped to hold the censors at bay and indeed allowed the industry to censor itself. A similar situation existed in Britain where the British Board of Film Censors, funded by the industry, was founded in 1912.

Exercise 1.2

Identify how film-viewing during the era of early cinema would have been different from your own experience of film-viewing. Take account of viewing context, other available forms of entertainment and the unique qualities of film as a form of communication.

The films

Film form changed dramatically between 1895 and 1915. The beginnings of cinema were marked by simple narratives and primitive film techniques. Initially little importance was attached to camerawork and editing; the emphasis was on *mise en scène*. Particular films have been recognized as indicating major steps in the development of film techniques, but, as with film technology, it is important to remember that new techniques were being explored by many different

film-makers in many different countries. There was much cross-fertilization of ideas as film-makers influenced one another.

Movement and the moving image

The first five years of cinema produced few films with identifiable narratives. Films tended not to contain stories in which events were clearly explained and linked together. Shots often seemed to exist in isolation and there was a lack of logical progression in the actions on the screen. None of this should surprise us since the initial fascination with film resulted from its ability to record movement; that it could do this at all was often enough to impress an audience. The first task for film-makers was to understand the different ways in which a camera could be used; only once film-makers had come to terms with using cameras could they begin to think about telling coherent stories on film. As Kristin Thompson notes: '[D]uring most of the primitive period, films appealed to audiences primarily through simple comedy or melodrama, topical subjects, exotic scenery, trick effects and the sheer novelty of photographed movement' (Bordwell, Staiger and Thompson, 1985, p. 157).

The earliest films were very much the creations of the camera operator, who was usually also the director and scriptwriter. However, the emphasis gradually changed over the years as control shifted from the camera operator to the director and/or the producer. Film-making was from the outset very much a male-dominated profession, with the notable exception of Alice Guy from France, who was making films by 1896. Also from France, and best known for their early work, were the Lumière brothers and Georges Méliès. Their productions were radically different, though, with the Lumières tending towards non-fiction films whereas Méliès concentrated on fiction.

It is perhaps not surprising that travel was a common theme in early films. Not only were modes of transport such as cars and trains rapidly developing at that time, which in turn led to speculation about future modes of travel, but transport is of course about movement, which was exactly what the new cine-cameras could capture on film. What did not provide movement in early films was the camera itself, which usually remained static. This is partly explained by the cumbersome early cameras which were not easy to move during filming, but it is perhaps also explained when we think of the types of popular entertainment that preceded film. Music-hall and theatre performances took place on the stage with action statically framed by the stage curtain, and early films often have the appearance of a recording of a stage performance. This is especially true of many of Méliès' films.

Georges Méliès

In *Journey to the Moon* (1902) Méliès used a static camera and extreme long shots. It would be easy to believe that the events we see take place on a stage, as

characters walk on from and off to the sides of the frame, and the action takes place against what is obviously a backdrop. The film is typical of much of Méliès' work; it is a mix of comedy and fantasy and could be claimed as the first science fiction film: a group of scientists travel in a rocket to the moon.

The Impossible Journey was made by Méliès the following year and deals with similar themes. Passengers board a train, the train takes to the skies and eventually flies into the sun, where the passengers emerge from the crashed train and end up on a submarine which submerges into the sea. Méliès built his own studio, in which he constructed elaborate, fantastic sets. His complex stage designs were complemented by the frequent use of models, especially for simulating travel scenes in fantasy worlds. He often created magical effects on film through the use of stop motion techniques to join together different takes. In *The Impossible Journey*, stop motion is used to link together actions where the join is disguised through the use of smoke and fire. The film's fantasy world is emphasized through the use of strong colours which were used by Méliès to hand-tint the film, making it stand out from the usual repertoire of black-and-white films. As before, takes are static – though a pan shot is used at one point to follow movement – and extreme long shots are used throughout. The film lasts for six and a half minutes and contains fourteen takes, meaning an average of approximately thirty seconds per take; moreover, so skilful is Méliès' use of stop motion that it is sometimes difficult to ascertain exactly when he has used it. He also makes extensive use of dissolves to link shots together. Such early examples of special effects engendered those of today (see Chapter 10).

The use of long takes was a common characteristic of early cinema, as it was for Méliès' films. An individual take was often referred to as a tableau. The take commonly covered a whole scene and its length, combined with its being a static extreme long shot, tended to isolate it from the rest of the film. The individual takes, or tableaux, were virtually autonomous as editing did not link takes closely together. Editing was not used to produce or clarify meaning, the content of the takes alone providing meaning. The lack of coherence in some early films is not surprising, partly because of historical and cultural differences for a modern viewer, but especially because the use of long shots and the lack of close ups means that detail in these films is often unrecognizable.

The Lumière brothers

Travel was also a theme for other film-makers. One of the Lumières' first films was *L'Arrivée d'un train en gare* (1895). A static camera framed a station platform and an arriving train with an extreme long shot to record the passengers disembarking. The film was most memorable for its depiction of diagonal movement towards the camera by the train. Most early films lacked a sense of perspective and emphasized two dimensions only.

The Lumières' very first film from 1895 was *Workers Leaving the Factory*. The brothers owned a large photographic company and filmed their employees emerging through the factory gates: a typical example of an actuality film, which is what the Lumières concentrated on. They did, however, also produce fictional comedy films, their best known being *The Waterer Watered* (*L'Arroseur arrosé*, 1895). A gardener is watering plants until a boy stands on the hose pipe to stop the water, at which point the gardener looks quizzically at the end of the hose pipe; the boy steps off, leaving the water to suddenly shoot out over the gardener. As far as is known, this was the first comedy film.

Experimentation

Early cinema had no conventions; it was all about experimentation. Once the obvious visual possibilities of film had been recognized, some film-makers began to realize the further potential of the medium. The emphasis on recording the real world gradually gave way to attempts at creating the impossible on film. We have already seen examples of this in Méliès' work; he was a professional magician and was already skilled in creating illusions. As noted above, Méliès used stop motion, using editing to create a kind of jump cut in which elements within a shot suddenly change position, appear or disappear. In addition, film-makers experimented with running film backwards, with speeding up and slowing down time and with multiple exposures, which involved running the film through the camera more than once to superimpose different images on top of each other. Méliès himself used multiple exposures to brilliant effect in his 1900 film *The One Man Orchestra*. A man walks on stage to play an instrument and then the same man walks on seven times to play seven different instruments, at which point the orchestra is complete.

Early British films

Britain also had its share of film pioneers and experimenters. One of the earliest British films was *Rough Sea at Dover*, made by Birt Acres in 1895. It contained a static long shot of Dover harbour during a storm and was impressive for its recording of movement. G. A. Smith's *Grandma's Reading Glass* (1900) broke new ground in the techniques used, showing a boy borrowing his grandma's magnifying glass and looking at various objects. The film was interesting in that the action was broken up into several takes, including extreme close ups from the boy's point of view through the magnifying glass. This was radically different when compared to the usual long shots that covered all the action in other films.

Another notable British film from 1900 was James Williamson's *The Big Swallow*. This begins with a man becoming aware that he is being filmed. He gradually becomes more irate until he moves towards the camera, mouth wide open, and appears to swallow the camera as his mouth blanks out the screen. At

this point an edit takes us to a shot of the cameraman falling into a black hole, followed by another shot of a black screen from which the camera tracks back as it seems to emerge from the man's mouth. The transitions from shot to shot are well timed and hardly noticeable.

To return to the theme of travel, Cecil Hepworth made two films in 1900 with cars as the main theme. *How it Feels to be Run Over* shows a car driving towards the camera; just as the car fills the screen an edit cuts to a black screen on which appears the message 'oh, mother will be pleased'. *Explosion of a Motor Car* uses stop motion. A car travels down a road and a large cloud of smoke billows from the car. At this point an edit cuts to another take in which a very similar cloud of smoke clears to reveal bits and pieces of a car lying on the ground. The two shots appear as one continuous take. This is followed by a policeman looking into the sky and then from off screen parts of the car's passengers come falling down. Such reference to events outside the camera frame was unusual. R. W. Paul's *The Motorist* (1906) contains several examples of stop motion and includes the use of models to make the impossible appear on screen. A policeman is caught on a car's bonnet; a convincing dummy falls off in front of the car, which runs over it; the policeman stands up again and runs after the car. Where the running-over seems to be a continuous take, it is in fact two, the second one beginning with the policeman getting up having apparently been run over. Other stop motions in the film create the illusion of a car driving up the front of a house and a car being transformed into a horse and cart. With the use of models, the car appears to be driving over clouds and around the moon.

Cecil Hepworth's 1905 *Rescued by Rover* was notable for editing that was more complex than that usually found at that time. The film tells the story of a baby that is stolen. The parents are alerted by their dog, Rover, who leads them to the place where the baby has been hidden. There is a coherence to the way the story is told which is lacking in other early films. The editing provides consistency of direction and pace of movement between each shot. Time and space are presented in a way that makes the film's narrative intelligible. The film was so popular that it was remade twice after the negatives wore out from producing so many copies.

Edwin S. Porter

To return to the United States, another film that broke new ground in the methods used to tell a narrative was Edwin S. Porter's *The Great Train Robbery* (1903). A gang of outlaws rob a train; a telegraph operator alerts the sheriff, who rounds up a posse to track down the outlaws. The innovation was in the use of cross-cutting when the film shows the outlaws robbing the train but then cuts to the telegraph operator sending a message. We assume he is trying to alert someone to the robbery. At another point we see the outlaws fleeing on horseback, then after a cut we see the sheriff and his posse; the cross-cut edit indicates to the viewer that

there is likely to be conflict. However, the effect is partly lost because of the difficulty of knowing which set of characters we are looking at, since the predominance of extreme long shots makes character identification difficult. Another scene in the film, a tableau, is also made fairly incomprehensible by reliance on an extreme long shot: when the outlaws order all the passengers off the train, the passengers are presumably being robbed by the outlaws but the lack of detail makes it difficult to ascertain if this is the case. The uncertainty of the shot is increased by the fact that it lasts almost two minutes.

Another unusual element in the film is the inclusion at the end of a close up of one of the outlaws looking straight to camera and firing a gun, effectively at the audience. The shot exists outside the narrative, but has the effect of reminding us of the complex relationship between the film and the audience by transforming the viewer into the one being viewed by a character in the film – a technique which has remained unusual throughout cinema history, though we should note the clear homage at the end of Scorsese's *GoodFellas*!

::::::::::::::::::::::::

CASE STUDY

Alice Guy-Blaché

A roll call of key names from the early days of cinema reveals an era that appears to be exclusively male: Thomas Edison, the Lumière brothers, Cecil Hepworth, George Méliès, Birt Acre, Edwin Porter. However, these notable directors and producers were also complemented by a French woman who had an immediate and lasting impact on film, Alice Guy. Her directorial debut was with *La Fée aux Choux* (1896), a one minute story about children born in a cabbage patch, the second fiction film, following the Lumière's *L'Arroseur Arrosé* (1895) by a few months.

Alice Guy directed more than 300 films between 1896 and 1920 and was also the producer for much of her work. She initially worked for the Gaumont Film Company. Her output was impressive in terms of quality and quantity and she soon became the head of production, supervising other directors. As well as playing a central role in the development of cinematic techniques and narratives, Guy also contributed to technical advances. She used early Gaumont motion picture equipment and Chromophone sound recording technology from the early 1900s. Guy was also an early experimenter, along with Méliès, in special effects such as double exposure and running film backwards. It has also been suggested that she was the first to use representations of aspects of homosexuality in films with the inclusion of effeminate men and women dressed as men.

Alice Guy married Herbert Blaché, head of Gaumont distribution in Britain, and they moved to the USA to oversee Gaumont's interests there. Together they went on to form their own production company, Solax, in New Jersey, helping

to establish the East Coast as the centre of US film production before the industry's gradual gravitation towards the West Coast and ultimate settlement in Los Angeles' Hollywood.

END OF CASE STUDY

Film techniques and narratives

The lack of clarity in some early films, partly due to the lack of sound, was the reason why inter-titles were often used, either to explain the situation within which events were happening or to elaborate upon an interaction between characters. Similarly, the acting in early films frequently seems exaggerated and theatrical rather than naturalistic because in the absence of sound it too could help clarify the narrative. The exaggerated use of gesture already had a long history in unlicensed theatre, in which dialogue could not be used; this had led to the evolution of the stage melodrama and of a melodramatic acting style. The increasing use of genres also helped explain narratives and raise particular expectations in the audience. Common genres of the time were fantasy, comedy, crime, melodrama, chase and actuality (see Chapter 14 on genre).

By 1905, films were regularly built around narratives which had an identifiable beginning, middle and end, contained motivated characters and concluded with some kind of resolution. However, this highlighted the problem of how to clearly tell a visual story. Thompson and Bordwell have identified this issue and the film-makers' response as follows:

> Filmmakers came to assume that a film should guide the spectator's attention, making every aspect of the story on the screen as clear as possible. In particular, films increasingly set up a chain of narrative causes and effects. One event would plainly lead to an effect which would in turn cause another effect, and so on.
>
> (Thompson and Bordwell, 2003, p. 43)

Over the next ten years conventions were to become established which aided the coherent presentation of film narratives.

Film form and conventions

Movement takes place over time and within space. It was necessary that time and space be dealt with appropriately if films were to be able to tell stories clearly. Camera and editing techniques were to provide the solution. The content and function of shots were clarified through the breaking up of scenes into several takes using different shot sizes and camera angles. The increasing use of close ups provided information and detail to the viewer and made it easier to identify characters and develop greater characterization. Variety of camera angles gave a stronger

sense of space through the provision of different perspectives on action and location. However, using a greater variety of shot types meant that how the takes were edited together became more important. Consistency in shot content was necessary in terms of speed and direction, as well as of location and props. An eye-line match also became necessary when editing between one person and another as they interacted with each other. Cross-cutting also became more common (see Chapter 8).

The emphasis on consistency between the takes that were edited together resulted in the concept of continuity editing. The types of shots filmed and the way they were edited together needed to present a smooth flowing narrative that progressed logically and clearly so that the story could be easily understood by the audience. By 1915 these techniques were in common use and were in effect film-making conventions, identified by Noël Burch as the 'Institutional Mode of Representation', as distinct from the 'primitive' mode of representation that had gone before. Film form had changed radically since the birth of the medium.

Two films that neatly sum up the results of the evolution of film form between 1895 and 1915 are Chaplin's *The Tramp* and D. W. Griffith's *The Birth of a Nation*, both made in 1915. *The Tramp* is the story of how a vagabond saves a girl who has been attacked and is then taken in by her family. He comes to believe that she is in love with him, as he is with her, but his heart is broken when her lover arrives. The film makes extensive use of close ups and achieves a depth of characterization unusual in early cinema. The effectiveness of the character development resulted in Chaplin being recognized and remembered for his ability to get an audience to empathize with his character on screen. *The Birth of a Nation* is set during the American Civil War and while its racism is objectionable, its use of film techniques is admirable. Griffith brought together and refined the techniques that had been developing since 1895. The use of camera and editing not only provided a clear narrative but also managed to involve the viewer emotionally. Variety of shot size and of camera angle were employed throughout with effective use of cross-cutting, the principles of continuity editing were applied to ensure narrative coherence, and characters were well developed and given a depth not often present in films of the time. The film was an epic: it lasted over three hours and cost $110,000 to make.

CONCLUSION

It is important not to see early films as nothing more than a stage in the development of what we now see as mainstream conventions. Early films existed in their own right as expressions of individual film-makers' creativity and expertise; they also had a particular relationship with audiences of their time and reflected aspects of their respective cultures and societies. It must also be remembered that, in contrast to our own contemporary entertainment cinema, the main aim of early cinema was not to tell coherent narratives. The principal urge was to explore and experiment with the possibilities of the moving picture medium.

> Exercise 1.3
>
> What similarities and differences can you identify between the film techniques and narrative forms of early cinema and those of contemporary film-making?

SUMMARY

↪ In 1895 film form was fluid as there were no conventions, and early film-makers had no guidelines – these manipulators of light were working in the dark.

↪ The new medium had a primitive form; narratives were simple and film techniques crude; telling a story via film was difficult and tended to result in a lack of clarity.

↪ Film-makers often opted to simply record the world in front of the camera rather than construct a story on film, and it took several years for film to become the basis of a new industry.

↪ With the gradual development of sophisticated camera and editing techniques, it became possible to present complex narratives on film.

↪ The types of stories and the style of film-making in place by 1915 were to make a major contribution to the established conventions that still underpin much of today's film-making.

REFERENCES

Bordwell, D. Staiger, J. and Thompson, K. (1985), *The Classical Hollywood Cinema*, London: Routledge.

Thompson, K. and Bordwell, D. (2003), *Film History: An Introduction*, New York: McGraw-Hill.

FURTHER READING

Balio, T. (ed.) (1976), *The American Film Industry*, Madison, WI: University of Wisconsin Press.

A comprehensive book about US cinema with detailed coverage of the beginnings of the industry.

Burch, N. (1990), *Life to Those Shadows*, Berkeley, CA: University of California Press.

A very useful text that provides context for early cinema.

Cook, P. (ed.) (2007), *The Cinema Book*, 3rd edn, London: BFI.

A wide-ranging book about film with extensive coverage of early cinema.

Elsaesser, T. (1990), *Early Cinema: Space, Frame, Narrative*, London: BFI.

A very useful study on the aesthetics of early cinema.

Guy Blaché, A. (1996), *The Memoirs of Alice Guy Blaché*, Lanham: Scarecrow Press.

A fascinating insight into the life of one of cinema's early pioneers.

McMahan, A. (2002), *Alice Guy Blaché: The Lost Visionary of the Cinema*, New York: Continuum International Publishing Group Ltd.

One of the few books about Alice Guy Blaché, well researched.

Monaco, J. (2000), *How to Read a Film*, 2nd edn, Oxford: Oxford University Press.

An informative book providing a detailed overview of the origins of the moving image.

Thompson, K. and Bordwell, D. (2002), *Film History: An Introduction*, 2nd edn, New York: McGraw-Hill.

A comprehensive text with detailed material on the origins of cinema.

FURTHER VIEWING

Cinema Europe (BBC2, 1995)
A series of programmes about the era of silent movies in Europe. BBC Active, BBC Television Centre, Wood Lane, W12 7RJ

Early Cinema: Primitives and Pioneers (BFI, 1992)
A comprehensive collection of key silent movies. BFI, 21 Stephen Street, London W1T 1LN

Silent Britain (BBC/BFI, 2006)
An in-depth programme documenting developments in early cinema within Britain. BFI, 21 Stephen Street, London W1T 1LN

The Last Machine (BBC1, 1995)
A series of documentaries looking at the early years of movies. BBC Active, BBC Television Centre, Wood Lane, W12 7RJ

Chapter 2

US cinema

In this chapter we shall focus on the US film industry which is often, incorrectly, referred to as Hollywood. The studios traditionally regarded as constituting 'Hollywood' in fact only account for 33 per cent of US films. The remaining 67 per cent are made by 'independents', many of which have close links to the major studios and produce mainstream movies. While the precursors to and origins of the US film industry have been examined in the previous chapter on early cinema, here we shall be examining US cinema from its heyday, the 'mature' studio system between the years 1930 and 1949, through to what has variously been called post-1948 Hollywood, New Hollywood or contemporary US cinema. While tracing the development of the US film industry, we shall also look at the growth of the 'independents' and their relationship to the major studios in terms of finance, distribution and exhibition.

Histories of the US film industry have changed over time. Early histories were little more than first-hand accounts of the industry, written by individuals who were often part of the very system they claimed to analyse. This raises questions about the objectivity and usefulness of such accounts. From the 1970s onwards,

however, a new academic form of film history emerged from the university campuses which sought to revise the earlier, often uncritical, histories. In turn, these histories were themselves challenged in the late 1970s and 1980s and scrutinized by others who had adopted Marxist-materialist perspectives. Then by the mid-1980s, another mode of film history, which focused upon institutions, began to emerge. Academic understanding of US cinema, therefore, has developed as the writing of film history itself has changed. Our intention is simply to focus upon certain key periods; we acknowledge that the boundaries that mark different periods in the history of US cinema (and, indeed, what to call them) are still in dispute, but we shall not enter into that debate here.

//

The studio system

The origins and early history of the motion picture industry in the USA is discussed in the previous chapter; our emphasis here will be on the years between 1930 and 1949, which have been described as the 'Golden Age' or the 'Classical Era' of US film. To understand why this is so, we need to examine the nature of US film production during this period, which Thomas Schatz (1998) has referred to as 'the genius of the system'. It is during this period that we see the studios trying to remove any element of surprise or unpredictability from the film-making process at every level, from a film's conception to its exhibition. It must be pointed out here, however, that many of the techniques that were so effective during the heyday of the studio system were being developed from 1909 onwards and were already firmly in place by 1930.

Oligopoly

By 1930, eight studios dominated the US film industry in the form of an oligopoly: a situation where the market is completely dominated by a small number of companies, resulting in limited competition. These companies were divided into the 'Majors' or 'Big Five', which were Warner Brothers, Loews-MGM, Fox, Paramount and Radio-Keith-Orpheum (RKO), and the 'Minors' or 'Little Three': Columbia, Universal and United Artists (UA). The major studios were vertically integrated, which means they exercised control over production, distribution and exhibition, whereas the minors generally concentrated on production.

The US film industry's position of global pre-eminence was made possible partly by the advent of the First World War in 1914. The war temporarily destroyed European competition, particularly in France and Italy. For the next four years the USA dominated the film world, establishing an impressive global distribution network. It has been estimated that in 1914 the USA produced 50 per cent of the world's films; by 1918 it produced nearly all of them. By 1925, foreign film rentals amounted to 50 per cent of total US cinema revenues.

Vertical integration

Vertical integration meant that the major studios dominated film production, distribution and exhibition. They made, released and marketed their films, even owning the cinemas in which they were shown: exhibition was the most profitable sector of the film industry. In the days before television and VCRs, box-office sales were the source of income for recouping budgets spent on making films. The heads of the major studios wanted to ensure that there was a constant outlet for their product, and this led to a series of initiatives designed to dominate the industry.

In 1916 Adolph Zukor developed a system of 'block booking' for film distribution. He forced theatre owners to rent Paramount's star vehicles along with groups or 'blocks' of other less desirable and less commercially viable films. Zukor thus ensured a steady outlet for his films regardless of their quality, meaning that money was made on everything Paramount produced.

Within a year every major production company had adopted this practice. The studios already controlled production and block booking represented an attempt to control distribution and exhibition as well. This desire to dominate exhibition was extended by the studios' attempts to acquire as many cinemas as possible during the 1920s. By the 1930s the majors were pouring most of their investments into exhibition, and as a result between 1930 and 1949 they owned almost three-quarters of first-run US cinemas. The majors had divided the country into thirty markets and these were again subdivided into zones, in which the cinemas were classified as first-run, second run, and so on. First-run cinemas showed films as soon as they were released. They tended to have large numbers of seats, were situated in key locations in urban areas, and charged higher admission prices. Each film had to be shown for fourteen to forty-two days before it could move to the next zone, and this meant a maximum profit for the majors from each release. The majors' ownership of theatre chains, in particular first-run cinemas, together with block booking practices, ensured maximum exhibition of their films. Although they only owned 15 per cent of all US theatres the majors took 70 per cent of box-office takings.

As mentioned above, the studios had already established an impressive global distribution system by the 1920s, and a major factor in their success was an international market for their films. The major studios dominated this distribution network as a direct result of their control of exhibition. The minors had some involvement in distribution, most notably United Artists, which was set up in response to Zukor's block booking initiatives by Mary Pickford, Douglas Fairbanks, Charlie Chaplin and D. W. Griffith in 1919 for the exclusive distribution of their films. However, they had to co-operate with the majors' system of distribution, and in practice this meant that the majors ensured that their own films received priority over those of the minors. It was these initiatives that increased cost-effectiveness and guaranteed profits and helped to account for the commercial success of the studio system after 1930.

Assembly-line production

During the 'Golden Age' of the US film industry, the studios produced one film each per week per year. At its height, the studio system released 350 films in a single year. The studios were able to achieve such remarkable production figures through rationalization of working practices. Adopting a 'scientific management' approach to film production, the studios began to model themselves on factories, employing assembly-line techniques, hierarchical structures, and a strict division of labour; the 1920s also witnessed hundreds of Model T Ford cars as well as an array of other consumer items rolling off assembly lines. In fact Thomas Ince had initiated such practices in the film industry as early as 1908 in the first West Coast studio, Inceville. Each studio had its own back lot, wardrobe department, props and contract actors. At first, studio heads exercised almost total control over film production, holding responsibility for approving the original film concept and its budget, allocating the director and team of writers, approving the completed screenplay, supervising casting and hiring of other personnel, checking the film's progress, and overseeing the editing.

In 1931, however, Columbia announced the introduction of a producer-unit system whereby a head of production was responsible for running the studio; directly beneath him/her were several associate producers responsible for supervising a number of films and delivering them to the head of production. These methods were designed to save money since each associate producer could now monitor his/her own projects more closely than one central figure could. Often, the producer was the only person to see the film through from conception to completion. In addition to this, particular specialisms could be developed under particular associate producers, which led to more innovation, creativity, and ultimately better quality films. Altogether, these new working practices improved the efficiency and consistency of film production in the studio system.

At Warner Brothers, for example, as many as twenty writers would work on a single script. The script was prepared to an extremely detailed standard and the writers were usually present on set. Once the producer had approved the completed screenplay, the stars/actors were cast and the director, art director, composer, camera operator and editors were appointed. During the studio era the director rarely had any say over any of these personnel; directors were salaried employees 'there to make sure the actors hit their marks while the camera was running' and who left production once shooting had been completed (Biskind, 1998, p. 19). The film was then passed on to the editing department, which cut it according to a set of general specifications. Indeed, the style of each film owed more to the values of the studio as a whole than to those of any particular individual working on it.

As the largest, most profitable and productive of the studios during the 1930s, MGM mainly produced melodramas, musicals and literary/theatrical adaptations notable for their high key lighting, rich production design and middle-class US values (*The Wizard of Oz*, 1939; *Gone with the Wind*, 1939). In contrast, Paramount had a definite 'European' feel since many of its directors,

craftspersons and technicians had come from Germany. It made sophisticated and visually lavish films such as 'sex-and-violence' spectacles, musical comedies, and light operas (*The Sign of the Cross*, 1932; *The Love Parade*, 1930). Warner Brothers had a reputation as the studio of the working class and focused on low-life melodramas and musicals with a Depression setting (*The Public Enemy*, 1931; *Wild Boys of the Road*, 1933; *Gold Diggers of 1933*, 1933). Under Busby Berkeley, the musical flourished at Warner Brothers (the *Gold Diggers* series) while RKO became the home of the Fred Astaire–Ginger Rogers musical as well as of liter-ary adaptations (*Flying Down to Rio*, 1933; *The Hunchback of Notre Dame*, 1938). Twentieth Century Fox films such as *The Grapes of Wrath* (1942) were charac-terized by their 'hard, glossy surfaces' (Cook, 1996, p. 292). As for the minors, Universal produced low-budget features designed for the double bill and made a niche for itself in the horror-fantasy genre (*Dracula*, 1931). Columbia specialized in Westerns, while UA became more a distributor for independent directors than a production company (*City Lights*, 1931; *The Front Page*, 1931).

Style

It was during this period that the studios developed a set of film techniques known as the 'continuity system'. Films of the studio system were constructed in a particular way to ensure that everything was made clear to the viewer. Tech-niques included psychologically rounded characters with clear goals, character-driven action, the removal of 'dead time', a cause-and-effect, chronological linear narrative, a sense of closure, continuity editing and verisimilitude. This enabled the viewer to suspend disbelief while watching a smooth flowing narrative with a clear ending. These techniques became known as 'classical' film form and will be described in Chapters 8–10.

Genre

Another form of standardization that facilitated the use of factory production-line techniques during the studio era was the development of genre. Genre simply means a type or category of film (or book or other artwork; the term is not restricted to Film Studies). Genres provided the formulae for making films during the studio era, and, as noted above, each studio specialized in a particular genre or set of genres in an attempt to attract customer brand loyalty through product differentiation. Genres suited the nature of the studio system for two main and connected reasons. First, they offered a financial guarantee. They were formulaic, they contained conventions and they were repetitive (see Chapter 14). Consequently, they could easily be recycled over and over again, promising standardized consistency. Once a formula had been tried and tested, it was hoped that future success could be guaranteed. Why innovate when past experience based on a specific formula had been profitable? This allowed the studios to successfully target, select and predict audiences. Generic films could be pre-sold to an audience along with a particular

star. Generic differences allowed the easy identification of audiences for which specific films could be made, which in turn facilitated standardized production. The audience would recognize the characteristics of that genre and the promise that its storyline would develop with a measure of predictability, thus providing the desired outcome and hence providing satisfaction and fulfilling desires.

Second, genres provided a means for the studio to save money. With the establishment of a particular formula, the sets, props, equipment, techniques, storylines and stars could be re-used time after time and frequently were. For example, RKO producer Val Lewton (known as the 'Sultan of Shudders') outlined his recipe for horror: 'Our formula is very simple. A love story, three scenes of suggested terror, one scene of actual violence and it's all over in less than seventy minutes' (quoted in Burman, 1999, p. 9).

Genre, therefore, was one of the ways in which the studios sought to eliminate the unpredictability that is the nature of a creative medium like film. Principal examples of genre in the studio system were: Western (*Stagecoach*, 1939); horror (*Frankenstein*, 1931); musical (*42nd Street*, 1933); gangster (*Little Caesar*, 1930) and film noir (*The Maltese Falcon*, 1941).

The contract system

As mentioned above, the US film industry was rationalized and subject to scientific management techniques. This included a highly specialized division of labour designed to facilitate mass production of films. Accordingly, during the years 1930 to 1949 the studios employed all personnel, even their stars, on long-term or permanent contracts. The stars, directors and crew were contracted to a particular studio and even those who had established a reputation in the industry were employed on a contract basis. This meant that individuals could be assigned to their roles with ease, speed and minimal expense. Contracts tied stars to a particular studio, which helped to target and attract a big audience for the studio's films. If, however, a star refused to work on a particular film then s/he was not given an alternative and had to sit out for one and a half times the duration of that production while suffering loss of income. As a result many seven-year contracts were extended to twice that length. Often stars were loaned out to other studios; Columbia regularly borrowed stars from its rivals. The contract system may have been a source of bitterness for many stars during these years, but it contributed to the success of the studio system.

New technologies

During this period new technologies were developed which had a significant effect on promoting the success of the studio system. Of paramount importance were the introduction of sound technology from 1926 onwards, of cameras with greater mobility, depth of field photography and colour film. These are dealt with in more detail in Chapter 10 on film technology.

Context

What must not be ignored in explaining the success of the studio system is the context within which the films were made and consumed. It must be remembered that between 1929 and 1949 the United States underwent a series of traumas: the Wall Street Crash of 1929, the Great Depression, and the Second World War. In 1929 the Stock Market crashed, plunging millions into poverty. Banks were closed, farms were ruined, and many lost their jobs in the subsequent depression, the likes of which had never been witnessed in US history. The Depression felt even worse because it came immediately after the prosperity and consumer boom of the 1920s, which many have labelled 'the Jazz Age'. During this time of despair and stress, the movies provided a means of escape from the harsh realities of US life and films, with a few exceptions, tended to downplay the worst aspects of the Depression. In part, this was due to the strictures of the Hays Office (see p. 256 below). What is more, under the New Deal, Franklin D. Roosevelt's series of initiatives designed to get the USA back on the road towards recovery, the restrictive practices of the film studios were tolerated. Similarly, during the Second World War, while other industries either nationalized or closed down (vacuum cleaners and motor cars, for example), the film industry was not only left untouched, but it also flourished because the government deemed it an 'essential industry'. Not only did it provide a diversion from the war, but also its help was also enlisted in fighting the war. Studios helped to sell war bonds, they made training and information films, and assisted in producing and disseminating propaganda co-ordinated by the Office of War Information's Bureau of Motion Pictures, such as Frank Capra's '*Why We Fight*' series.

CASE STUDY

Casablanca (Michael Curtiz, 1942) (Warner Brothers)

Casablanca has been described as one of the most typical products of the studio system, which is why we have chosen to focus on it here. Warners produced it for $953,000, Michael Curtiz directed it and it starred Humphrey Bogart, Ingrid Bergman, Paul Henreid and Claude Rains. The film was an instant success and became one of the biggest hits in studio history, winning Oscars for Best Picture (1942 and 1943), Director (1943) and Screenplay (1943); its producer, Hal B. Wallis, won the Thalberg Memorial Award.

Plot: *Casablanca* is set in neutral French Morocco, North West Africa in late 1941, where refugees from war-torn Europe anxiously await exit visas to escape to Lisbon and from there to the USA. The action focuses around the Café Américain owned by Rick (Bogart). Victor Laszlo (Henreid) arrives in Casablanca with his wife Ilsa (Bergman), both trying to escape the Nazis. We learn that Rick had previously had an affair with Ilsa in Paris. The Nazis, as represented by Major

Strasser (Conrad Veidt), are desperate to prevent Laszlo from leaving *Casablanca* and the chief of police, Captain Renault (Claude Rains), is asked to assist.

Production: Warners' mode of production was highly centralized. As Executive in Charge of Production, Hal B. Wallis had first pick of story properties, directors, performers, and any other contract talent. The head of the studio, Jack Warner, also agreed to hire any additional talent that Wallis felt was fundamental to the production. Finally, Wallis had total control to edit the film. As producer, therefore, Wallis had a huge amount of control over the film. Furthermore, Warners' directors were adjusted to the assembly-line mode of production; they were expected to work on four to five films per year with little active participation in preproduction and postproduction. They were excluded from story and script development as well as from editing. Their role was confined almost exclusively to intensive filming, and when most of a film had been completed they were assigned to another project. They had little creative freedom since they were subject to an inflexible studio organization and strict production schedules. This was the case even for Warners' 'star' directors like Curtiz, who had become the studio's top staff director by 1941 having made films such as *Angels with Dirty Faces* (1938), *The Front Page* (1935), *Captain Blood* (1935) and *The Adventures of Robin Hood* (1938).

Genre: *Casablanca* is a love/romantic story and a thrilling adventure/war story in the classical style. It is simultaneously two films, allowing for dual readings and different levels of enjoyment for different audiences.

Style: *Casablanca* exemplified the Warners' style which, more than that of any other studio in the 1940s, tended towards film noir. Warners had already made *The Maltese Falcon* (1941), starring Bogart as a hard-boiled detective in an espionage thriller. Curtiz, who was appointed to direct *Casablanca*, developed a noirish style for the film which continued in his later films *Passage to Marseilles* (1944) and *Mildred Pierce* (1945). The noirish style was based on expert camera movement, low key lighting, rapid pacing and shadows, including many night scenes. Such cinematography fitted in with Warners' strict budget policy and helped to disguise cheap sets, particularly during wartime when materials for set design were lacking and films had to be made in more austere conditions. *Casablanca* illustrates this well: location work was avoided and most of the shooting occurred in a studio. The action rarely leaves Rick's café and most scenes are either interior shots or set at night. The final sequence demonstrates the creativity of the set designers in creating the illusion of a fully operational airport. Filmed on a stage, the view from the hangar depicts a cardboard model plane in the distance. In order to achieve 'realism' and to maintain the perspective, midgets acted the roles of the mechanics.

Script: The film was based on an unpublished play, *Everybody Comes to Rick's* by Murray Burnett and Joan Alison. It was then adapted for the screen by a series of writers before shooting began. Aeneas Mackenzie and Wally Kline began the initial treatment; they were later removed by Wallis and replaced by Casey Robinson, Warners' in-house expert on romantic melodrama. Finally, Warners'

'top script doctors' Julius and Philip Epstein were officially appointed and cred-
ited with the screenplay while Robinson received no official recognition for his
work. During filming, Wallis appointed Howard Koch to rework the character
of Rick, for which he received a credit. And when preview audiences expressed
disappointment with the ending, Wallis himself is alleged to have added the last
line of dialogue: 'Louis, this could be the beginning of a beautiful friendship.'

Stars: Bogart was selected for the role of Rick and on 1 January 1942 he
signed a seven-year deal with Warners for $2,750 per week. Bogart was chosen
because he was the Warners tough guy – cynical and self-reliant. Although he
became a top star at Warners and won an Oscar nomination for his role, he was
still tied to his seven-year contract and went on to make a series of war films.
David O. Selznick loaned Bergman to Warners for $15,000 per week and Paul
Henreid was loaned out by RKO against his will.

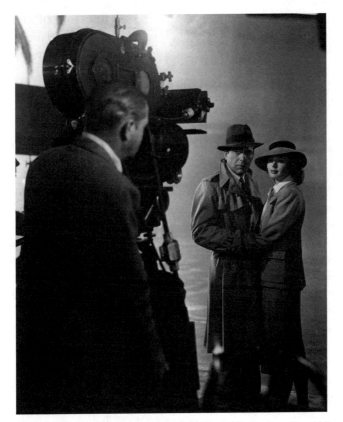

Figure 2.1 *Casablanca*: the star system at work (*Casablanca*, 1942, actors Ingrid Bergman and
Humphrey Bogart, dir Michael Curtiz/© Warner Bros/The Kobal Collection/Woods, Jack)

END OF CASE STUDY

Exercise 2.1

Take any film from the 'mature' studio era (1930–49) and examine how it was produced under studio conditions. You may wish to consider the following elements: producer, script, genre, style, director, stars, set design and sound. How did these elements combine to form a successful film?

Decline of the studio system

In 1949, the studio system began to decline as a result of a number of inter-related factors:

→ Divorcement in 1948 effectively ended vertical integration as the US courts required the 'Big Five' studios to divorce production and distribution from exhibition because the practice broke anti-trust laws; this brought to an end the oligopoly of the studio era. In the 1940s the studios had already agreed to end other restrictive practices such as block booking and blind selling.
→ The huge demand for films during the 1940s led to a rise in independent production, and in an attempt to reduce overheads the majors subcontracted production to other companies.
→ Stars began to seek greater independence from the studios. In 1943 Olivia de Havilland took Warner Brothers to court over her contract; this resulted in the development of fixed-term rather than unlimited contracts. Stars and crew now had greater freedom than ever before.
→ Costs of production rose as a result of wage increases brought about by the growth of trade unions in the industry.
→ Import tariffs were imposed on US films, as foreign countries wanted to prevent the export of dollars while audiences were growing more interested in European art cinema.
→ During the 1950s many families moved to the newly established suburbs; this had an adverse effect on audience figures, as cinemas were mainly located in urban rather than suburban areas. Although drive-ins were introduced, this did not help to arrest the declining trends since such enterprises tended to favour independent films.
→ Television competed with cinema after 1948 and attendances fell as TV became the focus for leisure activity.

Together, these seven factors combined to increase the costs of production while decreasing the revenues which films brought in. Audiences fell by half between 1946 and 1956, approximately 4,000 cinemas closed, and there were massive staff cuts. This led to the end of the 'factory' production-line system as the studios

had no guaranteed outlet for their films. Facing competition from the independents, the studios discovered that their structure was too expensive to maintain. In 1957 RKO, for example, was disbanded. In place of the studio system a new structure for the film industry gradually emerged.

//

US cinema from 1948 to the present

Divorcement and the newly established television networks led to increased competition and decreased integration in the film industry. As a result, film production became more and more fragmented as independent film production was boosted and new smaller companies began to supply low-budget films (see the section below on 'independent US film' for more detail). The majors increasingly subcontracted production and were eager to lease studio space to these companies, which further exacerbated the fragmentation of the US film industry. During the 1950s the major studios also increasingly moved into producing TV programmes.

Although structural changes in the mode of film-making from the 1950s onwards may have resulted, it can still be debated whether this actually constituted a decisive break with the traditions of the studio system. The term 'New Hollywood' may be widely used to refer to the post-1950s film industry in the USA, but there is a great deal of debate over what is actually 'new' compared with the earlier studio system. Labels and periodizations that seek to divide the industry into distinct periods are continuously in dispute and an academic consensus has not yet been reached.

Oligopoly

Film production is still dominated by seven major studios: Warners, Paramount, Disney, MCA/Universal, MGM/UA, Twentieth Century Fox and Columbia Tristar. Together they produce 33 per cent of films in the USA, but receive 90 per cent of revenue. Furthermore, the majors have continued to control domestic and international distribution, and although the theatre chains had been split off in 1948 they still continued to dominate exhibition. Douglas Gomery (2007) has called this new arrangement a 'bi-lateral oligopoly', replacing the oligopoly of the period 1930–49.

Vertical integration

The anti-trust legislation of 1948 forced the majors to divorce their lucrative exhibition arms, resulting in a major loss of revenue. In 1985, however, this legislation was overturned, reflecting President Ronald Reagan's more tolerant attitude towards big business, once again allowing the major studios to buy profitable

theatre chains. Thereafter Coca-Cola (the owners of Columbia) bought the Walter Reade chain; MCA/Universal bought a 49 per cent share in Cineplex Odeon; Columbia/Sony bought Loews Theaters; and Paramount and Time-Warner Brothers both bought their own cinemas in the UK, known as UCI and Warner Village Cinemas respectively. However, this trend has again reversed, this time with studios and their conglomerate owners choosing to distance themselves from ownership of exhibition facilities. In 1998, Cineplex Odeon Theatres merged with Loews Theatres to form Loews Cineplex Entertainment Corporation which was merged with AMC Entertainment in 2006 to form the second largest theatre chain in the USA. Regal Entertainment Group owns the largest exhibition chain after amalgamating Regal Cinemas, Edwards Theatres and United Artists Theatres in 2001. Warner Village Cinemas was bought by SBC in 2003 and rebranded Vue Cinemas while UCI was taken over by Odeon Cinemas in 2004.

The package unit system

In place of the studio system and its mass production of films, a new 'package unit system' developed in the 1950s whereby individual productions were wholly or partially financed by a studio. Under the studio system ideas were developed almost entirely within the studio, but now 'packages' were developed outside the major studios, which then became sources of labour and materials for film production. In the absence of mass production, major companies had to compete for projects initiated outside their studios. Independent producers assembled a package consisting of a script, director and stars on a one-time-only basis in order to acquire finance. The producer, rather than a mogul or studio executive, was now responsible for a film, overseeing its progress from conception to exhibition (see Chapter 6). Alfred Hitchcock, for example, had a contractual agreement with Universal to use their studio staff and equipment.

Film-makers, however, were still reliant upon the majors for finance, production and distribution. Studio executives, with little experience of industry, gambled on bankable producers, directors, and stars with strong track records. This caused a shift in power away from the major studios towards new 'star' producers, directors and actors. Film-making is now increasingly dominated by 'the deal' negotiated between the producer and the studio. Nowadays the star may also receive a percentage of the profits. As control has shifted from the studios to the producers and directors, responsibility for the budgets has moved away as well, with the result that the influence of producers and directors has increased. Furthermore, many directors now enjoy more creative freedom to pursue their personal and artistic vision.

The major studios have been willing to tolerate this trend towards expanding budgets. Since the early 1950s the US film industry has been increasingly hit-driven following the success of big-budget, star-studded blockbusters such

as *The Ten Commandments* (1956) and *The Sound of Music* (1965). The budget for the former ($12 m) broke the all-time record for a film at that time.

From the 1960s onwards, the major studios have followed a 'boom or bust' philosophy and this trend has become particularly marked since the 1970s as it was matched by increasing box-office figures. Thomas Schatz argues that not only has the blockbuster mentality significantly intensified among the major studios, but since the release of Steven Spielberg's *Jaws* (1975), it has also been consolidated. According to Schatz, *Jaws* underlined the value of saturation booking and advertising and the increased importance of a film's box-office performance in the opening weeks of its release. It set new standards for popular cinema and convinced the film industry that an expensively produced and highly publicized film will automatically turn into a blockbuster (Schatz, 1993, pp. 17–25). Compare this to the tight budgets and schedules of the studio system era.

Today the industry's success is based upon very few films. Approximately one film in ten makes a profit on the first run, and so the majors release only 150 films per year between them in an attempt to minimize their financial risks. Compare this to the 350 films that were produced in one year at the height of the studio system. In planning new productions studios increasingly look for sequels, prequels, series and copies of other successful formulae to try to build upon an already proven formula.

Style

In contrast to the 'classical' film form of the studio era, films that came out of the post-1948 US film industry did not always follow mainstream film techniques. While classical conventions were and are still in evidence, greater individuality and creativity on the part of the director, together with an increased willingness to incorporate European art cinema, led to the appearance of more 'alternative' films (see Chapter 5 on alternative cinema). A new generation of directors was emerging whose styles had been shaped by influences very different from those of the studio system. Many of these new directors had been through film schools and had encountered alternatives to mainstream US film. Directors such as Francis Ford Coppola, Martin Scorsese, George Lucas and Steven Spielberg were labelled the 'movie brats' because of the way they challenged established directors and film styles. However, this initial challenge soon came to be seen as US cinema's saviour. A number of the 'movie brats' films of the 1960s (*The Graduate*, *Bonnie and Clyde*, *Midnight Cowboy*, *Easy Rider*) embodied alternative and 'art' techniques. These films were relatively low budget but were very popular with teenage audiences because of the issues covered, the styles used and the frequent use of contemporary music. The studio was no longer responsible for the style of a film. Whereas previously the studio could be distinguished by a film's 'look', under the new conditions it was very difficult to discern a film made by a particular studio as there was no consistency.

Genre

Under the new structure, the standardized conventions of genre were largely discarded. Instead of the formulaic genre mode of film production of the studio system, the US film industry has increasingly espoused innovation and hybridity. Despite the blockbuster mentality, the success of two relatively inexpensive and unconventional films, *Butch Cassidy and the Sundance Kid* (1969) and *M*A*S*H* (1969), caused the US film industry to begin changing direction. More innovation was introduced as a new generation of US-based directors including Robert Altman, Arthur Penn, Mike Nichols, Bob Rafelson, Stanley Kubrick and Roman Polanski emerged, influenced by the European art cinema of Bergman, Fellini, Truffaut and Antonioni, to join forces with the movie brats.

Without the restrictive walls of genre, such directors were able to experiment with as well as challenge generic conventions. This has also taken on an economic dimension for the major studios since mixing genres could broaden the potential appeal of a film. As we have seen, *Casablanca* was an early example of this, blending a love story, a romantic thriller and an adventure–war story. More recent examples include *Star Wars* (1977), a mix of science fiction, Western, action and war; *Blade Runner* (1982), science fiction, action/adventure, detective, film noir and horror; and *Pulp Fiction* (1994), gangster and comedy. In New Hollywood, genres have become blurred and often hybrid, particularly since the emergence of postmodernism (for more detail see Chapters 12 and 14).

Free agents

The ending of studio contracts for creative personnel in the early 1950s meant that important stars, directors, writers and other talent could now negotiate their own deals with the production companies. Increasingly, agents negotiated deals with studios on behalf of individuals, thus ending the restrictive contracts of the studio system. The most powerful talent agencies today are the Creative Artists Agency, the William Morris Agency, International Creative Management and MCA.

The end of the contract system and the decline of the rigidly hierarchical studio mode of production combined to give more creative autonomy to the director. Freed from the restrictive directives, budgets and schedules of the studio moguls and executives, a director could impose a more personal imprint upon a film. S/he now had more input into preproduction and postproduction, overseeing story and script development, casting and editing. This new power was validated by the emergence of auteurism (see Chapter 13 on authorship).

Similarly, it can also be argued that actors can now have more input into their roles, interpreting them with more individuality than was possible under the studio system. The power of star actors has also increased massively since the ending of the restrictive contract system. It has even been suggested, notably by John Boorman (*Deliverance*), that five or six key stars have usurped the studios

in the hierarchy of the US film industry. This power has translated into bigger fees, and many stars now have creative control over a film, including approving its final cut (see Chapter 15 on stars). The overall effect has been a shift in power away from the studios and an increase in film budgets.

New technologies

Since the studio system era, the US film industry has continued to see new technologies developed which have played a significant part in the success of the industry. This happened in two ways. First, improvements in camera, sound, colour, special effects, viewing and computer/digital technologies have led to the creation of more technologically sophisticated films which have helped attract audiences back into the cinemas (see Chapter 10 on film technology).

Second, the major studios sought to maximize the potential of the rapid growth of new media technologies, in particular cable, satellite, video, DVD and digital technology. Cable and satellite stations were eager to pay large sums to screen US films, and increasingly most films now recoup initial budgets on DVD sales and rentals. Altogether, the revenue from cable TV, satellite, rental and DVD sales has begun to overtake that from theatrical release.

Context

As was the case during the days of the studio system, US films continued to be significantly determined by the context in which they were produced. The onset of the Cold War in 1947, the investigations of the House Un-American Activities Committee (HUAC) into the film industry in 1947 and 1951, and the hysteria of the McCarthy years combined to produce a climate of fear and a blacklist. The result was a decline in socially conscious films and the rise of the anticommunist and science fiction feature. The ending of the blacklist by the end of the 1950s re-energized US film production. By the late 1960s anti-establishment and counter-cultural tendencies were clearly evident in US film, no doubt influenced by the assassination of JFK, by the Beatles, the pill, drugs, US involvement in Vietnam, and the high-profile assassinations of Martin Luther King and Robert F. Kennedy. Furthermore, the Production Code had been liberalized since the early 1960s, and was formally dropped in 1968. By this point the Civil Rights movement of the 1950s had become more militant and violent, transforming itself into Black Power, and this was matched by the students' and women's struggles. These issues spilt over into the 1970s, exacerbated by continued involvement in Vietnam. Watergate compounded the USA's troubles by revealing the presidency to be flawed and corrupt. In the 1980s, however, Reagan sought to restore confidence in the USA and its foreign policy, and this decade saw a renewed interest in Vietnam and other conflicts. This was the period of 'high concept' film-making (see Wyatt, 1994). By the 1990s the

end of the Cold War led the film industry to seek new enemies both outside and within the USA. This has perhaps accelerated since 11 September 2001.

CASE STUDY

Apocalypse Now (Francis Ford Coppola, 1979)

The production of *Apocalypse Now* most clearly demonstrates the dramatic changes in film production following the decline of the studio system. United Artists produced it for more than $30m, Francis Ford Coppola directed it and it starred Marlon Brando, Robert Duvall and Martin Sheen. The film was a box office success, taking in over $37m, receiving favourable critical reviews and winning Oscars for Best Cinematography and Sound (1979).

Plot: *Apocalypse Now* can be read both as a physical journey, up a primitive river in the quest for a man whose discovery promises revelation, and as a metaphorical journey into the darkest recesses of the human mind. During the Vietnam War, Captain Willard (Sheen) is sent along a tributary of the Mekong into a tip of Cambodia to assassinate Colonel Kurtz (Brando), once a promising young officer but now insane and surrounded by a gang of worshippers. Coppola's stated reason for making the film was to assist US citizens in 'putting the Vietnam experience behind them'. It has since emerged as a provocative and influential film that closely approximates the horror as well as the emotional and physical upheaval of the US experience in Vietnam. *Apocalypse Now* demonstrates the combination of astute political comment with spectacular aesthetics.

Production: Coppola was one of the 'movie brats': a film school–educated director (in this case UCLA) influenced by European art cinema who had directed *The Rain People* (1969) and the first two parts of *The Godfather* (1972, 1974). In contrast to the tight production schedules of the studio system, preproduction began in mid-1975 and postproduction ended in 1979. The film was originally scheduled to be shot over six weeks and to open in 1977, but various setbacks, such as a typhoon that destroyed the sets, and financial overruns, plagued filming, and shooting lasted 16 months instead. Overall, production lasted for four years. Similarly, the initial budget was $12m, far in excess of earlier studio budgets, and this rocketed to $31.5m.

Genre: Although it can be classified as a war story, the film's philosophical implications, which examine the horror and madness of war, take it beyond the traditional war genre. Its controversial political comment, for example, widened the boundaries of the war genre, as *Casablanca* had done. It has also been described as a 'quest' film that moves through several other genres such as thriller, horror, adventure and even comedy.

Style: In contrast to the studio influence on products of the 1930s and 1940s, UA was not responsible for the style of *Apocalypse Now*. The film owes its particular style to the vision of Coppola and cinematographer Vittorio Storaro,

combining art cinema with popular entertainment. It contains some spectacular set pieces, such as the opening dissolves and superimpositions of Sheen's face with a ceiling fan and a helicopter attack; the 'Ride of the Valkyries' battle sequence; and the napalm destruction of Kurtz's compound during the final credits of the film. In contrast to earlier productions that were almost entirely filmed on studio sets, *Apocalypse Now* was filmed on location in the Philippines.

Script: *Apocalypse Now* was a loose adaptation of Joseph Conrad's novel *Heart of Darkness* (1899) co-written by Coppola and John Milius (the latter went on to make militaristic films such as *Red Dawn* (1984)). Michael Herr, who had written *Dispatches* (1977) using his experiences as an army correspondent in Vietnam, provided additional material. As a result, the film displays a clear ambivalence in regard to its view of the Vietnam War, displaying both pro- and anti-war sentiments. Many scenes and cinematic techniques work to further a pro-military, pro-war interpretation of the conflict, but these are always balanced by anti-war, dove-like sentiments. These opinions are never wholly reconciled and lead to what can be described as a somewhat surreal and confusing ending that did not leave critics completely satisfied.

Stars: Harvey Keitel was originally cast as Willard, but two weeks into production Sheen replaced him. In contrast to the studio contracts, Brando was paid $1 m in advance to be in the film. He turned up on set late, overweight and allegedly drunk, having read neither the script nor the book on which the film was based, illustrating the new power held by key stars. The film also featured many young actors who would later become stars, such as Dennis Hopper, Laurence Fishburne and Harrison Ford.

END OF CASE STUDY

Exercise 2.2

Look at the production of a particular US film made after the 1960s. What are the differences and similarities between films made under the new system and the studio system? How do differences in the structure of the film industry affect the film itself?

Independent US film

Independent US film is not a new phenomenon. It has existed since the early days of the film industry; indeed, many of the major studios began life as independent production companies. During the height of the studio system independent film companies known as 'poverty row', such as Disney, Republic, Monogram and Tiffany, supplied B-features for double bills.

Divorcement in 1948 boosted independent film production and companies like Allied Artists and American International Pictures began to supply low-budget films for the growing teenage market. In this period, the majors were eager to lease studio space to independent production companies and increasingly subcontracted production to them; this resulted in such films as *Marty* (1955) and *The Bachelor Party* (1957), which were produced by the Hecht-Lancaster company established in 1947. UA, which was the distributor for such films, released several notable films including *Kiss Me Deadly* (1955), *The Night of the Hunter* (1955), *The Sweet Smell of Success* (1957) and *Paths of Glory* (1957).

In the 1960s, the relaxing of the Production Code (see Chapter 11 on cinema, audiences and society), together with the further decline of the majors, favoured the independents. In 1960, John Cassavetes made *Shadows* entirely outside the studio system and hence has been described as the 'father' of independent US film, drawing upon a long history of maverick film-making that was pioneered in the USA by Orson Welles and *Citizen Kane* (1941). During the 1970s, companies began to specialize in certain genres: martial arts, action, erotica, blaxploitation and horror. Many of today's independent film-makers cut their teeth on the low-budget films of the 1970s.

Fuelled by the expansion in home video and cable, independent films have been ever more prominent since the 1980s, emerging from companies such as Circle Films, Hemdale, Island Pictures, New Line Cinema, Cinecom, Cannon, De Laurentis, New World and Miramax. Low-budget productions could be financed entirely from presales to video, thus missing out the need for cinema release and going straight to video. Some of these companies attempted to work outside the sphere of the majors and accordingly fared badly. During the mid- to late 1980s, however, a new pedigree of 'neo-indies' emerged. Carolco, Morgan Creek, Castle Rock, Imagine Entertainment and Largo all possessed sufficient finance to produce their own films outside the major studios, but they worked very closely with them for distribution and exhibition. Independent film is very much alive in the USA today, enjoying both critical and box-office success. Dimension Films, for example, reinvigorated the teen horror genre with the *Scream* and *Scary Movie* series.

How do we define independents?

Can independents be defined economically? A truly independent company, it is argued, can finance, produce and distribute its own films. It operates outside the control of the majors and competes directly with them for a share of the film market. However, even the large independents are not truly independent, as they are reliant on exhibitors, sometimes linked to the majors, for their films to be screened. In reality, independent film-makers choosing to work outside the constraints of the major studios, whose films are mostly low-budget in order to retain creative freedom, are closer to being fully independent as their films are often screened outside the exhibition chains owned by the majors.

However, independent production companies are often owned by a larger company; for example, much of Castle Rock's initial funding came from Coca-Cola, which used to own Columbia. Castle Rock is now a subsidiary of Warners, and Miramax is owned by Disney. Furthermore, independents are usually reliant on the majors for distribution (Castle Rock uses Columbia) and some may even receive studio backing, which surely militates against their total freedom. What is more, independent films are often planned in close co-operation with the majors for exhibition and distribution rights as well as finance. Although Spike Lee's *Do the Right Thing* contains some alternative aesthetic and ideological elements and was produced by his own independent production company, 40 Acres and a Mule, it was made for MCA/Universal. Nor are all independent production companies small- or low-budget. Companies like Carolco, Morgan Creek, Castle Rock, Imagine and Largo were respectively responsible for these big-budget, star-studded blockbusters in 1991: *Terminator 2, Robin Hood, City Slickers, Backdraft* and *Point Break*. However, Carolco and Largo have now ceased production. Most independent companies agree that the label 'independent' is somewhat misleading (see also Chapter 9). While it is agreed that an independent is defined by its capability to finance its own films, today most independent film companies can be described as simply 'outgrowths' of the majors.

The Sundance Film Festival has existed in one form or another since 1978, adopting its current name in 1991. It is an annual event held in Utah state, which provides a platform for independent films with prizes for US and international productions. The event has become a respected supporter of films made without the backing of the major film companies and helps promote new directors and artists. The scale of the festival grows year by year and it has become an institution looked to by those aiming to make films outside the mainstream genres or outside mainstream sources of funding. However, the festival is expensive, and there has been a gradual reliance on sponsorship from the types of companies from which independence is sought, such as Sony, Paramount and Warner. Sundance has helped launch the careers of successful film-makers such as the Coen brothers, Quentin Tarantino, Kevin Smith and Jim Jarmusch. Independent directors often evolve to gain mainstream recognition with an 'Oscar' at the annual Academy Awards, as have the Coen brothers and Tarantino with their screenplays for *Fargo* and *Pulp Fiction* respectively.

Joel and Ethan Coen have been writing and directing feature films since 1984. Their first production, *Blood Simple*, received a Sundance Film Festival award and helped start their careers as independent film-makers. As with many other independent film-makers they have eventually resorted to co-productions involving major film companies. With their rapidly established successes it wasn't hard for them to raise finance. However, of their fifteen films only five have involved majors, these being Twentieth Century Fox, Warner, Universal and Paramount.

The Coens' reputation as independent film-makers is due in part to the types of films they make, lying as they do outside the mainstream. While many films

embody more than one genre, their films often mix several genres in unlikely combinations. It is not unusual to find comedy, crime, thriller and drama alongside each other. The humour is often dark, the crimes violent, the drama quirky and the thrillers noirish. Storylines tend to be loose, can be complex and frequently take unexpected turns.

CASE STUDY

Do the Right Thing (Spike Lee, 1989)

Spike Lee's first feature film was *She's Gotta Have It* (1986) and was a commercial, as well as critical, success. Lee's position as a director was further established with *Do the Right Thing*, followed by an average of a film per year over the next nineteen years. Not only was *Do the Right Thing* a financially independent production but it also established an independent stance on the issue of race. Lee's films haven't relied on the Sundance Film Festival for promotion and nowadays his independent productions gain publicity from his well established reputation.

Plot: It's a hot day in Brooklyn and racial tensions that have been bubbling under rise to the surface. The community is divided between blacks, Italians and Koreans, overseen by white police officers. Mookie, played by Spike Lee, delivers pizzas for Sal, an Italian who owns the popular local pizzeria. The area is predominantly black and a request is made for pictures of famous black people to be placed on the pizzeria's walls but Sal refuses, resulting in an unsuccessful attempt at a boycott. The mutual suspicion and hatred between the racial groups builds as the story develops and ends with a fight in the pizzeria which results in a key local character, Radio Raheem, dying when the police try to arrest him. The pizzeria is burnt down in revenge. The film ends the next morning with Sal and Mookie exchanging angry observations on the previous day's events. The ups and downs, and highs and lows of the local community are overseen by the local radio dj, Mister Señor Love Daddy, who tries to encourage peace between the sections of the community.

Production: Spike Lee set up his own production company, 40 Acres and a Mule Filmworks, in 1983, a name referring to the compensation promised to freed slaves after the Civil War. However, the big problem for independent film-makers is how to get their films distributed and exhibited. Spike Lee used Universal Pictures for distribution.

Genre: The film's primary classification is Drama; it focuses on relationships with a strong emphasis on emotion. However, it is a political film because of the way it places race at the centre of the film. Lee tackles the issue in a complex manner, criticizing all areas of the community, and complements the main theme with other issues such as parenthood, the generation gap and black economic aspirations.

Style: Lee goes beyond using simple storytelling techniques. There is a strong use of music which goes beyond being merely incidental by placing contemporary songs at key moments in the narrative. Lee also has characters talking straight to camera as a way of getting across the racial hatred of the various groups. A frequent use of low and tilted angles adds further to the film's unique visual style.

Script: If the term 'auteur' is to be used then Lee is a good example. He wrote the script for *Do the Right Thing* and also directed and starred in the film. His scripts have recurring themes and elements too. They are often set in Brooklyn and race is usually a key element of the plot, even if not directly earmarked as such. He is often critical of aspects of the black community as well, and has emphasized the need for blacks to shape their own economic circumstances while maintaining their own cultural identity.

Stars: Lee has become a star himself and usually appears in his own films. Amongst the stars who frequently appear alongside him are Samuel L. Jackson and John Turturro.

Exercise 2.3

Pick an independent film of your choice and assess how its independence may have shaped the values and content of the film. Does it have any unusual features or striking storylines that set it apart from mainstream US films? Consider how far any film can be truly independent.

END OF CASE STUDY

CONCLUSION

We have seen in this chapter how US cinema has changed over time. The US film industry has developed from a highly structured, centralized, factory-style studio system to a more fragmented package unit system in which individual films are pitched by independent producers to competing studios. The result has been a shift from assembly-line production, with its formulaic use of genres, studio, styles and stars, to a system in which directors, stars and others have more creative freedom to work outside the limitations of genre, studio style, budgets and other restrictions. Beneath the surface, however, there are some essential continuities and similarities between these two periods of US film history. Despite a short interlude, the film industry in the USA today, like the old studio system, is still essentially a vertically integrated oligopoly. In addition, the studios both of the past and of today have utilized new technologies to maximize profits and to bring audiences into cinemas. Independent film has always existed in the USA but flourished particularly during and after the 1950s

following the decline of the studio system. While it may now be hard to distinguish an independent from a major studio, independent films are still a key part of film output in the USA.

SUMMARY

↝ Both the studio system and post-1948 US film industry can be described as 'oligopolies', dominating through vertical integration.

↝ The studio system was structured according to assembly-line production, leading to a high number of films each year. The post-1948 US film industry is arranged around a 'package unit system', producing fewer films and more blockbusters.

↝ Each studio developed its own style and favoured particular genres, but today this is not so evident.

↝ The contract system which tied directors, crew and stars to the studio has now ended, leading to greater creative autonomy.

↝ Studios have maximized the potential of new technologies to benefit film production.

↝ US films have always been influenced by the context in which they were made.

↝ Independent US film has existed since the film industry's origins, but was boosted by 'divorcement' in 1948, the relaxing of the Production Code in the 1960s and the expansion of home video and cable.

↝ Economic independents finance, produce and distribute their own films, which are often but not always small and low-budget, operating outside the control of the majors. However, larger companies often own independents and the majors work very closely with them.

REFERENCES

Biskind, P. (1998), *Easy Rider, Raging Bulls: How the Sex 'n' Drugs 'n' Rock 'n' Roll Generation Saved Hollywood*, London: Bloomsbury.

Burman, M. (1999), 'The Val of Death', *The Guardian Review*, 8–9.

Cook, D. A. (1996), *A History of Narrative Film*, 3rd edn, New York and London: W.W. Norton & Co.

Gomery, D. (2007), *The Hollywood Studio System*, Berkeley: University of California Press.

Schatz, T. (1993), 'The New Hollywood', in J. Collins, H. Radner and A. P. Collins (eds), *Film Theory Goes to the Movies*, London and New York: Routledge, 8–36.

Schatz, T. (1998), *The Genius of the System: Hollywood Film-making in the Studio Era*, London: Faber & Faber.

Wyatt, J. (1994), *High Concept: Movies and Marketing in Hollywood*, Austin: University of Texas Press.

FURTHER READING

Balio, T. (ed.) (1985), *The American Film Industry*, Madison, WI: University of Wisconsin Press.

Perhaps dated but still useful and thorough history of the US film industry.

Casper, D. (2007), *Postwar Hollywood 1946–1962*, Oxford: Blackwell.

Detailed account of postwar Hollywood.

Cook, P. (ed.) (2008), *The Cinema Book*, 3rd edn, London: BFI.

A key film studies anthology covering many topics related to the history of the US film industry.

Gomery, D. (2007), *The Hollywood Studio System*, Berkeley: University of California Press.

A foundational text exploring how the Hollywood studio system functioned.

Hillier, J. (1992), *The New Hollywood*, London: Studio Vista.

Explores the US film industry in the contemporary era.

King, G. (2005), *American Independent Cinema*, London: I B Tauris & Co Ltd.

Focuses on the US 'indie' and what that means. Case studies include *Kill Bill Vol. 1*.

Lewis, J. (1998), *New American Cinema*, Durham: Duke University Press.

A wide-ranging and eclectic anthology exploring various aspects of American Cinema.

Maltby, R. (2003), *Hollywood Cinema: An Introduction*, 2nd edn, Oxford: Blackwell.

A dense but classic text.

McDonald, P. and Wasko, J. (eds) (2008), *The Contemporary Hollywood Film Industry*, Oxford: Blackwell.

A series of useful essays exploring the contemporary US film industry.

Neale, S. and Smith, M. (eds) (1998), *Contemporary Hollywood Cinema*, London and New York: Routledge.

Another series of useful essays exploring the contemporary US film industry written by some of the biggest names in film studies.

Wasko, J. (1994), *Hollywood in the Information Age*, Cambridge: Polity.

An in-depth investigation of the impact of new technologies on production, distribution, exhibition and marketing in Hollywood.

FURTHER VIEWING

A Personal Journey with Martin Scorsese through American Movies (BFI, 1995)
> An extremely useful and personal account of American cinema by Martin Scorsese. BFI, 21 Stephen Street, London W1T 1LN

Darryl F. Zanuck – Twentieth Century Filmmaker (Twentieth Century Fox, 1995)
> A documentary focusing on Twentieth Century Fox studio head Darryl F. Zanuck. http://www.fox.co.uk/

Easy Rider, Raging Bulls: How the Sex 'n' Drugs 'n' Rock 'n' Roll Generation Saved Hollywood (BBC, 2003)
> Documentary based on the Biskind book. BBC Active, BBC Television Centre, Wood Lane, W12 7RJ

Hearts of Darkness: A Film-maker's Apocalypse (Bahr & Hickenlooper 1991)
> A fascinating documentary chronicling the making of *Apocalypse Now*. http://www.zoetrope.com/

The Universal Story (Universal, 1995)
> A documentary exploring the history of Universal Studios. http://www.universalstudios.com/

Chapter 3
British cinema

British cinema has existed since 1895, and many of its innovative and memorable films have attracted international acclaim. It has covered many different themes, styles and genres and produced numerous stars, from Charlie Chaplin to Kate Winslet, and auteurs from Alfred Hitchcock to Ridley Scott who have gone on to work in Hollywood and elsewhere. This chapter aims to identify what exactly is meant by the term 'British cinema' and to trace its history in terms of the films, the industry and the audiences. British cinema has taken different forms at particular moments in the nation's history, and these trends and developments are to be identified and explained. There is not, of course, just one British cinema; the countries that make up Great Britain – England, Scotland and Wales, all have very different cultures and film industries. The picture is further complicated with reference to the disputed territory of Northern Ireland which is part of the United Kingdom of Great Britain and Northern Ireland. All four countries are discussed within this chapter and their films are, to varying degrees, funded by the UK Film Council. However, the reality is that film production has been, and still is, concentrated in England, as illustrated by the preponderance of references to English films in this chapter. Case studies will be used to identify how aspects

of British culture and society have been represented in British films, in terms of class, race, gender, sexuality, age and national and regional identity.

///

What is British cinema?

There are two principal approaches to defining British cinema: the first approach emphasizes the role of the film industry, while the second is concerned with the films' representations of British cultural life. The British film industry has existed in one form or another since the beginning of the twentieth century and as such can be regarded as an institution – it is well established, even though it goes through periodic changes. When we talk of British cinema as an institution, we are concerned with the industry in terms of ownership and control, of how films are financed and who produces, distributes and exhibits films. The institutional definition of British cinema, as determined by government, has changed much over the years but has essentially referred to finance, production context and personnel, and cultural content. Thus, for a film to be classified as British, it has been necessary that a certain percentage of the finance, production staff and actors, and film content be British, or that the film is made in Britain.

Film finance

Using this current approach to determine the national characteristics of a film results in *The Full Monty* being classified as only partly British as its finance was supplied by Twentieth Century Fox. Similarly, *Chariots of Fire*, despite looking every inch a British film, was in fact mainly financed from the USA and Egypt. We might also imagine that the Bond films are British because of the nationality of their hero, the nationality of much of the production staff and the location of many of the storylines, but in fact the latest Bond movies were financed and thus are owned by MGM/UA, an amalgamated US company. Nor is the director useful as an indication of the nationality of a film. Ridley Scott and Alan Parker are British, as of course was Alfred Hitchcock, but most of their films have been US productions, in that they were financed by US companies. Again, using the economic and production-based definition, *Land and Freedom*, a film set in Spain about the Spanish Civil War, is classified as British because of the source of its funding (Film Four, the film finance wing of the TV company Channel 4), plus the nationality of its director, Ken Loach, and of much of the production staff.

While the majority of films screened in Britain are funded by US companies, a significant number of low-budget films have drawn their funding from British companies, and some have gone on to be successful. Film Four became the main source of funding in Britain and financed successes such as *Secrets and Lies* (1995) and *Trainspotting* (1995), as well as co-financing Mike Newell's *Four Weddings and*

a Funeral; however, the follow-up, *Notting Hill*, was financed without Film Four by Universal and Polygram. Co-financing is now common in Britain and has seen the British Film Institute partly funding Ken Loach's *Riff-Raff*, the Arts Council contributing to David Caffrey's *Divorcing Jack* and the BBC funding Lynne Ramsay's *Ratcatcher*. A further source of funding is the National Lottery, which has made significant contributions via various organizations, the main one now being the UK Film Council. However, a significant number of films made by small production companies which have received lottery funding have been critical and financial failures. Merchant–Ivory have also been a consistent source of funding for what has been called 'heritage cinema'. However, some sources of funding have unfortunately disappeared, such as Goldcrest and Palace Pictures, both companies folding in the 1980s. Production costs for British films are extremely low when compared with Hollywood films, for which costs have run as high as $600 million. Median production costs for solely British-financed films made during 2007 were £1.9 million (UK Film Council Statistical Yearbook, 2008, p. 124).

British culture

The institutional approach to British cinema clearly leads us towards some important observations about Britain's film industry in terms of finance and ownership, but the cultural approach is also useful in providing an understanding of British cinema, although the emphasis is on the films themselves rather than the industry. The UK Film Council provides three categories that can result in a film being regarded as 'British', based on a 'points system'. Firstly, films may be about aspects of British culture, may be made in Britain or have a substantial number of British citizens involved in their making. Secondly, films may be produced with countries who have signed up to the European Convention on Cinematographic Co-Production. Thirdly, films may be produced with countries who have signed up to the Bi-lateral Co-production Treaties. Thus, despite *Slumdog Millionaire* (2008) being set in India and being based on an Indian novel, it is classified as a British film as it was financed by Film Four, had a British director, Danny Boyle, and the UK has a co-production deal with India.

A cultural definition is concerned with how films represent aspects of British life, especially with regard to social groups and ideologies that exist within British society. Thus the cultural approach looks at how issues relating to class, race, gender, sexuality, age and national and regional identity, as well as values and beliefs about social institutions and practices such as family, work, leisure, religion, education and politics in Britain, are depicted in films. A cultural approach enables films such as *Chariots of Fire* and *The Full Monty* to be interpreted as British films, even though their finance came from outside the UK, because they deal with aspects of British culture.

Representation is a central issue in every sector of the media, be it film, television or some other media form, because the media mediate; they show

things. Representation is an important and often controversial topic in studies of the media because there is always more than one way to represent something; choices are always made. Representations can be positive or negative, dominant or alternative. Thus there is always the possibility of an individual, or a social group, believing that they have been represented inaccurately or unjustly, in other words, misrepresented. Behind representations lie ideologies; values and beliefs shape how things are shown to us. Film, like other media, is a form of indirect communication: we experience an interpretation of the world second-hand. The messages we receive are mediated; the process of production comes between us and the things being represented within a film. It is always possible that our perception of the world, of British society and the social groups it contains, could be shaped and influenced by the representations we experience in films. What appear to be natural ways of seeing aspects of British society may in fact be no more than selective interpretations. For this reason, the latter part of this chapter focuses on identifying representations and stereotypes in British films that have perhaps resulted from the repeated use of particular representations over a period of time.

Exercise 3.1

Identify and describe the criteria you think should apply for a film to be regarded as 'British'.

An overview of British cinema

One of Britain's first film-makers was Birt Acres, who began by making actuality films, one of which was *Rough Sea at Dover* (1895). G. A. Smith tended more towards short stories such as *Grandma's Reading Glass* (1900). Experimentation was an important element in early British films and both Cecil Hepworth (*Explosion of a Motor Car*, 1900) and James Williamson (*The Big Swallow*, 1901) developed a range of special effects for their early films, which tended to be comedies (see Chapter 1 on early cinema).

It was at least ten years before an identifiable film industry emerged in Britain. The above film-makers had established their own production companies, the main ones being the Hepworth Manufacturing Company, the Sheffield Photographic Company, Williamson's Kinematograph Company and George Albert Smith Films. Exhibition of films was led by the Associated British Pictures Corporation and Gaumont-British (a subsidiary of the French company). By 1912 the British film industry was deemed large enough for it to require a national organization to monitor and regulate the content of films, and the industry set up the British Board of Film Censors in 1912. However, the First World War interrupted the

development of the British film industry. Before the war, 15 per cent of films screened in Britain were British, with 50 per cent being supplied by Europe and the remaining 35 per cent coming from the United States, but by the end of the war the US figure was 80 per cent (Murphy, in Barr, 1986, pp. 50–1).

The British studio system

The dominance of US cinema in Britain has steadily grown since the First World War, despite intermittent attempts to hold back its control of UK production, distribution and exhibition. The British government passed the Quota Act in 1927, decreeing that exhibitors had to ensure that at least 5 per cent of films screened were British and that this figure should rise to 20 per cent by 1936 (Murphy, in Barr, 1986, p. 52). In fact, the quota percentages were often exceeded, but many of the British films shown were of poor quality and were cheap, rushed productions (known as 'quota quickies') whose sole purpose was to meet the quota target. These films were often made by British companies financed by Hollywood studios. However, many of the new companies that emerged as a result of the quota legislation went bankrupt with the ending of the silent era as they could not afford the sound technology required to keep pace with larger production companies.

While the Hollywood studio system had clearly taken shape by the late 1920s, a British version was also emerging which consisted of two 'majors', British International Pictures and the Gaumont-British Picture Corporation, and three 'minors', British and Dominion, London Film Productions and Associated Talking Pictures. Michael Balcon and Alexander Korda were key figures at this time, establishing international reputations as studio heads. Balcon established Gainsborough Studios as a source of popular films, which continued with film production through to the postwar years and became an associate production company as part of the Gaumont-British Picture Corporation. In 1938, Balcon took over as head of production at the newly established Ealing Studios, remaining there until 1959. Major studio facilities were built at Shepperton and Pinewood.

British International Pictures amalgamated with the exhibition company Associated British Cinemas, and in 1929 produced the first major British sound film, which was also Alfred Hitchcock's first 'talkie', *Blackmail*. Other studios moved into producing sound films, some of which became popular abroad as well as in Britain. *Sally in Our Alley* (Basil Dean, 1931) was popular with audiences and was unusual in that it focused on working-class life at a time when films tended to avoid themes relevant to contemporary Britain. Alexander Korda, a Hungarian-Jewish film-maker, built his own studios at Denham and attracted significant financial backing, especially from United Artists. When, in 1933, his London Film Productions made *The Private Life of Henry VIII*, its commercial success in the USA was indicative of the growth of the British

film industry. This expansion in film production capacity resulted in a number of studios being built in the Elstree area, which subsequently became known as 'the British Hollywood'. Another company to join the burgeoning British film industry in the 1930s was British National Films, formed by J. Arthur Rank in 1934. It became a vertically integrated company in 1935 with the formation of General Film Distributors. By the mid-1940s, Rank's company was the most powerful in the British film industry.

Although feature fiction films constituted the vast majority of productions in Britain, an influential documentary film movement was initiated in the late 1920s. As a director and producer, John Grierson was central to the growth of documentary film-making; he believed that films could have an educational, informative and social function. As an employee of the Empire Marketing Board, he was paid to promote trade within the Empire, but his first film, *Drifters* (1929), stands in its own right as a documentary film rather than a marketing exercise. The film revealed the tough life of fishermen at sea and combined documentary footage with imaginative film techniques to produce a successful documentary film. The Empire Marketing Board was dissolved in 1933 and the film unit transferred to the General Post Office, with Grierson at the head of the GPO Film Unit. One of the most popular films from the unit was *Night Mail* (Watt and Wright, 1936), which covered the overnight mail train's journey from London to Glasgow and provided exterior shots of the British countryside and interior shots of the train and of its crew at work. Another key documentary from this period was *Housing Problems* (Anstey and Elton, 1935), which was sponsored by the Gas, Light and Coke Company in an effort to expand its business through the modernization of housing. The film exposed the poor housing conditions in much of Britain through location shooting, combined with interviews and voice overs.

Films for victory

The Second World War was soon to have a huge impact on the British film industry, on both feature and documentary cinema. The GPO Film Unit came under the control of the Ministry of Information and the Unit made documentaries that aimed to strengthen the war effort and maintain morale. *London Can Take It* (Watt, 1940) documented London during the Blitz and illustrated how Londoners coped with the nightly bombing raids by German planes. The Ministry of Information also co-financed some feature films with the aim of uniting the nation and building patriotism. Michael Powell and Emeric Pressburger worked together on several wartime films and caused controversy with *The Life and Death of Colonel Blimp* (1943), to the point where Churchill tried to ban the film. In addition to exposing the old-fashioned ('blimpish') inefficiency of parts of the war effort, the film features a German refugee who has chosen to escape from Nazi Germany and highlights the hostility that can greet a foreigner arriving in Britain.

Wartime films were generally intended to help hold the nation together, to create a unity of purpose against the enemy and prepare the nation for victory. *Went the Day Well?* (Cavalcanti, 1942) tells the story of a complacent English village which is unexpectedly invaded by German paratroopers, supported by a traitorous country squire. The film's message was clearly a plea for all to be vigilant and prepared. *Millions Like Us* (Launder and Gilliat, 1943) emphasizes the common experiences of wartime Britain, using a fictional story to illustrate home life, life at work and leisure activities. There is a strong emphasis on women making the transition from working at home to taking up employment previously carried out by men. *This Happy Breed* (David Lean, 1944) similarly provides a sense of common purpose and shared experiences. David Lean and Noël Coward directed *In Which We Serve* (1942), in which the crew of a sunken British ship are adrift on a life-raft. The survivors on the life-raft include an upper-middle-class captain, a lower-middle-class officer and a working-class rating. These characters, who represented the British class system, shared their experiences and lives and their immediate situation as an example to the rest of Britain about the need for unity across divisions within society for the sake of the war effort.

Gainsborough Studios continued film production throughout the war years, but tended towards melodramas and historical films, which provided an escape from the common realist aesthetic of other wartime films. *Madonna of the Seven Moons* (Arthur Crabtree, 1944) focuses on changing values with regard to femininity and convention, sexuality and repression, as symbolized by mother and daughter. *The Wicked Lady* (Leslie Arliss, 1945) challenges conventional expectations of female behaviour. The female protagonist marries a friend's lover, has an affair, seeks adventure as a highwaywoman, kills someone, and has another affair before being killed herself. These films, and other Gainsborough productions, were popular (particularly with women) perhaps because they raised questions about female identity at a time when such issues were becoming increasingly topical, partly because of the changes in lifestyle that women had experienced during the war years.

The year after the end of the Second World War saw Britain's highest ever cinema attendance figures, with an average of over thirty-one million admissions per week throughout 1946. The main cinema chains were ABC (owned by the Associated British Picture Corporation, whose production wing was BIP) and Odeon and Gaumont-British (owned by Rank). Rank's production facilities had been gradually expanding over the years, with Pinewood Studios being supplemented with the purchase of Gainsborough's Shepherds Bush studios in 1941 and a finance and exhibition deal being signed with Ealing Studios in 1944.

However, Britain's film production capacity had been weakened by the war as a result of resources being redirected and of many employees being called up for national service. In the postwar years US films dominated the British market and this prompted the government, in 1948, to introduce a quota whereby 30 per cent of screenings had to be British films. The Eady Levy was introduced, taking a

percentage of box-office receipts for reinvestment in the film industry. This state intervention by the postwar Labour government was mirrored in other areas of society such as health, education and housing, where the government invested and reorganized rather than leaving the free market to decide.

One of the major directors to emerge in the postwar years was David Lean, who was responsible for many popular films through to the 1960s, including *Brief Encounter* (1945), *Great Expectations* (1946), *Oliver Twist* (1948), *Hobson's Choice* (1953), *Lawrence of Arabia* (1962) and *Doctor Zhivago* (1965). Carol Reed also made his name in the late 1940s with films such as *The Odd Man Out* (1947) and *The Third Man* (1949), both of which contained elements of an expressionist style. Powell and Pressburger continued working together after the war, making films such as *Black Narcissus* (1947) and *The Red Shoes* (1949), which through its effective use of expressionist techniques became an unusual example of popular art cinema.

From comedy to horror

Ealing Studios continued to be a source of popular films, with 1949 seeing the release of *Passport to Pimlico* (Henry Cornelius), *Kind Hearts and Coronets* (Robert Hamer) and *Whisky Galore!* (Alexander MacKendrick). Further successes followed, including *The Lavender Hill Mob* (Charles Crichton, 1951) and *The Ladykillers* (MacKendrick, 1955). These films and others like them became known as 'Ealing comedies'. Actors who came to prominence through these films included Stanley Holloway and Alec Guinness. The studio's success was aided by the agreement previously signed with Rank, but by the mid-1950s cinema attendances were falling, partly reflecting the increasing availability of entertainment via television: there were two million television sets in Britain by 1953. In 1955 Ealing Studios was sold to the BBC. The studio left a legacy of memorable comedy films, identifiably British (or mostly very English) in their style and content, typically dealing with ordinary people in everyday situations, frequently consisting of individuals challenging authority, and often using class and status as key ingredients.

Just as the 1940s saw new directors, actors and film styles coming to prominence, so too did the 1950s. Hammer Films was a small independent film company that produced successful low-budget horror and science fiction films. Hammer took advantage of the X-certificate rating which had been introduced by the British Board of Film Censors in 1951, which allowed for more explicit sex and violence in films. Among the successful science fiction films were *The Quatermass Experiment* (Val Guest, 1955), *X the Unknown* (Leslie Norman, 1956) and *Quatermass II* (Guest, 1957). Hammer's popular early horror productions included *The Curse of Frankenstein* (1957), *Dracula* (1958) and *The Mummy* (1959), all directed by Terence Fisher. Christopher Lee and Peter Cushing achieved fame through their roles in Hammer horrors, which were often remakes of Universal Studios' 1930s horror films.

These films tended to appeal to teenage audiences who saw the realist style of 1940s films and the innocent humour of Ealing comedies as unadventurous and irrelevant to their generation. The phenomenon of the 'teenager' appeared in the 1950s as an awareness of a 'generation gap' grew, manifesting itself in terms of different values and beliefs, especially with regard to sexuality and the role of the individual in society. Teenagers were a cultural market to be targeted because of their relative wealth in terms of disposable income and interests in music, film and fashion. Hammer's last film was *To the Devil a Daughter* (Peter Sykes, 1976) and the company, suffering a decline shared by much of the film industry in the 1970s, went bankrupt in 1980.

Another distinct form of British cinema also began in the 1950s and ended in the 1970s: the *Carry On* films. There were twenty-eight in all, the first being *Carry on Sergeant* (Gerald Thomas, 1958) and the last *Carry on Emmanuelle* (Thomas, 1978); an attempt to resuscitate the genre with *Carry on Columbus* (like all the *Carry On*s, directed by Thomas in 1992) was unsuccessful. The same actors usually appeared in each film and included Sid James, Kenneth Williams, Charles Hawtrey, Joan Sims, Barbara Windsor, Kenneth Connor, Jim Dale and Hattie Jacques. The films' humour arises from the use of sexual innuendo, double meanings, embarrassing situations, stereotyping of gender, sexuality, class and race, and a strong disregard for authority and accepted standards of decency and morality. The films were made possible by, and no doubt found their appeal in, the general questioning of morals that had gradually gained pace in the years after the war and the growth of a more 'permissive' society. The *Carry On* films declined in the late 1970s, perhaps because this process of moral change had been generally concluded and the particular brand of smuttiness which they embodied had been overtaken by more explicit representations of sexuality (for example, in the *Confessions Of* series).

Sex, pop and realism

While the *Carry On* films were light-hearted, cheeky entertainment, a new type of film emerged in 1958 which took a very different form. Social realist cinema, or 'kitchen sink cinema' as it came to be known to reflect the common use of domestic locations such as kitchens in the films, presented a gritty, raw inter-pretation of everyday life. Typical themes were alienation, frustration, fighting the system, and ambition for a better life away from the drudgery of everyday life. As John Hill has noted, 'one of the most striking characteristics of the British cinema towards the end of the 1950s was its increasing concern to deal with contemporary social issues' (1986, p. 67).

The 1950s had supposedly ushered in a new era of affluence within a meri-tocratic society, but the world presented in these films is a class society with far more limited possibilities. The protagonists are usually male, working-class and angry. The 'angry young man' had become a common character in plays written

and performed during the mid-1950s, the best known being *Look Back in Anger* by John Osborne. This play was turned into a film in 1959 by Tony Richardson and was the first film to be made by Woodfall Films.

The company's three principal directors were Lindsay Anderson, Karel Reisz and Tony Richardson. They had previously worked together in the early 1950s in the Free Cinema movement, which had sought to politicize cinema by using it to analyse contemporary society through documentary forms, with the aim of exposing injustices and proposing alternatives. These directors were responsible for a number of social realist films. They were Britain's answer to France's 'new wave', in terms of the unusual style and content of the films they made. Amongst their best-known films are: *Look Back in Anger* (Richardson, 1959), *Saturday Night and Sunday Morning* (Reisz, 1960), *A Taste of Honey* (Richardson, 1961), *The Loneliness of the Long Distance Runner* (Richardson, 1962) and *This Sporting Life* (Anderson, 1963). These films helped establish actors such as Rita Tushingham, Albert Finney and Tom Courtenay. As a film movement it was short-lived, lasting only from 1959 to 1963, but it influenced other directors, most notably Ken Loach.

By 1963, pop culture was well established, and audiences tended to be more interested in entertainment than social issue films. This was the year the Beatles came to fame and the following year they were to make their own film, *A Hard Day's Night* (Richard Lester, 1964), which showed the 'fab four' as representatives of British youth, resisting and mocking the outdated and unnecessary restrictions of British society. This was the 'swinging sixties' and life was meant to be 'fun'. Also well suited to this new era was the suave, sophisticated yet rugged womanizer, James Bond. The first Bond film, *Dr No*, had been made in 1962, with Sean Connery in the starring role. Bond smoothly combined being a British spy with an international playboy image which mirrored the supposed sexual permissiveness of the 1960s together with the espionage of the Cold War.

However, although mid-1960s British cinema was often characterized by the themes of fun, pleasure, promiscuity, adventure and escape, some films took a slightly more critical approach and others chose to deal with completely different issues. *Alfie* (Lewis Gilbert, 1966) focused on a Cockney character and his sexual exploits. The film begins by revealing the promiscuous lifestyle he leads and the fun he has as he moves from woman to woman. However, by the end of the film he is revealed as a friendless, isolated man who has no meaningful relationships. In the same year, Ken Loach made *Cathy Come Home*. The TV film was a far cry from the celebrations of pop culture and the swinging 1960s; instead, it revealed the harsh reality of homelessness in Britain and the injustices many people suffered.

Ken Loach had been influenced by the work of the social realists and the documentaries of the Free Cinema movement. He began making films at the BBC, including *Up the Junction* (1965), before moving on to cinema releases with *Poor Cow* (1967) and *Kes* (1969). Loach has often made use of hand-held camerawork to add to the 'realism' and believability of his films. He continues, over forty years later, to make social issue films from a left-wing perspective.

One of the key social realist directors from the early 1960s had adopted a very different style of film-making by the late 1960s, though arguably with a similar motive of exposing social injustice. Lindsay Anderson made *If...* in 1968 as a statement about class privilege in Britain, as revealed through a story set in a private school. The film was very much of its time, the revolutionary inclinations of the three main protagonists mirroring the revolutionary upheavals of the same year across Europe and the USA. However, the film was far from the realism of Anderson's early films and the story frequently slips into bafflingly surreal scenes.

1

Decline and fall

Many British films of the 1960s were made with US money, but by the end of the decade such finance had declined, thus weakening British cinema. There was also an exodus of British directors and stars who sought work in the US film industry or on British television, and most box-office hits in Britain were US films. Two of the most prominent directors to leave for Hollywood were Alan Parker, who made *Midnight Express* in 1978, and Ridley Scott, who made *Alien* in 1979.

Ironically, Stanley Kubrick had made the reverse journey, basing himself in Britain, and began the decade with *A Clockwork Orange* (1971), a controversial film set in a violent future Britain. The James Bond films continued to be produced, but *Diamonds are Forever* (1971), *Live and Let Die* (1973) and *The Spy Who Loved Me* (1977) were US productions and were released by United Artists, as Bond films always had been.

Pop culture music films, which came into their own in the 1960s, continued to be popular in the 1970s. The decade began with Nicolas Roeg and Donald Cammell's *Performance* (1970), featuring Mick Jagger. The film was well suited to its time and bridged what was often perceived as the idealistic 1960s and the harsher 1970s. It combined sex, drugs and rock 'n' roll with the violence of the gangster genre all filtered through an unusual story told with imaginative production techniques. Ken Russell directed a film version of the Who's rock opera, *Tommy*, in 1975. In the latter half of the decade the influence of punk sub-culture made itself known, effectively moving into mainstream pop culture with *The Great Rock 'n' Roll Swindle* (1979), a film about the Sex Pistols directed by Julian Temple. Derek Jarman made *Jubilee* (1978), which also employs aspects of punk style to critique modern urban life.

A more overtly political form of cinema also developed in Britain in the 1970s as a continuation of the revolutionary perspectives that had emerged in the late 1960s, alongside student and worker strikes and occupations in Britain, Europe and the USA. Small, radical, independent production companies such as Cinema Action and Amber Films made films throughout the 1970s which focused on political issues and campaigns in working-class communities, often covering industrial disputes with the intention of providing an alternative perspective to that offered by the mainstream media. A focal point for independent film production was the London Film-makers Co-operative, which was founded in

1966 and became established during the 1970s. Feminism was perhaps the main radical movement of the decade, with film-maker and theorist Laura Mulvey among those who raised gender issues and moved the debate forward. It is no coincidence that the London Women's Film Group emerged during the 1970s. Mulvey's *Penthesilea* (1974) and *Riddles of the Sphinx* (1977) and Sally Potter's *Thriller* (1979) analyse the role of women in the home and the workplace in terms of power relationships, identity and resistance in a patriarchal society.

The latter three themes were also the driving force for the Black British Cinema which began to find its feet in the 1980s. Individual black directors began to deal with themes of black culture and identity and of racism (Horace Ové with *Pressure* (1975), Menelik Shabazz with *Burning an Illusion* (1981)), but the most important films arguably emerged eventually from the Black Audio Collective (BAC) and from Sankofa. These were film/video production groups in which tasks were rotated and shared, but the principal directors were Sankofa's Isaac Julien (*Territories*, 1985; *Young Soul Rebels*, 1991) and BAC's John Akomfrah (*Handsworth Songs*, 1986).

With regard to mainstream film production, the 1970s were a lean period for the British cinema. Audience figures declined dramatically from 501 million per year in 1960 to 193 million per year in 1970 (Dyja, 1999, p. 30). Throughout the 1970s cinemas were frequently converted for multi-screen exhibition to attract audiences back by offering greater variety, although it is questionable just how much choice was available. The last *Carry On* film was made in 1978 and the last Hammer Film in 1976. However, studios such as Pinewood and Shepperton were still used by US companies for production, and *Star Wars* was partly filmed at Elstree Studios. Among the more popular British films from this decade were the innovative gangster film *Get Carter* (Hodges, 1971) and the alternative humour of *Monty Python and the Holy Grail* (Gilliam and Jones, 1975) and *Monty Python's Life of Brian* (Jones, 1979), two films which earned the comedy team an international reputation. A popular contemporary director who began making films at the time is Mike Leigh, whose first feature film was *Bleak Moments* (1971).

Something from nothing

After a range of successful work for television, Mike Leigh firmly established himself in the 1980s with *High Hopes* (1988), which contained his usual mix of simple storyline, everyday situations, social comment and amusing, if somewhat stereotyped, characters. The 1980s also saw success for British cinema as a whole, which is ironic given that the Conservative government elected in 1979 had made things even tougher for the industry by abolishing the Eady Levy and the National Film Finance Corporation, both of which had provided finance for film production.

One particular group of films that proved successful in the 1980s became known as 'heritage cinema', the stories being set in Britain's resplendent past. Among the

best known were *Chariots of Fire* (Hugh Hudson, 1981) and *A Room with a View* (James Ivory, 1985), both produced by newly formed companies, Goldcrest and Merchant–Ivory respectively; however, the bulk of funding for *Chariots of Fire* came from the USA and Egypt and was in many respects ideally suited to the early 1980s. Thatcher's Conservative government emphasized, in both its rhetoric and its legislation, the importance of nationality, Britain's 'greatness' and individualism. The film itself harks back to an age when Britain was still a world power and still had its Empire. Furthermore, it focuses on the individual endeavours of two athletes, with the emphasis on initiative and hard work, both supposedly key elements in that government's ideology. However, the film also deals with issues that were not at the heart of the Thatcher regime's concerns, namely class injustice and racism. The issues of class and race emerge in the bigotry shown by the university and sports establishments towards the working-class Scot, Liddell, and the middle-class Jew, Abrahams. The film is very 'English' not only because of its location but because of its use of supposedly English attributes such as reserve, fair play, gentlemanly conduct, stoicism, and perseverance in the face of adversity.

The other area of success in British cinema could not have been more different, dealing as it did with the reality of contemporary Britain. After five years of planning, Channel 4 was finally launched in 1982 with a remit to provide programmes that catered for minority tastes. This ethos spilled over into the channel's funding of film productions, via its Film Four subsidiary. Two of the company's biggest successes were *Letter to Brezhnev* (Chris Bernard, 1985) and *My Beautiful Laundrette* (Stephen Frears, 1986), both dealing with working-class life, in Liverpool and in South London respectively, and with issues relating to class divisions, race, nationality and sexuality.

Many other memorable and successful films emerged from 1980s British cinema. *Gregory's Girl* (1980) is a Scottish comedy about football and teenage love directed by Bill Forsyth, who had another success two years later with *Local Hero*, which tells the tale of a wise old Scotsman who outwits a large multinational oil company. *Defence of the Realm* (David Drury, 1985) follows a journalist's encounters with the secret establishment when he tries to expose an MP as a spy and reveal a nuclear cover-up by the government. *Distant Voices, Still Lives* (1988) is set in post-Second World War Liverpool and follows the lives of an extended working-class family; however, Terence Davies' style is a far cry from the raw, documentary techniques of social realism and Ken Loach, showing instead a more self-conscious and artistic approach. The renaissance of British cinema during the 1980s is all the more surprising because most of these films were low-budget, usually costing less than £3 million compared to the average Hollywood budget of ten times as much. The Conservative government's philosophy of non-intervention in industry left the British film industry weak compared with Hollywood and other national film industries. The success of British cinema in the 1980s is also surprising when set against trends in cinema attendances at that time, which reached an all-time low in 1984 of just over one

million per week, contrasting starkly with the all-time high figure of thirty-one million admissions per week in 1946.

Channel 4's successes continued into the 1990s with its involvement in a range of films. *The Crying Game* (Neil Jordan, 1992) tells an unusual story which deals with the politics of Northern Ireland and with transvestism. *In the Name of the Father* (Jim Sheridan, 1993) also addresses the politics of Northern Ireland, in relation to the British state, the security services and the legal system. It tells the story of the Guildford Four, falsely imprisoned for fourteen years having been found guilty, on faked evidence, of planting a bomb. In reality, a prolonged campaign for their release was eventually successful. *Bhaji on the Beach* (Gurinder Chadha, 1993), the first British feature film to be directed by an Asian woman, deals with issues such as mixed race relationships, gender relations, conflict between generations and multiculturalism within an Asian community and Britain as a whole. The film takes an imaginative, comic and perceptive look at race and culture in contemporary Britain. Sarita Malik writes:

> In *Bhaji on the Beach*, we see an ensemble of Asian women temporarily inhabiting a public sphere (Blackpool beach) which is predominantly associated with 'Englishness' and 'whiteness'. The quintessential 'Englishness' of Blackpool is juxtaposed with the 'Indianness' of the female protagonists, both culturally and visually. At the same time, we do not get the sense that any one culture has 'crossed over' or been assimilated, but that a new form of cultural identity is emerging. This hybrid identity is 'British-Asianness', a fluid evolving entity, which cannot be reduced to any one thing.
>
> (1996, p. 213)

Derek Jarman's *Blue* (1993) consists of a blue screen accompanied by a meditative soundtrack and voice-over narration, and tells the story of his experiences of dying from AIDS. *Trainspotting* (Danny Boyle, 1995) was a phenomenal success which cost £1.7 million but took over £60 million. The film takes the issue of heroin addiction and, through the effective use of a mix of characters and contemporary music, manages to tell an entertaining story that doubles as a warning about drugs. *Brassed Off* (Mark Herman, 1996) turns to another social issue, unemployment, and the destruction of traditional working-class communities. *Twin Town* (Kevin Allen, 1997) is set in Swansea and focuses on two twin brothers and their everyday lives. It is an uncompromisingly black comedy that moves across a range of issues from unemployment, police corruption and violence to joyriding, drug-taking and murder. *East is East* (Damien O'Donnell, 1999) is a comedy based on a Pakistani family living in 1970s Britain which experiences upheaval as the children drift away from a traditional Muslim upbringing in response to other cultural influences.

Channel 4 went on to set up its own satellite film channel Film Four, screening films from outside the mainstream. The BBC also continued to fund films

and found critical success with Lynne Ramsay's *Ratcatcher* (1999), which follows the lives of children in Glasgow during the 1970s; the film also obtained some lottery funding. *Lock, Stock and Two Smoking Barrels* (1998) used several financial backers and proved to be yet another low-budget, high earning British film.

The two largest grossing films to emerge from Britain during the 1990s were *Four Weddings and a Funeral* (1994) and *The Full Monty* (1997), both of which were heavily marketed and proved popular in the USA. *Four Weddings* was part funded by Film Four, cost £3 million to make and made £210 million. *The Full Monty* was made for £2.2 million and took £50 million in its first year alone, before video sales and rentals and television screenings are taken into account. However, both these films were mainly funded from abroad. *Notting Hill* (1999) attempted to cash in on the success of *Four Weddings* with a similar form of humour, the same male lead star (Hugh Grant) and a rather quaint view of England that presents a polite, white, middle-class world no doubt manufactured as much for foreign viewing as for the British.

The 1990s were also to be a phenomenal decade for Ken Loach, who made no less than seven films, five of which were set in Britain and dealt with the political and social issues that Loach habitually weaves into his storylines. His first film of the decade, *Hidden Agenda* (1990), was unusual in that it was a political thriller. Set in Northern Ireland, it focuses on deceit and corruption in the armed forces, security services and government. *Riff-Raff* (1991) deals with the effects of the political legacy of the 1980s which had undermined trade unions and in this particular film had resulted in the growth of temporary contract labour in the building industry, where workers often had no employment rights and frequently worked in dangerous conditions. *Ladybird, Ladybird* followed in 1993, *Raining Stones* in 1994 and *My Name is Joe* in 1998. Mike Leigh was also to have a productive decade with *Life is Sweet* (1990) and *Naked* (1993), the latter darker and less humorous than most of Leigh's films, although the usual array of strong character types are present. *Secrets and Lies* (1996) won several awards in film festivals around the world including the Academy Awards and Cannes, and this was followed by *Career Girls* (1997).

Cinema attendances generally improved through the 1990s, with the annual figure reaching 136 million in 1998 (Dyja, 1999, p. 30). The growth of multiplexes continued apace and exhibition was dominated by six companies: Warner, Odeon, Virgin, UCI, ABC and Cine UK. With the election of a Labour government in 1997, some progress was made towards further funding of the film industry. The Arts Council was given the role of deciding how National Lottery money was to be used as a source of finance for production companies.

Small films, big movies

The start of the twenty-first century saw significant changes in the British film industry. In 2000, the Department for Culture, Media and Sport set up the UK

Film Council to lobby for film finance and administer lottery funding for films. There are national and regional agencies that decide how the money is to be spent.

Funding elsewhere declined with the closure of Film Four in 2002 as a result of increasing losses on its investments in films. However, after reorganization and a much more careful approach to funding a diminished number of films, the company returned as Film Four in 2006. Polygram has also disappeared as a distributor in its own right with its incorporation into Universal Pictures. Cinema admissions have continued to rise steadily with 162 million attendances in 2007. The major change in UK exhibition was the sale of the Warner multiplex chain to SBC International Cinemas in 2003 with the chain being renamed as Vue Cinemas.

Despite the vagaries of the movie world the actual business of making films remains relatively encouraging. In 1986, only forty-one UK films were made compared to sixty-one in 2006. The new millennium saw considerable successes with films that had varying degrees of UK input including *Calendar Girls* (2002), made by British based company Harbour Pictures for Disney's Touchstone Pictures. Mike-Leigh made his eighth film, *All or Nothing* (2001), with funding from a range of sources. The Harry Potter films of 2001, 2002, 2004, 2005, 2007 and 2009 have all had a significant UK input in terms of story, cast, crew and location although the films are owned by Warner Brothers.

The BBC has continued with its involvement in films, one of the most successful being *Billy Elliot* (2000), co-financed through Lottery funds and Working Title Films. The film's story takes place during the 1984 miners' strike and explores issues of class and sexuality through Billy's attempts to transcend the conventions of his working-class roots by developing a career in ballet which requires him to move to London to lead a different life among a different class. The BBC has continued to co-finance productions, the most surprising of recent years probably being the two *Lara Croft: Tomb Raider* films of 2001 and 2003. It also co-financed *Sweet Sixteen* (2001) with Scottish Screen, which allocates lottery funds via the UK Film Council for Scottish productions. The BBC also continued its partnership with Lynne Ramsay, who directed *Morvern Callar* (2001) as well as contributing to Stephen Frears' *Dirty Pretty Things* (2001).

Working Title Films continues to be one of the most successful production companies based in Britain, having been in operation since 1985. Its successes include *High Fidelity* (2000), the Bridget Jones films of 2001 and 2004, *Captain Corelli's Mandolin* (2001), *Johnny English* (2002), *Love Actually* (2002), *Bride and Prejudice* (2004), *Shaun of the Dead* (2004) and *Hot Fuzz* (2007). *Shaun of the Dead* took advantage of the scriptwriting, directing and acting team of Simon Pegg, Edgar Wright and Jessica Stevenson, who have had two successful television series of the sitcom *Spaced*. A television comedy series that made a direct transition to the cinema screen was *Stella Street* (2004), at the cost of a mere £600,000 to Columbia Tristar. *Son of Rambow* (2007) was a low-budget

hit financed from a variety of sources from the UK and Europe. Pathé Films continue to contribute to production and distribution in the UK film industry, including *Slumdog Millionaire* (2008) and *Hunger* (2008), both of which also had backing from Film Four. A further Film Four success was *In Bruges* (2008), which was nominated for an Oscar and won a BAFTA for 'best screenplay'.

The UK Film Council has had several successes, often in liaison with Film Four, and later with the restructured Film Four. Substantial box-office takings and critical acclaim were achieved by *Gosford Park* (2001), *Bend It Like Beckham* (2002) and *Touching the Void* (2003). A number of British films made with the involvement of the UK Film Council and Film Four won awards: *Brick Lane* (2007), *Hallam Foe* (2007) and *This is England* (2007). *Shock Doctrine* (2009) was Michael Winterbottom's nineteenth film, ten of which have been released since 2000, *24-Hour Party People* (2002) being his most successful. As well as using his own production company, Revolution Films, he has frequently worked with the BBC, Film Four and the UK Film Council. Britain's two best-known UK-based directors have continued to make low-budget, popular films: Mike Leigh with *Vera Drake* (2004) and *Happy Go Lucky* (2008) and Ken Loach with *The Wind That Shakes the Barley* (2006), *It's a Free World* (2007) and *Looking for Eric* (2009).

Exercise 3.2

With reference to any British film, identify the ways in which it reinforces or challenges dominant ideology.

British films, culture and ideology

The following films, covering a period of over sixty years, provide useful examples of the various ways in which values, beliefs and social groups have been represented in British films. It will be seen not only that there have been changes in how society's morals, ideas and cultures are shown to audiences over time, but that at any particular moment there are a range of possible ways of representing such ideologies.

CASE STUDIES

Brief Encounter (David Lean, 1945)

Laura Jesson is a mother and a housewife and is happily married until she meets Alec Harvey at a railway station. By coincidence they meet again and from then on their encounters are intentional. Although Laura and Alec's relationship is never obviously consummated, she is filled with guilt about betraying her

Figure 3.1 Brief Encounter: social class and sexual restraint (*Brief Encounter*, 1945, dir David Lean)

husband. Compared to her husband, she finds Alec interesting, humorous and exciting. Their relationship does not last long, however, and they soon return to their respective partners (see Fig. 3.1).

Although the story appears rather tame now, in 1945 the film was dealing with something that would not normally be discussed; in fact, it is possible to see this 1945 film as being very relevant to its time. The Second World War had resulted in many women living without their partners and many men being conscripted, leaving women to do their jobs. In effect, women had more independence and were perhaps more open to temptation. The film acknowledges this reality while ultimately upholding traditional morals. Laura's return to being a faithful wife can be interpreted as reflecting the situation at the end of the war when men returned to their jobs and (most) women returned to the home.

The ways in which gender, class and sexuality are represented result in particular values being reproduced by the film. Laura and Alec's relationship, as a male/female relationship, consists of active and passive roles. Alec is the active partner, taking the initiative, suggesting they meet, go for walks, go to the cinema. Laura is the passive partner, submitting to his advances, desiring a better marriage.

Class becomes an issue through the ways in which Laura and Alec are represented as middle-class and the station porter and café woman as working-class. The most immediate way in which we identify their class is through accent, though the

café woman does noticeably attempt a 'refined' voice, indicating the desirability but impossibility of the working class attaining middle-class status. Employment also indicates class, the porter and café woman undertaking manual labour whereas Alec's profession of doctor involves study, skill, knowledge and responsibility, and Laura lives comfortably from her husband's income. Of more interest though is what is said about class. The working class is represented as unintelligent through the conversations of the porter and café woman. Their contributions to the film consist of inane comments and mindless trivia typical of people who don't think before they speak. In other words, the working class is represented negatively. By contrast, Laura and Alec's conversations appear to be thoughtful, intelligent and well-informed, thus representing the middle class positively.

In *Brief Encounter* representation of sexuality appears to be linked to class and gender. Laura's sexual desire results in feelings of guilt and is integrated into her desire for a satisfying marriage. For Alec, sexual desire seems to exist in its own right with no connotations of guilt or marriage. However, the couple ultimately act 'responsibly'; they restrain their desires. When they are compared to the working-class porter and café woman, clear differences in representation become apparent; the latter two do not exhibit the same degree of restraint with regard to their sexuality. Their suggestive conversations are not hidden and their implied sexual relationship outside marriage could be seen as representing the working class as immoral and irresponsible.

Alfie (Lewis Gilbert, 1966)

In many respects *Alfie* epitomizes 1960s British cinema more than any other film. It embodies aspects of the 'swinging sixties' through its portrayal of sexual promiscuity and use of pop music contemporary to that time, both of which are interwoven with what is, at times, a gritty drama that reveals the influence of social realism in its depiction of the reality of everyday life. Out of this combination come issues relating to sexuality, gender and class, occasionally underpinned by strong moral messages.

Alfie, as a character, is summed up in the first five minutes of the film. We see Alfie and Siddie emerging from a car, presumably after sexual intercourse: Siddie forgets to put her knickers back on and Alfie refers a couple of minutes later to 'having it off'. Alfie shows a lack of concern for the feelings of the women he has brief relationships with, dropping them as soon as he is satisfied. At the beginning of the film, although Alfie is with Siddie he has an intermittent conversation with the audience, talking to camera, referring to Siddie as 'it' and revealing that 'she won't be around for much longer'. On leaving Siddie to return to her unexciting husband, Alfie makes his way to see Gilda, who is described as a 'standby'.

The first few minutes of the film use such representations to establish characters and themes. Men are represented as either dominant, macho and sexually active, as in Alfie's case, or submissive, timid and passive, as with Siddie's husband,

and these representations are repeated elsewhere in the film. In contrast to Alfie, the female characters are represented as subservient to him; they are less active, yet more interested in developing a relationship. However, Alfie eventually meets his match in Ruby. She chooses to have a brief relationship with Alfie, dropping him in favour of a younger man. It is to be noted though that Ruby is not typical of the female characters in the film, in that she is wealthy and from the USA.

Sex is dealt with in a noticeably different way compared with the previous decade. There is no restraint; sexual desire is satisfied, in keeping with the popular perception of the 1960s as the decade of sexual freedom. However, sexuality can perhaps also be linked to social class in the film. The characters in *Alfie* can be identified as working-class by their accents, their employment and their homes, and the film can be read as implying that those from the working class tend to be sexually active, placing sex at the centre of their lives.

Later in the film, Alfie's life of pleasure gradually declines. When Lily becomes pregnant, he helps to arrange an abortion, which leaves him feeling guilty and briefly sorrowful. Gilda also becomes pregnant, again leaving Alfie with the prospect of responsibilities, marriage and decisions to make, none of which come easily to him, as his whole life has been focused solely on himself. Alfie declines marriage and so Gilda eventually marries someone else who will help bring up Alfie's son. By the end of the film, Alfie is a lonely character with a rather empty life. He admits that he does not have 'peace of mind'.

My Beautiful Laundrette (Stephen Frears, 1985)

My Beautiful Laundrette seems at first to be an unlikely story: a racist, white, working-class youth has a homosexual relationship with a middle-class Pakistani youth. However, the film was widely acclaimed and helped consolidate Film Four as 'the' film company of the 1980s and 1990s. It works partly because the story ends up being about much more than an unlikely relationship and perhaps partly because of the era it is set within, 1980s Britain. The country was in many respects in a state of turmoil, far-reaching changes were taking place, almost anything could have happened, nothing would have surprised.

Omar is the son of a disillusioned socialist, a journalist from Pakistan who has settled in London. He is keen that Omar gets an education and a respectable job. In the meantime he settles for asking his successful brother, Nasser, if he can give Omar some work and also suggests Omar marries his daughter Tania. Omar takes over the running of a laundrette. One evening while driving home Omar is threatened by a group of racists, at which point he recognizes one of them as Johnny who used to go to his school. They talk and their friendship is renewed. Omar introduces him to his family and Nasser invites Johnny to join the laundrette business if he helps him evict some tenants, which Johnny agrees to.

One of Nasser's business partners, Salim, takes a dislike to Johnny, who returns the sentiment. On seeing the group of racists who previously threatened

Omar, Salim tries to run them over and injures one of them. After the laundrette has had its opening party the racists wait and attack Salim. Johnny reluctantly comes to the latter's aid, to the consternation of his old racists friends who then turn on Johnny. Omar cleans up Johnny's wounds.

The political ideology in Britain at the time was right-wing Conservatism with Margaret Thatcher as prime minister. The theory was that anyone who worked hard would be a success, it was the age of the entrepreneur. However, the reality was different. Unemployment was at an all-time high, society was increasingly fragmented, traditional communities were breaking up and racism was an increasing problem. *My Beautiful Laundrette* reflects the 1980s in an imaginative and complex way. Johnny is part of a disenfranchised white working class: he is unemployed, the world around him is changing, he is rootless. At one point a friend of Johnny's says 'Don't cut yourself off from your own people. There's no one else who really wants you. Everyone has to belong'.

One of the paradoxes of Thatcherism was that it used nationalism, and its appeal to racists, to galvanize support for policies which undermined much of the traditional working-class population. But whilst immigrants were identified as a problem, elements of the Asian communities with middle-class and business backgrounds frequently benefited in the economic climate of that time. Nasser says to his friends and family, 'We'll drink to Thatcher'. Omar's father provides the ideological alternative to Thatcherism, but he is clearly disillusioned about the possibility of socialism in Britain. He says to Johnny, 'The working class are such a great disappointment to me'.

The Asian community is also seen to be fractured by the forces of change and clash of cultures. Nasser's affair with a white woman is eventually defeated by traditional values but these same values are in turn challenged by the younger generation. Omar and Tania have no interest in an arranged marriage and Omar's suspected gay relationship is met with embarrassed disbelief.

My Beautiful Laundrette raises ideological issues relating to class, race, age and sexuality and provides some alternative representations within complex contexts. If representations of class and race are occasionally simplistic this is perhaps because separating stereotypes from cultural characteristics can be problematic. Ultimately the film reveals aspects of 1980s Britain without giving simplistic answers to problems.

It's a Free World (Ken Loach, 2007)

Ken Loach has a long history of making social realist films. With more than twenty films to his name he has focused on the problems of everyday life in the contemporary world and from the past, in his home country of Britain and elsewhere. What his films don't do is provide escapism. He shows things as they are and interweaves political observations.

It's a Free World is set in contemporary Britain and tells the story of Angie whilst raising a number of issues along the way. Angie is sacked from an employment agency after objecting to sexual harassment. She decides to set up her own agency with her friend, Rose, in competition with her previous employer. As a working-class entrepreneur Angie is ambitious and hard-working, but she soon encounters obstacles within the ruthless industry she has entered. Initially, Angie's agency finds work for East Europeans but as the pressure from employers grows for cheaper labour she reluctantly resorts to providing illegal immigrants.

Angie's parents have been looking after her son, Jamie. Her father turns up with her son at her place of work one morning and realizes what kind of business she's running. He expresses his objections and emphasizes that she needs to be spending time looking after her son who is getting into trouble at school. Angie is soon exploited by a company that fails to pay her for the labour she has provided. She in turn is unable to pay those workers which results in her being attacked and money being stolen from her apartment. The film ends with Angie and Rose attempting to relaunch their agency.

Ken Loach clearly takes an ideological position of opposing exploitation. None of the employers are represented positively; they are shown, to varying degrees, as ruthless. How Angie is represented is more complex. Initially she has been exploited and we are encouraged to admire the way she fights back and takes the initiative in setting up her own company in competition. We soon have doubts about her, however, as she becomes almost as ruthless as the other employers she deals with. Doubts are also cast on her abilities as a mother. Although she has been left in the difficult position of being a single parent with the need to earn a living, the lack of time she spends with her son appears to be having a negative effect on him.

The principled and moral core of the film lies in the father who is concerned not only about Angie and her son but also about the exploitation of workers. The contrast between Angie and her father illustrates the distance that lies between 'old' Britain and 'new' Britain, between two generations. In his time, social progress was achieved. In Angie's Britain there is less job security, unemployment is rising, working conditions are deteriorating, the traditional family is disappearing. A future Britain is represented by Angie's son who is going through troubled times.

Loach's films not only remind us of what we already know, they also give us insights into the world around us. In this film we are shown the lives of illegal immigrants seeking a better life through hard work, and asylum seekers fleeing political persecution and possible death in their homelands. What we don't see in this film is organized resistance against exploiters. Angie is helpless in opposing her former employer and similarly the workers Angie employs have no organized response apart from those who attack her to retrieve their wages. The exploited appear as helpless victims, with no positive alternative proposed. This may be an accurate reflection of contemporary Britain.

END OF CASE STUDY

> Exercise 3.3
>
> Compare two British films that are separated by at least twenty years and determine whether/how the values and beliefs represented within them differ from each other. Identify any stereotypes that you believe are used.

CONCLUSION

There is undoubtedly something that can be referred to as a British or UK film industry but what is open to debate is how stable, productive, creative and distinctive that industry is. Being a small industry compared to Hollywood or other areas of the media means British cinema is vulnerable to changes within global cinema or other areas of the economy. Similarly, being a relatively weak industry economically is bound to limit the number of films that can be made and their quality in terms of production values. The UK film industry inevitably ends up trying to compete to a degree with other producers of films, especially of course Hollywood, and this is bound to restrict the types and styles of films made, resulting in a tendency towards mainstream, often formulaic genre films which appear most likely to do well at the box office. It is, however, probably the case that there are particular characteristics to British cinema. The films are frequently comedies or dramas, sometimes effectively combining both. The comedy is likely to be slightly eccentric or to have elements of slapstick humour. The films tend towards what is generally regarded as 'realism' in their concern with identifiable everyday issues. However, the depth of human expression and closeness of human interaction are often restrained, pulling up short of unbridled emotion, reluctant to get too far beneath the surface, maybe dissipating the drama of a situation by resorting to humour. Perhaps this reflects the commonly perceived reserve and stoicism of the British.

The UK Film Council seems clearly focused on what it believes needs to be done to assist the UK film industry. It remains to be seen whether this will result in more or less successful productions and more or less films being made.

SUMMARY

- ↬ Although British films have never been central to world cinema, they have consistently, in one area or another, been influential.
- ↬ From early special effects films, through documentary cinema, Hammer horror films, Ealing comedies and social realism to the low-budget independent films of the 1980s and 1990s, British cinema has left its mark.
- ↬ Despite a consistent lack of significant financial support for the industry, films continue to be made that entertain, challenge, and deal with contemporary social issues.

↔ Social groups and issues, institutions and cultural practices, ideologies and ideas and values and beliefs have been shown in a variety of ways, both positively and negatively, resulting in both dominant and alternative representations of aspects of British life.

REFERENCES

Barr, C. (ed.) (1986), *All Our Yesterdays*, London: BFI.

Dyja, E. (ed.) (1999), *BFI Film and Television Handbook 2000*, London: BFI.

Hill, J. (1986), *Sex, Class and Realism*, London: BFI.

Malik, S. (1996), 'Beyond "The Cinema of Duty"?', in A. Higson (ed.), *Dissolving Views*, London: Cassell.

Murphy, R. (1986), 'Under the Shadow of Hollywood', in C. Barr (ed.), *All Our Yesterdays*, London: BFI.

UK Film Council Statistical Yearbook 2008 (http://www.ukfilmcouncil.org.uk).

FURTHER READING

FPRG. (1998), *A Bigger Picture: The Report of the Film Policy Review Group*, London: Department for Culture, Media and Sport, Annex 2.

Friedman, L. (ed.) (1993), *British Cinema and Thatcherism*, London: UCL Press.

A useful text that investigates the films that appeared in Britain during the 1980s.

Hill, J. (1999), *British Cinema in the 1980s*, Oxford: Oxford University Press.

An interesting book that analyses films from a particular social, economic and political era and highlights the rebirth of British cinema.

Hurd, G. (ed.) (1984), *National Fictions*, London: BFI.

A book that identifies ways in which British films have represented their country of origin.

Lay, S. (2002), *British Social Realism*, London: Wallflower Press.

An overview of a particular form of British cinema from its beginnings and through to its influence on later films.

McArthur, C. (ed.) (1982), *Scotch Reels: Scotland in Cinema and Television*, London: BFI.

A useful source of information about popular and lesser known Scottish productions.

Murphy, R. (1992), *Sixties British Cinema*, London: BFI.

Places British films from various genres in the context of the period of their production.

Murphy, R. (2000), *British Cinema of the 90s*, London: BFI.

Traces the continuing rebirth of British cinema through the films made and their conditions of production and distribution.

Murphy, R. (ed.) (2009), *The British Cinema Book*, 3rd edn, London: BFI.

A comprehensive book providing a history of the films within the context of their production and distribution.

Pettitt, L. (2000), *Screening Ireland*, Manchester: Manchester University Press.

Useful coverage of an often forgotten area of film.

Richards, J. (1997), *Films and British National Identity*, Manchester: Manchester University Press.

An insightful publication on the ways in which 'Britishness' has been represented in films.

Street, S. (1997), *British National Cinema*, London: Routledge.

A history of British cinema covering the films, their genres and their cultural contexts.

Warren, P. (2001), *British Film Studios*, 2nd edn, London: Batsford Ltd.

A summary of the key areas of film production that have been responsible for much of British cinema.

FURTHER VIEWING

Brit Pix (Film Education, 1999)
Looks at British films from the 1940s to the 1990s in relation to representation, culture and ideology. Film Education, 91 Berwick Street, London W1F 0BP

Flames of Passion (BBC, 2007)
Key British films from the 1940s and 1950s. BBC Active, BBC Television Centre, Wood Lane, W12 7RJ

Hardship, Humour and Heroes (BBC, 2007)
An investigation of British Social Realism from its origins in the 1950s through to its influence on later films. BBC Active, BBC Television Centre, Wood Lane, W12 7RJ

Omnibus: Made in Ealing (BBC, 1986)
A celebration of the films that emanated from the famous studios. BBC Active, BBC Television Centre, Wood Lane, W12 7RJ

Silent Britain (BBC/BFI, 2006)
An introduction to a wide range of British films from the first thirty years of cinema. BFI, 21 Stephen Street , London W1T 1LN

Typically British (BFI TV and Channel 4, 1994)
A useful overview of the key films that have help give British cinema its reputation. BFI, 21 Stephen Street , London W1T 1LN

Chapter 4

World cinemas

Most of this book is concerned with Hollywood cinema and its influence, which is a reflection of Hollywood and US dominance since the 1920s. Nevertheless, there have been moments when other national cinemas have attracted the interest of film theorists, critics and historians (and indeed of audiences), and in this chapter we shall explore some such moments, both historical and more recent. First, however, we should reconsider the meaning of 'national cinema' (see also Chapter 3 above).

National cinema

If it is rare to find the term 'US cinema' used, this is largely because the dominant modes of cinema are American; as we have seen, this is reflected in the influence of Hollywood on film-making practices and on 'film language', in the way films are marketed and consumed and in film financing and media ownership. When we speak of 'British cinema', 'Indian cinema', 'Finnish cinema' or any other national cinema, part of its meaning is thus in some kind of opposition to the dominance of the United States. Indeed, the term 'World Cinema' is

highly problematic: it is commonly used to refer to non–US cinema; but is it not ideologically significant that US films somehow stand apart and are not to be considered as part of the 'world'? As has been the case with values and ideologies associated with maleness and white imperialism in the past, US cinema is all the more powerful for being unnamed and for being taken as a norm.

But why can we say that 'French Cinema' is French? What makes a film 'French'? Is it because all or most of the money to make the film came from France? Is it because the director was French? Because the principal actors were French? Because the film was made in France? What about the technicians? Or is it because the film is about French characters, society or history And what about the language?

Another way to approach the notion of national cinema is to ask what relation a group of films has with the film institutions (the government, the production, distribution and exhibition structures) of the country. Colin Crofts, for example, adapts Andrew Higson's work to produce a list of possible defining characteristics of any national cinema, on which the following modified list is based (Table 4.1). This may be compared with the 'official' list for British films noted above (p. 45).

The complexity of writing about national cinemas dates, of course, from the 1980s and the rapid growth of globalization; before then it was a little easier to identify films and film movements as coming from, say, Germany or Brazil. Increasingly, also, some films are now aimed at niche 'ethnic' markets (for example 'beur' cinema in France), and this is further complicated by the ease

Table 4.1 Criteria for defining national cinema

Criterion	Key questions
Production	How nationally specific are the production practices?
	To what extent do they depend on American practices and finance?
Distribution and exhibition	What percentage of 'home-made' films are shown?
	How does this compare with films from USA or elsewhere?
Audiences	Which films are 'popular'? Why?
Discourses	How do critics and theorists write about the films of a country?
	Are they seen as entertainment in competition with US or multinational productions or as expressions of a 'national' voice?
Textuality-cultural specificity	Are themes of nationality or national identity treated in the films?
	How are cultural identities within a nation dealt with?
The role of the state	How much is the state involved in regulating the nation's film industry?
	To what extent do subsidies, quota legislation, censorship etc. 'protect' the indigenous film industry?

with which, with the aid of the internet and of the cheapness of DVD copying, films can be marketed for expatriate audiences in other countries. Commercial Indian film production, for example, has become increasingly tailored to the tastes of the large global NRI (non-resident Indian) audience. The introduction to a recent book, *Remapping World Cinema* (see Further Reading), is particularly instructive on such developments.

Exercise 4.1

Select any three non-US films made at different times, perhaps one from the 1960s, one from the 1980s and one recent release, and discuss how easy or difficult it is to describe each as for example, a British, Indian or Italian film. If there is time, you may want to do some research on the films' production contexts and exhibition box-office figures etc.,.

Some major national cinemas and other movements

Before going further we should note a difficulty with the word 'movement'. Though we use it here in a loose sense to indicate a coherent group of films (and film-makers), strictly speaking, the term should only be used where the film-makers defined themselves as a 'movement'. While some of the groups of films which we shall discuss certainly can be said to be part of a 'movement', others cannot, and are linked by style rather than by any agreed programme or aims. Nevertheless for the sake of simplicity we have followed a common practice and retained the word as a general term. Be warned!

Historically, then, a number of 'national cinema movements' have emerged as significant to the development of new film styles or as particular manifestations of a particular country's social/historical context at a particular time. There are as always some problems of definition (are the 1930s German 'mountain films' best described as a 'movement', a genre or a subgenre?) and it would be impractical to look at every conceivable 'movement'.

The national film 'movements' most frequently mentioned in textbooks tend to have originated in Europe, representing as they do a version of film history which has been produced almost entirely by European and North American writers about film. The omissions would thus be those Asian, African and South American national cinemas which have imposed themselves (usually only during the 1980s and 1990s) as significant objects of study.

Space will not permit a complete examination of all the major 'national cinema movements'. We shall here have to limit ourselves to a brief look at a selection of the significant 'movements' from Europe, Asia, Africa, Australasia and Latin America.

German Expressionism

Although the first German Expressionist film, *The Cabinet of Dr Caligari* (Wiene, 1920) (Fig. 4.1), was a startling success, it did not come as such a surprise. The reason for this was that Expressionism had been an important current in theatre and painting (and, indeed, in literature) since around 1906. Nevertheless Wiene's film was clearly different from anything that had been seen before, and was the first of a cycle of commercially successful and critically praised German Expressionist films culminating in Fritz Lang's *Metropolis* in 1927 (released as a restored and re-edited print in 1984 with a rock music soundtrack which met with mixed reviews).

The 'Expressionism' which developed in Europe (and especially in Germany) at the beginning of the twentieth century was principally a reaction against and a rejection of the realism which had come to dominate art at the turn of the century, and the methods of expressionist theatre were successfully transferred to the cinema. The *mise en scène* featured distorted buildings and interiors, with non-vertical walls and hardly a right angle in sight. Theatrical backdrops featured disorientatingly garish colour compositions. The acting was anti-realist and (in the theatre) involved screaming and shouting as the expression of extreme mental states and of 'inner feeling'. Actors' movements were choreographed so

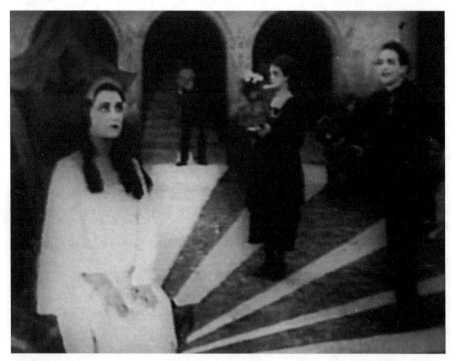

Figure 4.1 The Cabinet of Dr Caligari: expressing insanity (*The Cabinet of Dr Caligari*, 1920, Dir Robert Wiene, Actors Werner Krauss & Lil Dagover © Decla-Bioscop)

as to complement the jarring *mise en scène*. Although lighting was predominantly 'flat', there was often an effective use of shadows for frightening effect.

There is disagreement about whether only those films which show the above characteristics should be described as expressionist, or whether others, where the narratives and the characterizations can be read as consistent with expressionist themes of mental disintegration, can be included. In any case, after *The Cabinet of Dr Caligari*, the principal German Expressionist films included *The Golem* (Wegener and Boese, 1920), *Destiny* (*Der müde Tod*, Fritz Lang, 1921), *Nosferatu the Vampire* (Friedrich Murnau, 1922), *Dr Mabuse the Gambler* (Lang, 1922), *Die Niebelungen* (Lang, 1924), *Faust* (Murnau, 1926) and *Metropolis*.

While these silent films are fascinating in themselves, there are two further ways in which they are significant. In his massively detailed (and not undisputed) book *From Caligari to Hitler*, Siegfried Kracauer saw German Expressionism as a symptom of the German people's readiness for Hitler: the evocation of evil and the forces of darkness, the threat to sanity, the re-imposition of a healthy order through efficiency and through symmetry. The overwhelming use of geometrical symmetry in the interiors of *Algol* (Werckmeister, 1920), the trees in *Die Niebelungen* and the architecture of *Metropolis* seem to look forward to the fascist *mise en scène* of Leni Riefenstahl's *Triumph of the Will* (1935), with its construction of Hitler as a god-like figure and feverish rendering of his mass appeal. To be fair to *Caligari*, however, it can be read as a critique of power and authority, even if power remains in place at the end of the film. Similarly, *Metropolis* is an attack on dictatorship (though again with a cop-out ending) rather than a plea for order and efficiency.

If there is some truth in Kracauer's general sense of the Germany of the 1920s, the fate of many of the film-makers of that time tends to tell another story. Few of the artists (in film or indeed in any other medium) stayed in Germany to find out what Hitler would bring; they had already guessed. Those who stayed were on the whole either dedicated idealists or Nazi sympathizers. Those who left Germany bring us to the other important consequence of German Expressionism.

Among those who emigrated to the United States from Germany (under various degrees of pressure) were Fritz Lang, his cameraman Karl Freund and scriptwriter Carl Mayer, Friedrich Murnau, Billy Wilder and Otto Preminger. Some of these were established and respected directors and technicians, others (like Wilder and Preminger) were just beginning their careers in film-making. It would perhaps be wrong to see the link as too straightforward, but it has often been suggested that the visual style of film noir (see p. 321 below) was indebted to the arrival of European (largely German) film-making talent in Hollywood in the 1930s. Certainly the sense of threat and of mental instability of many films noirs, from *The Maltese Falcon* (Huston, 1941) to *Kiss Me Deadly* (Aldrich, 1955), was well complemented by the low key lighting and the unusual and disconcerting camera angles; while these were not necessarily typical aspects of German Expressionism, it has been argued that, in the contemporary US context of anxiety about the Second World War, and subsequently about the role of men

and about atomic weapons, the *mise en scène* and camerawork of film noir were a reworking of the aesthetics of German Expressionism.

If we also consider the later development of tech noir in the 1980s (*Blade Runner*, 1982/1991), and the self-conscious use of 'expressionist' sets and lighting in, for example, the *Batman* films, we can see that the indirect influence of German Expressionism has been great indeed.

CASE STUDY

Nosferatu the Vampire (Friedrich Murnau, 1922)

Though firmly identified with German Expressionism, Murnau's *Nosferatu*, the first and most celebrated of vampire films based on Bram Stoker's *Dracula* written in 1897, is in fact not an entirely typical expressionist film.

The emphasis on horror and menace is certainly in keeping with the expressionist style (and in this sense the film is quite different from the post-1960s Dracula cycles which increasingly emphasized the camp and sexually deviant aspects of the character, as well as concentrating on special make-up effects). The grotesqueness of Dracula's body, his costume and movements, is expressionistic.

The lighting in *Nosferatu*, however, is not so typical; though the use of shadow is certainly effective, it is not common to other expressionist films. *Nosferatu* was also shot largely on location, with the sense of threat being created through cinematography and editing rather than with the distorted *mise en scène* of *The Cabinet of Dr Caligari*, for example. This led Lotte Eisner to praise Murnau for creating 'expressionist stylisation without artifice' (1965, p. 102).

END OF CASE STUDY

Soviet Montage cinema

If German Expressionism was to influence the *mise en scène* of later Hollywood films, the other major European film movement of the 1920s set itself up in opposition to Hollywood. The aftermath of the 1917 Russian Revolution saw years of struggle before the noble aims of communism were extinguished under the tyranny of Stalin in the 1930s. What is of interest here is the political and intellectual struggle of the 1920s over the forms and uses of 'art' (including cinema). By 1934 Stalin's support had ensured that the 'realist' tendency became official policy (though Soviet Socialist Realism was a very strange kind of 'realism'), but in the more open and stimulating 1920s, the 'realist' camp had to compete with two other strong tendencies: those who argued that art had to be directly at the service of the workers (the proletariat), and should be a tool of education and propaganda, and those who argued that the very nature of art had to be transformed before new revolutionary ways of seeing the world could be produced.

This latter argument has usually gone under the umbrella term of Formalism (see also pp. 186–7 below), and in its effect on film it is perhaps best remembered for Soviet Montage theory.

The five names most attached to Soviet Montage (though there were several others) were Lev Kuleshov, Alexander Dovzhenko, Vsevolod Pudovkin, Dziga Vertov and Sergei Eisenstein, but it is the last of these who produced by far the most comprehensive writing on theories of montage and whose films are best known.

Indeed, it was a time of excitement and experiment (see Further Reading) and there was little clear agreement among the Formalists. While Kuleshov was an important and dynamic teacher about film (at the time, between 1919 and 1924, material shortages in the Soviet Union were so severe that students at the new Film School had to make films in their heads, without any film), he made few films and disagreed strongly with Eisenstein. His approach was closer to that of Pudovkin (*Mother*, 1926), for whom montage and editing in films had to remain at the service of the narrative: an approach rather closer to the 'classical narrative' of Hollywood. Dziga Vertov was a documentary film-maker who dismissed entertainment narratives as 'cine-nicotine' and for whom the camera and the lens (the 'film-eye') should be instruments of '*kino pravda*': 'film truth'. When lighter cameras and better sound recording equipment later revolutionized documentary film-making in the early 1960s, the new methods were called *cinéma vérité* in honour of Vertov, who himself glorified the camera and made it a 'star' in his films (most famously in *Man With a Movie Camera*, 1929).

The most influential figure, however, was Sergei Eisenstein (*Strike*, 1925; *Battleship Potemkin*, 1925; *October*, 1928). While Pudovkin (and Kuleshov) spoke of shots in terms of 'elements' or 'building bricks' which could be linked or built into a text, Eisenstein spoke of shots as 'cells', and saw the potential relationships between shots in terms of conflict and collision. For Eisenstein the arrangement of shots into narrative sequence was only one special case (and a not very interesting one at that). In his theoretical writing, eventually published in English as *Film Sense* (1942) and *Film Form* (1949), he explores the various ways in which pairs of shots can 'collide' to create new meaning: the dialectical process we mention in Chapter 9 below.

The 'conflict' between shots could, for example, be graphic or geometric: Eisenstein recognized that shots with similar diagonal lines in the frame or with similar lighting would fit together harmoniously (the common Hollywood approach), while what interested him more was the sense of conflict or unease which could result from deliberately jarring juxtapositions of diagonals, of patterns of light or of the balance of objects in the frame (see Fig. 4.2).

Montage could also create the illusion or sense of movement or change of some sort (Eisenstein would have been aware that this was an extension of the illusion of movement on which cinema itself is based). In *Battleship Potemkin*, for example, a shot of a woman with pince-nez glasses is soon followed by a shot of her screaming with blood running down her face: she has been shot.

Figure 4.2 Battleship Potemkin: two shots indicating Eisenstein's graphic conflict ([a] *The Battleship Potemkin*, 1926, Dir Sergei Eisenstein, ODESSA STEPS. © Goskino. [b] *The Battleship Potemkin*, 1926, Dir Sergei Eisenstein, Mother: Prokopenko, Boy: A. Glauberman. wounded boy ODESSA STEPS. © Goskino)

Less 'logically', more metaphorically, soon after this there are three consecutive shots of different statues of lions that appear to 'rise' from sleep to a roaring posture: here Eisenstein symbolizes the awakening of the sailors of the Potemkin to revolutionary action.

Through most of his discussion of montage, Eisenstein stresses the importance of graphic matches between shots in achieving montage 'effects' (for example, direction of movement, shapes in the frame, patterns of light and shade). He was not afraid of fragmenting time and space, of sacrificing the continuity editing being developed in Hollywood to create new kinds of meanings. The famed Odessa Steps sequence of *Battleship Potemkin* thus takes rather longer (some five minutes) than it would take the soldiers to march down the steps: events overlap, different shots of the same event are juxtaposed, and a variety of camera angles are used to create a highly effective (though not conventionally 'realist') representation of the massacre. A 'smaller' (but interesting) instance of fragmentation of time and space occurs earlier in the film when a sailor angrily smashes a plate: eleven rapid shots from a variety of angles show overlapping fragments of the action, and an action which would have taken about a second takes up about three seconds of screen time. Though made in entirely different entertainment-oriented contexts, the shower murder in *Psycho* and the final shoot-out in *The Untouchables* (De Palma, 1987) are clearly indebted to Soviet Montage, the latter a clear pastiche of the Odessa Steps.

Montage could also be put to emotional effect, for what Eisenstein called emotional dynamization. Thus the significance of a conference (in *October*) is 'dynamized' by intercutting shots of delegates arriving with rapidly spinning motorcycle wheels. A clearer emotional impact is achieved at the end of *Strike* by the intercutting of shots of strikers being killed by police with shots of a bull being slaughtered in an abattoir.

Eisenstein and the other Formalists were producing work which, though it naturally looks dated some eighty-five years later, foresaw some of the film experiments and debates which occurred many decades later. The films are a reminder of one of the most important moments in film history; it is also worth remembering that many free-thinking radical Soviet artists of the 1920s were eventually thrown into prison or sent to Siberia; several died there. Eisenstein himself survived at the cost of formally denying his previous films and writing, and was obliged to co-operate with the Stalinist regime in directing the masterful but 'realist' *Alexander Nevsky* (1938) and *Ivan the Terrible* (Parts 1 and 2) (1944, 1946).

Exercise 4.2

Discuss recent films in which time and space are fragmented: can you think of examples where screen time is greater than event duration? How do recent films carry the influence of early experiments with montage?

Italian neorealism

The warning about 'movements' at the beginning of this chapter is particularly relevant to Italian neorealism: a group of films and film-makers was identified and celebrated by critics in the middle and late 1940s, but there was (at the time at least) no 'programme', no explicit statement of shared purpose.

The Italian neorealist films of 1945–51 were a stark contrast to the bland entertainment films of the fascist period, sometimes referred to as 'white telephone films' because of their storylines concerned with the lifestyles of the sophisticated rich, often symbolized (as in some Hollywood films) by the use of white telephones as props in the films. Although Mussolini's Italian fascist regime (which was in power from 1922 until the Spring of 1945, shortly before the end of the Second World War) was less brutal and more tolerant of artistic experiment than Hitler's Nazism in Germany, the end of the war in 1945 brought a sense of release to most Italians, and the 'Italian Spring' began. With the main Rome film studios (Cinecittà) all but destroyed and with severe shortages of equipment and film, a number of directors made a virtue of necessity and began filming on location, producing stories about ordinary working people struggling to survive in the poverty of postwar Italy.

In fact two of the first neorealist films, while dealing with everyday stories and shot entirely on location, were made before the end of the war and were concerned with the impact of the war on ordinary people: *Rome Open City* (1945) and *Paisà* (released 1946), both directed by Roberto Rossellini. The other major Italian neorealist films included *Germany Year Zero* (Rossellini, 1947), *Bicycle Thieves* (Vittorio De Sica, 1948), *The Earth Trembles* (*La terra trema*, Luchino Visconti, 1948), *Bitter Rice* (Giuseppe De Santis, 1948), *Stromboli* (Rossellini, 1949) and *Umberto D* (De Sica, 1951). This last film, dealing with a retired civil servant and his struggle against eviction and depression, was at the time described by the eminent French critic André Bazin as 'one of the most revolutionary and courageous films of the last two years…a masterpiece' (1967, p. 79).

If these films were praised by critics like Bazin for their 'realism' and won prizes in international festivals, they were not especially popular with Italian audiences, who generally preferred Hollywood films (of which they had of course been deprived during the war years). The Catholic Church and conservative elements of the coalition government were also very hostile to such films, claiming that they created a 'slanderous' image of Italy.

Indeed, the 'Italian Spring' ended in 1948 as the Christian Democrats won a general election and engineered legislation (the 1949 'Andreotti Law') which increased economic protection for the Italian film industry but signed the death-knell of the neorealist style by insisting on vetting scripts as a condition for state finance: a form of preproduction regulation and censorship.

The 'neorealist' directors (chief among them Rossellini, De Sica and Visconti) in fact came from different backgrounds and did not necessarily share the same

political views: Visconti, though from an aristocratic family, was a Marxist, Rossellini later had difficulty denying his links with Christian Democrat ideology, De Sica was a Social Democrat. Nevertheless their films of the neorealist period were similar in significant ways. We can discover these by looking in a little detail at a humble, unspectacular film from 1948 which still regularly makes its way into the top ten or so films of all time.

CASE STUDY

1

Bicycle Thieves (*Ladri di biciclette*) (Vittorio De Sica, 1948)

An important characteristic of neorealism has already been mentioned in passing above: the use of locations. *Bicycle Thieves* was filmed largely in the streets and buildings of Rome, though not a Rome which visitors would have recognized: the focus here was on poverty and unemployment. The bulk of neorealist filming was done on location, most famously for Rossellini's *Rome Open City* and *Paisà*, both of which were shot during the war in some secrecy. Some films did make limited use of studios (we should remember that studio space was in very short supply), and the most notorious examples of 'false' use of locations occur in *Germany Year Zero*, in which a boy wanders the derelict streets of postwar Berlin: a number of the sequences in this film represent action which supposedly happened in Berlin, but which was shot in Italy against back-projected footage of Berlin streets.

We have also already referred to the downbeat subject matter of the neorealist films: the struggles of everyday Italians at the end of the war, poverty, the underprivileged. The narrative of *Bicycle Thieves* is deceptively simple: the father of a poor family manages to get a job putting up posters, uses all the family savings to buy back his bicycle, then has the bicycle stolen on his first day at work. The rest of the film follows him and his young son as they search hopelessly for the missing bicycle (without which he cannot do the job), until in an act of despair he himself tries to steal a bike. Shaken and ashamed, he walks off with his son into the anonymous crowd, again reduced to an unemployment statistic.

The neorealist directors shared a postwar social concern to exorcize the fascist years and to create a better society. However, the individual and political approaches of these directors were, as we have noted, quite different. *Bicycle Thieves* itself, though effectively portraying the postwar poverty and social problems of Rome, has been criticized from a more left-wing perspective for not providing any effective political analysis of the sources of the problems.

A third characteristic shared by most neorealist films is the use of nonprofessional actors. The elderly civil servant of *Umberto D* was played by a university professor; Antonio Ricci and his son Bruno in *Bicycle Thieves* were played by a factory worker and a boy whom De Sica cast because of the way he looked walking next to his 'father'. Although De Sica (having himself been a successful actor) was careful in his casting, in this sense he was much closer to

the neorealist ideal than Rossellini, who combined non-professionals with star names (Anna Magnani in *Rome Open City*, Ingrid Bergman in *Stromboli*).

Lighting and camerawork in neorealist films were unspectacular and designed to further the 'realist' illusion of simple observation. The ideal was to use natural light and to avoid artificial lighting set-ups, though this was sometimes not practical. Dramatic camera angles and sudden camera movements were avoided; close ups were sparingly used. The scene in *Bicycle Thieves* where Antonio and Bruno walk the streets of Rome and Antonio fears that Bruno may have drowned in the river is a good example of 'undramatic' camerawork: one need only imagine how the suspense of such a scene could have been manipulated by, say, Hitchcock. This apparent artlessness, however, was not unprepared: most neorealist films were very carefully planned and scripted, and up to six cameras were used for a number of the outdoor sequences of *Bicycle Thieves*.

Editing in neorealist films was typically slower and again less concerned with manipulating dramatic tension than in most films. Though takes were not especially long (as they would become in later experiments with realism), editing was designed simply to further the impression of observation of a unified diegetic space. There was relatively little use, for example, of point of view shots, or of shot/reverse shot methods for conversations compared with Hollywood films. While this trend is clearly visible in *Bicycle Thieves*, it has to be pointed out that there are also moments when the spectator's attention is being directed and manipulated: thus, for example, when Antonio and Maria go to redeem his bicycle, the editing is different and puts the spectator in the couple's position as they watch an employee climb the enormous stack of bedsheets which have already been pawned: a clear symbol of the desperate poverty of the working class.

A final point to be made about Italian neorealist films (and one which clearly undermines their 'realist' status) is that virtually all Italian films of the period were post-synchronized: voices were dubbed onto the image track in a sound studio. In addition, most neorealist films (*Bicycle Thieves* is no exception) were accompanied by a sentimental, melodramatic score, which further undermines the claims to 'transparent representation of reality' which have been made on behalf of Italian neorealism.

END OF CASE STUDY

Italian neorealism is an important and interesting moment in film history, but its influence on future film-makers has also been considerable. Many Asian, South American and African directors made deceptively simple films about their own societies and cultures; excellent examples include the Indian director Satyajit Ray's Apu trilogy, made between 1955 and 1960 (see p. 88 below), *Salaam Bombay!* (Mira Nair, 1988), also from India, *Central Station* (Walter Salles, 1998) from Brazil, and a number of other African, Latin American and recent Iranian films. Gillo Pontecorvo's Italian-Algerian co-production *The Battle of Algiers* (1966)

was inspired by Italian neorealism. The neorealist impulse has also continued in Europe, not least through the British New Wave of 1959–63 and the work of British directors who continue to be active in the new millennium such as Ken Loach.

The French New Wave

This term (*nouvelle vague* in French) is used to describe the French films made between 1959 and the mid-1960s by two slightly different groups of film-makers. One was a group of enthusiastic young men with little experience of making films; the other was a slightly older group of men and women, sometimes referred to as the 'Left Bank' (*Rive gauche*), committed to 'art' but not exclusively to the cinema, who had made films before and whose reputations were enhanced by the *nouvelle vague*.

The French New Wave was largely a product of critical impatience with 'le cinéma de papa' as expressed in *Cahiers du cinéma* (see Chapter 13 below). Youthful exuberance certainly helped, but the film-making careers of Jean-Luc Godard, Claude Chabrol, François Truffaut, Eric Rohmer and Jacques Rivette were indebted to at least two other factors.

The first was the unexpected success of *And God Created Woman* (*Et Dieu créa la femme*, Roger Vadim, 1956), which alerted financiers and distributors to a potential new youth market which may have tired of the 'classics' of the 1940s and 1950s. Without Vadim's success it is unlikely that Godard and the others would have secured funding for their early films. The second factor was the development at the time of far more portable cameras and sound recording equipment, which increasingly freed filming from the studio and gave far more creative freedom to the director.

It is not possible to give any coherent overview of the New Wave here: between 1959 and 1968, Godard made or collaborated on some twenty films, Truffaut nine, Chabrol eighteen. The older group of Agnès Varda, Alain Resnais, Georges Franju and others remained active. It is possible in these pages only to evoke some of the innovative and exciting techniques used in a few of the early films; the word 'exciting' is appropriate because, in contrast with Italian neorealism, the French New Wave films of the 1960s were popular with both critics and audiences.

The films of the new directors were quickly and cheaply made; they experimented with film style so that the camerawork and editing were highly innovative at the time – see, for example, the hand-held camerawork and freeze-frames of *Jules et Jim* (Truffaut, 1962). The narratives were often built around apparently chance events and were often digressive and open-ended. Characters were typically young, somehow dissatisfied with life. Dialogue was idiosyncratic and fragmented and often included lengthy meaningful silences. Little family life was ever shown. Settings were contemporary, often urban (and most often Paris). In keeping with the ex-critics' intellectual passions, many of their films (and particularly those of Godard) became intensely intertextual, constantly 'quoting' books, art and other films.

If there were common characteristics in the early French New Wave films, the careers of the three most significant directors soon took different paths to different kinds of world fame. Claude Chabrol established a reputation for archetypally French psychodrama crime thrillers (*Le Boucher*, 1970; *Blood Wedding* (*Les Noces rouges*, 1973)), and has often been compared with Hitchcock; having made over forty films and several TV episodes by the mid-1990s, he emerged as the most commercially flexible of the New Wave directors. The films of François Truffaut (who had experienced a traumatic childhood and had been largely brought up by André Bazin), though stylistically very much part of the New Wave, were much more personal, from his semi-autobiographical *The 400 Blows* (*Les 400 coups*, 1959), *Stolen Kisses* (*Baisers volés*, 1968), *Bed and Board* (*Domicile conjugal*, 1970) and *Love on the Run* (*L'Amour en fuite*, 1979) to films such as *The Wild Child* (*L'Enfant sauvage*, 1970), which were also intensely personal. His aim was perhaps not so much to transform French cinema as to revive it. Truffaut died in 1984.

Jean-Luc Godard is perhaps seen as the most 'typical' French New Wave director: unpredictable, innovative, provocative and prolific (he has remained an active director and producer in the new millennium, with films such as *Notre musique* (2004) continuing his tenacious interrogation of the meaning of cinema and of representation). As Thompson and Bordwell observe, 'the inconsistencies, digressions and disunities of Godard's work make most New Wave films seem quite traditional by comparison' (1994, p. 525).

■■■■■■■■■■■■■■■■■■■■■
CASE STUDY

A bout de souffle (Godard, 1959)

Godard's *Breathless* (*A bout de souffle*, 1959) was the first of many films in which he used an increasingly experimental and fragmented style to challenge the spectator's assumptions: a favoured saying of Godard's at the time was: 'ce n'est pas une juste image, c'est juste une image' (it's not a 'just' image, it's just an image).

The 'hero' of *A bout de souffle* is a petty crook Michel (played by Jean-Paul Belmondo, who went on to a profitable career based on such characters), who is wanted for shooting a policeman; he becomes attached to a young American woman, Patricia (played by Jean Seberg, the first of many 'foreigners' in Godard's films), in Paris and they agree to run away together, but our hero must first pick up some money from a very elusive debtor. He eventually manages to get the money, but as the police close in, Michel restates his commitment to Patricia and is killed as he runs from the police.

What is (still) disconcerting and surprising about the film is the way this apparently straightforward plot is narrativized. Michel's killing of the traffic policeman is casual and barely explained; his meeting with Patricia is accidental and their relationship seems casual; there are no conventional indicators of 'love'. Jump cuts and discontinuity editing abound. Most of the film is concerned

with unfocused conversations between Patricia and Michel and with the latter's unconvincing attempts to find his money. The spectator never really learns anything about the underworld or the reason why the money is not forthcoming. Stripped of conventional narrative and psychological 'motivation', *A bout de souffle* became the archetypal New Wave film: art for a new generation.

The initial *Cahiers* infatuation with Hollywood (which as we shall see in Chapter 13 was important in the development of the auteurist approach) soon became for Godard a love-hate affair as love for the stars and icons of Hollywood gradually gave way to a politicized hatred for US imperialism. Thus in *A bout de souffle* the main characters go to see US films and the otherwise typically French hero clearly has a Humphrey Bogart fixation; by the time of *Contempt* (*Le Mépris*) of 1963, a story set in Hollywood and with veteran German Expressionist Fritz Lang playing a tyrannical director, commercial film-making is seen as a heartless, exploitative business which leads to suffering and death.

END OF CASE STUDY

Exercises 4.3

1 One of Quentin Tarantino's production companies for *Pulp Fiction* was named 'A Band Apart' (the title of a 1964 Godard film). What signs are there in Tarantino's films of his interest in Godard's early work?
2 Watch Godard's *A bout de souffle* and Jim McBride's 'remake' starring Richard Gere, *Breathless* (1983). Compare the style and the narratives of the two films.

Japanese cinema

The history of Japanese cinema is in fact longer than that of Hollywood. The first studios were built in 1905 and soon led to a studio system very similar to that in the United States. While from the 1920s Hollywood had its 'Big 5', in Japan the two biggest studios (Nikkatsu and Shochiku) were joined in the 1930s by Toho to create the 'Big 3'. As in the USA, from a very early stage the industry was vertically integrated. While in the USA early films portrayed vaudeville acts and began to develop rudimentary Western and crime genres, early Japanese films showed traditional kabuki plays and 'swordfight' narratives. These were extremely popular, and enabled Japan to cement its commercial dominance in Eastern Asia. It is worth noting that Japan is virtually the only country in the world whose domestic product was not overshadowed by US films; despite rapid westernization during the 1920s and 1930s, Japanese cinemagoers preferred to see Japanese films. It was not until much later, in 1976, that US films came to dominate Japanese cinemas.

An interesting difference in the silent period was the presence for many screenings in Japan of commentaries spoken by professional speakers called

benshi: films were thus accompanied by spoken explanations of dialogue and action which were often performances in themselves. Indeed, the union strength and influence (and popularity) of the *benshi*, and the Japanese reluctance to be dominated by US technology, meant that the replacement of silent film by synchronized sound was considerably delayed. While Hollywood moved rapidly into sound film production between 1927 and 1929, it was not until 1931 that the Japanese Tsuchihashi sound system had been developed, and a series of strikes by the *benshi* also delayed effective distribution of new sound films. By 1935 half of Japanese films were still silent. This should not, however, simply be seen as blinkered conservatism; the few Japanese silent films which survive indicate that the 1920s, though marked by reliable genres such as swordfight films, comedies and family dramas, were also a period of dynamic experiment in narrative, camerawork and lighting, comparable to the better known European 'movements' such as German Expressionism.

The two most significant Japanese directors of the 1930s were Yasujiro Ozu and Kenji Mizoguchi. Both established themselves with 1930s genre films before gaining international recognition with their contrasting styles in the 1950s (Ozu with *Tokyo Story* (1953), Mizoguchi with *The Life of Oharu* (1952) and *Ugetsu Monogatari* (1953)). Mizoguchi's style was expansive and dramatic. His subject matter was epic, the drama heightened by a refusal of close shots and a preference for relatively long takes in long shot.

By contrast, though he began by making a wide variety of different genre films, Ozu soon developed a very personal style which was to become his trademark. Dealing principally with life's little stories, his films contain little camera movement; every shot is very carefully framed, and many shots are held for a few seconds after significant action or dialogue has finished: it has been suggested that emptiness and absence reflect a specifically oriental or Zen philosophy to be contrasted with Western emphasis on presence. There are very few high or low angle shots; virtually all shots are filmed horizontally from a height of about one metre, significantly lower than is usual. It is likely that this is at least partly influenced by the traditional Japanese practice of sitting or kneeling on the floor. Another Ozu trademark is the cutaway shot, often to an object or an exterior detail, which serves no narrative function but which evokes a relevant emotion.

The careful frame composition works together with the editing in a unique way. Ozu was one of the first directors to systematically break the 180 degree rule (Nagisa Oshima was also to do so much later, in *Death By Hanging* (1968)). Ozu worked according to his own system whereby camera angle changes could be any multiple of 45 degrees, which meant that space was constructed quite differently from that built up by continuity editing. At the same time, it is graphic matches and contrasts that determine the editing. Thus in films such as *Passing Fancy* (1933), the figures may occupy identical positions in the frame. According to David Bordwell: 'Ozu instructed his cameraman to film medium shots of different-sized characters from different distances, so that the figures would be the same size in

each shot…Even the eyes had to be in the same position from shot to shot' (1988, p. 98). The 180 degree rule is broken, yet the spectator is not entirely disorientated. It is interesting to compare Ozu's use of such graphic matching with Eisenstein's concern with such matches and contrasts in Soviet Montage.

After the devastation suffered during the Second World War, Japan's restructuring was dominated by the United States until 1952. Many wartime Japanese films were destroyed, but the structure of the film industry remained more or less intact and by the mid-1950s production had returned to pre-war levels. The films of Ozu, Mizoguchi and Akira Kurosawa (*Rashomon*, 1950; *The Seven Samurai*, 1954; *Throne of Blood*, 1957; *Yojimbo*, 1961; *Ran*, 1985) gained recognition at international festivals and began penetrating overseas markets, while domestic consumption was well served by comedies and melodramas, which were not so exportable, and then from the mid-1950s by the monster genre inaugurated by *Godzilla* (1954), which was.

Kurosawa was a particularly key figure in the development of two-way traffic between Japanese and Western cinema. Western themes and sources were very evident in a number of his films, from the relativity of truth examined in *Rashomon* (1950) to the influence of John Ford (*The Seven Samurai* (1954), *Yojimbo* (1961)) and the use of Western source texts, most notably Shakespeare: *Throne of Blood* (1957) was an adaptation of *Macbeth*, *Ran* (1985) of *King Lear*. With their stylized Japanese style, films such as *Rashomon*, *The Seven Samurai* and *Yojimbo* in turn influenced a generation of European and US film-makers, most evidently in films such as *The Magnificent Seven* (Preston Sturges, 1960) and *A Fistful of Dollars* (Sergio Leone, 1964).

The early 1960s saw the Japanese New Wave, which stimulated the careers of Oshima, Shohei Imamura and Yoshishige Yoshida. Though this was superficially similar to the French New Wave of the same period, the significant difference is that while the French movement was a reaction against tradition, the Japanese New Wave was manufactured by the industry itself. The modernist experimentation of the directors was real enough, and the assaults on traditional values were severe, but in the Japanese case the revolt was managed by the industry itself. As in France, however, the popularity of the films dropped off after 1964 in face of the competition from television. The studios began to struggle and, as in the United States, survived by letting out studio space and by investing in TV and other productions. The studios thus survived, but there was an explosion in 'independent' film-making.

The studios also survived by cashing in on highly successful formulaic genres such as the monster movie and by investing in foreign (including US) productions. Indeed, the international careers of Kurosawa, Imamura and Oshima were largely dependent on international projects.

By the 1980s Japanese film production had become much more fragmented but nevertheless remained internationally successful and exportable. Post-apocalyptic anime animations, manga and visceral heavy-metal sex-and-violence were the stuff of the 'New Japanese Cinema', itself a post-punk reaction against the experimental and intellectual modernism of the 'New Wave'.

Since 1976, however, most cinema admissions in Japan had been for US films. If Japanese films now retained their popularity, it was surely in large part by (often very effectively and inventively) mimicking the entertainment values of the foreign imports. Films for the 1980s home market were produced very cheaply to appeal to an affluent youth market, and according to Thompson and Bordwell (1994, p. 758) at least half of the films produced around 1980 were soft pornography.

Since the 1990s, US companies have moved into exhibition in Japan by opening their own multiplexes, while powerful Japanese companies have taken over US entertainment companies such as Columbia and Universal. If Japanese directors and films no longer carry the prestige of Ozu or Kurosawa, there is a lot of Japanese money and influence in the increasingly globalized media industries, partly reflected by the commercial success of the ultra-violent manga films and of cult horrors such as *Ring* (Nakata, 1998). As is often the case with cult films, a successful US remake of *Ring* was released in 2002.

Hong Kong cinema

Though the Hong Kong film industry only began in the 1950s, its success and international standing have been considerable, particularly considering the size of the previous British Crown Colony which was returned to China in 1997.

Until 1970, the virtual monopoly of Run Run Shaw's 'Shaw Brothers' studios turned out a successful series of swordfight films, melodramas and films inspired by Chinese opera traditions; the vertically integrated company dominated the market in south-east Asia. When a new martial arts genre was developed in the 1960s (borrowing from Japanese samurai films, spaghetti Westerns and Chinese opera), competition appeared in the form of Raymond Chow's 'Golden Harvest' company, which unleashed Bruce Lee on the world.

As well as achieving massive domestic popularity with his genuine but balletically choreographed kung fu skills (he was also an explicit pro-Chinese and anti-Japanese symbol in a number of his films), Bruce Lee brought Hong Kong cinema to international attention with *Fists of Fury* (1971), *Enter the Dragon* and *Return of the Dragon* (both 1973). His untimely (and unexplained) death in 1973 increased his cult hero status.

The 1970s thus saw Hong Kong cinema producing over 100 films a year and with far-reaching market influence: its profitability was aided by cheap production methods and by the 'forbidden' appeal of films made in an area with relatively liberal censorship regulations. The films did very well both at home and abroad. Gradually the martial arts genre declined, though despite desperately contrived parodic excesses it also retained popularity, much as did the Italian spaghetti Westerns. Thrillers, comedies and 'underworld' action films became the favoured genres, and, more significantly, these were resolutely set in a modern urban environment.

It is in this context that Hong Kong's 'First New Wave' appeared in the late 1970s. While the French New Wave and other European cinema had clearly influenced directors such as Ann Hui, Shu Kei, Tsui Hark, Patrick Lam and

John Woo, the innovation of the Hong Kong directors was concerned less with the development of a new kind of cinema than with seeing how far they could go with existing popular genres.

At the risk of 'New Wave overload', it may be worth stressing at this point the difference of Hong Kong cinema compared with neighbouring Chinese cinemas. There was, for example, a resurgence in Taiwanese cinema in the 1970s, sparked by King Hu's very challenging *A Touch of Zen* (1971). Very different, on the other hand, was the story of Chinese cinema itself (which it is not possible to go into in detail here); following the so-called 'Cultural Revolution' of 1966–76 (during which very few films were made in China), a 'Fifth Generation' of film-makers were trained in Beijing, whose 1980s films, though sometimes subject to various forms of censorship in China, found a ready audience in the West. Among these were *Yellow Earth* (Chen Kaige, 1984) and *Red Sorghum* (Zhang Yimou, 1987). With the drastic and continuing suppression of civil rights symbolized by the events of Tiananmen Square in 1989, some Chinese directors made their way to the West, including Chen Kaige (*Farewell My Concubine*, 1993).

Since the nineties however there has been a gradual liberalization which has enabled new directors and challenging films to emerge. Jia Zhang Ke has been directing films since 1995 which often combine elements of realism with moments of surrealism. *Still Life* (*Sanxia Haoren*, 2006) follows the journeys of Chinese citizens returning to their home town for the last time before it is flooded for the completion of a dam on the Yangtze river. The film unfolds human dramas against the backdrop of large-scale industrialization, a contemporary theme in China, revealing the dehumanizing brutality of such industrialization.

While the distinction between 'mainstream' and 'alternative' films had in fact always been rather blurred in Hong Kong, there was a second 'New Wave' in the 1990s, typified by the more experimental and idiosyncratic films of Wong Kar-Wai, aided and abetted by his equally creative Australian camera operator Chris Doyle (*Ashes of Time*, *Chungking Express* (both 1994)). Lyrical but disjointed, carefully constructed but narratively opaque, Wong's films are stylistically 'hypermodern' – the 'MTV generation' is constantly evoked in writing about his films – yet deal with themes of isolation and the random determinants of love which have led to his films being compared with the work of European directors such as Alain Resnais and Krzysztof Kieslowski.

In an age of media saturation and omnipresent video images, Wong's films questioned the very nature of cinema as cinema, and were perhaps suitable signs of the 'culture of disappearance' in pre-1997 Hong Kong. Yet despite the imminent takeover by China, Hong Kong films were already widely available on the mainland.

Indian cinema

The Indian film industry has often been described as 'the biggest in the world' in terms of production output. It also has a long history dating from its roots in 1896

and from the work of Dadasaheb Phalke, who directed the first Indian feature film (*Raja Harishchandra*) in 1913. By the 1920s Indian studios were already producing over 100 films a year, considerably more than either the British or French industries. Output was prolific but, perhaps partly hampered by the variety of cultures and languages of the subcontinent, the major production companies were unable to secure any measure of vertical integration to consolidate their position. Though the studios (most typically those at Tollygunge in Calcutta which were nicknamed 'Tollywood') were modelled on Hollywood, they retained a 'family' ethos, and the most favoured (and highly popular) genres were the 'mythological' or religious tales, 'stunt' adventure films and a smattering of socially responsible romantic melodramas. Most significantly, virtually all films, of whatever genre, were punctuated by (apparently non-diegetic) song and dance numbers.

By the eve of the Second World War in 1939, the Indian film industry had attained a deceptive position of apparent strength. Some 200 films were being made each year, yet though many of the films were popular within India, they were not dominant in the way that Japanese and (later) Hong Kong films dominated their home markets. This was no doubt partly due to the wide variety of Indian cultures and languages (which made it impossible for a single film to appeal to a truly massive audience), but must also have been exacerbated by the financial instability of the film companies themselves, which were prey to corruption and nepotism as studio heads were increasingly held to ransom by star actors and actresses demanding exorbitant fees.

Though the old Indian studio system collapsed in the 1940s and hundreds of small independent companies sprang up, little changed in the postwar years; by the early 1960s some 300 films were being produced each year by an intensely competitive industry (with its principal bases in Bombay and Madras), conforming largely to the same genres, with the addition of the 'historical' genre inaugurated by Chandralekha (*Vasan*, 1948). This genre complemented the 1950s moves to censor representations of sexual activity, particularly wanton kissing and 'indecorous' dancing – though dancing and singing, of course, remained essential ingredients of almost all Indian films, aimed as they were at a rural audience which was at the time still largely illiterate.

Nevertheless, the 1950s also saw some changes, with some directors beginning to experiment deliberately with European influences. Thus while Raj Kapoor's comedy dramas were popular and populist, the *mise en scène* was new to Indian audiences. More innovative still were the films of Satyajit Ray, a writer and commercial artist who turned to film after seeing *Bicycle Thieves* – it is clear that Ray was in no way 'typical' of Indian film-making of the time. His semi-autobiographical trilogy *Pather Panchali* (1955), *Aparajito* (1956) and *The World of Apu* (1960) introduced the methods and ideals of Italian neorealism to Indian cinema: no songs, no dancing, but a careful, undramatic but sensitive and beautiful observation of the hardships of a poor family. When De Sica's scriptwriter Cesare Zavattini saw *Pather Panchali*, he responded: 'at last, the neorealist cinema that the Italians did not know how to do' (quoted in Das Gupta, 1981, p. 61). While Ray's

films have probably been appreciated more in Western 'art cinema' circles than in rural Indian cinemas, his influence on later Indian films (for example, Mira Nair's *Salaam Bombay!* (1988)) has been considerable. Indeed, even *Mother India* (Mehboob Khan, 1957), at the time the greatest Indian box-office hit of them all (and still playing occasionally on British terrestrial TV), despite its use of song and dance, was perhaps more 'realist' than previous films of the genre.

Though the song-and-dance formula continued to be popular (and, indeed, still is), and the 1960s saw a consolidation of home markets and the beginning of profitable exports, there were government attempts to move Indian cinema beyond its entertainment base. From 1969, Film Finance Corporation funds were provided for a Bombay-based 'Parallel Cinema', which became the 'New Indian Cinema' of the 1970s. This was a more self-consciously experimental, artistic and politicized cinema, made by directors such as Satyajit Ray but also by Mrinal Sen (*Bhuvan Shome*, 1969), Ritwik Ghatak (*Reason, Argument and Tale*, 1974) and *Basu Chatterji* (*The Whole Sky*, 1969). The influence in these films of European attitudes to material otherwise censorable in India, and of leftist critiques severely critical of ruling ideologies, led (perhaps not surprisingly) to increased censorship of such 'alternative' films and to revised guidelines for allocation of finance for funding such projects. A further problem was the lack of any alternative distribution system for such relatively challenging films.

In a country of (then) over 500 million people, however, it is no surprise that such marginal films continued to be made (largely in the more left-wing/ communist states such as Kerala), side by side with the staple entertainment: by 1980 Madras had become 'the most prolific filmmaking capital in the world' (Thompson and Bordwell, 1994, p. 771). Export markets continued to grow (particularly with the boom in video sales of classics such as *Sholay* (Ramesh Sippy, 1975) and record-breaking *Naseeb* (*Destiny*, Manmohan Desai, 1981)) and soon included Indian populations in Europe, Canada and Australia as well as in East Africa; in Britain's Birmingham and London and elsewhere, specialist cinemas showed (and continue to show) Indian and Pakistani films to full houses night after night, an established staple diet of romance, action, drama, comedy and musical genres coexisting in each single film, a spicy mix which resulted in such films, be they from Mumbai, Madras or elsewhere in India, being referred to as *masala* movies. Bollywood is clearly more popular than Hollywood in some parts of the world, and indeed it has been argued that films such as *Sholay* and *Deewar* (Yash Chopra, 1975) have begun to replace the *Ramayana* and the *Mahabharat* as 'mythological' references! By 1990 some 950 Indian films were being made annually; although a number of these were international co-productions, this is still some kind of record.

As has already been noted (see p. 71 above), Indian films produced over the last decade or two have exemplified an increasingly symbiotic relationship with their global audience: though numerically dwarfed by the indigenous Indian audience, the NRIs of the UK, Canada and elsewhere are courted in the appeal

of films such as *Kabhi Khushi Kabhie Gham* (*Sometimes Happiness, Sometimes Sorrow*, Karan Johar, 2001) or *Om Shanti Om* (Farah Khan, 2007) to a more global audience: foreign box office income for some such films can be almost half that generated domestically. Though Bollywood films have long integrated a variety of 'world music', the deliberate – and often self-parodic – westernization of music tracks in, for example, *Lakshya* (Farhan Akhtar, 2004) or *Kal Ho Naa Ho* (*Tomorrow May Never Come*, Nikhil Advani, 2003) has not been to all Indian critics' taste. Indeed for a film such as *Hum Tum* (Kunal Kohli, 2004) the music is predominantly British-Asian. There have arguably been signs that the diaspora are going home – there is now a Bollywood acting school in London. There has however been adverse comment on the now frequent use of European locations (particularly Switzerland, an increasingly popular holiday destination for affluent Indians) for Bollywood films. In this sense at least, Indian cinema is indeed truly global.

African cinema

It is clearly not technically correct to treat African cinema as a 'national' cinema, as Africa comprises over fifty nation states. Yet, with the exception of the Mediterranean countries such as Egypt, Tunisia, Algeria and Morocco, and to some extent South Africa (the relative prosperity and contact with Europe of these countries having enabled the development of some film-making – indeed, Egypt has a rich and varied film history), almost no indigenous film-making took place in the continent for most of the twentieth century, and indeed until the 1980s or so there were very few cinemas and virtually no attention was paid by individual governments to developing film industries. When one considers the more pressing problems of drought, starvation, war, and the repayment of crippling debts to Western governments and banks whose imperialist policies were a large part of the problem in the first place, however, it is perhaps not so surprising that developing national cinemas was not such a high priority. Despite obvious variations in the histories and cultures of many of the countries, it has been common to treat 'Black African Cinema' (as it should perhaps be called) as a critical category.

Prior to the start of Black African film-making, and indeed since that time, the overwhelming majority of films shown in Africa have been distributed by US and European companies; the entertainment agenda has been dominated (increasingly so since the spread of satellite TV and video in Africa) by cheap US films and by Egyptian, Indian and more recently Hong Kong products. Insofar that such films addressed African issues at all, they did so only in crude and caricatural terms: even 'respectable' films like *Out of Africa* (Pollack, 1985), *Gorillas in the Mist* (Apted, 1988) and *Cry Freedom* (Attenborough, 1987) did not escape this judgement.

The first steps towards the development of Black African film-making were taken with the establishment of Film Festivals at Carthage in Tunisia in 1966 and, more crucially, in Ouagadougou in Burkina Faso in 1969. These festivals secured the essential outside finance needed to launch indigenous film-making, and it

was in the French-speaking Senegal and the Ivory Coast that the first films were made and shown – it would be interesting to explore the possible legacy of the pioneering French documentary film-maker Jean Rouch, who made a number of films throughout much of central and West Africa between 1946 and 1977.

The first group of Black African film-makers included Med Hondo (Mauritania), Paulin Vieyra (Senegal), Désiré Écaré (Ivory Coast), Oumarou Ganda (Niger) and the 'father' of Black African film, Ousmane Sembene of Senegal, who is credited as having directed the first Black African film, the twenty-minute *Borom Sarret* (1963). Several of the early African films made surreal use of documentary and neorealist techniques to mount biting attacks on the ills of postcolonial African societies; many of this first generation of Black African film-makers had been trained in Europe and so were influenced by European 'movements' such as Soviet Montage theory and Italian neorealism, and had also developed a revolutionary left-wing political analysis (Ousmane Sembene, for example, had studied in Moscow). When these film-makers began to explore the African past in the 1970s and 1980s, the films were powerful critiques of colonialism and imperialism.

The problem, however, was not just getting films made; there was at the time almost no distribution network for such films, which found their audiences almost entirely in the 'art cinema' circuits of Europe and North America. The result was that films such as Ousmane's *God of Thunder* (*Emitai*, 1971), *The Curse* (*Xala*, 1974) and *Ceddo* (pronounced 'Yeddo', 1976) and Hondo's *Sarraounia* (1968) and *Soleil O* (1970) were too often written about and analysed as if they were European art films, and their specifically African nature was sometimes forgotten.

Yet despite the European influence, and despite the growth of some 'Western' style film-making/genres such as comedy and thrillers in some countries with stronger Western links such as Nigeria and Cameroun, a specifically 'African' cinema was slowly born. Constructions of space and time are different; the work of 'magic' (such as characters suddenly appearing or disappearing, for example in *Emitai* and *Sarraounia*) is integrated into some films in a matter-of-fact way; and perhaps most significantly, oral story-telling techniques (often involving a story-teller or *griot*) are woven into the narration (*Ceddo* is an excellent example).

These themes, and perhaps especially the narration of time and space, were taken up by the next generation of Black African directors, who included Safi Faye of Senegal, Souleymane Cissé of Mali (*The Wind* (*Finyé*), 1982; *Brightness* or *The Light* (*Yeelen*), 1989) and Idrissa Ouedraogo of Burkina Faso (*Grandmother* (*Yaaba*), 1989; *Tilaï*, 1990). There has also been some debate about the status of some other black film-makers such as Haile Gerima and Sarah Maldoror: not resident in Africa, should they and other diaspora figures (a term used to describe those who have spread – for whatever reason, in this case originally through slavery – throughout the world) be included in 'African' cinema?

The films mentioned above reflect the increasing photographic quality made possible by the modern technical facilities in Burkina Faso, and they accordingly did well on the European art circuit. Nevertheless, as well as exploring universal

themes, a film such as *Tilaï*, for example, is also intensely specific to the culture in which it was made. When a traveller returns to find that his father has married the woman of his own desire, an affair develops between the traveller and his stepmother. Is this incest? Should the couple try to run away to avoid the man's death which is demanded by custom? What are their rights and their obligations in their society? While lyrical and contemplative in its camerawork, *Tilaï* is an exploration of cultural questions very relevant to Burkina Faso.

Indeed recent African films from the region continue to explore politically delicate issues: *Moolaadé* (Ousmane Sembene, 2004) and *Delwende* (Pierre Yaméogo, 2005) are respectively concerned with controversial issues of female circumcision and the ostracization of old women perceived as 'witches' – the latter film provides an interesting comparison with *Yaaba*, which deals with very similar issues. Fanta Regina Nacro's *The Night of Truth* (*La Nuit de la vérité*, 2004) is an effective examination – no less powerful for being entirely fictionalized – of the problems of 'truth and reconciliation' following genocidal conflict such as that in Rwanda in 1994.

Nigeria has demonstrated the most rapid growth in film production in Africa, though strictly speaking we should perhaps refer to the country's films as part of a video industry since productions tend to be recorded as digital video. The films are low-budget, shot on location rather than in studios, and frequently go straight to video release rather than cinematic exhibition. Since the 1990s the industry has grown to become the third largest production centre in the world in terms of titles released, and is frequently referred to as 'Nollywood' in recognition of its position in relation to Hollywood and Bollywood. *Living in Bondage* (1992) is regarded as symbolizing the beginning of Nollywood's expansion as it typified what was to follow in terms of film style and content. The videos tend to deal with contemporary issues in the form of drama, thrillers and comedies. In contrast to most of the examples noted in this section, themes typically include corruption, gender roles, AIDS, religion and the role of morals within a changing society.

Questions of culture, relevance and adaptation to a rapidly changing world are central to debates about the future of African cinema. At the 1995 Ouagadougou Festival, a 'queer' South African film dealing openly and provocatively with homosexuality sparked a mass walk-out by the Black African audience. Among the urgent tasks facing Black African film-makers and cinema is engaging with such relatively 'new' moral and cultural issues. In this they may, finally, be helped by the increasing links being formed with other black film-makers abroad, with the diaspora; among films which explore more contemporary themes and which are set in more urban locations are those of Jean-Pierre Bekolo, notably *Quartier Mozart* (Cameroun/France, 1992).

Iranian cinema

Iran occupies an interesting cultural position between the influences of India to the East and Arab and other Middle Eastern cultures to the West. Its cinematic

history was for many decades underdeveloped as it remained, under the Shah of Persia and the Pahlavi dynasty, under a variety of Western influences – first British, then US –, the chief motivation being the money that could be made from the country's large oil reserves. Until the late 1970s, most film entertainment in Iran was imported, with US films dominating but with Indian films also enjoying much popularity. Among the films of relatively few indigenous film-makers, *The Cow* (Dariush Mehrjui, 1969) and the work of Abbas Kiarostami drew the attention of Western cinephiles at Film Festivals in the 1970s. After many years of popular opposition to subservience to foreign interference, however, the Islamic Revolution of 1978–1979 installed an Islamic theocratic government under the leadership of Ayatollah Khomeini whose laws would be a direct reflection of Islamic doctrine.

While the Islamic government is still in place, there have been considerable changes, both broadly and, more specifically, in terms of cinema. During the 1979 revolution many cinemas were burned down – with considerable loss of life – and films were initially regarded by the regime with great suspicion. A rigid censorship system was introduced and most Iranian films over the next fifteen or so years were either dramas with an explicitly Islamic moral or war films extolling the heroism and/or martyrdom of soldiers during the protracted 1980–8 Iran–Iraq war. Censorship ensured that few films dealt with contentious social issues, and one of the strategies developed by film-makers who wanted to make more socially critical films was to use children as central characters. Women were largely absent from Iranian screens; in keeping with orthodox Islamic precepts, women could not be sexualized and so their roles were confined to mothers/homekeepers. The *hijab* dress code was rigidly enforced, women were usually filmed in long shot wearing loose-fitting clothing, and no suggestion of sexual intimacy was permitted. Where Western films were shown (and Hollywood films certainly remained highly popular, particularly with the spread of video recorders in the 1980s) exposed body parts were blacked out with an indelible pen. It was also extremely difficult for women to work in the industry since they were not free to move about in public unaccompanied by a responsible man such as a father, husband or brother.

Political and social conditions were gradually relaxed, however, and the election in 1997 of Mohammad Khatami as President saw further liberalization, though this was and still is hotly contested by the Islamic establishment. While the influence of religious orthodoxy is still strong, the position of women in particular has slowly improved, though progress has been very uneven and many women are still trapped in highly oppressive patriarchal situations. On the other hand, it has become possible for women to work outside the family, and this has been reflected not only in growing numbers of women working in medicine, education and politics but also in a dramatic rise in the profile of women making films. Among the best known and outspoken of these are Rakhshan Bani Etemad (*The May Lady* (1998), *Under the Skin of the City* (2001)), Samira Makhmalbaf

(*The Apple* (1998), *The Blackboard* (2000), *At Five in the Afternoon* (2003)) and her sister Hana Makhmalbaf (*Joy of Madness* (2003), *Buddha Collapsed out of Shame* (2007)). The latter sisters come from a remarkable family of film-makers: the Makhmalbaf Film House website run by their father Mohsen Makhmalbaf (and mother Marzieh Meshkini (*The Day I Became a Woman* (2000), *Stray Dogs* (2004)) gives a remarkable account of the family's output. Samira made *The Apple*, a reconstruction of a recent case in which two sisters had been imprisoned in their home by their parents, with both the girls and the parents playing themselves, at the age of seventeen; it won prizes at several international festivals. Her sister made *Joy of Madness*, a fascinating documentary about the making of her sister's *At Five in the Afternoon*, at the age of fourteen. The father Mohsen Makhmalbaf's *Kandahar* (2001) and *Sex and Philosophy* (2005) were preceded by many films going back to 1983 and he remains a prolific writer and producer.

It must however be remembered that Iran is not ethnically or culturally homogenous. A sizeable minority of Kurds in the north of the country, for example, share little of the culture or aspirations of many other Iranians, and are more concerned, together with other Kurds in Iraq and Turkey, to fight for an autonomous state. A number of notable Kurdish films have gained international recognition, including Bahman Ghobadi's *A Time for Drunken Horses* (2000) and *Turtles Can Fly* (2004).

Other film-makers have also made films which depict a more modern Iran: veteran Abbas Kiarostami's *Ten* (2002) consists of ten conversations in the car of a woman taxi driver – unusual in itself in Iran – with a variety of customers, including a prostitute. Jafar Panahi's *The White Balloon* (1995) used a young girl as the central character to show Iranian patriarchy through a child's eyes, and his films have generally attempted to cast a critical eye on Iranian society.

▪▪▪▪▪▪▪▪▪▪▪▪▪▪▪▪▪▪▪▪▪
CASE STUDY

Offside (Jafar Panahi, 2006)

Offside is about girls/young women desperately trying to get into a football match, from which females are of course banned. The girls adopt a variety of ruses to try to enter, but are rounded up and held just outside the stadium guarded by two soldiers – the film was shot during a crucial World Cup qualifying match against Bahrain, which Iran won to get through to the 2006 finals. The dialogue clearly outlines the variety of the girls' backgrounds and their relationships with parents/families, and one or two of the girls are openly rebellious. The soldiers are somewhat bemused but are not hostile; their principal concern is not to get into trouble by allowing the girls to escape and to be able to go home after their military service. When one of the girls has to be accompanied to the toilet – and of course there are no toilets for women in a football stadium – there is some fascinating insight into Iranian toilet culture; there are graffiti in the toilet and

even a surprising suggestion of homosexuality. The film ends after a van arrives to take the girls in for detention, but amid the celebrations of Iran's victory after the match even the heavies guarding the girls seem to relent and effectively allow them to disappear into the crowd.

Offside was subject to obstruction while the screenplay required much rewriting, yet even the final version does voice fairly explicit criticism of the restrictions placed on girls and women. The film also raises the question of the target audience for Iranian films; while *Offside* gained a (limited) release in Iran, many of the Makhmalbafs' and others' films have not been released in Iran but have done well at international festivals, on the 'art house' circuit and through DVD sales.

END OF CASE STUDY

The increasing international visibility (and liberalism) of such Iranian cinema has seen a surge of interest from film distributors, writers and students all over the world. One may speculate that the ruling powers in Iran may be happy to see signs of increasing emancipation in films for export to the west while not permitting Iranians at home to see such films. It appears moreover that both Hollywood and Indian films remain highly popular in Iran.

Australasian cinema

Australasian cinema consists of films from Australia, New Zealand (Maori name 'Aotearoa') and neighbouring islands. It is probably fair to say that Australasian cinema is not particularly well known globally; nor is it prolific, no doubt partly because of the area's relatively small population and their film industries tending to be outside the major distribution networks. However, Australia and Aotearoa have increasingly featured as national cinemas and as significant players in world cinema.

Both countries were involved in production during the early days of film, with the first feature film, *The Story of the Kelly Gang*, being made in Australia in 1906 by Charles Tait. Nowadays Australian cinema tends to be identified first and foremost through a number of actors and their performances in Hollywood and Australian films, the country's first internationally renowned star being Errol Flynn. Since the revival of Australian cinema in the 1970s, Eric Bana, Russell Crowe, Cate Blanchett, Mel Gibson, Nicole Kidman, Guy Pearce and the late Heath Ledger among others have established themselves through Australian films, which often serve as launching pads for bigger Hollywood careers. The same is true of many directors who, having achieved success at home, move to Hollywood.

As would be expected, Australian films have often placed the country's geography and cultures at their heart. Ironically a film that helped put Australia on the map cinematically was a British-made film, *Walkabout* (1971), directed by Nicolas Roeg. It wasn't particularly popular in Australia but drew international

attention to the country's unique landscapes and indigenous culture. Australian cinema was further highlighted in 1975 with Peter Weir's *Picnic at Hanging Rock*, which tells the story of a day trip by girls from a private school and the disappearance of three of the schoolgirls and a teacher. On one level it works as a drama and mystery story; however, it can also be seen as highlighting the very different worlds of the modern settlers' Australia and the ancient aboriginal land of Australia.

1979 saw the release of the first *Mad Max* action movie directed by George Miller, set in a future dystopia. Mel Gibson plays a vigilante cop who takes the law into his own hands and fights injustice. So popular was the film that two sequels followed during the 1980s. The 1980s also raised the profile of Australian comedy, perhaps initially experienced through the Barry McKenzie movies of the 1970s. *Crocodile Dundee* (1986) introduced us to Michael Dundee, a crocodile hunter who lives in the Australian outback. Romance blossoms when he visits New York but the main entertainment arises from Michael's experiences with modern city life compared to his simple rural life in the outback.

The 1990s provided films that offered a humorous alternative to the more masculinist movies of the 1980s. Baz Luhrmann's *Strictly Ballroom* combines romance and comedy as two dancers challenge ballroom orthodoxy with their new steps. *Muriel's Wedding* (1994) continues the comedy with Muriel's search for romance and her dreams of her wedding day. *The Adventures of Priscilla, Queen of the Desert* (1994) features two drag queens and a transsexual who perform in drag shows: they travel in Priscilla, their tour bus, and we follow them as they travel to a performance in Alice Springs.

Luhrmann achieved further international success in 2001 with *Moulin Rouge!*, a romantic musical featuring Nicole Kidman. 2002 saw aboriginal life placed at the heart of Australian cinema with the release of *Rabbit-Proof Fence*. Shot in black and white, it tells the story of three Aboriginal girls who had been taken from their mothers in 1931 because they were mixed-race. They escape from the institution they have been placed in and walk for nine weeks to return to their home. In 2005, *The Proposition* (2005), a Western starring Guy Pearce, was set in the harsh context of the convict settlements of the late nineteenth century. *Jindabyne* (2006), an adaptation of a Raymond Carver short story, set in a small Australian town, not only deals with relationship and family tensions, but also touches upon issues of anti-aborigine racism. *Ten Canoes* (2006) is two stories told in aboriginal dialect. Emphasis is placed on the importance of oral traditions as a means for passing on a culture and its values. The pace is slow and the shots linger, in stark contrast to the fast-moving editing and camerawork of most contemporary films. Such films have been subject to analysis from a post-colonial perspective, analysing the relationship between aborigine and non-aborigine cultures. 2006 also saw the release of a very different movie about a baby penguin: *Happy Feet*, directed by George Miller, won an Oscar for best animation.

Aotearoa cinema is usually identified primarily through two of its directors, Jane Campion and Peter Jackson, and through the choice of the country as the

location for four of the biggest films of all time, the *Lord of the Rings* trilogy (2001–3) and *Avatar* (2009). Peter Jackson started out making low-budget horror and comedy films such as *Bad Taste* (1987), *Brain Dead* (1992) and *Meet the Feebles* (1989). His work moved to another level however with the epic *Lord of the Rings* trilogy, with a total running time of 558 minutes! The films made great use of Aotearoa for locations and the country has attracted a lot of film-makers since. *Once Were Warriors* (Lee Tamahori, 1994) gives a different perspective, set in urban Auckland and concentrating on a family that has broken its links with its Maori past. The family is headed by an unemployed, alcoholic, violent father and the children gradually drift into trouble; redemption is driven by the strong-willed mother and a son who rediscovers his Maori roots. The film deals very effectively with contemporary social problems and the conflict between Maori tradition and modern Aotearoa life. A somewhat lighter insight into Maori culture and history is provided by *Whale Rider* (2002), directed by Niki Caro. However, the film takes a critical approach to patriarchal Maori traditions through the actions a young girl, Pai, who challenges the traditions of the tribe she has been born into. Her grandfather, Koro, is the chief of the coastal village tribe and intends to appoint a male successor against Pai's claim that she should be the new chief.

Jane Campion's early films, *Sweetie* (1989), *An Angel at My Table* (1990) and *The Piano* (1993) were set in Aotearoa. She focuses on relationships and families, revealing strength within her characters through the dramas and romances they encounter. Her female leads are strong and independent, whether it's Nicole Kidman exploring Europe in *The Portrait of a Lady* (1996), Kate Winslet exploring India in *Holy Smoke* (1999) (see Chapter 15 on stars for more detail) or Meg Ryan exploring her sexuality in *In the Cut* (2003). But they are not without their problems, often trying to resolve the less desirable effects of family life, relationships and society. Campion's films give a female perspective on the world her characters inhabit and the typically slow pace of the narratives enables a depth to be developed that provides insights not usually found in contemporary films.

Very few films have come out of the other Pacific islands, but World Cinema takes an interest in even such 'microcinemas'. For example, the Fiji film *The Land Has Eyes* (Vilsoni Hereniko, 2004) has received exposure in Europe and the USA, though it must be said that this was due almost entirely to the tireless efforts of the husband-and-wife team touring and promoting the film. The cinemas of such parts of the world, which even now have gained little or no global recognition, have recently been referred to as a 'Fourth Cinema' (see 'Third Cinema' in Chapter 5 below).

CASE STUDY

The Piano (Jane Campion, 1993)

It was *The Piano* that brought Jane Campion international acclaim along with three Oscars. Although the film was set in Aotearoa it was mainly funded by the

Australian Film Commission, Campion having learned her trade in Australia. The film focuses on Ada McGrath, a mute woman from Scotland who is forced to travel to Aotearoa to undergo an arranged marriage to Alistair Stewart. She takes her daughter and her beloved piano with her. Ada communicates through sign language and through her piano, an instrument that releases her passions. After a night spent waiting she is eventually met by Stewart, his friend Baines and several Maoris, who have been engaged to carry the heavy load of possessions, including the grand piano, through very difficult forest terrain to Stewart's home. Baines has adopted aspects of the Maori lifestyle and lives a life somewhere between the native people and the settlers.

Stewart wants to leave the piano as he has no room for it, a traumatic beginning for Ada and her new life. Baines trades the piano for land to Stewart and moves the instrument to his home. Ada visits Baines and he offers to let her have the piano back, one key at a time, if she plays for him and accepts his increasingly amorous advances. Stewart eventually discovers the growing relationship his wife is having with Baines, whilst his relationship with his wife has never developed. He imprisons her in his home. Ada declares her love for Baines inscribed on a piano key which is discovered by Stewart, who then chops off one of her fingers to prevent her from playing the piano again. Afterwards he sends Ada and her daughter to Baines after ending their marriage. They depart in a boat from which Ada wants to push the piano overboard. She is about to throw herself overboard as well but changes her mind at the last moment.

END OF CASE STUDY

The film contains all of Jane Campion's trademarks: the strong female lead, drama, romance, passion, relationships and family, and a pace that allows us to linger on detail and think about the narrative. The causes (and eventual resolution?) of Ada's muteness remain enigmatic, and the relationship of Ada with her young daughter is arguably more central than that with the men in her life. The use of the wild forest locations is striking; the initial dumping of the frail-seeming Ada with her little girl and a grand piano on a desolate windswept beach on the other side of the world is particularly powerful.

Latin American cinema

Our final snapshot of non-anglophone cinemas is even more blurred than that of African cinema. While one reason for speaking of 'African cinema' is that in many individual African countries few films have been made, this does not apply to South and Central America: Argentina, Brazil and Mexico in particular have long, well documented film histories going back to silent cinema, and significant film industries have long existed in other countries such as Bolivia, Chile and Venezuela.

The reasons for the label 'Latin American Cinema' are twofold, if linked. First, and in contrast to African cinema, many Central and South American countries, as the word 'Latin' suggests, share a common language. While Portuguese is the official language of Brazil, and many indigenous languages are also spoken across the continent, Spanish is generally the *lingua franca*. Secondly – and more importantly – it was film-makers themselves who, between 1962 and 1967, began rallying round the banner of 'El Nuevo Cine Latinoamericano', for reasons which we shall briefly explore.

The founding of New Latin American Cinema in the 1960s was partly due to a recognition of a shared history/heritage, but was more importantly also a reaction to a worsening political situation across South America. Initially led by Fernando Birri, who had started a documentary film school in Santa Fé in his native Argentina in 1956, and inspired also by the international 'film club' in Cuzco in Peru, the new grouping drew together many left-wing film-makers who were concerned about increasingly totalitarian suppression of civil liberties in a number of South American countries. Though this affected all the continent over the next three decades and it is clearly impossible to give a full history in these few pages, some of the key moments were the 1964 coup d'état in Brazil followed by twenty years of military rule, a similar pattern of weak government and military rule in Bolivia, the 1973 military coup in Chile (on the 11th of September) which removed and killed Salvador Allende and led to thousands of deaths and disappearances under General Pinochet, another 1973 putsch in Uruguay again leading to widespread repression and torture, and the equally murderous 1976–83 junta regime in Argentina which deposed the popular and populist Eva Peron, the country already having suffered increasing military interference and repression since 1955.

The military regimes were encouraged, often covertly, by the CIA and by shadowy US interests, with training in counter-revolutionary warfare, including torture, being provided at the 'School of the Americas'. It is not for nothing that the brave South American critics of the time, many of whom were silenced or exiled, opposed US imperialism – of which Disney and other commercial entertainment was only the least malign form.

In startling contrast, events in Cuba took a different turn. The US puppet regime of Fulgencio Batista was overthrown on 31 December 1958 and replaced by an avowedly communist government presided over by Fidel Castro. As we write this chapter fifty years later the remarkably stable government is still in power despite continuous and repeated US efforts at destabilization, most notably through a trade embargo going back to 1962.

The relevant point here is that from 1959 Cuba became a focal point for the New Latin American Cinema. Under the leadership of Julio Garcia Espinosa, the ICAIC (Cuban Institute of Cinematographic Art and Industry) in Havana became a model of good practice and a haven for South American film-makers in exile. Yet post-revolutionary Cuban films were never overly didactic and did not follow

a 'party line'; there was room in Espinosa's 'imperfect cinema' for influences as diverse as Italian neorealism (Espinosa and Birri had studied together in Rome in the early 1950s), the Grierson school of documentary, European art cinema, Soviet montage, as well as more indigenous forms. Tomas Gutierrez Alea's *Memories of Underdevelopment* (1968) and *The Last Supper* (*La ultima cena*, 1976), Sarah Gomez' *One Way or Another* (*De cierta manera*, 1977) and Santiago Alvarez' *LBJ* (1968) and *79 Springs* (1969), while politically engaged, used a wide variety of cinematic styles.

Through the 1960s and 1970s, then, film-makers in much of South America struggled against censorship and various degrees of repression. Some 'movements', such as the 'nuevo cine' in Argentina, were criticized by activists for not taking a strong enough stand against those in power.

Two strands of opposition, however, were particularly noteworthy. In 1968 – and it was no coincidence that this was also the year of social upheaval across much of Europe – Fernando Solanas and Octavio Getino, who were also part of a group called Cinema Liberación, made *The Hour of the Furnaces* (*La hora de los hornos*), a four and a half hour call to revolution and overthrow of the corrupt Argentine regime. Still a remarkable audio-visual document, the film was shot, edited and then shown clandestinely: all those associated with the film risked imprisonment, torture and death. In its insistence on a new kind of film-making and indeed on a new kind of involvement with the audience, this film marked the founding of 'Third Cinema', a programme developed by Solanas and Getino in their subsequent writing (see Further Reading). The notion of Third Cinema was also taken up and elaborated by Teshome Gabriel (though he was writing in an academic, less dangerous context) in relation to national cinemas seeking to develop indigenous structures of storytelling and film production and a more egalitarian, less imperialistic relationship with their audiences. Such a model has lent itself well to the study of African cinema, for example.

Another important voice of protest was that of the Cinema Nôvo group in Brazil, and especially of Glauber Rocha. While Brazil was not subjected to the worst excesses of military rule, the repression was real enough and was felt particularly by the many poor. Thus it was that Glauber Rocha (*Black God, White Devil*, 1964; *Antonio-das-Mortes*, 1969) wrote of a 'Cinema of hunger' and a 'Cinema of violence', violence being the only solution for desperate people in desperate poverty.

There were of course other film-makers who made brave films: Ray Guerra's *The Guns* (*Os fuzis*, 1964) dealt with the extreme poverty of north-east Brazil; in Bolivia Jorge Sanjines' *Blood of the Condor* (1969) exposed a covert US mission to sterilize indigenous villagers.

While Cuba continued along its path, the 1980s saw the end of overt military rule across South America. The transition to democracy found film industries across the continent weak or non-existent. The situation in Argentina was perhaps typical, and it is salutary to note that in 1983 there was one sound studio in the country; an entire popular national culture seemed to have been eliminated. Though some memorable films were made, for example *The Official Version*

(*La historia oficial*, Luis Puenzo, 1985) and *Camila* (Maria Luisa Bemberg, 1984), properly indigenous film industries struggled to re-establish themselves anywhere in South America and the neoconservative cultural aims of the collective juntas had been achieved: US domination of the cultural market.

Indeed this was a kind of end of 'New' Latin American Cinema. If Argentina can be taken as an example, few films from other Latin American countries were distributed, and the few successful films (such as *The Official Version*, which won the Academy award for Best Foreign Language Film in 1986) were made with international distribution in mind. Where there has been a greater measure of success, this has depended – as in Venezuela for example – on mining the popularity of TV soaps and 'pornochanchadas', or, as in the case of Mexico, on using the Spanish connection to reach a wider European and world market: examples include *Like Water for Chocolate* (Arau, 1992) and *Amores perros* (Inarritu, 2000). This has also led to a number of fruitful co-productions such as *Pan's Labyrinth* (del Toro, 2006).

It took many years for indigenous Latin American film industries to recover, though even then US influence was evident. While there were attempts to replicate the grass-roots collectivist film-making ideals of Cuba in Nicaragua during the Sandinista period and more recently in Venezuela, and despite the leftward political shifts in Brazil, Venezuela, Bolivia and elsewhere in the past decade, Latin American cinema has arguably never achieved the liberation of which Birri and Espinosa once dreamed.

CONCLUSION

We can only repeat here the regret with which this chapter began: that space does not permit a proper examination of other significant strands of world cinema. Indeed, even the *Oxford History of World Cinema*, running as it does to over 800 pages, cannot cover everything. Regrettably, we have been unable to include here extended discussion of Chinese cinema or the newly vibrant Thai cinema, among others. Cinema is pervasive and the world is a big place.

SUMMARY

↪ 'National cinemas' are usually defined in opposition to the dominance of US/Hollywood cinema.

↪ The best-known European film 'movements' include 1920s German Expressionism and Soviet Montage, the Italian neorealism of the 1940s and the French New Wave of the early 1960s.

↪ Indian films (particularly those of the studios known as 'Bollywood') have, in terms of audience figures and popularity, arguably been more successful than those of Hollywood.

↪ Despite their considerable success, other Asian cinemas, particularly those of Japan and Hong Kong, have generally been critically neglected in the West.

REFERENCES

Bazin, A. (1967, 2004), *What is Cinema?*, vol. 1 (transl. H. Gray), Berkeley, CA: University of California Press.

Bordwell, D. (1988), *Ozu and the Poetics of Cinema*, London: BFI, pp. 88–105.

Crofts, C. (1998), 'Concepts of National Cinema', in J. Hill and P. Church Gibson (eds), *The Oxford Guide to Film Studies*, Oxford: Oxford University Press.

Das Gupta, C. (ed.) (1981), *Satyajit Ray*, New Delhi: Directorate of Film Festivals.

Eisner, L. (1965), *The Haunted Screen: Expressionism in the German Cinema*, London: Secker & Warburg.

Thompson, K. and Bordwell, D. (2002), *Film History: An Introduction*, 2nd edn, New York: McGraw-Hill.

FURTHER READING

Bazin, A. (1971), *What is Cinema?*, vol. 2 (transl. H. Gray), Berkeley, CA: University of California Press.

Bazin's ground-breaking pieces about realism, ontology and Italian neorealism should be required reading for any serious film student.

Bondanella, P. (2001), *Italian Cinema: From Neorealism to the Present*, 3rd edn, New York: Continuum.

A good, fairly comprehensive account of postwar Italian film history.

Braudy, L. and Cohen, M. (eds) (2009), *Film Theory and Criticism*, 7th edn, Oxford: Oxford University Press.

An excellent compendium of many important and influential pieces of film-theoretical writing.

Dabashi, H. (2001), *Close Up: Iranian Cinema Past, Present and Future*, London: Verso. A good, concise and accessible book on Iranian cinema.

Dennison, S. and Song Lim, H. (eds) (2005; 2006), *Remapping World Cinema: Identity, Culture and Politics*, London: Wallflower Press; also Columbia University Press.

Some challenging essays on the influence of globalization on notions of national cinema.

Eisenstein, S. (1949), *Film Form* (transl. J. Leyda), New York: Harcourt Brace Jovanovich; also Mariner Books, 1969.

Eisenstein's original revolutionary writings about the importance of montage.

Eisner, L. (1965), *The Haunted Screen: Expressionism in the German Cinema*, London: Secker & Warburg; also Berkeley, CA: University of California Press, 1974.

A thorough if also contentious examination of the place of German expressionism in interwar German society during the rise of Nazism.

Elena, A. and Diaz Lopez, M. (eds) (2003), *The Cinema of Latin America*, London: Wallflower Press.

A collection of reviews of significant Latin American films.

Fowler, C. (2002), *The European Cinema Reader*, London: Routledge.

A useful overview of much of European cinema.

Gabriel, T. (1982), *Third Cinema in the Third World: The Aesthetics of Liberation*, Ann Arbor, MI: University of Michigan Press.

Useful for comparing the social and political agendas of different kinds of film production in Africa, South America and Asia.

Gillespie, D. (2000), *Early Soviet Cinema*, London: Wallflower Press.

A useful accompaniment to Eisenstein's theoretical writing.

Hill, J. and Church Gibson, P. (eds) (1998), *The Oxford Guide to Film Studies*, Oxford: Oxford University Press.

A comprehensive if at times overstretched guide.

Leyda, J. (1973), *Kino: A History of the Russian and Soviet Film*, London: George Allen & Unwin Ltd.

A very detailed account of Russian/Soviet film history to 1970.

Liehm, M. (1986), *Passion and Defiance: Film in Italy from 1942 to the Present*, Berkeley, CA: University of California Press.

A more personal collection of essays about postwar Italian cinema.

Martin, M. (ed.) (1997), *New Latin American Cinema*, Detroit, MI: Wayne State University Press.

One volume gives an overview of key strands and concepts in Latin American cinema; the other consists of extended chapters about each of the principal film-producing Latin American countries.

Mast, G. and Cohen, M. (eds) (1974), *Film Theory and Criticism*, Oxford: Oxford University Press (see also Braudy and Cohen).

An excellent compendium of many important and influential pieces of film-theoretical writing, particularly from before the 1980s.

Mishra, V. (2002), *Bollywood Cinema: Temples of Desire*, London: Routledge.

An exploration of key themes in Bollywood films.

Murphy, R. (ed.) (2002), *The British Cinema Book*, 2nd edn, London: BFI.

A very useful, concise exploration of British cinema; see also other books written or edited by Murphy on separate decades of British cinema.

Nowell-Smith, G. (ed.) (1997), *The Oxford History of World Cinema*, Oxford: Oxford University Press.

Though aspiring to be comprehensive, like the other *Oxford Guide* this is at times overstretched and duplicates quite a lot of that book.

Overbey, D. (ed.) (1978), *Springtime in Italy: A Reader on Neo-Realism*, London: Talisman.

Particularly good on the social and political origins of Italian neorealism.

Silbergeld, J. (1999), *China into Film*, London: Reaktion Books.

A useful introduction to Chinese cinema.

Tapper, R. (ed.) (2002), *The New Iranian Cinema: Politics, Representation and Identity*, I B Tauris.

A very good collection of pieces about selected aspects of the recent history of Iranian cinema.

Thackway, M. (2003), *Africa Shoots Back: Alternative Perspectives in Francophone African Film*, James Currey/Indiana Press.

An excellent systematic overview of an important strand of African cinema.

Thompson, K. and Bordwell, D. (1994), *Film History: An Introduction*, New York: McGraw-Hill.

Detailed and fairly thorough, with many useful film stills.

Ukadike, F. (1994), *Black African Cinema*, Berkeley, CA: University of California Press.

A wide-ranging collection of more personal essays particularly on Francophone West African cinema.

FURTHER VIEWING

Cinema Europe (BBC2, 1995)
 A series of programmes about the era of silent movies in Europe. BBC Active, BBC Television Centre, Wood Lane, W12 7RJ
Cinema Cinema: The French New Wave (Channel 4, 1992)
 Excellent overview of the film movement, its style and influence. Channel 4, 124 Horseferry Road, London SW1P 2TX
Close-up on Battleship Potemkin *by Roger Corman* (BBC2, 1995)
 Excellent, accessible textual analysis of Eisensteins's Odessa Steps sequence. BBC Active, BBC Television Centre, Wood Lane, W12 7RJ
New Cinema of Latin America (dir. Michael Channan, Channel 4, 1983)
 Informative documentary about an area of cinema rarely covered. Channel 4, 124 Horseferry Road, London SW1P 2TX

Chapter 5

Alternative cinema

We shall look in Chapter 9 at how some films, such as those of counter-cinema, stand apart from mainstream entertainment cinema in their partial or total refusal of narrative conventions and commercial film techniques. In this chapter we shall briefly consider some other groups of films – some bigger than others – which in their different ways have challenged dominant film conventions.

Surrealism

Like German Expressionism, surrealism was an artistic tendency which developed in the early years of the twentieth century. It inspired a small number of film-makers to make 'surrealist' films, and the surrealist influence still echoes strongly in the films of Terry Gilliam and David Lynch, for example.

Surrealism developed from dada into an art form which valued the spontane-
ous and the unconscious and which celebrated Lautréamont's wonder at 'the
chance encounter of a sewing machine and an umbrella on a dissecting table'.
Very influenced by Freudian ideas (though in a way which disgusted Freud
himself), the Surrealists had by the mid-1920s developed into a group of paint-
ers, poets, writers and musicians with very fragmentary but passionately held
beliefs; the group published a manifesto in 1924 and was constantly splitting as
artists accused one another of betraying the cause, of not being 'true' Surreal-
ists. Among important figures in the group, which was based in Paris, were Paul
Éluard, Louis Aragon and André Breton. A few film-makers began to experiment
with dream-states on the screen, for example Man Ray (*Emak Bakia*, 1928) and
Germaine Dulac (*The Seashell and the Clergyman*, 1928).

In 1928, however, two young, then relatively unknown members of the group
made a film which tore up the cinematic map: *An Andalusian Dog* (*Un chien
andalou*). Salvador Dali was to become arguably the most famous (and most
notorious) twentieth-century artist, and Luis Buñuel would go on to make over
thirty films: more of him later.

A man stands on a balcony, watching thin slivers of cloud cut across the moon.
A razor is sharpened. A woman sits passively, her eye is held open, and, echoing the
clouds passing across the moon, the razor slices open the eye (Fig. 5.1). So begins *Un
chien andalou*, which was intended to scandalize French audiences and succeeded.
The sliced eye can be seen as symbolizing the sexual act; ants crawling into a hand
may symbolize decay; the female character has a choice between remaining with her
tame, rational suitor or following lust and passion with his alter ego or other side.
She opts for the former and the film ends with the couple buried to their necks in
a sandy beach: the living dead. Though there were other possible readings of the
film, it was clearly a savage assault on religion and on bourgeois values. The film
was also not given a UK censors' certificate until 1968. Filled with images symbol-
izing sexual desire and frustration, *Un chien andalou* is said to have been written by
Buñuel and Dali in such a way that any scene which made rational or logical sense
was discarded; much of the film is based literally on its creators' dreams. Indeed,
it remains a disturbing, dreamlike film: dreamlike not in the soft-focus Hollywood
sense but because of the dreamlike 'logic' which guides the narrative.

Buñuel and Dali then collaborated again in 1930 on *The Age of Gold* (*L'Age
d'or*), another exploration of sexual passion and its suppression which was attacked
violently: a screening of the film in December 1930 was disrupted by fascists and
anti-Jewish groups: paint was thrown at the screen and many books and art-works
in an exhibition were vandalized. Members of the audience were beaten up.
Interestingly, the police did not intervene and the film was banned for a time.

These films are still seen as the founding moments of surrealism in the
cinema. They were followed by Jean Cocteau's *The Blood of a Poet* (*Le Sang d'un
poète*, 1932). Though such films remained on the margins of film exhibition,
we must remember that over the next decade or two, Freudian theories about

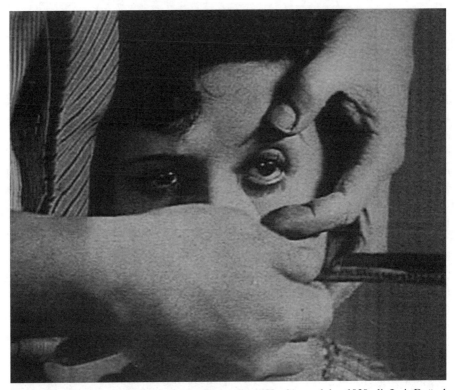

Figure 5.1 *Un chien andalou*: the shock of surrealism (*Un chien andalou*, 1929, dir Luis Buñuel and Salvador Dalí)

dreams, the unconscious and their social significance were to become part of conventional wisdom in the USA and Europe (see also Chapter 12 below).

Though the number of genuinely 'surrealist' films was small, their influence was great, and was aided in no small measure by the subsequent career of Luis Buñuel. Though he made many other films in a remarkable career, his *Viridiana* (1961), *The Discreet Charm of the Bourgeoisie* (1972) and particularly *That Obscure Object of Desire* (*Cet obscur objet du désir*, 1977) marked a successful fusion of French/Spanish 'art' cinema with Buñuel's abiding surrealist impulse. The latter film (his last) is interesting not only because it continues and develops Buñuel's scathing attacks on the hypocrisy and moral bankruptcy of the bourgeoisie and of the Church, but also because two actresses are used to play a single character, symbolizing different aspects of the central male character's desire.

The object of desire usually remains obscure: if we think we desire a man, a woman, a bar of chocolate or a Porsche, it usually hides a desire for something else. Insofar that some recent film-makers have been aware of this, they have sought to integrate such Freudian–surrealist insights into their own films. David Lynch, for example, in his *Eraserhead* (1976), *Blue Velvet* (1986) and *Lost Highway* (1996), has explored the dark unconscious underside of the American

psyche; his TV series *Twin Peaks* (1990–1), though more comedic and playful, occupies the same territory. *Mulholland Drive* (2001) took Lynch's themes and style into Los Angeles with a story about an aspiring actress intent on success in Hollywood. And though postmodernism may also have something to do with the questioning of 'reality' and of consciousness in films like *eXistenZ* (Cronenberg, 1999) and *The Matrix*, the surrealist legacy also retains a strong influence.

The surrealist influence is more diluted in films which may be described as 'fantasy cinema'. Finding inspiration in dream but less rigorous in their exploration of the psychological or social significance of the unconscious, such films would include the early *Orphée* (Cocteau, 1950), *Alice* (Švankmajer, 1988), *Institute Benjamenta* (Brothers Quay, 1995), *Delicatessen* and *The City of Lost Children* (Jean-Pierre Jeunet and Marc Caro, 1990 and 1995), several of Raul Ruiz's films (especially *Shattered Image*, 1998), and perhaps even those of Pedro Almodovar. Such films blur the boundaries between dream, fantasy and 'reality', but generally leave the door open for a rational interpretation of the film's events.

Almodovar began making films in the late 1970s after the end of Franco's fascist regime. His work was part of a radical response to the suffocating restrictions of the country's previous cultural establishment. His work wasn't overtly political but it challenged orthodoxy through its break with contemporary film, choosing instead to mix elements of realism with complex fantasy worlds full of colourful, unlikely characters. The results frequently questioned the norms of religion, family, patriarchy and sexuality in Spain and his successes, especially from *Women on the Verge of a Nervous Breakdown* (1988) onwards, have brought Spanish cinema to the attention of those previously unaware of its existence.

Federico Fellini's roots were in Italian Neorealism, elements of which can be seen in *La Strada* (1954), but his filmic style gradually shifted away from realism. After *La Dolce Vita* (1960) his films moved towards containing elements of fantasy and dream-like sequences, as epitomized in *8½* (1963). Another European director from the same era, Ingmar Bergman, frequently employed elements of the surreal in his dramas, usually set in his native Sweden. In films such as *The Seventh Seal* (1957) and *Wild Strawberries* (1957) through to *Fanny and Alexander* (1982) he explored aspects of existence and the human condition such as death, memory and relationships using symbolism and fantasy.

Documentary film

When we think of film we usually have in mind works of fiction, which indeed account for the vast majority of films; yet the birth of cinema was heralded by documentary, a form which has been with us ever since. The simplest definition of documentary, as film of unmanipulated reality, can easily be picked apart (and often has been – see for example Grant and Sloniowski (eds) in Further Reading), but here we propose to simply provide brief snapshots of some important

documentary moments. The rationale for including a section on Documentary Film in a chapter on alternative cinema is that documentary films are not only the exception in a form dominated by fiction, but feature-length documentaries frequently take ideologically oppositional positions on the topics they deal with. Documentaries such as *Tibet: Cry of the Snow Lion* (Piozet, 2002), *Fahrenheit 9/11* (Moore, 2004), *Why We Fight* (Jarecki, 2005) and *An Inconvenient Truth* (Guggenheim, 2006) challenge government ideologies and campaign for change.

There are many types of documentary film and they serve different functions. The Lumière brothers' early work consisted of 'actuality' films such as *Workers Leaving the Factory* (1895), which were recordings of events from everyday life. As film-makers, they simply recorded what was in front of the camera. Actuality footage is the principal raw material of documentaries but can be edited and presented in a variety of ways to serve particular functions.

Soviet film-maker Dziga Vertov documented aspects of life in the Soviet Union during the 1920s, but his films already presented their material in ways not usually associated with documentaries. He used experimental postproduction techniques that included superimposed images, animation, split screens and editing together shots that have visual associations. *Man with a Movie Camera* (1929), for example, is an unusual mix of information, propaganda and entertainment. By the end of the film we are as aware of Vertov's style of film-making as we are of aspects of Soviet society. The film celebrates much about the Soviet Union but celebrates film-making too.

Another innovative documentary film-maker and producer was Scotland's John Grierson (see also Chapter 3 above), who did not merely document events in his films, but ensured that material was creatively shot and that imaginative editing presented the film's subject matter so that it was coherent, interesting and entertaining. *Drifters* (1929) does more than show us fishermen at sea; the shots are visually stunning, the editing produces drama; the film is informative and educative but also moving and gripping.

Leni Riefenstahl's 1930s documentaries had a somewhat different purpose: she was employed by the Nazis to produce propaganda films. *Triumph of the Will* (1935) is a record of a Nazi rally but does far more than simply record events. The *mise en scène*, camerawork and editing serve one function: to praise Hitler, the Nazi party and the Aryan race. The camera captures the choreographed speeches and the massed, geometrically arranged ranks of obedient citizens and soldiers; all in all, a stunning performance. The editing ensures that the message does not escape the viewer: Hitler as saviour and leader, backed by a strong party (and an army), with the purpose of making the heroic and mythologized German people victorious and great again. This is clever propaganda and effective documentary.

Ten years later in Italy, Roberto Rossellini found another use for documentary. He had supported the Italian partisans during the Second World War and made fictional films about life in Italy during the Nazi occupation and their defeat in 1945. *Paisà* (1946), one of the first neorealist films, consists of six fictional

stories, but the closeness to reality of each episode is emphasized through the use of actuality footage from Italy's war years. Common documentary devices in the film include the use of archive footage and a voice over to provide explanation.

Another typical documentary technique is the combining of actuality footage with interviews. In the mid-1950s, Lindsay Anderson, Karel Reisz and Tony Richardson, of the British-based Free Cinema movement, established themselves with films that documented and analysed contemporary working-class issues. They produced innovative films such as *Momma Don't Allow* (1955), *Every Day Except Christmas* (1957) and *We are the Lambeth Boys* (1959). The group had been strongly influenced and inspired by Grierson's work and they wanted their documentaries to be informative and provocative, analytical and revealing.

Dealing as they do with the real world often results in documentaries being an ideal vehicle for political comment. Krzysztof Kieslowski began his film career in Poland with documentaries that focused on the everyday life experiences of Polish citizens. His work was frequently critical of aspects of Polish society and the conditions within which people lived. As such his films could be regarded as implicitly political and subsequently attracted the attention of the Polish government, resulting in some of his documentary work being censored. He eventually turned to fiction, seeing it as more effective for investigating Polish society. This change of direction resulted in the internationally acclaimed *Dekalog* (1989), a series of ten films set in Warsaw.

Not all documentaries have a social or political purpose, however; many have entertainment as their priority. Music documentaries ('rockumentaries') came to prominence in the 1960s and one of the most memorable is *Don't Look Back* (Pennebaker, 1966), which documented Bob Dylan's British tour. The film used 'direct cinema' techniques in that the use of mobile cameras enabled the unfolding events to be filmed directly rather than situations being set up for the camera. The camera operator wasn't a part of the events but merely an observer. *Woodstock* (Wadleigh, 1970) is also regarded as a landmark film in its recording of events at a music festival by several cameras and with innovative editing. However, music documentaries tend to be well planned and are far from being transparent recordings of events. This is not of course to say that such documentaries are worthless; indeed, *Stop Making Sense* (Demme, 1984) is a carefully crafted recording of a Talking Heads performance that is widely regarded as a classic of its kind. *The Buena Vista Social Club* (Wenders, 1999) has similarly been claimed as a quality documentary in its use of direct cinema techniques, interviews and live recordings to investigate the lives of some old Cuban musicians, the narrative culminating in a reunion concert.

Another documentary style, *cinéma vérité*, also makes use of mobile cameras and sound equipment but holds open the possibility of the camera operator being part of events through his/her involvement with people filmed. Jean Rouch's *Chronicle of a Summer* (*Chronique d'un été*, 1960) is often regarded as the first *vérité* film. Andy Warhol's *Chelsea Girls* (1966) provides an unusual example

of the technique in that visitors to his open art studio in New York were given cameras to record events, resulting in a poorly filmed record of rather tedious conversations. A more purposeful use of *cinéma vérité* is found in *Harlan County, U.S.A.* (Kopple, 1977), which documents a strike by Kentucky coal miners for trade union rights. The film-makers lived with the mining community and became part of the events, with the result that the film has a closeness to the action and issues unusual in documentaries.

A further documentary device is fly-on-the-wall filming. Here the camera is often fixed in position, thus doing away with the need for a camera operator; the camera can record events without people being reminded of its presence. This technique tends to be reserved for television documentaries rather than film, though the fictional *Truman Show* (Weir, 1998) took the concept to an extreme with Truman being unaware of his twenty-four-hour surveillance by a multitude of cameras. The intention of fly-on-the-wall documentaries is that we see an unmediated reality in that the presence of the camera does not interfere with the people being filmed and does not influence their behaviour. However, as with all films, documentary and fiction alike, decisions are made that in effect mean we only get a representation of reality. The positioning of the camera immediately shapes what we see but more importantly, fly-on-the-wall footage is normally edited, again involving choices which influence what we see in the completed documentary. The popular series *Big Brother*, broadcast since 2000, employs several fly-on-the-wall cameras, but these are located in carefully selected positions, and the prime-time programmes are obviously heavily edited to condense twenty-four-hour footage from many cameras into a series of roughly one-hour programmes – though one can also watch 'live' footage on other digital channels in addition to the heavily edited version.

The term 'non-fiction' is of course itself a problem, and some commentators have all but abandoned the distinction between 'factual' subject matter and 'fiction'; all that really remains is the documentary style. What then do we make of what is termed faction, the reconstruction (common on TV) of (usually recent) 'real' events? Examples (among many) would include films such as *In the Name of the Father* (Sheridan, 1993) (about the 'Guildford Four') and *Apollo 13* (Howard, 1995) (about the spacecraft launch disaster), and TV films such as the Channel 4 2000 reconstruction of the David Irving libel trial and that of TNT in the same year about the Nüremberg Trials of 1945/6. The highly acclaimed *Hunger* (2008), directed by artist Steve McQueen, portrays the hunger strike by IRA prisoner Bobby Sands in 1981 and is notable for the variety of techniques used by McQueen in his interpretation of the events, ranging from handheld camerawork, to lingering shots where little seems to happen, to a sixteen-minute still shot of a conversation between Bobby Sands and his priest. McQueen's representation of the events is unconventional, perhaps emphasizing the artist's personal interpretation and creation of meaning. Can any reconstruction, however faithful, be called a documentary? Again (see pp. 186–8 below) we are faced with ontological questions.

Exercise 5.1

In small groups, discuss any recent film or TV drama-documentaries you may have seen. Are the events portrayed 'real'? Can such programmes or films be described as documentaries?

Even if documentaries contain non-fiction material, it is impossible for them to be completely objective. Participants are usually aware of the camera, footage is usually edited, camera position provides a particular perspective, interviews structure what verbal information is to be revealed, and postproduction voice-overs guide us towards particular interpretations and understandings. However, this is not necessarily undesirable. A well-planned and intelligently produced documentary can analyse a topic, reveal information about a subject, develop understanding and still be entertaining – indeed the 'entertainment' is surely undeniable in *American Movie: The Making of Northwestern* (Smith, 1999), as it is in Michael Moore's highly polemical *Bowling for Columbine* (2002) and *Fahrenheit 9/11* (2004) and in *Super Size Me* (Spurlock, 2004). The release dates for these films perhaps testify to a resurgence of public interest in documentaries, primed as it has been by a subgenre of 'mockumentaries' of which the best-known example probably remains *This is Spinal Tap* (Reiner, 1984). Or is it that audiences in a 'postmodern' age have finally jettisoned the distinction between documentary and 'fiction'?

Feminist film

Throughout the history of film, as of the other arts, the vast majority of those associated with the medium have been men. In part this is simply a reflection of a patriarchal culture which guards male privilege and allows women into film only as objects of the gaze (see pp. 270–1 below); perhaps, though, the technical complexity of film (and indeed of developments via video, CGI and DVD) has also reinforced the idea of 'toys for boys'. The vast majority of computer enthusiasts are also male.

There have always, however, been a few pioneering women film-makers, beginning with Alice Guy. Leni Riefenstahl, despite the fascistic content of her best-known films (*Triumph of the Will*, 1935; *Olympia*, 1938), was a gifted director. Maya Deren (*Meshes of the Afternoon*, 1943), influenced by surrealism and interested in voodoo, was among the first famous female film artists. Dorothy Arzner was the first female Hollywood director (*Dance Girl Dance*, 1940) whose career was re-excavated in the 1970s. Ida Lupino (*Outrage*, 1950) and Stephanie Rothman (*Knucklemen/Terminal Island*, 1973) were other rare female directors of commercial films.

Though women directors in mainstream production remained rare, the 1960s, 1970s and 1980s saw a marked increase in numbers of women making 'art' or alternative films. Among the best known of these were Agnès Varda, Marguerite Duras in France, Margarethe von Trotta, Helma Sanders-Brahms and Ulrike Ottinger in (then West) Germany, Laura Mulvey and later Sally Potter in Britain, Jackie Raynal and Yvonne Rainer in North America, Chantal Akerman in Belgium, and Marleen Gorris (pronounced 'Horris') in the Netherlands.

The emergence of female film-making was clearly linked to a general loosening of previous social prejudices and assumptions, and to the almost-revolutionary events of May 1968, when through strikes and direct action students and workers (particularly in France but to some extent in other Western countries) came very close to bringing down governments; it is difficult for later generations to grasp the excitement of that time when anything seemed possible; the subsequent disillusionment of social revolutionaries was deep indeed; in France there were many suicides.

In such a climate – which, influenced in the USA by the Civil Rights and New Left movements and inspired by Betty Friedan's *The Feminine Mystique*, also gave birth to the Women's Liberation Movement – an important concern for alternative film-makers (both male and female) was to explore the nature of capitalism and patriarchy and to create a new kind of oppositional or counter-cinema. We shall look at some aspects of such films in Chapters 9 and 12 below, but an additional dimension was the feminist concern with changing the way a gendered spectator was addressed by a film, indeed, with changing how gender was itself constructed.

This involved dealing with new subjects, but for many of these female directors it also involved dealing with them in radically new ways: it meant searching for a new 'language', a women's language. Akerman's *Jeanne Dielman, 23 Quai du Commerce, 1080 Bruxelles* (1975), for example, concerns the everyday household activities of a housewife-prostitute. Activities such as cooking and cleaning are shot in long takes which correspond to the monotony of the tasks; the camera remains at head-height to share the character's perspective. Duras and Varda both developed highly individual styles which rejected most mainstream narrative conventions; Varda coined the term cinécriture ('film-writing') to describe her own style. A good example of the latter is *Vagabond* (*Sans toit ni loi*, 1985), which uses flashback to recount the events leading to the death of the central female character Mona, portrayed as an uncaring, selfish vagrant who eventually freezes to death in a ditch. The flashback contains episodes which overlap in a complex way, with a variety of interview-style remarks from people who have come across Mona. Most of the tracking shots of Mona walking through a cold, desolate landscape are (very unusually) from right to left; many such tracking shots begin without Mona in the frame and end after she has left the frame.

Vagabond is a challenging work, like many of its feminist sister-films. Among the other best-known examples are Varda's own *Happiness* (*Le Bonheur*, 1965),

Akerman's *News From Home* (1976) and *Les Rendez-vous d'Anna* (1978), Duras's *Nathalie Granger* (1972) and *India Song* (1975), Mulvey's *Penthesilea* (1974) and *Riddles of the Sphinx* (1977), von Trotta's *The German Sisters* (*Die bleiende Zeit*, 1981), Ottinger's *Ticket of No Return* (*Bildnis einer Trinkerin*, 1979), Susan Clayton and Jonathan Curling's *Song of the Shirt* (1979), Connie Field's *Rosie the Riveter* (1980), Potter's first film, *Thriller* (1979) and Gorris's *A Question of Silence* (1982). The last of these is about three women who meet for the first time in a clothes shop and murder the proprietor, apparently for no reason. The female psychiatrist assigned by the court to investigate the women's sanity concludes that they are completely sane and that the insanity lies in the oppressive male-dominated society they inhabit (please see Udris, 2004).

While Hollywood and the mainstream film industry are still overwhelmingly male, the last thirty years or so have seen a few more women taking creative (and, indeed, executive) roles. Kathryn Bigelow (*Blue Steel*, 1990; *Point Break*, 1991; *Strange Days*, 1995; *K-19: The Widowmaker*, 2002; *Mission Zero*, 2007; *The Hurt Locker*, 2009) has been making action/adventure films: an example of 'genre-bending' with a female director making action-packed and sometimes violent genre films. A number of female directors established themselves: Amy Heckerling (*Look Who's Talking*, 1989; *Clueless*, 1995), Sofia Coppola (*The Virgin Suicides*, 1999; *Lost in Translation*, 2003). Jodie Foster took up producing and directing. Jane Campion made *An Angel at My Table* (1990) and *The Piano* (1993).

Jane Campion is one of the few female directors who are referred to as auteurs. Her work is closer to art cinema than it is to mainstream cinema yet her work has achieved commercial success. Campion's films defy easy genre categorization and their recurring themes and visual techniques have resulted in her work having an identifiable style. She is known for her six feature films beginning with *Sweetie* (1989), *An Angel at My Table* and *The Piano*, *The Portrait of a Lady* (1996), *Holy Smoke* (1999) and *In the Cut* (2003). While *The Piano* was awarded several Oscars and earned Campion an international reputation, she has pursued an idiosyncratic, personal path: *The Water Diary* (2006) picked up the themes of childhood evident in her earlier films and her subsequent work has consisted principally of collaborative work on compilation films.

There are elements of melodrama in her work, with a strong emphasis on relationships, family, and exploring characters' emotions, sometimes through an effective use of dark humour. The frequent criticisms of patriarchal society and the strong female protagonists of her films have led to her being regarded as a 'feminist' director. The central female characters tend to be obstinate and independent free spirits, often troubled and frequently searching for meaning and spirituality in their lives. Other themes in her films include analysis of the effects that society has on individuals, observations on the relationships between men, women and power, and a reversal of perspective that provides a female view of the world. Jane Campion's films are visually and aesthetically

impressive, with imaginative use of cinematography, occasionally using expressionistic devices and symbolism which further mark her work off from mainstream cinema.

Mainstream films, however, did start to deal with issues of gender and sexuality; indeed, male directors also seemed to begin making films which could be described as 'women-friendly'. *Thelma and Louise* (Ridley Scott, 1991) concerns two women who end up on the run from the police after their weekend outing goes wrong when Louise (Susan Sarandon) shoots and kills a rapist in defence of her friend Thelma (Geena Davis). Most men in the film are stupid, violent or weak (or all three); even the otherwise sympathetic cop played by Harvey Keitel is ultimately powerless. The viewer's sympathy is surely with the women as they opt to drive over a cliff rather than return to such a stupid male-dominated society. Though there is no overt physical contact between Sarandon and Davis and their characters are clearly signalled as heterosexual, the bonding between the women indicates a clear lesbian subtext.

Other films also began to deal with gay and lesbian representations more explicitly. Thus *Desert Hearts* (Donna Deitch, 1985) is told as a fairly straightforward love story, lesbian sex scenes and all. *Kissing Jessica Stein* (Herman-Wurmfeld, 2001) explores lesbian issues through the character of a middle-class Jewish journalist. The postmodern disintegration of stable gender identity is explored in the much more British film *Orlando* (Sally Potter, 1992), an adaptation of the Virginia Woolf novel. The film follows the adventures of the male Orlando (played by the female Tilda Swinton) who lives through various experiences in the seventeenth and eighteenth centuries (without ageing), changes in sleep from male to female ('same person, no difference at all…just a different sex'), and who then passes through some more episodes to arrive in late twentieth century Britain, an androgynous woman with a daughter who films her happiness with a video camera. The film is full of ironic commentary on male and female gender roles, suggesting that such roles are obsolete and a thing of the past. Sally Potter continues to direct films perched between mainstream and art-house, her most recent *Rage* (2009) being an interrogation of the gaze in a digital age dominated by the internet.

The feminist experiments with film form continue but reach only small audiences. Hollywood/mainstream cinema has taken on previously controversial issues of sexuality, gender and violence against women. But does this mean that feminist films which continue to struggle for a new mode of expression are no longer of any interest? It could be argued that such alternative film-making remains more vital than ever; mainstream entertainment films may have more active female heroes and may deal with tougher issues, but the underlying forms and ideologies remain the same; female sexuality is still used to sell films as the female body is exhibited and objectified. We should remember what happened to Patricia Charbonneau after her lesbian role in *Desert Hearts*: she was unable to find work for several years.

Third cinema

We have given some attention in Chapter 4 above to the cinema of what used to be called the 'Third World' (is the term 'Developing Countries' any less patronizing?). The label 'Third Cinema' has been applied to films produced principally in South America, Asia and Africa, but also to some extent in Europe, which promote indigenous and/or ethnic minority cultures but which stand in opposition to Western imperialism.

The best known of these cinemas is perhaps the South American 'Cinema Nôvo' ('New Cinema') of the 1960s: *Os Fuzis* (Guerra, 1964), *Antonio-das-mortes* (Rocha, 1969). At a time when the Brazilian and other South American film and TV industries were buying in cheap American films and soap operas, the 'Cinema Nôvo' film-makers ran considerable risks in making and promoting their films. They had to compete not only with hostile US media interests, but with CIA-backed state terrorism which put their lives at risk. Solanas and Getino's epic *Hour of the Furnaces* (1969) was filmed secretly and made the directors marked men for Argentina's CIA-funded military regime. It should also be noted that it was in their written manifestos that Solanas and Getino coined and developed the notion of Third Cinema (please see Further Reading).

While in South America (and in parts of Africa and Asia) such 'Third Cinema' was (and in some cases still is) produced at considerable physical risk, other films of this type were made in more benevolent or at least tolerant environments. The Cuban films of Tomas Gutierrez Alea (*Memories of Underdevelopment*, 1968) and Santiago Alvarez (*79 Springtimes*, 1969), for example, attacked US imperialism from a democratic socialist Cuba. Curiously, British films such as *Territories* (Isaac Julien/Sankofa, 1985) and *Handsworth Songs* (John Akomfrah/Black Audio Collective, 1986) could also be seen as 'Third Cinema' in their oppositional stance in relation to the institutional racism of white British culture.

Avant-garde and structural-materialist film

The avant-garde of any art form, be it literature, painting or film, is concerned with stretching the limits of the medium. In theoretical terms, this perhaps places such artists close to the formalists (among them Eisenstein and Arnheim) who felt that film could only be 'art' if it made maximum use of its possibilities: to use sequences of photographic images to manipulate space and time rather than to try to reflect 'reality'.

Many early avant-garde film-makers were thus concerned with film as a plastic art rather than with any recording of 'reality'. For Man Ray, Fernand Léger, René Clair, Oskar Fischinger and the surrealists, the emphasis was clearly on what could be done with the (then still relatively new) medium.

Exercise 5.2

If it is possible, look at one or more avant-garde films of the 1920s or 1930s, for example *Entr'acte*, *Le Ballet mécanique* or *Un chien andalou*. Compare it/them with recent experimental TV work and with pop videos and credit sequences. The technical differences are obvious enough, but how are technological innovation and audio-visual 'art' treated and sold now? Compare the present production and consumption situation with the time at which such films were made.

The best-known avant-garde films of the mid-century were produced in the United States, by Maya Deren, Stan Brakhage, Jonas Mekas, Bruce Conner and others. Then came Kenneth Anger's *Fireworks* (1947) and *Scorpio Rising* (1964), both troubled explorations of the director's sadomasochistic homosexuality (Anger went on to write *Hollywood Babylon*, a vitriolic exposé of the dark side of Hollywood). Anger's films gave impetus to what became known as 'Underground' cinema, at first a US phenomenon but then spreading to other industrialized countries. Underground films were marked by shock value and by a quasi-documentary focus on sex: George Kuchar and Jack Smith became notorious, the latter's *Flaming Creatures* (1963) being banned (though this did not stop the film being shown clandestinely).

And then of course there was Andy Warhol. The ground-breaking *Sleep* (1963) and *Empire* (1965) were minimalist 'concept' films: these and many other Warhol films contain little or no camera movement or editing; the camera simply 'observes' a man sleeping or several hours in the stony life of the Empire State Building in New York. Warhol was also responsible for 'The Factory', which produced such indulgences as *Chelsea Girls* (1967) and *Lonesome Cowboys* (1968) and launched the troubled careers of Joe Dallesandro, Paul Morrissey and the Velvet Underground. Warhol also saw the commercial potential of what would later become postmodernism earlier than most, commissioning and exhibiting the famous Warhol's cans of Campbell's soup and his own endlessly reproduced 'portraits' of Marilyn Monroe.

If artistic personal expression led some avant-garde artists inexorably back to Hollywood and Babylon, other film-makers took a different path. The 'structural-materialist' films of the 1960s and 1970s more clearly developed the formalist concerns of the 1920s pioneers: little or no narrative, no characters, just an exploration of the possibilities of film. Thus Michael Snow's films (*Wavelength*, 1967; ↔ (also called *Back and Forth*), 1969; *Central Region*, 1971) were explorations of the images created by rigorously and mathematically controlled camera movements; *Wavelength* appears to be a forty-five-minute zoom from one end of a room in to a close up of a picture on a wall, which nevertheless teases the audience as the soundtrack indicates that events seem to

occur off camera which encourage speculation about a possible narrative. Hollis Frampton's *Zorns Lemma* (1970) is constructed according to strict mathematical principles. Ken Jacobs' *Tom, Tom the Piper's Son* (1969) is a 'documentary' exploration of a short 1905 silent film which brings film-making centre-stage, much as did Dziga Vertov. Peter Gidal's more personal explorations of everyday space are often difficult and disorientating, with their strange camera angles and abrupt camera movements. Where any kind of narrative is used, it is invariably deconstructed, as in Malcolm Le Grice's *Blackbird Descending* (1977), in which very similar (but not identical) events are repeated over and over again as the spectator learns that in its own way each event is a recording of a recording of a recording…

Other film-makers explored the nature of the film medium itself: images were painted or drawn directly onto the film (recalling the experiments of Georges Méliès in the earliest years of film), the film was etched with acid, fungus was grown on it, 'hairs in the gate' and other foreign bodies were integrated into the viewing experience; in this connection it is difficult to know if the Monty Python line about one of their films being 'made entirely on wood' was the usual Python absurdity or a knowing reference to avant-garde film-making!

Guy Debord made a number of films employing a range of experimental techniques. He was the main protagonist behind the formation of the Situationist International in 1957, and his book *The Society of the Spectacle* summed up the group's beliefs. The concept of the 'spectacle' referred to the increasing tendency for people to be in effect passive observers of the world around them rather than active participants. The most obvious example of this was to be found in the representation of the world through television, but Debord emphasized that the 'spectacle' was not just a visual phenomenon but a general condition to be found within social relations of all forms. This analysis of the contemporary world was in many respects a precursor to the concept of postmodernism, popularized and elaborated by writers such as Jean-François Lyotard and Jean Baudrillard in the 1970s and 1980s. The proposed solution to the problem of the 'spectacle' was the creation of 'situations' which provided insights into possible alternative ways of living. Debord's early films tended to be regarded as art, but his best known production, *The Society of the Spectacle* (1973), a screen version of his book, was more clearly political. It contains archive news footage, film clips, television adverts, photographs, intertitles from the book and voice-over narration, but no new footage. The film aims to subvert the existing purposes of the material to create new meanings. Furthermore the film's intentions are not immediately obvious, thus requiring the viewer to actively engage with the film rather than passively accepting its content, effectively challenging the normal usage of film as a medium.

While such films were interesting experiments, not surprisingly they were seen by few people. The advent of video and then DVD, however, means that since the 1980s video/film installations have found a niche in galleries and exhibitions, often as part of a multimedia environment, and artists such as Bill Viola and

Steve McQueen have reached a new kind of audience. Instead of being screened at specific times, experimental video works of whatever length (Douglas Gordon's *24-Hour Psycho* is a projection of Hitchcock's *Psycho* at an eighth of its proper speed) are now shown on a continuous loop, with gallery visitors arriving and leaving at any point. Through programmes such as *10x10* and *Fourmations*, such films/videos have also received exposure on terrestrial television – indeed such artists' practical exploration of the relationship between technology and art has hastened the development of the new academic discipline of 'Screen Studies'.

/////////////////////////
Dogme 95

A small but important recent example of 'alternative' film-making emerged in 1995 when a small group of Danish directors launched a manifesto entitled 'Dogme 95'. The group's self-imposed 'vows of chastity' are given in Figure 5.2.

Though the 'manifesto' was clearly at least partly a publicity stunt, it did result in a number of films which generated a great deal of debate and which have led some other film-makers to reconsider their methods. In addition to making the cult-destined *Kingdom* (1994) and *Kingdom II* (1998), Lars von Trier achieved international recognition with *Breaking the Waves* (1996) and *Idiots* (1999) (the lack of director credit demanded by the manifesto has clearly not impeded his career!), and went on to explore and bend the Dogme rules with *Dancer in the Dark* (2000), *Dogville* (2003) and *Manderlay* (2005). While the hand-held 'scope camerawork' of *Breaking the Waves* has reportedly induced something like seasickness in some spectators, it is with *Idiots* (officially entitled *Dogme 2*) that von Trier most effectively challenges barriers of 'taste' and aesthetics.

As part of their provocation of bourgeois prejudices, the members of an experiment in communal living 'pretend' to be mentally disabled in public places. As well as scandalizing the local public, this is also supposedly part of a liberating and emancipatory 'discovery of the inner idiot'. As frictions and disagreements develop in the group, however, and as a party develops into an orgy (with penetrative sex displayed on the screen), it becomes troublingly unclear whether the film's characters are 'acting' or whether they really are taking part in some kind of psycho-social 'experiment'. Although such ambiguity is not entirely new (and indeed strangely echoes the ambiguities of Larry Clark's *Kids* (1995) and Harmony Korine's *Gummo* (1997) and *Julien Donkey-boy* (1999) – the latter 'officially' titled *Dogme 6*), the Dogme 95 approach perhaps makes it particularly disturbing.

The first film 'officially' produced according to Dogme principles, *Dogme 1* (*Celebration* (*Festen*, Thomas Vinterberg, 1998)), uses Dogme 95 methods to full effect: a patriarch's birthday party goes badly wrong when one of his sons accuses him of sexual child abuse in front of all the guests. Again the hand-held pseudo-documentary camerawork, lack of any 'superficial action' and 'here-and-now' nature make this a particularly powerful film (though it is at times clear

Dogme95

Film-makers must put their signature to this:

I swear to the following set of rules drawn up and confirmed by Dogme 95:

1. Shooting must be done on location. Props and sets must not be brought in. (If a particular prop is necessary for the story, a location must be found where the prop is to be found.)

2. The sound must never be produced apart from the images or vice versa. (Music must not be used unless it occurs where the scene is shot.)

3. The camera must be hand-held. Any movement or immobility attainable in the hand is permitted. (The film must not take place where the camera is standing; shooting must take place where the film takes place.)

4. The film must be in colour. Special lighting is not acceptable. (If there is too little light for exposure, the scene must be cut or a single lamp attached to the camera.)

5. Optical work and filters are forbidden.

6. The film must not contain superficial action. (Murders, weapons, etc. must not occur.)

7. Temporal and geographical alienations are forbidden. (That is to say the film takes place here and now.)

8. Genre movies are not acceptable.

9. The film format must be academy 35mm.

10. The director must not be credited.

Furthermore, I swear as a director to refrain from personal taste! I am no longer an artist. I swear to refrain from creating a 'work', as I regard the instant as more important than the whole. My supreme goal is to force the truth out of my characters and settings. I swear to do so by all the means available and at the cost of any good taste and any aesthetic considerations. Thus I make my vow of chastity.

<div style="text-align: right">Copenhagen, Monday 13th March 1995</div>

Figure 5.2 The Dogme 95 Manifesto

that the camera is deliberately being shaken to increase the tension – one may wonder if there were lessons here for the makers of the *Blair Witch Project*).

While the Dogme 95 method does indeed impose constraints on how a film is made, it says nothing about two crucial areas: how actors are to be deployed in a narrative, and how the film is to be edited. The status of the 'acting' in *Idiots* remains unclear, while for *Festen*, Vinterberg reportedly rehearsed actors for the birthday scenes but did not tell them about the shattering allegations that the son

would make, so the shock of the party guests is in a sense 'unacted'. There is in fact an additional degree of manipulation on top of the already strong narrative, about the writing of which the manifesto is silent. And editing is crucial to both *Idiots* and *Festen*; while shooting is limited to one or more hand-held cameras with ambient light and direct sound, there are (as with any other film) otherwise few limits to how shots can be recombined.

//////////////////////
Cult films

Finally, and to stray a little from the beaten path, there is a body of films (ill-defined to be sure) which has become a focus for study, perhaps partly because the significance of these films rests less in their own qualities than in the ways they have been used by their audiences. Cult films may be defined by the passionate devotion they inspire, by fans' obsessive and encyclopaedic knowledge of such films and of their plots, by ritualistic viewings sometimes involving dressing up in appropriate costume (the best-known example must be *The Rocky Horror Picture Show* (Sharman, 1975) which for many years was screened at the Baker Street 'Screen' cinema in London, and in a Paris cinema as part of a Rocky Horror New Year's Eve Party), sometimes by the existence of societies and fan clubs devoted to particular films.

The origins of cult films may lie in the star-worship of early Hollywood, but at least three further factors have been important. First, marginal subcultures (which are also 'interpretive communities') found that celebrating shared tastes gave them strength and solidarity. A good example of this (explored to excellent effect by Richard Dyer) was the popularity of icons like Judy Garland and James Dean among the gay community, particularly before the legalization of homosexuality in the UK in 1967.

A further impetus to cultishness was provided by the advent of widespread access to video from the mid-1970s onwards: favourite films could be recorded or bought, viewed repeatedly, and more or less memorized, and the resulting familiarity shared with other fans. Finally, the internet has provided an easy means for sharing cult knowledge through societies, fan clubs, etc., a facility which has of course not been lost on advertising and marketing companies, so that 'cult' is already becoming another empty marketing category.

Exercise 5.3

In groups of three or four, discuss some of your favourite films (especially films which are not massive commercial successes). How well do you know them? Do you have friends who share your affection for the film(s)? How do you share your pleasure with others who like the film?

Nevertheless it is not entirely clear what makes a genuine 'cult' film. 'Good' (or critically acclaimed) films can attain cult status (*Casablanca*, *Blade Runner*), but so can 'bad' or critically undervalued films (those of Russ Meyer or Ed Wood for example: Wood's *Plan 9 From Outer Space* (1956) has often been described as the worst film ever made). It has been suggested that three ingredients are necessary for a film to attain cult status (irrespective of its initial commercial success or failure).

First, a (relatively specific) interpretive community must be addressed: sci fi cinephiles for *Blade Runner*; ageing ex-1960s students (or their successors) in the case of *Withnail and I*; a gay or camp audience in relation to *The Wizard of Oz*). Second, the film should contain episodes and characters which can be 'memorable' when taken out of narrative context: thus, for example, Monty Python's 'Parrot Sketch', most of Monty Python's *Life of Brian* (Jones, 1979), sections of *Dune* (Lynch, 1984) and the public toilet in *Trainspotting*. Finally, and surely most obscurely, the film needs to contain 'quotable' dialogue and catchphrases, familiarity with which can become a sign of membership of the cult. The Jules–Vincent dialogue about the Big Mac and the Royale in *Pulp Fiction* (1994) is an obvious recent example, as is 'You're the money' in *Swingers* (Liman, 1996); but 'I feel unusual', 'It's resting' and 'That's a damn fine cup of coffee' are cult folklore.

CONCLUSION

The aim of this chapter has been to supplement the previous chapter in providing some further examples of types of film which depart from mainstream expectations. As with the chapter on world cinemas, however, it should be clear that it is not possible in an introductory book like this to deal with everything: there has been no discussion here of educational films, propaganda films or pornography, for example, or of the Queer cinema which inspires a growing number of university courses. It must also be acknowledged that some forms are more 'alternative' than others and that there is a constant interplay with 'mainstream' tastes. While structuralist-materialist films are likely to remain a minority interest, it is clear that defiantly surrealist films can coexist with the more whimsically surreal, militantly feminist directors can eventually make accessible and aesthetically pleasurable films, and documentaries can reach mass audiences.

SUMMARY

↔ 'Alternative' films are generally marked by their rejection of mainstream narrative conventions.
↔ Documentary film has usually been defined in terms of the unmanipulated nature of the 'reality' being recorded. Following the development of *cinéma vérité*, and more recently 'performative documentary', such definitions have been challenged.

- ↪ Many feminist films represent a rejection of a film style which is seen as perpetuating patriarchal and male-dominated ideologies.
- ↪ Avant-garde films usually require the spectator to reflect on the material nature of both the film-making process and the ways in which meaning is constructed.
- ↪ Previously experimental and marginal film-making techniques have now been largely absorbed into mainstream film-making.

REFERENCES

Udris, J. (2004), 'A Question of Silence', in E. Mathijs (ed.), *The Cinema of the Low Countries*, London: Wallflower Press.

FURTHER READING

Barnouw, E. (1974, 1993), *Documentary: A History of the Non-fiction Film*, Oxford: Oxford University Press.

A useful introduction to different categories of documentary film.

Cook, P. (ed.) (2007), *The Cinema Book*, 3rd edn, London: BFI.

Though challenging in places, a fairly thorough introduction to most of film theory.

Debord, G. (1995), *The Society of the Spectacle*, New York: Zone Books.

An acute critique of consumer society and a manifesto for an alternative role for the visual media.

Dyer, R. (1987), *Heavenly Bodies*, London: BFI.

One of Dyer's original ground-breaking books on stars and how they are constructed and decoded.

Eco, U. (1983), *Travels in Hyperreality*, New York: Harcourt Brace Jovanovich.

Reflections on the changing nature of representation and postmodernity from one of the great twentieth century writers.

Gabriel, T. (1982), *Third Cinema in the Third World: The Aesthetics of Liberation*, Ann Arbor, MI: University of Michigan Press.

Good for situating film production of the 'Third World' in a context of political theory.

Gidal, P. (ed.) (1976), *Structural Film Anthology*, London: BFI.

An introduction to the esoteric world of radical experimental cinema.

Grant, B. K. and Sloniowski, J. (eds) (1998), *Documenting the Documentary*, Detroit: Wayne State University Press.

A study of different types of documentary through inventive use of a wide range of case studies.

Hill, J. and Church Gibson, P. (eds) (1998), *The Oxford Guide to Film Studies*, Oxford: Oxford University Press.

A fairly comprehensive and thorough guide.

Jackson, R. (1981), *Fantasy*, London: Methuen.

A challenging theoretical exploration of the ways fantasy has been reflected in various media.

Le Grice, M. (2001), *Experimental Cinema in the Digital Age*, London: BFI.

Very interesting on experimental cinema, but not really so much on digital film-making.

Macdonald, K. and Cousins, M. (1998), *Imagining Reality*, London: Faber & Faber.

A useful collection of extracts from important writing on documentary.

Rodley, C. (ed.) (1997), *Lynch on Lynch*, London: Faber & Faber.

Taking the surreal into fresh territory.

Thompson, K. and Bordwell, D. (1994), *Film History: An Introduction*, New York: McGraw-Hill.

Wide-ranging and thorough, with excellent use of film stills.

Williams, L. (1981), *Figures of Desire*, Berkeley, CA: University of California Press.

Challenging further exploration of the nature of desire from a largely psychoanalytic perspective.

FURTHER VIEWING

Arena: Scene By Scene (BBC2, 1999) [Lynch on surrealism]
 Excellent overview of examples from surrealist films. BBC Active, BBC Television Centre, Wood Lane, W12 7RJ
Imagine: It's the Surreal Thing (BBC1, 2007) [Alan Yentob on surrealism]
 An investigation of the roots of surrealism, its various manifestations and continuing legacy. BBC Active, BBC Television Centre, Wood Lane, W12 7RJ
This Film is Dogma 95 (Channel 4, 2000)
 Interesting and useful documentary about the film collective. Channel 4, 124 Horseferry Road, London SW1P 2TX

Chapter **6**

Production, distribution and exhibition

How does a film eventually reach the screen? In this chapter we shall examine the process of making and showing a film, from original idea to screening. We trace the life of a film from its earliest stages of finance, preproduction, production and postproduction while explaining key roles in the film industry. The process by which films are distributed, classified, promoted and marketed to the audience will then be explored. Finally, we shall look at where and how films are exhibited as well as at reviewing and criticism. Although film production, distribution and exhibition are global phenomena, our focus here will be on the contemporary US and UK situations. In particular, we shall be looking at the period from the end of the First World War to the present day and at those elements that are not covered in other chapters on US cinema and early cinema.

///////////////////////

Production

This section will trace the process by which an idea is transformed into a celluloid reality. The process of production itself is subdivided into four further stages: finance, preproduction, production and postproduction.

Finance

Film is a blend of creativity and commercialism. It must always be remembered that most film production is an 'industry', a business designed to make money through entertainment. The profit motive of the industry cannot be stressed enough. The film industry in the USA, for example, is the country's second largest source of export. At the same time, film production is very expensive and involves high overhead costs. Finance, therefore, is essential to every stage in the life of a commercial film and those who provide the money – investors, financiers, distributors and exhibitors – have great influence over the film itself.

Investors

The types of investors for any one film can vary considerably. If a major studio such as Warner Brothers, Columbia TriStar or Dreamworks produces the film, it will already have enough capital to finance production through other previously successful and profitable films. On the whole, US studios finance their own development and production out of their cash flow and loans. Independent producers also usually have a contract with a studio. *Extreme Measures* (1996) and *Mickey Blue Eyes* (1999) were both made under a housekeeping deal between Liz Hurley and Hugh Grant's Simian Films and Castle Rock (a subsidiary of Warners). They developed the projects using Warners' finances, giving them first refusal on the film. On acceptance Warners fully financed the production.

When seeking finance a film company will usually approach the executive producer of a studio or a production company. For independent film production, however, this capital is not guaranteed and thus it must be secured from a variety of sources such as banks, private investment companies, the government, self-financing wealthy individuals, foreign sales, distribution pre-sales, television rights and equity finance. Sid Sheinberg, ex-head of MCA/Universal, described the difference between securing finance for a US major studio and for an independent production as 'the difference between flying a 747 and one of those devices that people in the Middle Ages used to put wings on, flap and jump off cliffs' (quoted in McNab, 1999, p. 12). It is hard to pinpoint why exactly investors invest in a particular film, but the script, the producer, the director, the stars or any combination of these elements may appeal to them. They may have what is known as bankability, that is, it is felt that they can guarantee an audience, which will provide a good financial return on the original investment.

The rise of blockbuster movies in the 1970s was accompanied by the belief that there were what could be called 'high concept' movies, films whose story and essential attraction could be summed up in a sentence, or even in one or two words (think '*Top Gun*'). The ability to encapsulate a film in such a simple fashion appealed from the point of view of marketing, which we refer to below. It also appealed from the perspective of a producer trying to secure funds from potential backers and was useful for a screenwriter seeking to be commissioned by a studio. This scenario is parodied wonderfully at the beginning of *The Player* (1992). The ultimate example of a high concept movie is perhaps *Snakes on a Plane* (2006) for which the title tells you all you need to know; clearly there is no direct link between 'high concept' and 'high quality'. Trade journals, such as *Screen International*, list 'loglines' for newly released films, which are essentially one-sentence descriptions.

CASE STUDY: INVESTMENT IN THE UNITED KINGDOM

The government

In many European countries, and particularly in France, film-making is a state-funded activity with plenty of government subsidies for production, distribution and exhibition. Through a combination of taxes, tax incentives and government contributions, the French film industry is the most vigorous in Europe. Although government funding for film-making in the UK is small, there has been increasing recognition of the need to finance the industry: direct funding rose from £14.9m in 1988 to £27.7m in 1994. Government money is currently provided through the Film Council, which was set up in April 2000. The Film Council is a new strategic body for film funded by the Department of Culture, Media and Sport. Headed previously by director Alan Parker (*The Commitments*, 1991; *Evita*, 1996) and currently by Stewart Till, it absorbed the British Film Commission, BFI Production, the Arts Council of England's Lottery Film Department and British Screen Finance. It distributes around £27 million from the National Lottery and £27 million from the government annually to support script development, film production, short films, film export and distribution, cinema, film education, culture and archives, festivals and audience support schemes. It has helped to fund, in one way or another, films such as *Red Road* (2006), *This is England* (2006), *London to Brighton* (2006), *The Wind that Shakes the Barley* (2006), *Stormbreaker* (2006), *Severance* (2006), *Miss Potter* (2006), *Becoming Jane* (2007), *Volver* (2006), *Tell No-One* (2006), *St Trinian's* (2007), *Brideshead Revisited* (2008) and *How to Lose Friends and Alienate People* (2008).

Television companies

Television companies are an important source of funding for films; as well as a financial return on their investment they receive the broadcast rights after the

film has been released in cinemas. The arrival of pay TV (satellite, cable and digital) has led to an increased demand for films. Abroad, major players such as HBO (US) and Canal+ (France) have been financing film production for some time. In comparison to their foreign counterparts, however, TV investment in the UK is low. The major investors in the UK are the following:

↝ Channel 4, through its feature subsidiary Film Four, is the biggest TV investor in Britain and has contributed to over half of all UK films made since the 1980s. Approximately 10 per cent of its annual programming budget is spent on new UK films and it aims to co-produce fifteen to twenty feature films per year. Since its launch in 1982 it has helped to make more than 300 films, including *Four Weddings and a Funeral* (1994), *Brassed Off* (1996) and *Slumdog Millionaire* (2008).
↝ BBC Films has a relatively small budget, but has funded films such as *The Van* (1996), *Billy Elliot* (2000) and *Revolutionary Road* (2009). In February 2006 it announced its intention to invest at least £100m in the UK film industry over 10 years as a result of a new partnership between the BBC and the UK Film Council.
↝ ITV Companies generally do not fund film production, but some noticed Film Four's critical success and began to invest. For example, Granada Television co-financed *My Left Foot* (1989).

Foreign investment

Often UK film-makers look abroad for foreign investment, most of which is provided by the major US studios. Foreign studios financed all the following 'British' films: *Chariots of Fire* (1981), *A Fish Called Wanda* (1988), *Sense and Sensibility* (1995), *Emma* (1996), *Hamlet* (1996) and *The English Patient* (1996). Many countries offer finance or tax incentives if a significant proportion of the main photography is done there.

Private investment

Private investment is another way of financing a film. This is uncommon since the high costs of producing a film are beyond the capacities of most private investors. Until 1993 the Business Expansion Scheme attracted many small-scale private investors by allowing significant tax relief on investments of up to £40,000, leading to the production of low- to medium-budget films such as *Henry V* (1989). This scheme was replaced in 1994 by the Enterprise Investment Scheme, a tax-based investment programme. Using this scheme, Paradise Grove plc offered investors roles in the film as extras if they invested at least £1,000. Films that benefited from the Enterprise Investment Scheme were *The Scarlet Tunic* (1998) and *An Ideal Husband* (1999). Production companies can also meet

production costs by negotiating special fees with crew members and equipment suppliers, and by securing product placement deals. This provides a symbiotic relationship between film-maker and advertiser. While the latter gets valuable coverage of a product, the former does not have to pay for use of that product, although some advertisers do charge for placement. Past examples include Tom Cruise swigging Red Stripe lager in *The Firm* (1993) and Tommy Lee Jones and Will Smith wearing Ray-Ban Wayfarer sunglasses in *Men in Black* (1997). Bond movies have long benefited from use of product placement, including Dom Perignon and Bollinger Champagnes, Stolichnaya and Smirnoff vodkas, Samsonite luggage and the BMW Z8.

END OF CASE STUDY

The producer

It is the job of the producer to secure finance for the film and then to supervise its expenditure. The producer is involved in every stage of a film's development from conception to exhibition and is engaged in the film longer than any other person; this continuity is essential for effective production. The producer deals with the idea, which may originate from a writer, director, producer, book or play, and must clear the screen rights for the material and then secure finance by assembling a package that includes an outline script (detailed storylines, possible stars, locations), proposed budget, a storyboard of several scenes, a possible director and any potential stars. The producer presents the package in such a way that it stands out from the competition in order to attract investment. This process of selling the package is known as the pitch. A successful package will not only appeal to financiers and investors; it will also reassure them that a return on their investment is possible. If the pitch is successful, a deal is struck between the producer and the investors.

Exercise 6.1

Do you think the UK government should fund film-making? What are the main sources of production finance for UK film-makers or for film-makers outside the major US studios working on low- or relatively low-budget productions?

Preproduction

Preparation

Once the funding has been secured, the film can enter the next stage of its life: preproduction. Research and planning for production can begin and development money is used to develop the outline script. The producer then

assembles a complete package, overseeing and assisting in the hiring of the director and technical crew, in casting and in choosing locations. It is now the task of the producer to steer the film into production, and his/her role can be summarized as the conduit between the idea, the script and the marketplace. The producer has overall responsibility for production and mediates between the film and its financiers, yet beyond this the role is not precisely defined and can vary considerably. Some producers take a 'hands on' approach during production while others delegate to an associate producer who directly supervises the daily shooting. Sometimes there is a credit for an executive producer, usually the head of a studio or a production company, who will not be too closely involved as s/he will be supervising several films in various stages of production.

The producer works closely with the director. A good working relationship between them is essential to the film's smooth progress, for where the producer is responsible for financial decisions the director is only concerned with artistic and technical ones. Since film-making is so expensive, a great deal of time and effort is spent meticulously planning and scheduling the shooting of the film in order to ensure that it runs as smoothly as possible. Planning covers all of the activities involved in preparing, editing and filming the script, including casting, finding locations, hiring technicians and other crew, organizing insurance, designers, accommodation and travel equipment. During preproduction the script will have been developed into a detailed screenplay, which is broken down into scenes and then storyboarded. This involves visualizing the script's narrative in a series of drawings that indicate the content of each shot and may also include audio information and camera instructions. A shooting schedule is then prepared, and before filming begins a production script is likely to be required. This not only gives script information but also provides written details on how the script is to be filmed, such as camera instructions, further audio information and guidance to actors. Once production has begun, a more precise budget than that proposed during the pitch will be finalized. Budgeting is divided further into above-the-line and below-the-line costs. Above-the-line costs include the salaries of the director, actors and crew whereas below-the-line costs refer to any other expenditure such as film stock, equipment hire, hotel costs, food, scenery and costumes.

Production

Production is the actual process of shooting the film. It is usually the most expensive stage in a film's life as it involves a large number of staff; hence the long credits at the end of a film! If the planning during preproduction has been carefully done, then the production should run smoothly and according to schedule. This is not always the case, however, and length of production varies from film to film. Kevin Costner's *Waterworld* (1995), for example, ran well over

schedule and budget as it involved filming on the open sea subject to favourable weather conditions (see also *Apocalypse Now*, pp. 34–5).

Key production roles

The following list is by no means comprehensive and does not cover all of the roles on a film. Some of the most important roles in production, however, are:

- ↪ The producer: see above.
- ↪ The line producer is responsible for the daily running of the production, in particular the day-to-day budget.
- ↪ The scriptwriter develops the original script/screenplay. Some films may employ more than one writer as the script is written and rewritten even as the film is being shot (see the section on *Casablanca*, pp. 25–7).
- ↪ The director is the individual responsible for translating the script into a film. Arguably s/he is the most important individual on the set. S/he usually takes the artistic decisions regarding camera angles, type of shot, shot length, lighting, how the actors should interpret their roles, and editing. As with the producer, the role of the director varies according to each individual. Some may be described as *metteurs en scène*, basically skilled technicians, while others are referred to as auteurs – more like artists who attempt to stamp their own personal imprint upon the film (see Chapter 13 on authorship).
- ↪ The art director or production designer is responsible for set design (*mise en scène*) and graphics.
- ↪ The cinematographer is also known as the director of photography or lighting cameraman and is responsible for the 'look' of a film, as s/he is in charge of camera technique. S/he translates the director's vision onto the screen, advising the director on camera lenses, angles, lighting and special effects.
- ↪ The costume designer conceptualizes and supervises the characters' outfits and works closely with the art director.
- ↪ The casting director selects and hires the support cast and negotiates fees with agents.
- ↪ The camera operator physically operates the camera under the guidance of the cinematographer.
- ↪ The assistant camera operator will help with camera movement, setting up the camera and operating controls, such as 'pulling focus'.
- ↪ The assistant sound technician will often be involved in operating a boom microphone, which is directional, meaning that it only picks up sound from the area the operator is pointing it towards.
- ↪ The locations manager finds suitable locations for filming and negotiates their use.

- ↪ The unit publicist promotes the film during production and collects useful publicity materials.
- ↪ The sound technician is responsible for the complex process of recording sound. When recording 'live' sound during filming, recording levels have to be set low enough so as not to introduce distortion and high enough so that dialogue can be heard. Sound checks are carried out before recording.
- ↪ The gaffer is responsible for the lighting under the direction of the cinematographer.
- ↪ The best boy is the gaffer's assistant.
- ↪ The key grip is in charge of all other stagehands, who are known as grips.

Postproduction

The final part of the overall production process is postproduction. Once approved, the rushes (film shot that day) will be sent to the editor, who will begin to put together a rough cut of the film. Once filming is complete, the shots are selected and put together to form the completed film. All recorded material is logged; shot and take numbers are indicated with times, descriptions of each shot and appropriate comments on the quality of each take. The completion of the log sheet is followed by an edit decision list. This identifies the takes that have been selected for the final edited film, gives their order and includes any other information that is needed at the editing stage. Editing is the process of joining together the chosen takes in the appropriate order with the inclusion of any extra audio–visual material.

Film editing

The role of the editor is possibly the most important in imposing a narrative structure on the film. S/he supervises the splicing or cutting together of the many rolls of film shot during production into their final structure and will work closely with the director to ensure that his/her vision is fulfilled. The editing process includes the selection, shaping, and arrangement of shots, scenes, sequences and special effects. The editor will assemble a rough cut from the daily rushes during production, and this will then be refined in postproduction to achieve the finished edit or fine cut.

Sound editing

The dubbing mixer, much like the editor, assembles a single soundtrack from the multiple soundtracks recorded during production such as dialogue, music and sound effects (all sounds that are neither music nor dialogue). During film

production sound is recorded separately from the film, and the two must then fit together so that the sounds match the images on screen. The soundtracks must also be mixed together at appropriate volumes. This may involve additional alterations to the tone of dialogue and frequently actors are recalled (sometimes months after production has finished) to re-record their lines. Sound effects are the responsibility of the foley team, who create appropriate noises for the images. The sound is then optically or digitally added to the film stock.

The composer will work closely with the director to achieve the 'feel', atmosphere, mood, tension and emotion of the film. Frequently s/he will compose and often conduct an original score for the film in accordance with the director's wishes. Increasingly soundtracks are assembled from existing popular and classical music. The sound designer creates sounds for the film, many of which are specially created as they are not reality/earth-based (e.g. spaceships, extraterrestrial beings, etc.).

The Special Effects Department creates a range of illusions to enhance the film that are unobtainable during production. These involve using optical effects such as front and rear projection, models, mechanical or physical effects such as fires, explosions, flying or falling objects, and increasingly computer-generated imagery. Graphic artists work on the titles and credits of the film.

///////////////////////////
Distribution

Once the director has approved the final cut, a preview screening is arranged for the distribution company. The distributor aims to exploit the film in order to profit from it or at the very least to recover the initial development and production costs. Effective distribution is fundamental to the film's success and many potentially prosperous films have failed at this point. In order to make a profit, a film must make roughly two and a half times its production costs at the box office. A distributor can acquire the distribution rights to a film by investing in it, by buying the rights after it has been made, or by being part of a larger company responsible for both production and distribution, such as a major US studio. Often the rights to distribute the DVD are acquired at the same time, which is a large source of revenue. A distribution company is subdivided into Publicity and Marketing (promotion), Film Sales (booking films into cinemas) and the Print Department (making copies of the film). The major distributors in the USA and the UK are UIP, Walt Disney Distribution, Twentieth Century Fox, Warners, Sony, Universal, Paramount, Fox and Columbia Tristar. Independent distributors include Entertainment, Rank/Granada International, Artificial Eye, Pathé, the BFI (British Film Institute) and Momentum, and also Eros Entertainment, an important distributor of many lucrative Indian films.

Based on an estimation of what a film will make at the box office and through rentals, the print and advertising budget (referred to as the P & A budget) is

created for marketing. This determines the amount the distributor is able to spend on promoting the film and getting it into cinemas. Again this is divided into above-the-line costs, such as advertising, and below-the-line costs such as publicity, merchandise and flying in the stars. The distributor typically receives about 40 per cent of box-office revenues, 30 per cent of which is spent on marketing, promotion, prints, certification and administration. Any money left over will then be paid to the producer, who will in turn pay the film's investors, artists, creditors and crew.

The tasks of the distributor include:

↪ acquiring a film;
↪ negotiating both the number and timing of the prints to be released to the exhibitors (distributors send hundreds and sometimes thousands of copies of each film to individual cinemas around the world, at approximately £1,000 per print. This can cost more than £3m for a film on wide release);
↪ arranging the distribution of these prints to the exhibitors;
↪ supplying the publicity material, advertising and trailers to the exhibitors in order to promote the film;
↪ arranging promotional partnerships to tie in with the film (known as tie-ins);
↪ dubbing and subtitling foreign language films;
↪ arranging and paying for a certificate;
↪ acquiring the rights to distribute the film on DVD.

Certification/Classification

Before a film can be screened to a paying audience in Britain it is a legal requirement that the British Board of Film Classification (BBFC) classifies it. In the United States there is a similar rating system which, although not a legal requirement, makes it unlikely that a film will be screened without a certificate (for more on this process see the section on regulation and censorship in Chapter 11 below). Certification is important when targeting an audience since it will determine the age of the audience at which the marketing will need to be pitched. A distributor may want to maximize the potential audience and aim to achieve a particular classification, as lower categories are on the whole believed to be more commercially advantageous. *Monty Python and the Holy Grail* (1975), for example, generated some amusing (and probably not untypical) correspondence about how much swearing to 'lose' (see Fig. 6.1). The standard cost to the distributor for the certification process is £837 (plus VAT) for a ninety-minute English language feature film, which means that the per-minute cost is about £9.

The producers of the Bond films targeted the young teenage audience throughout the 1990s. In another instance, the distributors of *The Mummy* (1999)

August 5th, 1974.

Dear Mike,

The Censor's representative, Tony Kerpel, came along to Friday's screening at Twickenham and he gave us his opinion of the film's probable certificate.

He thinks the film will be AA, but it would be possible, given some dialogue cuts, to make the film an A rating, which would increase the audience. (AA is 14 and over, and A is 5 – 14).

For an 'A' we would have to:

Lose as many shits as possible
Take Jesus Christ out, if possible
Lose "I fart in your general direction"
Lose "the oral sex"
Lose "oh, fuck off"
Lose "We make castanets out of your testicles"

I would like to get back to the Censor and agree to lose the shits, take the odd Jesus Christ out and lose Oh fuck off, but to retain 'fart in your general direction', 'castanets of your testicles' and 'oral sex' and ask him for an 'A' rating on that basis.

Please let me know as soon as possible your attitude to this.

Yours sincerely,

Mark Forstater

Figure 6.1 Monty Python, swearing and certification

(Universal) wanted a 'twelve' certificate for the film in the UK, but a hanging scene was deemed too graphic for such an audience. Universal were given a choice either to cut the offending scene or accept a higher classification. Since Universal wanted to maximize the potential audience, it cut fourteen seconds from the scene and got its 'twelve' classification. Similarly, *Lethal Weapon 4* (1998) was voluntarily re-edited at the request of the UK distributor in order to obtain a 'fifteen' certificate instead of the less profitable 'eighteen'. This was also because, in the words of the BBFC, 'the British audience preferred its entertainment with the blood-letting toned down' (BBFC, 1999 Report, p. 9). Voluntary cuts in trailers are often made to achieve a wider category in order to appeal to a broader audience. The BBFC has tried to encourage these commercial motives where they can be made to operate in the public interest.

An analysis of the BBFC's figures shows that, after a peak in the 1970s (reaching 33.9 per cent of films submitted in 1974), the number of cuts made to films has steadily declined. Since 2003, for example, the percentage of films subject to cuts has never risen above 2 per cent.

Marketing

Once a film is finished it becomes a product – something that needs to be sold. The aim of marketing is to raise awareness of the product. Audiences must be

informed that a film exists, their interest in it must be aroused and they must be persuaded to go and see something they neither necessarily need nor want. This is the job of the distributor. Marketing a film often begins months before a film is released, creating anticipation in audiences that it is coming to a nearby cinema soon.

The distributor devises a marketing strategy so that the film finds its audience, and needs to determine the prime target audience at which the film will be aimed. In order to do this the distributor conducts audience research. Preview screenings are set up whereby the distributor can receive a range of opinions and reactions to the film, which can be a good indication of the prime target audience. The distributor will also turn to regular weekly research known as tracking undertaken by the National Research Group.

The process of marketing can be divided into three areas.

↔ Advertising: the distributor devises an advertising campaign using trailers, posters and radio, newspaper and TV spots, all of which are carefully tested. Interviews are conducted to ascertain a response and TV and radio slots are scheduled in order to reach the target audience. The campaign must be consistent so that the audience receives a single message about the film. Usually this message is based around a film's unique selling point (USP) – that single thing that differentiates it from other films – which could be the director, the stars, the plot or the special effects. Trailers are particularly important as they allow audiences to sample the film first hand. An effective trailer will generate interest in a film while a poor one may dissuade viewers completely.

↔ Publicity is free advertising that either cannot be bought or is too expensive to buy, such as the front pages of newspapers, magazine covers, newspaper editorials, television and radio coverage. This involves press kits for journalists, photographs, star interviews, press screenings, gala premieres and free public screenings. New films can gain valuable publicity at film festivals held around the world, such as Cannes and the Sundance Festival.

↔ Promotional merchandising has become an important feature of marketing films following the phenomenal success of *Star Wars* (1977). DVD sales and rentals are important, but initial budgets are now also recouped by sales of promotional merchandising, tie-ins and Original Sound Tracks. This has been accelerated by the trend towards conglomeration in the film industry, as a film is now often perceived as only one part of a product line of toys, clothes, food and drink, video and computer games, novels, comics and other spin-offs. Sales of these items also help to promote the film, while the film encourages sales of merchandise.

The most effective marketing method is word of mouth as it not only costs nothing, but also reaches its prime target audience successfully. Personal

recommendations from friends, relatives or acquaintances, particularly those with shared tastes, are the most powerful devices for getting people into cinemas. Increasingly this is being replaced by word of mouse whereby films are marketed via the internet. Today most major releases have a website. Together, word of mouth and of mouse combined to create the unprecedented hype surrounding the release of *The Phantom Menace* (1999). Officially tolerated and unofficial fan-based websites created an expansive source of information about the film prior to its release, even including a scene-by-scene breakdown of the film. *The Blair Witch Project* (1999) was almost exclusively marketed on the web in the USA prior to its release there. Similarly, *The Omega Code* (1999) benefited from strategic promotion on the internet without a single frame being shown to the mainstream press.

Another promotional technique is labelled 'viral marketing'. The aim is to plant news, stories and rumours about a product, in this case a film, within existing social networks with the intention of the message being transmitted exponentially. Typically, the marketing campaign relies on traditional 'word of mouth' and more recently the internet (e.g. Facebook, email, YouTube). One film which made good use of this technique was *Cloverfield* (2008), which attracted a fair amount of attention for its use of viral marketing as much as for the film itself.

The timing of release is vitally important in determining a film's box-office success. Many factors are taken into consideration: genre, subject matter, and also other films due for release either by the distribution company or its competitors. The peak release dates are summer and winter holidays as these provide maximum leisure time for families. *The Blair Witch Project* was released in the UK to coincide with Halloween. The release may also be timed to coincide with the Academy Awards or a major film festival as these can have an important impact on box-office performance. *The English Patient* (1996) was released in the USA in March 1996 to coincide with the Oscar nomination period of February onwards. It was then later released in the UK deliberately to feed upon its Oscar successes in the USA. In contrast, Twentieth Century Fox deliberately delayed the release of the controversial *Fight Club* (1999) in order to avoid the Senate hearings on how to curb violence in films and thus to evade any adverse publicity that the film may have received. Ultimately, however, despite the best efforts of those promoting and marketing the film, it is the public who decides if a film will be a success or not.

Exercise 6.2

Compare and contrast the routes through distribution and exhibition of a typical mainstream US film and a smaller British film. Does the latter have the same options and opportunities as the former?

///////////////////////

Exhibition

The next stage in a film's life is where the real money is made. Exhibition is the key stage since it is the first outlet for the film product and is where the distributor earns revenue from the public. Exhibition is essential to a film's success, as it is the shop window in which films are sold to their audiences. A film must also, therefore, be 'sold' to the exhibitor, who works very closely with the distributor to promote the film to an audience.

Once the exhibitor has viewed the film, a release pattern and financial deal will be arranged to rent the film from the distributor. It is the task of the film booker to find films that will attract an audience and in turn create large box-office returns, and usually the exhibitor and the distributor will work together closely to ensure this. Mainstream films are usually booked between three and six months prior to release, but sometimes they can be booked up to a year in advance. The exhibitor will then advertise the film locally in order to attract as large an audience as possible. This will be done through listings in local magazines and newspapers, posters, competitions, trailers and other promotional material. Once the audience member has paid for his/her ticket, the cinema typically subtracts about 60 per cent to cover its running costs (the 'house nut') and its profit margin. The rest (about 40 per cent) is paid back to the distributor. In order to ensure a profit, the exhibitor also sells concessions (ice creams, hot dogs, sweets, drinks, etc.); this is a particularly important source of revenue if the film is a failure.

A brief history of UK and US exhibition

We have looked at the history of exhibition up to the end of the First World War in Chapter 1 on early cinema. Here we shall look briefly at the history of exhibition in Britain and the United States after 1918. Following the war, the US studios dominated exhibition through a system of vertical integration and continued to do so until divorcement in 1948 (see the section on the US studio system in Chapter 2). In Britain, the Cinematograph Act of 1927 attempted to prop up the flagging film-making industry in the UK by requiring that a quota of British releases be shown. Deals were then made between the large US distributors (who received about 25 per cent of the total gross from the UK), British film-makers and the emerging cinema circuits such as Provincial Cinematograph Theatres – England's first national circuit (established 1919). Three other large circuits soon appeared: Gaumont (1926), Associated British Cinemas (1928) and Odeon (1930s), resulting in the construction of many elaborate cinemas.

However, the Second World War stopped cinema building in the UK and, by the time restrictions had been removed in 1954, cinema attendance was in decline as a result of changes in leisure activity, the move to the suburbs and

greater disposable incomes (see Chapter 11 on cinema, audiences and society). In the USA, audiences declined as a result of a combination of TV and increasing suburbanization. In reaction, the major studios introduced new technologies in an attempt to lure audiences back into the cinemas. There was increased use of colour processes in the 1950s followed by the introduction of widescreen and 3D technologies. From the 1970s onwards, sound quality improved as stereo and Dolby playback were developed (see Chapter 10). However, the decline in audience figures was accelerated by the introduction of home video in the late 1970s. Many cinemas closed down and were converted (in Britain) into bingo halls, pubs, night-clubs or supermarkets or were pulled down and replaced by housing.

By 1985 vertical integration had returned in the USA, and the ownership of the theatre chains, such as Walter Reade, Cineplex/Odeon and Loews Theaters, was still concentrated among a small number of companies like Universal, Columbia, Paramount and Warners (see Chapter 2). A similar trend is evident in the UK, where the exhibition sector remains highly concentrated among a small number of exhibitors (e.g. Cineworld, Odeon and Vue). If these current trends continue, then past experience suggests that smaller operators will be swallowed by the bigger chains, leaving just several large exhibitors and a decreasing number of independent competitors.

The multiplex, multi-screen and megaplex

By the mid-1980s British cinema appeared to be in terminal decline as video rentals, combined with dingy cinemas, poor audio-visual quality and high ticket prices kept potential cinemagoers at home. The average Briton visited the cinema approximately once a year. As audiences dwindled, profits were affected, and the major US distributors recognized the need to revitalize the European exhibition sector. In the 1960s the major studios, such as Universal, Warners and Paramount, had begun to invest in refurbishing cinemas, improving audio-visual facilities and increasing the numbers of screens per cinema. This led to the launch of the multiplex – two or more screens housed in a single building – by AMC Entertainment in the USA in 1963, soon to be followed by Cineplex's development of the multi-screen in 1979. The watershed for the film industry in Britain was 1985, when the first multiplex cinema opened in Milton Keynes. Since then, cinemagoing has changed irrevocably. New 'fast-food-style' multi-plexes housing up to twenty screens sprang up across the country. Older large single-auditorium cinemas were divided into smaller screens, giving rise to the multi-screen cinema housing between three and eight screens. And soon there emerged the megaplex, which housed more than sixteen screens, with retail outlets, restaurants and other leisure activities.

Since 1985 multiplex expansion has been unrelenting as the major cinema operators have channelled their energies into this sector. Multiplexes with

more than five screens account for more than half of Britain's cinema screens. Almost 1,400 new cinema screens have opened at 140 multiplex sites in the UK and approximately 50 per cent of these opened in the years 1997–2000 alone (Table 6.1). In 1998 almost 300 screens were opened (more than in any twelve-month period for fifteen years) and nearly 700 new screens were opened in 1999 and 2000. This trend is continuing as the major operators have yet more multiplexes planned. At present, multiplexes dominate the UK exhibition sector – about half of the UK's population are no more than twenty minutes' drive away from a multiplex and about 60 per cent of all cinemagoers now attend multiplexes on suburban town fringes. In turn, this increased competition has gradually forced smaller inner-city and high street local cinema operators out of the market. In 1999, for example, the ABC in Golders Green (originally the Ionic), which was built in 1912, closed down because of the competition from two nearby Warner Village multiplexes. Similarly, Bangor in North Wales has no cinema, the last one closing in 2006, the direct result of the opening of the Cineworld in nearby Llandudno Junction.

By 2004, 73 per cent of screens in the UK were found in multiplexes – purpose-built sites with five or more screens – an increase of 2 per cent on 2003. During the period 1999–2004 there was a rise of 49 per cent in multiplex screens compared with a 19 per cent fall in the number of traditional and mixed-use screens. In real terms the UK has gained 802 multiplex screens since 1999 and lost 218 traditional or mixed-use screens (used for film screenings only part of the time). Overall, then, in 2004 the UK had approximately 3,342 screens in 646 cinemas. However, fewer new cinema screens have opened in the last few years as the pace of multiplex expansion has slowed down.

The major cinema chains rebranded themselves in order to attract customers away from other operators and to encourage customer brand loyalty. As a result, many now offer premium screens, 'arthouse' screens, cafés, bars, cappuccino shops, merchandising, children's facilities and other spending attractions in order to set them apart from the competition. Some cinema chains even offer sofas in the viewing area and serve food and drink at the seats. Concessions typically provide revenues of over £200m per year. Advertising revenues have also increased increasing, reaching the £200m mark. Meanwhile, average ticket prices have increased.

Despite the huge growth in cinema admissions and screens (see Table 6.2) the actual number of films widely available in the UK has not increased significantly. Rather than expanding the range of films, cinemas have tended to focus on exploiting a limited number of blockbusters. Films will play on multiple screens with multiple staggered start times, and despite early promises of maintaining an arthouse screen, many operators have passed this over in favour of offering another screen for the blockbuster.

One of the reasons why Britain's film industry is so weak is of course US ownership of the cinema chains. US exhibitors tend to block British products and,

Table 6.1 UK cinema sites, screens and seats 2000–8

	2000	2001	2002	2003	2004	2005	2006	2007	2008
Cinema screens	2,940	3,164	3,402	3,433	3,475	3,486	3,569	3,596	3,661
Cinema sites	686	692	775	775	773	771	783	775	772
Cinema seats	690,000	705,500	734,511	738,095	743,650	743,215		790,220	865,599
Change in cinema screens %	4.1	7.6	7.5	0.9	1.2	0.3	2.4	0.8	1.8
Change in cinema sites %	0.1	0.9	12.0	0.0	-0.3	-0.3	1.6	-1.0	0.0
Change in cinema seats %	3.0	2.2	4.1	0.5	0.8	-0.1			9.5
Average seats per screen	234.7	223.0	215.9	215.0	214.0	213.2		219.7	236.4
Average screens per site	4.3	4.6	4.4	4.4	4.5	4.5	4.6	4.6	4.7

Sources: Screen Digest; CAA.

Table 6.2 Cinema screens in the UK, 1950–2007

Year	Multiplex	Traditional	Total
1950	0	4,583	4,583
1955	0	4,483	4,483
1960	0	3,034	3,034
1965	0	1,971	1,971
1970	0	1,529	1,529
1975	0	1,530	1,530
1980	0	1,562	1,562
1984	0	1,275	1,275
1985	10	1,345	1,355
1986	18	1,315	1,333
1987	45	1,290	1,335
1988	142	1,320	1,462
1989	288	1,310	1,598
1990	390	1,325	1,715
1991	518	1,285	1,803
1992	562	1,280	1,842
1993	624	1,280	1,904
1994	689	1,275	1,964
1995	725	1,280	2,005
1996	864	1,358	2,222
1997	1,089	1,260	2,349
1998	1,357	1,224	2,581
1999	1,617	1,141	2,758
2000	1,830	1,110	2,940
2001	2,170	994	3,164
2002	2,295	1,107	3,402
2003	2,378	1,055	3,433
2004	2,430	1,045	3,475
2005	2,449	1,037	3,486
2006	2,532	1,037	3,569
2007	2,584	1,012	3,596

Sources: Central Statistical Office, Dodona Research (2000); Screen Digest; CAA (2008).

as a result, approximately 85 per cent of films screened in the UK are US origin. The US distributors, rightly or wrongly, believe British films to be unpopular with mainstream audiences and, consequently, low-budget and British films find it difficult to find exhibition opportunities outside independent and 'arthouse' cinemas.

Exercise 6.3

Carry out a survey among your class asking why people went to the last film they saw. What factors did they take into account? Did they feel that they had a real choice of films or were there many films that they did not want to see?

Arthouse cinemas began to appear in the early 1950s and by the early 1960s there were approximately 500 in the USA. They are distinguished by their specialist programming policies and the range of films that are shown. They can be defined as cinemas that feature foreign-language, independent, avant-garde, retrospective or classic films. In the UK they are also often referred to as 'repertory' cinemas. Such cinemas are generally small and rely on a select and discriminating clientele, but have nonetheless helped to increase cinemagoing. They are typically owned by individuals, smaller companies (e.g. Oasis, Apollo and Robins), or are subsidised by the government, operating apart from the major chains. Since the 1960s they have greatly decreased in number as the distinction between US and foreign-language films has become less significant and foreign films have had a very difficult time at the box office. However, in the face of competition from the multiplexes, many owners have refurbished their cinemas to offer a different experience including cafés, restaurants and bookshops. Some of the most notable of these cinemas are the National Film Theatre on London's South Bank, the Phoenix in East Finchley, the Tricycle in Kilburn, the Electric Cinema in Birmingham and The Belmont in Aberdeen. Perhaps the most impressive of the recently refurbished cinemas is the Rex in Berkhamsted which was built in 1938 with elaborate art-deco designs. It closed in 1985 following declining attendances, but after the humiliation of hosting bingo evenings it reopened in 2006 following extensive restoration. Despite being 40 km outside London, its mix of mainstream and art house movies regularly sell out.

Reviewing and criticism are important elements in the life of a film as they may help to determine its success. When a film is marketed, press screenings are arranged in the hope of positive write-ups from the critics. The typical film review will contain a concise summary of the plot, background information, a set of condensed arguments about the film and an appraisal. When reviewing a film, the critic will usually be looking for compositional, 'realistic', intertextual and artistic motivation, as well as social and entertainment value as both narrative and spectacle. Film reviewing also has other functions. It informs readers about the latest news and releases. It advertises and publicizes the film, encouraging readers to see it or to avoid it. And it analyses, describes and evaluates the film. The actual impact of the critic/reviewer, however, is hard to pinpoint. Extracts from positive reviews are often included in the poster campaign of a film, but what effect does reviewing have on the potential audience? Are we persuaded to see a

film or dissuaded from seeing it because of what someone else has written about it? Who writes about films and why are their reviews read? These are questions that cannot be easily answered, but they will be considered in Chapter 11.

Film festivals such as Cannes, Sundance and the London Film Festival provide important opportunities and useful events for both practitioners and audiences. Most festivals are competitive but many exist primarily to showcase the range of new films that are available; the prize in such festivals is having your film selected for screening. Other festivals cater for semi-professional and amateur productions, sometimes feature-length films (over seventy minutes) but often short films (usually under thirty minutes). Many of these festivals – particularly the smaller ones – are free to enter and for those seeking to publicise their productions, gain experience and form contacts, they are important events. The British Council website lists over one thousand film festivals, some specialist and some general, held all over the world each year. By contrast, an increasingly popular platform for short films is the YouTube website, frequently used by amateur and student filmmakers but also by professionals looking for another way to market their work.

Exercise 6.4

For a new release of your choice, read/collect as many different reviews as you can (including a wide range of newspapers and magazines). Try to account for the differences of approach.

The future of cinemagoing

What does the future of cinemagoing hold? Although trends over the last few years have indicated a rise in the number of multiplexes alongside a decline in traditional cinemas, experts predicted that the number of screens in the UK would reach saturation point somewhere between 2005 and 2010. Increasing capacity has overtaken the rise in cinema attendance, and pockets such as Bolton, Swindon and Sheffield are reportedly already unable to sustain any more new cinemas as a result of what has been called 'consumer fatigue'. Multiplexes are also expensive and many have been struggling to make profits. In addition, new planning laws in the UK (which encourage investment in town centres and reduction of car travel) have forced many operators to reconsider plans for stand-alone multiplexes on town fringes or in suburbs. The major cinema operators, such as Odeon and Vue, are delaying and withdrawing from planned projects in the UK and some are getting out of the market altogether. The suggested forecast is that smaller operators will be swallowed by the bigger chains or will simply drop out of the UK market. Cineworld and Empire are well established after takeovers and amalgamations.

Cinemagoing has been revolutionized over the years not only by new cinemas but also by changes in technology, particularly with the advent of VCRs, the internet and DVDs. Exhibitors reacted, as they have always done, with the introduction of improved audio-visual technology, which we shall look at in our chapter on film technology. *Toy Story 2* (2000), for example, was screened in the UK using digital projection, which may make the need for what have been perceived to be unwieldy and costly reels of film redundant. It is predicted that by 2012, 60 per cent of UK screens will be digitized, suggesting that digital projection may soon become the norm.

Other predictions made five years ago have failed to materialize. The merger of AOL and Time-Warner suggested that the internet may become the primary site for film exhibition in the near future, shifting viewing to the home, but this has not happened. Cinema admissions in the UK are on the rise, and box office revenues are up as cinema is still the preferred way to watch films, with DVD becoming the second most popular way.

Neither has introduction of IMAX and OMNIMAX technologies significantly affected the way we watch films, although 3D projection is becoming increasingly popular. But will these technologies have a significant impact or will the allure of downloading and viewing films from the internet or through online DVD rental within the comfort of the home prove too strong?

CONCLUSION

Despite certain continuities, aspects of the process by which a film eventually reaches the screen are continually changing. While the basic system of production, distribution and exhibition has remained the same, each stage in the life of a film has altered somewhat as it has adapted to changing circumstances and contexts. As a consequence, who knows what the future of film will hold?

SUMMARY

↝ There are three main stages in film-making: production, distribution and exhibition.
↝ Production involves the following:
 ↝ finance: a producer seeks to find investors and financial backing for a film package;
 ↝ preproduction: includes research, planning, budgeting, hiring director and crew, casting, finding locations, scripting and storyboarding;
 ↝ production: shooting the film;
 ↝ postproduction: editing, sound design, sound editing and dubbing, special effects and graphics.
↝ Distribution: the distribution, marketing, advertising, promoting and classification of the film.

↪ Exhibition: exposing the film to the audience, whether it is in a one-screen, multiplex, multi-screen, megaplex or arthouse cinema; also includes reviewing and criticism.

REFERENCES

BBFC Annual Report 1998 (1999), London: BBFC.

Mcnab, G. (1999), 'Hey, You Wanna Buy a Movie?', *The Guardian*, p. 12.

FURTHER READING

Garnham, N. (2000), *Emancipation, The Media and Modernity: Arguments about the Media and Social Theory*, Oxford: Oxford University Press.

An investigation into the influence and role of the media within capitalist societies.

Gomery, D. (1992), *Shared Pleasures: A History of Movie Presentation in the United States*, London: BFI.

A comprehensive history of the US film exhibition business from the nickelodeon to cable TV.

Hill, J. and Church Gibson, P. (eds) (1998), *The Oxford Guide to Film Studies*, Oxford: Oxford University Press.

Key chapters in this book cover topics such as 'Hollywood as industry' and 'Film audiences'.

Wasko, J. (1994), *Hollywood in the Information Age*, Cambridge: Polity.

An in-depth investigation of the impact of new technologies of production, distribution, exhibition and marketing on Hollywood.

Chapter 7

Cinema, the media and globalization

As a study of film, this book focuses on films as texts that communicate meanings, audiences as consumers of films, and cinema as an industry that produces films. This chapter is concerned with issues of ownership and power within cinema, while also considering it in the wider context of the media as a global phenomenon. What has become known as 'the media' consists of a number of industries including television, radio, print, music and of course cinema. It is increasingly the case that these industries cannot be seen as separate areas of activity; rather, they are often interlinked in terms of ownership and how they operate. Nor can we think of media industries and companies as functioning simply within individual countries. Media companies are increasingly multinational, and exist and operate across several countries. Furthermore, the marketing, distribution and consumption of media products have become globalized, with productions from one area of the world often being experienced elsewhere in very different cultures.

///

Ownership of the major studios

The major studios are well known to us already and have been referred to in Chapter 2. The names have been with us for more than eighty years: Columbia, Disney, MGM, Paramount, Twentieth Century Fox, United Artists, Universal, Warner Brothers. However, while the economic function of these companies essentially remains the same, their structure and conditions of ownership have changed dramatically. The above studios are, quite rightly, identified as large production companies in their own right; however, the size of these studios is put into perspective when we realize that they are just small parts of much larger multinational conglomerates that own a vast range of other companies, often with interlinking interests. As Richard Maltby notes, this restructuring of the film industry is nothing new and is now well established:

> During the 1960s most of the major motion picture companies merged with or were taken over by conglomerates attracted by their undervalued stock, their film libraries, and their real estate, and the years from 1966 to 1969 in particular saw an upheaval in company ownership more substantial even than that of the early 1930s.
>
> (Maltby, 2003, p. 173)

Columbia Pictures has existed since the early days of cinema, but the company's structure and ownership have changed considerably. In 1982 the Coca-Cola company bought Columbia, and in the same year Columbia itself formed TriStar Pictures as a means of diversifying its production facilities. Five years later the two companies were merged, resulting in what is now known as Columbia TriStar. Coca-Cola's venture into film production ended in 1989 when the Sony Corporation bought Columbia TriStar. Sony intended to ensure that its media hardware production would be complemented by media software, an area where it had failed when it developed its video system in the 1970s.

Two other studio names that have survived from Hollywood's heyday are MGM and United Artists, though both companies have had their problems. By the 1970s MGM had virtually ceased film production and in 1980 United Artists was severely weakened after the costly mistake of *Heaven's Gate*, which resulted in a $40 million loss. The following year the two companies amalgamated to form MGM/UA. This company went on to form the distribution giant United International Pictures (UIP) in partnership with Paramount and Universal. MGM/UA made a slow but steady recovery, and the 1990s saw the company re-establish itself through funding and distribution of the James Bond films. It simplified company activities with the sale of its share in UIP in 2000. After frequent rumours of takeovers MGM/UA was finally bought by a consortium led by Sony in 2005, and UA is now a subsidiary of MGM.

Paramount Pictures was one of the original major studios and was used as the test case for the 1948 anti-trust legislation. Like the other major studios, it is now part of a large multimedia conglomerate. In 1966 Paramount was bought by Gulf & Western and was eventually renamed Paramount Communications Inc. Viacom took over the company in 1994, bringing together television, publishing, radio and film interests. Viacom also owns the MTV channel and owned the international video/DVD sales/rental company Blockbuster until 2004 when they parted company.

Twentieth Century Fox has existed in one form or another since 1915. In 1985 Rupert Murdoch applied for US citizenship in order to acquire US media interests. In the same year he bought Twentieth Century Fox. His multinational company News Corporation already had significant media interests around the world, including television and satellite companies and the UK-based News International, which owns several big UK newspapers including *The Sun* and *The Times*.

Universal Studios dates back to 1912 and has also been through several changes over the years. Universal was taken over by the Music Corporation of America (MCA) in 1962, although this was often perceived as a merger because of the use of the title MCA-Universal. However, MCA itself was bought up in 1990 by Sony's Japanese competitor, Matsushita, who hoped to match media production with media technology, which was their area of specialization with equipment such as TV sets, VCRs and CD/cassette players. Matsushita had been successful with the launch of its video home system (VHS) in 1977. Although their video system was regarded by many as technically inferior to those of its competitors (Sony's Betamax system and Philips' V2000 system), it ensured success with the rights to more films for video release. However, Matsushita was less than successful with its venture into film, and in 1995 it sold MCA and its assets, including Universal, to Seagram, a Canadian drinks company. In 1998 Seagram expanded its media empire with the purchase of Polygram, which produces films and owns thirteen music companies, from Philips, which decided to concentrate on producing media hardware. In 2000 Vivendi, a French company with telecommunications interests, merged with Seagram to create Vivendi Universal, bringing together film, TV, satellite and internet business interests. In 2003 General Electric acquired a majority stake in Universal when it amalgamated its NBC television and studio subsidiaries with Universal's theme park and studio subsidiaries to form NBC Universal. General Electric is predominantly a hardware manufacturer but has had television and internet interests for a number of years.

Warners' beginnings were in film production but the company eventually expanded to become co-partner of the world's largest multimedia conglomerate, Time-Warner Inc. Warners was already a conglomerate with a range of media interests by 1973, the year in which it renamed itself Warner Communication Inc. (WCI). In 1989 WCI merged with Time Inc. to create Time-Warner, a

company with interests in film, video, television, music, distribution, exhibition and publishing. When the company acquired Turner Broadcasting in 1999, they also acquired Castle Rock Entertainment, a film and television production company that had been bought by Turner in 1994. Time-Warner's position as world leader was further reinforced through the merger in 2000 with America On-Line (AOL), the internet service provider, to form AOL-Time Warner. However, the subsequently poor performance of AOL resulted in the conglomerate dropping AOL from its title in 2003.

RKO was one of the original 'big five' Hollywood studios of the 1930s and survived until 1957. Since then it has had several reincarnations in various forms and is currently responsible for the occasional movie, though none have matched its former glory.

None of these five studios operate as their predecessors did; they no longer have direct involvement in film production, but they finance and distribute films and hire other companies to make the films.

Exercise 7.1

Look at your DVD collection or recall the last five films you have seen. What percentage of the films belong to/were produced by the six major studios?

//

Media conglomerate strategies

There are particular reasons for the trend towards amalgamating companies into multinational conglomerates. The ultimate purpose of such companies, as business enterprises, is of course to make a profit and to be commercially successful. Large companies have the advantage of being able to provide the financial resources necessary for further expansion, developing new products or marketing existing products. Smaller companies can find it hard to compete with the economic power of large conglomerates; amalgamating companies through mergers and buy-outs concentrates ownership and can reduce competition, thus increasing the likelihood of financial success.

Bringing together a range of media companies has its own particular benefits. The media are all about communication, and having interests in a variety of media industries places a conglomerate in a position where the various companies can in many instances promote the other areas of the conglomerate via, for instance, television, radio, newspapers, magazines or general marketing facilities. It is also the case that particular media products are often to be found duplicated in various media forms so that a film may have a television spin-off, a music soundtrack and magazines based on the original concept. The low-budget success *Lock, Stock and Two Smoking Barrels* (1998) was turned into a British television series in 2000 and *The American President* (1995) was the inspiration for the *West Wing* (1996)

political drama, the film and television programmes being scripted by Aaron Sorkin. It is to be noted that there has also been an increasing trend for television programmes to make the transition to film: *The Addams Family, The Flintstones, Batman, Mission Impossible* (1996).

With regard to media conglomerates, the links between hardware and software are becoming increasingly important. Media products such as films on VHS and DVD, television programmes, MP3s, podcasts, computer games and music CDs need technology such as VCRs, DVD players, TV sets and CD/tape/MP3 players for them to be consumed. The entertainment industry, now largely constituted by media conglomerates, has made major moves into acquiring hardware and software interests. With the growing importance of computer systems and digital technology, as seen in the advances made in digital television and internet access, further inroads are likely to be made into media hardware industries. The multinational and global nature of the contemporary media industries is illustrated by the locating of media companies in a variety of countries and by the consumption of media products around the world, but is also well served by the growth of telecommunications technology ('tele' literally meaning 'over a distance'). The previously mentioned multinational conglomerates have been quick to take advantage of the possibilities offered by becoming 'multimedia'. For example the merger of AOL and Time-Warner meant they could take full advantage of the internet. Increasing conglomeration has accelerated the trend towards perceiving films as only one part of a product line of toys, clothes, food, drink, video, computer games, comics, magazines and soundtracks (see Chapter 6).

By 2000, News Corporation had developed extensive cross-media ownership. Its media interests include: films (Twentieth Century Fox), newspapers (News International), broadcasting (Fox Television), satellite and cable broadcasting (BSkyB, Star TV and the National Geographic Channel, publishing (Harper Collins) and interests in internet services (MySpace). Murdoch's cross-media interests are frequently used to promote other areas of his media empire. His British newspapers, for example, often refer indirectly to his BSkyB satellite services.

The Sony Corporation had originally concentrated on the production of media hardware such as TV sets, VCRs, CD and tape players, but with the acquisition of Columbia it expanded into software production. This expansion has continued with the takeover of MGM in 2005, which owned a large number of classic Hollywood movies. Sony's software interests have also developed beyond film production, with interests in exhibition through Loews Theaters, TV production, video sales, and the purchase of CBS Records, subsequently renamed Columbia Records. The Sony Playstation systems have given the company a further foothold in hardware and software in the computer games industry. Behind Sony's expansion has been a strategy of synergy, whereby the various industries under its control are brought together to mutually benefit each other. Thus Sony televisions may be bought and used for screening its TV productions, Columbia's films, possibly on Sony videos, or for playing a

Playstation game. Similarly, music released by Sony's music division may be played on Sony CD or MP3 systems.

Time-Warner are ideally placed to practise synergy. It will readily be seen that a Warners' film may use a soundtrack produced and published by Warners' music division, use its distribution company, be publicized in Time-Warner magazines, release the film via its video company and no doubt screen it on Warners' television such as HBO or Turner Broadcasting. Time-Warner also has its own online shop for film merchandise and computer games based on its films, and has on occasions also cleverly resurrected and re-used old products in new films. The company owns DC Comics, in which the original Batman character appeared, and of course produced four *Batman* films. Similarly, the original Warner Brothers cartoon characters were relaunched in *Space Jam* (1997), which combined cartoon characters such as Bugs Bunny with actors through the use of computer technology. Time-Warner has reduced its exhibition facilities however with the sale of its cinema chain in Britain in 2003 to SBC International Cinemas, who renamed the facilities Vue Cinemas. Despite overestimating the value of AOL's internet service provision, Time-Warner still remains the largest media company and has further internet interests through ownership of Netscape.

General Electric has always focused on engineering but has increasingly expanded into the media, most notably with television channels and internet services. The company's central role within the media was confirmed in 2005 with the acquisition of Vivendi's Universal studio and theme park assets, plus its stake in the distributor UIP. Vivendi Universal was a typical example of a vertically integrated company as a result of the previous activities of one of its subsidiaries, MCA. In 1977 MCA and Paramount jointly formed the Cinema International Corporation (CIC) as a film distributor, later renamed United International Pictures (UIP). Co-operation between film companies has become increasingly common as a means of pooling resources and specialisms to maximize profits (in 1975 Twentieth Century Fox and Warners had co-produced *The Towering Inferno*). In 1987 MCA-Universal obtained part control of the Cineplex Odeon chain and went on to form United Cinema International (UCI) as an exhibition chain with Paramount. Thus Vivendi Universal was a well-established, vertically integrated company, capable of producing films, distributing them and screening them in its own cinemas. However, Vivendi sold a number of its companies after 2002. As well as its sales to General Electric it also sold its share of the cinema chain UCI which was bought by Terra Firma in 2004. Vivendi's remaining media assets are focused on television channels, music and video games.

Viacom is another company with elements of vertical integration, mainly due to the activities of its subsidiary, Paramount; however, its position potentially has been weakened through its sale of the UIP distribution company and the UCI exhibition chain. The 1948 anti-trust legislation ending vertical integration in the USA was repealed in 1985 by the Republican administration, headed by former B-movie actor Ronald Reagan. His administration pursued a *laissez-faire*

economic policy which sought to reduce government intervention in the economy, leaving the financial markets to regulate themselves. Paramount, as a production company, took advantage of this deregulation and developed distribution and exhibition facilities with MCA. Viacom's merger with CBS in 1999 ensured guaranteed access to television for Paramount films, thus adding to its existing broadcasting interests which also include various radio stations. However, for strategic reasons the company split in 2005 into Viacom and CBS Corporation.

Exercise 7.2

Which of the films you have seen over the past year have been linked to other media forms through CD and MP3 soundtracks, DVDs, magazine articles, television screenings or documentaries?

Concentration of ownership

Continued horizontal integration would ultimately result in one company monopolizing a particular industry. However, it is unlikely that this will happen in the film industry, if only because anti-monopoly legislation should prevent such a development – though it is worth bearing in mind that, as we have seen, legislation preventing vertical integration was eventually repealed in the USA, and in Britain proposed deregulation could result in ITV becoming US-owned and Channel 5 being bought by News Corporation.

Although the film industry is not monopolized by one company, it can certainly be described as an oligopoly, an industry that is dominated by a small number of companies. Essentially six companies control the international film industry: Disney, News Corporation, General Electric, Sony, Time-Warner and Viacom (North America is the most profitable cinema market and in 1997 these companies accounted for 80 per cent of that market). Thomas Schatz sees no signs of change in the current media conglomerates' strategy of buying into the film industry and notes that 'Because movies drive the global marketplace, a key holding for any media conglomerate is a motion picture studio; but there is no typical media conglomerate these days due to the widening range of enter-tainment markets and rapid changes in new technology' (Schatz, 1993, p. 30). Ownership could become even more concentrated with the continuing expan-sion of telecommunications companies such as AT&T and Cable & Wireless and the further growth of European media companies such as Bertelsmann and Fininvest, both of which have film, television, radio and publishing subsidiaries.

Current trends and possible future developments with regard to ownership raise the question of whether concentration of ownership within the film industry and media as a whole is desirable. From a purely economic perspective, it could be argued that large multinational conglomerates are necessary nowadays as

they are able to supply the huge budgets that contemporary films often seem to require. Smaller companies could not match the resources of the larger conglomerates. From a political perspective it could be argued that ownership has become concentrated in relatively few companies because they are the best at what they do and are the most competitive. From a capitalist perspective, a free market is desirable as competition results in the most effective companies surviving and consumers (so the theory goes) getting the best deal possible.

However, it could also be argued that conglomerates are basically a cartel which tends to protect the position of each company and that in effect the companies do not really compete with each other. The power of the conglomerates makes it difficult for smaller independent companies to compete on equal terms, thus ensuring the survival of the conglomerates. Production companies that are referred to as independent are usually dependent on the major companies for finance or distribution, and they often end up being bought by majors or going bankrupt in the face of unfair competition; Orion went bankrupt in 1992 and Disney bought out Miramax in 1993. The increasing power of multinationals is thus undemocratic and undesirable. From a Marxist perspective, multinationals are the logical result of an economic system based upon profit rather than need. The concentration of capital is predictable and self-perpetuating and while the types of films and media products made are intended to meet consumer demand, that demand is itself created by expensive marketing campaigns. A Marxist analysis may also suggest that the media products supplied tend to embody values and beliefs that reinforce the position of a political and economic dominant class.

CASE STUDY

The Walt Disney Company

Walt Disney Pictures was not one of the original major studios and did not begin film production until 1923. However, the Walt Disney Company is now one of the biggest media groups in the world, its most profitable activities being the theme parks in the United States, Europe, Japan and China. Disney formed the Buena Vista distribution company in 1953 and the company also expanded into TV production in the 1950s in order to fund the development of its Disneyland theme park which opened in 1955. Disney's television interests expanded further in 1983 with the launch of the Disney Channel. In 1984 it expanded its film production further with the creation of Touchstone Pictures. The Disney empire continued to grow with the opening of the first Disney store in 1987. The 1990s saw further growth with the acquisition of ABC TV in 1996. The Fox Family Network was purchased in 2001 and renamed ABC Family. The Disney Company provides an example of horizontal integration in the film industry: the

purchasing of companies that are operating in the same area of production, in effect buying out a competitor. Thus when the Disney Company, as a production company, bought Miramax Pictures in 1993 and Pixar Animation in 2006, it was expanding horizontally, in contrast to the previously mentioned examples of companies expanding vertically into other areas of the industry. In 2009 a distribution deal was signed with Dreamworks SKG, a production company which had regained its independence from Paramount in 2008.

END OF CASE STUDY 1

//////////////////////////

Globalization

The concept of globalization is not new, and was foreseen by Marshall McLuhan in the 1960s when he referred to the 'global village' in which communication from one part of the world to another effectively eliminated physical distances, as if we were all living in the same community. The 1960s saw international communications networks expanding, a high point being satellite communication with its possibility of instantaneous mass communication between different countries via satellite and television. Such communication was, however, limited to developed areas of the world which possessed the requisite technology. Global, albeit not instantaneous, communication had of course been taking place for most of cinema's history through films; films are imported and exported to and from all parts of the world, in effect, providing an exchange between cultures.

However, the obvious point to be noted is that the exchange is somewhat unbalanced. It tends to be US films and Western culture that are propagated around the world, with little in the way of non-US films and non-Western culture being allowed to return. An indication of the marginalization of films made outside Hollywood is the film category of 'World Cinema' used in many video/DVD rental shops in Britain, a handy label used to cover virtually anything made outside the USA, usually including British films. It is also interesting to note that when (in Britain) we refer to 'foreign films', we usually mean a film that uses a language other than English, ignoring the fact that (in the UK) US films are also 'foreign'. This illustrates the extent to which we have accepted US films and culture as being similar to our own.

There isn't of course anything necessarily wrong with US films being consumed in all corners of the world; indeed, it could be claimed that US hegemony with regard to films is simply the result of Hollywood's production of the types of films that people around the world want to see. The suspicion remains, however, that as long as studio ownership and control of distribution and marketing generally remain with the USA, US films are likely to remain dominant. The implication behind such a scenario is that choice is limited.

Although they question the degree to which cultural domination has taken place, Held *et al.* concede that:

> within the West there has been some degree of homogenisation of mass cultural consumption, particularly among the young, and that it is spreading to the more affluent strata of the developing world, especially in East Asia and Latin America. In popular music, film and television a single product will be consumed in a multiplicity of places. There is also some evidence to suggest that this has, as a consequence, squeezed some domestic alternatives out of the market. The most obvious impact of US domination of, say, the UK film market is that it has become harder for UK film-makers to produce and distribute movies in Britain.
>
> (Held, McGrew, Goldblatt and Perraton, 1999, p. 373)

The Indian film industry has shown remarkable resistance to US cinema, no doubt because of the long and well-established history of film production in India, but the point to note is that Indian cinema remains relatively isolated and Bollywood cannot compete globally with Hollywood.

The subject of globalization has led to fierce debate because of the claim that the imbalance in global communications amounts to cultural imperialism. In effect, the values and beliefs and ways of life represented in US films are, it is argued, gradually eroding the traditional values and beliefs of other cultures. This does not just apply to non-Western cultures but also to Britain where, since the 1950s, it has been claimed by cultural theorists such as Richard Hoggart that there has been a gradual 'Americanization' of society. Thus the replacement of indigenous cultures by what is argued to be predominantly US culture is seen as a form of imperialism in which one culture is controlled by another. The means by which this cultural imperialism is achieved extend beyond cinema and the media to the general exporting of consumer goods from one area of the world to another. A Marxist analysis identifies the relentless drive towards expansion, control of markets and the increased profits central to capitalist social organization as inevitably resulting in inequalities between developed and underdeveloped areas of the world in terms of economic and cultural independence.

However, the argument is perhaps not quite as straightforward as it first seems. We could for instance question the status of traditional culture, as it could be claimed that a people's way of life is always changing in one way or another, is always in a state of transition. Is there then an identifiable culture to be undermined? Annabelle Sreberny-Mohammadi has suggested

> [a] conceptual challenge to the 'cultural imperialism' model, stemming from new modes of analysing media effects which question the 'international hypodermic needle' assumption preferred by the 'hegemonic' model ... diverse audiences bring their own interpretative frameworks and sets of meaning to media texts.
>
> (Sreberny-Mohammadi, quoted in Curran and Gurevitch, 1991, p. 122)

Certainly, different cultures may well interpret films in ways that suit their own values and beliefs (see Chapter 12 on meaning and spectatorship). In other words, US ideology will not necessarily be interpreted as such by another culture; rather, that culture may extract meanings from a film different from those intended by, for instance, an US studio. The marketing departments of the major studios are aware of cultural differences between audiences that may watch Hollywood films. The James Bond films of the 1980s and 1990s used different advertising campaigns depending on which countries they were promoting the films in; this was especially noticeable in the publicity posters used.

None of this of course changes the fact that there is a far greater flow of films out of the United States than into it. Financial support from governments for their indigenous film industries would help redress the balance, but many countries do not have the surplus wealth necessary for such an initiative. But, then, a capitalist analysis emphasizes how competition, market forces and supply and demand ultimately determine what films are consumed, and where.

Exercise 7.3

1 What is the percentage of US films that you have seen over the last six months compared with non-US films?

2 Discuss your responses to US films. Do you think you 'read' such films in the same way as a US spectator would?

CONCLUSION

It would appear that the only certainty about the global media is that a small number of companies will continue to own, control, produce and supply a large range of products and services. Within the top ten companies that are responsible for the bulk of the media's provision there is little stability. Companies are regularly amalgamated or taken over, subsidiaries are frequently bought and sold, and while some conglomerates contract others expand. James Curran sums up the major media corporations thus:

> Their activities now conform to a classic oligopolistic pattern. They compete against each other, sell to each other; and have co-ownership, revenue-sharing, co-production and co-purchasing deals with each other. This enables them to increase profitability through economies of scale and scope, share the cost of risk-taking and above all limit competition.
>
> (Curran, 2002, p. 228)

The general picture is likely to remain this way for the foreseeable future. The film industry will lie at the heart of the global media which in turn will continue to pursue cross-media ownership, integrate their subsidiaries

horizontally and vertically and practise synergy as a method for consolidating their position.

SUMMARY

↪ Cinema as a central part of the international entertainment industry is continuing to expand.

↪ Multinational conglomerates concentrate ownership in fewer and fewer hands, the emphasis being on creating huge multimedia companies that match the various areas of media production to each other in order to strengthen their position.

↪ Synergy and vertical integration are common strategies within these multinational conglomerates.

↪ Film production and media ownership are concentrated in the Western world, especially the United States, and this has been accompanied by a globalization process which has resulted in films and media goods tending to make their way from Western cultures to other cultures around the world.

↪ The tendency towards a one-way cultural transfer has arguably led to cultural imperialism by which Western values and beliefs perhaps undermine and replace indigenous cultures.

REFERENCES

Curran, J. (2002), *Media and Power*, London: Routledge.

Curran, J and Gurevitch, M. (1991), *Mass Media and Society*, London: Edward Arnold.

Held, D., McGrew, A., Goldblatt, D. and Perraton, J. (1999), *Global Transformations*, Cambridge: Polity.

Maltby, R. (2003), *Hollywood Cinema*, 2nd edn, Oxford: Blackwell.

Schatz, T. (1993), 'The New Hollywood', in J. Collins, H. Radner and A. Preacher Collins (eds), *Film Theory Goes to the Movies*, London: Routledge.

FURTHER READING

Bagdikian, B. H. (2004), *The New Media Monopoly*, Boston: Beacon Press.

An investigation of mass media ownership.

Balio, T. (ed.) (1985), *The American Film Industry*, Madison, WI: University of Wisconsin Press.

A useful overview of the conditions of production, distribution and exhibition.

Curran, J., Morley, D. and Walkerdine, V. (eds) (1996), *Cultural Studies and Communications*, London: Arnold.

A wide-ranging book that covers the political economy of the media along with analysis of audiences, films and other media.

Featherstone, M. (ed.) (1990), *Global Culture: Nationalism, Globalisation and Modernity*, London: Sage Publications.

Detailed coverage of issues relating to media ownership and control and the role of multinational conglomerates.

Jowett, G. and Linton, J. (1989), *Movies as Mass Communication*, Thousand Oaks, CA: Sage Publications.

The economics of the film industry, social contexts and cultural effects.

Maltby, R. (1995), *Hollywood Cinema*, Oxford: Blackwell Publishers.

A comprehensive and detailed text covering the industry, the films and the production contexts.

Sreberny-Mohammadi, A., Winseck, D., McKenna, J. and Boyd-Barrett, O. (eds) (1997), *Media in Global Context*, London: Arnold.

A wide-ranging book that deals with key concepts relating to the political economy of the media, cultural contexts and new technologies.

Wasko, J. (1994), *Hollywood in the Information Age*, Cambridge: Polity.

A good introduction to cinema within the contexts of globalization, new technology and communication.

FURTHER VIEWING

Global Culture (BBC, 1992)
> The increasing homogenization of our socio-economic circumstances and lifestyles. BBC Active, BBC Television Centre, Wood Lane, W12 7RJ

Global Media (BBC, 1998)
> Investigation into claims that the media create cultural imperialism. BBC Active, BBC Television Centre, Wood Lane, W12 7RJ

Reflections on a Global Screen (BBC, 1995)
> The roles of film and television in globalization. BBC Active, BBC Television Centre, Wood Lane, W12 7RJ

Part 2

Film as text

Chapter 8

The language of film

There have been at least nine different TV and feature films made about the sinking of the Titanic. These range from a silent version made within months of the disaster (*Saved from the Titanic*, 1912), to the dryly titled *A Night to Remember* (1958), to *S.O.S. Titanic* (1979), to two films imaginatively called *Titanic* (1953 and 1997). The reason for mentioning these films is not to indicate the long history of the disaster movie genre but to highlight the fact that there is more than one way to tell a story in a film. The scripts for each of these films would of course have been very different, but essentially the story was the same: unsinkable ship makes maiden voyage, ship hits iceberg, ship sinks with some passengers escaping.

An understanding of how there can have been several versions of the Titanic story can be gained by studying the 'language of film'. All forms of communication have their own language. This book is communicating using the English language; music can use the written language of musical notation and its own aural 'language'; photography communicates meanings by using a language

that consists of concepts such as composition, framing, camera angle, shot size, lighting, contrasts between black and white, varying tones of colour; a radio programme may use the English language combined with an audio language consisting of practices such as fading volume up and down at appropriate times and mixing dialogue, music and sound effects together at various volume levels depending on what meaning is intended. Whatever the language being used, it consists of codes and conventions. Codes are particular methods for communicating meanings, and conventions are the ways in which those codes are usually used. The English language uses particular words and grammatical structures.

Film has its own 'language'. Various techniques are available to a film-maker and those techniques are used to present a narrative through the medium of film, a narrative being a chain of events that are (usually) causally linked. The language of film is used (usually) to tell stories. A film's form is determined by the ways in which the story is told by the film, and is a combination of style and content. The content is structured by the narrative and style is shaped by the film techniques employed. Chapter 10 covers film technology, which can be regarded as the 'tools of the trade'. Film techniques are the ways in which film technology is used; this chapter aims to identify what the language of film consists of and how film techniques produce meanings.

The film production process can be divided into preproduction, production and postproduction. Preproduction includes scriptwriting – putting into words the types of narratives we have already looked at. This is followed by storyboards which visualize the script's narrative in a series of drawings that indicate the content of each shot. The production stage is when filming takes place, the recording of images and sound. The editing of filmed material places shots in the required order, ideally matching what was planned in the storyboard, and is referred to as postproduction (see Chapter 6 on production, distribution and exhibition). With regard to film techniques, we are interested in the specific practices that take place during production and postproduction. These techniques are covered by four terms: *mise en scène*, cinematography, editing and sound, each of which subsumes a range of subsidiary techniques.

Mise en scène

This term originally developed in relation to theatre and means 'putting on the stage'. For our purposes it refers to 'placing within the shot'. A significant part of the meaning produced by a film comes from the visual content – this is to a large extent how the story is told. What a shot consists of is therefore crucially important. As James Monaco writes, '[b]ecause we read the shot, we are actively involved with it. The codes of *mise en scène* are the tools with which the film-maker alters and modifies our reading of the shot' (2000, p. 179). The elements covered by *mise en scène* are: setting, props, costume, performance, lighting and

colour. But in addition to choosing what is to be included in a shot, someone also has to decide how the elements are to be arranged. In other words, composition is also central to *mise en scène*.

A director needs to make a number of decisions when deciding on shot content and arrangement. It needs to be recognized, however, that although the director is the person ultimately responsible for such matters, film conventions established over time can also play a large part in shaping *mise en scène*. Genre films tend to require particular elements, thus restricting the director's freedom (see Chapters 13 and 14 on authorship and genre). It is also to be noted that while the director is responsible for guiding an actor's performance, a well-known actor may bring to a film qualities that raise expectations in the viewer and produce meanings irrespective of the aims of the director (see Chapter 15 on stars). We also need to be aware that while we may try to determine the meanings produced by a shot, it is very likely that other spectators will interpret differently, especially when viewing from a different cultural perspective. In other words shots can be polysemic; they can have many meanings (see Chapters 11 and 12 on cinema, audiences and society and on meaning and spectatorship).

Setting

The setting provides the space in which all the other elements of *mise en scène* are situated. The setting, like props and costume, sets up expectations for the viewer and can instantly produce meanings; it signifies certain things. This is especially the case with genre films (see Chapter 14 for more detail). A shot of a relatively barren landscape with a small town consisting of wooden buildings including a saloon bar and sheriff's office will immediately indicate a Western. Setting can be provided by filming on location, in a setting that actually exists, or by set design where the location is built for the specific purpose of the film. Typically, films use both studio sets and location filming, but many of the films from the Hollywood studio system era were filmed entirely within the studio. By comparison *Tilaï* (1989) was filmed entirely on location around a small village in Burkina Faso in Africa.

Props

Props are the inanimate objects placed within the setting. They may remain static or may be used by the characters in the film. Props may simply serve to strengthen the effect of the setting by making the environment in which the action takes place visually more convincing. Los Angeles in 2019 as the setting for *Blade Runner* (1982) is made more convincing by the addition of hi-tech equipment, flying craft and futuristic gadgets. Props may also have a more active function. The video camera in *The Blair Witch Project* (1999) and in *Cloverfield* (2008) is a prop that the films rely on, central as it is to their respective narratives.

Costume

Costumes help create an actor's character. They can place an actor within a particular historical period, indicate social class or lifestyle, and even determine what is possible and what is not. A space suit makes survival in space possible. A cowboy wearing a gun can survive a shoot-out. This example indicates that there can be an overlap between props and costume – at what point does the gun cease to be a prop and become part of a costume? As with the previous two categories, costume can also help define the genre of a film.

Performance

What an actor does within a shot obviously contributes significantly to the meanings produced. The way an actor moves could indicate confidence, uncertainty, panic or friendliness. The actor's facial expressions may show fear, anger, happiness or sadness. In addition to these examples of body language or non-verbal communication, and to the clear differences in the speech patterns of different actors, a performance may have a particular effect because of what the actor has previously done in other films. Actors may be identified with certain types of characters, and actors with celebrity status can bring connotations to a film that emanate not only from previous films but also from their lives outside the films (see Chapter 15 on stars). When we see Angelina Jolie in a film, is it possible to ignore her previous roles and what we know of her personal life?

Lighting and colour

Lighting illuminates the above-mentioned elements in a shot while itself also becoming an element within the shot. It has long been suggested that the human eye is drawn towards movement and towards the brightest area in a shot. A memorable shot from *Citizen Kane* (1941) illustrates the importance of movement and light. In the first flashback to Kane's early life, we see his mother and Thatcher in the foreground discussing his future. In the distant background we see Kane playing with his sledge. Despite the close proximity and important dialogue of Mrs Kane and Thatcher, we can't help but notice Kane in the distance because of the character's movement and because he is framed by a window against a bright backdrop.

Lighting is usually thought of in terms of high key (balanced) lighting and low key (chiaroscuro) lighting. High key lighting is usually used when a relatively normal, everyday scenario is being filmed – we generally attempt to illuminate the situations we typically find ourselves in. Illumination exposes detail and provides visual information. However, in many films, suspense and fear of the unknown are required, possibly within us as well as the characters. This is often achieved by providing a lack of visual information and by hiding detail; this can be obtained through low key lighting, lighting from one source

so as to create shadows and strong contrasts. *The Blair Witch Project* (1999) provides an extreme example of the use of low key lighting as a method for creating fear. During the night-time scenes the only source of light is a torch or video camera light in the darkness surrounding the characters. Only being able to see a small part of the forest emphasizes how little the characters can see.

When high key lighting is desired in a film, lighting from at least two sources is used. In reality at least three lights are usually employed (Fig. 8.1): a key light as the main source, a fill light to remove shadows, and a back light to highlight the edges of the figure. A fourth light, a background light, may also be used to create a sense of depth between the main subject and the background. The key light is usually placed at approximately eye level; however, it can be placed above the actor as top lighting or below the actor as under lighting. Top lighting tends to enhance the actor's features whereas under lighting distorts the features.

Colour has long been thought to affect mood; for instance, light green is believed to be a relaxing colour; red is a 'restless' colour. But as well as having a psychological effect, colours can also symbolize emotions and values, thus producing meanings in a text. White and black have respectively been used to represent good and evil, red can symbolize passion, romance and anger. Blue can symbolize detachment, alienation, a lack of emotion: futuristic, dystopian films such as *Blade Runner* (1982) and *RoboCop* (1987) use blue light to a significant degree.

Composition

Having selected all the above elements for inclusion in a shot, the director then has to place them as required. The arrangement of elements within a shot is known as

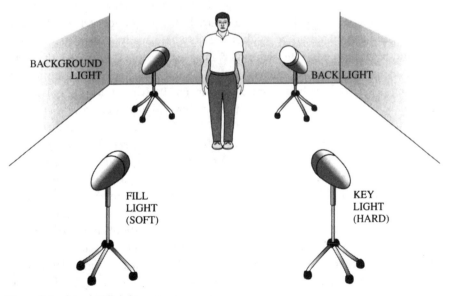

Figure 8.1 A typical lighting set-up

composition. Symmetrical composition places elements of a similar shape and size in similar positions on either side of the shot. Asymmetrical composition achieves an overall balance by having each side of the shot generally equate with the other in terms of areas of visual significance. A balanced composition is usually regarded as visually pleasing as opposed to unbalanced composition, which may make us feel uneasy or uncomfortable. Unbalanced composition can, however, be a useful creative device.

A fascinating shot for analysing *mise en scène* comes from *Psycho* (1960) during the scene when Marion and Norman converse in his room. The setting is a small room cluttered with props such as a table, chairs, pictures, ornaments, candlesticks, a chest of drawers, curtains and a table lamp, all of which are typical everyday items; yet combined with the setting they create a somewhat claustrophobic atmosphere. The props that stand out as unusual are several stuffed birds. The lighting is slightly low key but the only strong shadows are cast by the stuffed birds illuminated by under lighting. Interestingly, Hitchcock chose to film *Psycho* in black and white even though colour film had been available for twenty-five years.

Norman's costume does not appear to be of particular significance, but his performance is full of meaning. The mid-shot of just Norman concentrates our attention upon his performance. It is a low angle shot which gives us an unusual view of Norman, distorting his appearance. He is talking animatedly, using his hands, and has an intense, obsessed look on his face. Norman does not appear normal. Our doubts about his sanity are enhanced by the predatory birds on the wall, which indicate his obsession with taxidermy and symbolize his potential for preying on Marion. The composition of the shot is also unsettling in that while Norman is looking left towards Marion, his face is placed on the left-hand side of the screen. This is unbalanced composition because there is nothing on the right-hand side of the shot to balance out the left. It also introduces tension because Norman has no 'looking space' within the shot. Normally a character looking left would be positioned to the right to create space for him/her to look through. When Norman is placed up against the left side of the shot we have no idea if something is placed directly in front of him or not. It creates uncertainty because we are visually uninformed. All in all this shot shows highly effective *mise en scène*.

The still from *Some Like it Hot* (Fig. 8.2) contains a wealth of information that we identify through a reading of the shot's *mise en scène*. Marilyn Monroe, as Sugar, is talking to Tony Curtis (Joe) on the beach. Joe is wearing a ship's captain's uniform and sits formally in a sheltered chair, separating himself somewhat from the informally dressed occupants of the beach. He has an appearance of authority and status, albeit not a very convincing one. Sugar is sitting in close proximity to Joe and gazes up at him with a look of admiration and interest; Joe avoids her gaze and seems to be trying hard not to show any interest in her. The brightly lit beach carries connotations of leisure, pleasure and playfulness, as epitomized by Sugar, while Joe's appearance and his position above Sugar emphasize his comical attempt at cool detachment and composure.

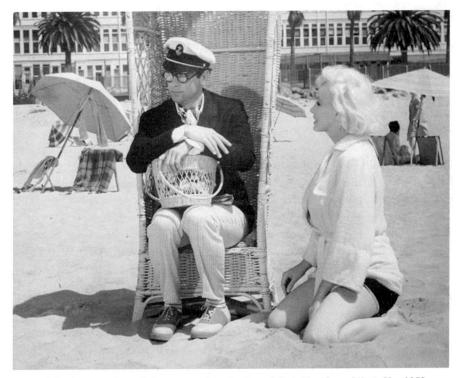

2

Figure 8.2 *Mise en scène* and shot composition in *Some Like it Hot* (*Some Like it Hot*, 1959, actors Tony Curtis and Marilyn Monroe, dir Billy Wilder/© United Artist/BFI Stills collection)

Exercise 8.1

Choose a scene from a film that has made a visual impact on you and that you remember clearly. Describe the ways in which the *mise en scène* contributes to the narrative's progression and development of character.

Cinematography

If *mise en scène* refers to what is placed in front of the camera, then cinematography is concerned with recording the elements within the shot. While photography is the recording of a static image, cinematography is the recording of a moving image. In order to obtain the desired images, the cinematographer must attend to two areas: control of lighting and operation of the camera. The images consist of reflected light and the camera records light. Indeed, in Britain a cinematographer (the person responsible for lighting and camerawork) is sometimes known as the lighting cameraperson or as the director of photography.

Framing

A key ingredient of cinematography is framing. This refers to the edges of a shot, in that framing determines both what is included and what is excluded. There is indeed a close link between framing, composition and *mise en scène*. *Mise en scène* refers to what is to be filmed and how it is arranged and therefore in effect defines what the framing will be; however, strictly speaking, the framing is only realized when the shot is filmed through the camera lens.

To refer back to the Norman and Marion conversation scene from *Psycho*, Hitchcock could have chosen to widen the framing so that we could see both Marion and Norman. However, this would have entailed including more height in the shot, which would perhaps have meant meaningless space and detail. The tighter framing chosen by Hitchcock means we get a mid-shot of Norman's actions and reactions in his conversation with Marion. Hitchcock nevertheless briefly gives us a long shot of both Marion and Norman at the beginning and end of the scene to provide us with a sense of the spatial relationship between them.

Shot size

Shot size in turn is determined by the framing. There are many possible choices of shot but we can think in terms of five basic shot sizes (see Fig. 8.3) with intermediate shots in between (medium long shot and medium close up). Shot sizes can be closely tied to narrative development, notably to the progression of scenes. Typically a film, and often a scene, will begin with an extreme long shot (ELS). Just as narratives tend to begin slowly in order to acquaint us with characters and locations, so films visually use an ELS (sometimes called an

EXTREME LONG SHOT
(ELS)

LONG SHOT
(LS)

MID SHOT
(MS)

CLOSE UP
(CU)

EXTREME CLOSE UP
(ECU)

Figure 8.3 The five main shot sizes

establishing shot) to place things in context. An ELS allows us to see a subject in relation to her/his surroundings. *Blade Runner* begins with several ELSs which gradually introduce us to Los Angeles in the twenty-first century, followed by the introduction of themes and characters.

A film can on the other hand begin with an extreme close up (ECU); this could be used to make us inquisitive, or it may simply be an impressive shot because of its content, but more often than not it won't make much sense. *The Good, the Bad and the Ugly* (1967) famously begins with an ELS which is immediately transformed into an ECU as a character walks into shot and looks straight to camera. The shot is interesting and intriguing while also being disconcerting; however, it makes no obvious sense in the context of the film. It does not enable us to get to know the character in greater depth, which would arguably be a pointless exercise anyway as he dies a couple of minutes later. The choice of shot seems to be more to do with style and experimentation than with illustrating the narrative. Furthermore, having a character look straight to camera is usually identified as a technique of alternative cinema (see p. 210 below).

A first close up is usually found when we are already accustomed to characters and locations. Typically a CU will concentrate our attention on an important detail to ensure that the desired meaning is communicated, or else a CU will be used as a reaction shot to show someone's response to an incident. It is common to find a CU of someone's face when their expression tells us something or a CU on an object that is to have a crucial function in the film. *Scream* in fact begins with a potentially confusing shot, a CU of a telephone; however, we do hear a phone ringing and we don't have to wait long for it to take on relevance. The camera tracks back to show Casey picking up the phone. These introductory shots are also soon followed by an exterior ELS (albeit a threatening one) of Casey's home to provide us with context.

Shot duration

If shot sizes tend to be large at the beginnings of films and scenes, an equivalent characteristic can be noted for shot duration. The average duration of a shot is approximately five seconds, usually less in mainstream US films, but introductory shots are often at least twice this length. Again, the pace tends to be slower in order to allow the viewer more time to become acquainted with characters and locations. If we look at two minutes from near the beginning of *Cinema Paradiso* (1989) we find only five shots. Within this time we are introduced to the main character Salvatore and his wife, who informs him that an old friend, Alfredo, has died. This leads into a flashback to his youth which goes on to provide his childhood memories, which constitute the bulk of the film. If we then look at a two-minute period from the climactic section of the film, when Salvatore saves Alfredo from a fire in the village cinema, we find fifty-two shots. The narrative allows for short shot durations because we know the location and characters well,

and the narrative also requires short shot durations because the scene involves action and panic. Imagine the effect if we reversed the shot durations: fifty two shots in two minutes to introduce characters and only five shots to cover two minutes of fast-moving action.

There can be other reasons for long shot durations in a film. Orson Welles famously, and Jean-Luc Godard infamously, have used long shot durations. In Godard's *Weekend* (1968) one shot lasts eight minutes and gradually reveals to us a long line of cars in a traffic jam. As well as also helping to ensure that the film is 'alternative', which was no doubt part of the director's intention, the shot also helps make one of Godard's points about cultural life and consumerism in 1960s France – the point being that while the trend of going away for the weekend grew, it increasingly resulted in people spending the weekend in traffic jams.

Welles began *Touch of Evil* (1953) with a shot that lasts over three minutes. It begins with a close up of a bomb being planted in a car. The camera then rises to give us a bird's eye view of the situation, including the car driving off. The camera cranes over a building and tracks to catch up with the car, then drops down to enable us to hear a banal conversation between a border guard, a woman and a man. This technique builds suspense as we are expecting an explosion, which soon follows and brings the shot to a close. Being the exception to the rule begs the question: why use a shot of long duration instead of editing together several shots covering the same action? It could be argued that in this instance we are given an overview of what is happening in adjacent locations simultaneously as a way of providing us with the bigger picture. However, if this is the intention, then why is the technique not used more frequently? Certainly Welles' shot has been remembered. Robert Altman's *The Player* (1992) begins with an eight minute tracking shot which was a homage to Welles.

Alternatively it could be argued that such a shot was motivated more by style than by the requirements of the narrative, which is not necessarily undesirable. For now it is sufficient to note that it is a technically impressive shot with incredibly complex timing, which has certainly gained a place within the study of film. As Richard Maltby notes:

> [v]isual style is not usually so conspicuous an element in a movie's performance. In *Touch of Evil* we notice the emphasis on the camera as an active agent in the manipulation of the audience precisely because we are used to the more anonymous and self-effacing strategies associated with Hollywood camerawork. Long takes or extravagant camera gestures stress the existence of an instrumental, manipulative presence.
>
> (Maltby, 2003, p. 377)

Having suggested that the shot at the beginning of *Touch of Evil* may be more to do with style than with content, it would be wrong to assume that this is always the case. *Tilaï* regularly uses shots throughout the film of almost a minute's duration. However, the duration of shots is not particularly noticeable because

they seem to suit the narrative. The film is set in a small, rural community in Africa. The pace of life is slow and the story is not action-driven. The cause-effect processes within the film develop gradually. The narrative requires long takes. What is also noticeable is the lack of camera movement in many of these shots. The camera allows the narrative to unfold in front of it without trying to add meaning through movement. A further reason for these shots of long duration, which often tend to be long shots too, is the location of the film. The village is surrounded by wide-open spaces; there is little to interrupt the vast horizons. Director Idrissa Ouedraogo allows events to unravel against this backdrop of uninterrupted space with a minimum of interference, whereas within the more enclosed confines of most film locations, there is a need to switch to different camera angles and shot sizes, if only to cover all the action.

Hitchcock took shot duration one stage further in *Rope* (1948). A reel of film lasted no longer than ten minutes and Hitchcock filmed so that each reel was one complete shot. What is more, he ended and began several of the reels with someone or something passing close to the camera lens so that the screen went dark. At these points the reels were edited together, resulting in invisible transitions, so that the whole film appears to be five long continuous shots lasting between fifteen and twenty minutes each. The camera continually tracks around the apartment in which the story takes place, following characters and actions to give a variety of perspectives.

Camera movement

As has already been mentioned in the above example, long takes usually involve camera movement of some sort, as it would be difficult to justify a long take in which the camera was static unless the action within the frame was sufficiently interesting to be able to hold our attention (one of the characteristics of early films was long takes with static cameras; see Chapter 1 on early cinema). There are four main types of camera movement: in a pan shot the camera rotates horizontally around a fixed position (often used to follow movement); a tilt shot moves the camera vertically around a fixed position (typically used to indicate height); a tracking shot involves a horizontal movement of the camera in which it changes location, usually fitted to a device called a dolly that runs on rails; a crane shot enables the camera to be raised and lowered and moved horizontally. In addition to the above, it is also possible to use a hand-held camera or to utilize the zoom facility, which strictly speaking is not a camera movement but movement within the camera – repositioning the lens in relation to the aperture.

The problem with hand-held camerawork is that the shots can be unsteady, but the use of steadicam equipment can overcome this problem and provide smooth moving shots (see Chapter 10 on film technology). However, films like *The Blair Witch Project*, *Cloverfield* (2008) and those of Dogme 95 achieve their impact partly through unsteady hand-held camerawork. The viewer is linked more directly to the

person filming, first because we usually see exactly what s/he sees via the camera but also because we are reminded of their presence through the shaky camerawork.

Crane shot

In his documentary, *A Personal Journey with Martin Scorsese through American Cinema*, Scorsese suggests that one of the greatest shots of all time is a crane shot lasting more than a minute, used by Hitchcock in *Young and Innocent* (1937). In this film a murder has been committed and those investigating believe the culprit is in a ballroom; the only clue they have is that the murderer has a facial twitch. Hitchcock gives the viewer information the investigators don't have with a crane shot that begins with an ELS of the ballroom, then moves over the heads of the dancers towards the band on the stage, ending with an ECU of the drummer's face, which begins to twitch.

Tracking shot

The penultimate shot from *Psycho* (see Fig. 8.4) contains a good example of a tracking shot, combined with unusual framing. Norman Bates has been caught

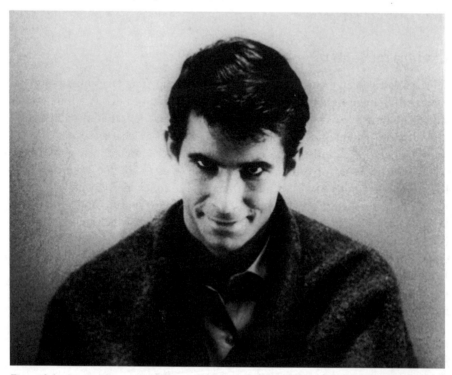

Figure 8.4 *Psycho*: the unbalanced Norman Bates (*Psycho*, 1960, actor Anthony Perkins, dir Alfred Hitchcock/© Paramount/The Kobal Collection)

and is being held in a cell. We see a long shot of Norman, but the framing produces an awkward composition in which he is placed to the left of the shot and his lower legs are out of the frame. It is an uncomfortable shot visually. The long shot emphasizes Norman's isolation in a bare, white room. The camera gradually tracks in to a close up of Norman's face in the centre of the screen, at which point he slowly looks up from under his eyebrows with an evil grin. At the beginning of the shot we feel safely distanced from Norman, but by the end of the tracking shot we are close to him and feel threatened.

2

Zoom and tracking shots

It will immediately be realized that a tracking shot is one way of bringing a subject closer by physically moving the camera nearer. However, another technique which produces a similar effect is that of a zoom, the main difference being that the camera does not physically move closer but the lens alters its focal length. But while both techniques bring the subject closer, they differ in how they deal with perspective concerning the relationship between what is in the middle of the shot and what is at the edges of the frame.

Hitchcock experimented creatively with this difference in *Vertigo* (1958). When Scottie, who suffers from vertigo, is running up the tower in the final scene, he twice looks down the centre of the stairwell. The film cuts to his point of view and brilliantly imitates the experience of light-headedness and nausea through fear of heights by distorting the perspective between the edge of the frame and the centre of the shot. Hitchcock achieved this through a track-in/zoom-out. As the camera zooms back from the bottom of the stairwell, it also tracks in to ensure that the edges of the frame stay exactly the same. The effect is to have the centre of the shot stretching away from the edges of the shot. Scorsese used the technique in reverse, a zoom-in/track-out, in *Goodfellas* (1990). Towards the end of the film Jimmy and Henry meet in a café to assess their situations after most of their mob have been killed, arrested or betrayed. They don't know who they can trust, not even each other. Their growing paranoia is symbolized as we see the world outside of the café visually closing in on them whilst the framing of their immediate world inside the café remains the same. A similar technique has since been used by Mathieu Kassovitz (*La Haine*, 1995) among others.

Camera angle

Camera angle provides another means of producing different meanings. Normally the camera angle is horizontal and at eye level: we usually communicate with each other at something approximating eye level and subconsciously expect to relate to the characters in films in the same way. However, high and low camera angles can be used too. A high camera angle can be useful for providing a general overview of a situation. A low camera angle may be required because

of the position of a character in relation to something else. High and low camera angles can also be used to represent a power relationship between characters in a film or to emphasize the subordinate or dominant nature of a character to the audience. An example of this technique is found in *Citizen Kane* when Kane is arguing with Susan. As Kane is talking, a low angle is used; he towers over Susan and over us. When Susan is talking, a high angle is used; we look down on her. Kane's power is symbolized further in this scene when his shadow gradually eclipses Susan. However, the meanings behind high and low camera angles remain linked to the narrative context.

An angled shot can also provide a distorted view. In *Psycho*, during Norman's conversation with Marion Crane, at one point a low angle shot is used of Norman which has the effect of exaggerating his 'strangeness'. We already suspect he is odd from the things he says and from his obsessive, unpredictable behaviour. At another point in the conversation Marion stands up and a high angle shot of Norman is used. This has the effect of reducing him to looking like a small child where before he was threatening, thus emphasizing his split personality.

Depth of field

One last aspect of cinematography remains, this being depth of field. Depending on shutter speed, aperture and the amount of light available, a camera can focus on just a small part of what is in the frame or on the whole scene. Focusing on only part of a frame is known as shallow focus and is often used as a device for encouraging the audience to concentrate on a particular part of the scene. Conversely, seeing everything in focus, from foreground to background, is known as deep field photography or deep focus.

This technique has probably never been shown more clearly than in the scene referred to earlier (p. 166) from *Citizen Kane* when Kane as a small boy is seen playing in the snow in the background while his mother and Thatcher talk in the foreground. The shot begins as an exterior shot of Kane. The camera then moves back through a window and past Kane's mother and Thatcher and continues to track back through a doorway, at which point Mrs Kane and Thatcher move to sit in front of the camera (Fig. 8.5). The shot was arranged and filmed by cinematographer Gregg Toland so as to be in focus from foreground to background. It is difficult not to suspect that the shot was contrived to illustrate deep focus; as with other techniques in *Citizen Kane*, such as use of low key lighting and extreme camera angles, the deep focus here is hardly subtle and can leave the viewer remembering the style of the film rather than its narrative. This is a criticism Robert McKee makes of Welles, claiming that *Citizen Kane* is all style and no content; in effect, style is the film's content, our eye stops at the screen and does not get through to the narrative. For McKee style should provide access to the narrative and strengthen it.

Figure 8.5 Citizen Kane and deep focus: Kane's parents decide his future as he plays in the background (*Citizen Kane*, 1940, Harry Shannon, Agnes Moorhead, Buddy Swan, George Colouris. © RKO Pictures)

> Exercise 8.2
>
> Compare and contrast the camerawork in the opening scenes and climactic scenes of an action/adventure film.

////////////
Editing

After the completion of filming, the final stage is editing, the selection and piecing together of shots to form the completed film. Just as a range of choices exists for the cinematographer when manipulating light and using a camera, so editing offers many possibilities.

Continuity editing

One of the key principles is continuity editing. Most films, in one way or another, attempt to have us fully engrossed in what we see. The intention is that we escape into the film for the duration of the screening. The concept of 'willing suspension of disbelief' sums up the experience of much film-going. We know that what we see on the screen isn't real, in other words, we disbelieve it, but in order

to fully engage with the film we willingly suspend that disbelief – we happily ignore our doubts about the authenticity of what we see. We allow ourselves to enter the world (the diegesis) of the film.

In order that we can experience films in this way, it is important that we are not reminded that we are watching a film and that we are not confused by an incomprehensible presentation of events in the narrative. Annette Kuhn writes: 'Continuity editing establishes spatial and temporal relationships between shots in such a way as to permit the spectator to "read" a film without any conscious effort, precisely because the editing is "invisible"' (in Cook, 2007, p. 46). For this to be possible, it is essential that the shots flow smoothly from one to another and that our attention is not drawn to the edit points. In effect, the shots support each other. One shot logically leads to the next and to a degree we expect the next shot: there is a continuity between one shot and the next. A number of techniques help make this possible.

Movement and speed of editing

To ensure such 'transparent' editing, it is necessary that the locations, props, costumes, actors and movement in one shot are consistent with what has gone before. The speed at which something happens and the space within which it occurs should be consistent across the relevant shots. In effect, continuity editing supports the meanings produced by the audio/visual interpretations of the narrative.

This principle can be illustrated by reference to a scene mentioned previously, the climactic moment in *Cinema Paradiso* when Salvatore rescues Alfredo from the fire that has started in the cinema projection room. The pace of editing is fast, people are panicking, events move with speed. Within this scene there is a consistency with regard to time and movement and similarly there is a consistency in the locations and space within which the events unravel. Failure to maintain this consistency would interrupt our involvement in the film and draw attention to the artificial and constructed nature of film.

Shot size and editing

The above scene from *Cinema Paradiso* also serves to illustrate another common principle behind editing, the use of a variety of shot sizes. On one level a variety of shot sizes helps maintain our interest visually through avoiding repetition, but it also serves another function. We have already noted the various meanings that shot sizes can produce, and through editing a logical progression is created out of shot size. In the scene from the above example we are provided with an extreme long shot of the village and cinema to provide context. The shots are then edited together to eventually take us onto a more personal level as we see Salvatore in extreme close up battling his way through the crowds to Alfredo.

Shot/reverse shot editing

Editing also helps to clarify situations by joining together shots from different angles to provide us with different perspectives, thereby creating a fuller understanding. This is common during conversations where a shot/reverse shot edit is frequently used. The shots themselves are often 'over the shoulder shots' in which we see part of the back of one person's head and shoulders and the front of the other person talking to her/him. The editing provides an understanding of the spatial relationship between the characters while also giving information on movement and facial expression.

Eye-line match

Conversations, and for that matter any interaction between characters, will usually also require an eye-line match in order to maintain continuity between edits. If character A is in a chair looking up at character B who is standing, when we cut to a close up of character A s/he should still be looking up, even if character B is out of shot – and vice versa for a close up of character B. In other words, the direction of a character's gaze needs to be matched to the position of the object s/he is looking at.

Match on action

Another form of edit that provides additional information about an event is a match on action. Here the edit brings together two shots from different angles or shot sizes of the same action being completed. Again, this gives us a slightly different perspective on an action and can often provide us with more detail through the use of a close up. We see a hand raise a gun – next we see an extreme close up of a finger pulling the trigger.

Cutaway shots

A cutaway shot may be edited into a scene. This type of shot is not directly related to the action taking place but it has an indirect link. We may see two people having a conversation in an apartment and, while we still hear their dialogue, for several seconds we may see a shot of the exterior of the apartment before returning to the conversation. The shot cuts away from the action but still retains some connection to the scene.

Cross-cutting

Cross-cutting is an invaluable editing technique and is commonly used for building suspense. It consists of editing together shots of events in different locations which are expected eventually to coincide with each other. We shall look in Chapter 9

at the way omniscient narration can build suspense by providing an overview of different areas of action, and cross-cutting is the realization of such a narrative approach. At the end of *Lock, Stock and Two Smoking Barrels* (1998) we are aware that Tom is desperately trying to get rid of two shotguns which he believes are incriminating evidence. However, we then cut to a pub where his associates have just learned that the guns are worth a fortune. Suspense is built through editing between Tom trying to dump the guns into the Thames and his associates desperately trying to phone him to stop him getting rid of the guns. In one respect, cross-cutting breaks the film's continuity by suddenly jumping to another scene; however, the close linking together of the two scenes ensures coherence.

The 180 degree rule

There are a couple of important 'rules' associated with editing. The 180 degree rule specifies that the camera should not have 'crossed the line' of action when two shots are edited together. This is particularly important during a scene where two characters are interacting with each other in some way. We will have subconsciously noted that one character is on one side of the screen while the other is on the opposite side. The line of action is an imaginary line passing through the two characters. If the camera were to be placed on the other side of the action in the next shot, then the position of the characters would be reversed (see Fig. 8.6). It could take the viewer a second or two to realize what had happened and this might interrupt involvement in the film. In reality audiences are fairly adept at quickly ascertaining what has happened in such an

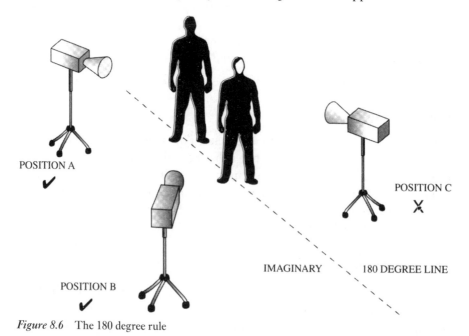

POSITION A

POSITION B

POSITION C

IMAGINARY 180 DEGREE LINE

Figure 8.6 The 180 degree rule

edit; indeed, it is increasingly common to see the line crossed. In the café scene when Jimmy and Henry meet towards the end of *Goodfellas* (1990), the camera crosses the line but our involvement is not dramatically disrupted. The two ways of safely crossing the line are to either track across the line in one continuous shot or have an intermediate shot on the line in between the two shots. Although 'crossing the line' becomes an issue when editing, it is at the storyboarding stage when shots are planned that the problem should be avoided.

The 30 degree rule

The 30 degree rule (Fig. 8.7) specifies that if two shots of the same location or action are edited together, then either the camera should move position by at least 30 degrees or the shot size should radically change. If this does not happen then the effect is a jump cut when the two shots are edited together. The elements within the shot appear to jump slightly, producing a disconcerting effect on the viewer.

Alternatives to cutting

Other techniques can be used at the editing stage to create a seamless unity for the film, whose narrative will usually contain many scenes within the overall story. If scenes were edited straight up against each other, then the transition from one to another could be confusing. The usual convention is to use a fade to black and a fade from black to end and begin a scene. Fades are introduced during the editing stage. Dissolves, wipes and shifts in and out of focus are often

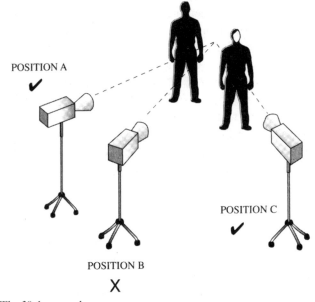

Figure 8.7 The 30 degree rule

used too: one shot gradually gives way to another to indicate a transition, sometimes from one scene to another, but more often than not this is used to indicate the passing of time.

Discontinuity editing

If most editing can be described as continuity editing, then it is equally true that a minority of films use discontinuity editing. As the name implies, there is no smooth flow to the shots that are edited together; there is a disruption between one shot and the next. However, discontinuity editing can be used to good effect. If continuity editing principally supports the meanings residing within the shots that represent the narrative, then discontinuity editing can be regarded as producing meanings from the ways in which the shots are linked together. The shots are not necessarily unified; rather, meaning comes from the way in which the shots interact.

Montage

The best known example of discontinuity editing is montage, which was much used by Eisenstein, most famously in *Battleship Potemkin* (1925) in the Odessa Steps sequence (see also Chapter 4). Here the shots that are edited together do not flow smoothly; instead they clash: they conflict with each other. The sequence switches, in a spatially disorientating way, between views of the Tsar's advancing troops and views of the fleeing citizens. The troops are armed, menacing and inhuman; the citizens are unarmed, vulnerable and all too human. The juxtaposition of meanings between the shots results in new meanings, produced by the viewer on seeing the montage of shots that are pieced together.

It is also possible for the pace of editing to create a rhythm which itself produces meaning. In the shower scene in *Psycho* there is no logical progression to the way in which the stabbing of Marion is visually presented; it is a montage of shots. The shots are short and are filmed from a variety of angles – a rhythm is set up by the editing which emphasizes the frenetic rhythm of the stabbings. The knife comes from different directions and these shots are intercut with short shots of Marion struggling. The effect of the sequence is to create a feeling of confusion, madness, panic. No doubt precisely what Hitchcock wanted.

Graphic match

Another editing technique that can break continuity is that of linking shots containing similar visual content. The shower scene in *Psycho* ends with a graphic match when the camera zooms in to a close up on water swirling down the circular drain in the shower and then dissolves to a revolving close up of Marion Crane's eye. Shot size, movement, shapes and composition are matched.

Symbolic insert edit

As the name implies, this term describes a shot which is edited in between other shots and which indirectly represents something else. Godard used this device in *Weekend*. Rather than show the murder of Corrine's mother, Godard inserts a shot of a dead rabbit covered in blood. The edit breaks the film's continuity as it makes no obvious sense in the context of the accompanying shots – it comes from outside the world of the film. However, throughout the film the editing frequently lacks continuity, and time and space often lack coherence from scene to scene.

Freeze frame

One final technique remains to be mentioned that is achieved at the editing stage. The freeze frame for obvious reasons creates a discontinuity – the moving image suddenly comes to a standstill. It is not a common technique but can be a useful device. In Truffaut's *Jules et Jim* (1962), at one point Catherine is pretending to pose like a model. Truffaut momentarily freeze frames the shots of her poses to create the impression of a photograph. At the beginning of *Trainspotting* (1996) several freeze frames of the characters are used, with a voice over providing information about the characters. A freeze frame can usefully give us time to analyse an image. Finally, and less problematically, since Truffaut's own *The 400 Blows* (*Les 400 coups*, 1959), a freeze frame can often be used to signal the end of a film.

Exercise 8.3

Analyse the editing in the first scene and climactic scene of a horror film, and identify the similarities and differences in technique.

//////////

Sound

Sound is of vital importance at both the filming and editing stages. Film is both a visual and an aural medium. The most important sound within a film is likely to be the dialogue, plus any accompanying sounds such as those caused by movement of characters or objects. These sounds will give us a lot of information, helping us to follow the story and complementing the images we see on the screen. However, it is likely that other sounds will be added to the film to further emphasize the meanings it is hoped the film will communicate.

Diegetic and non-diegetic sound

Sound originating from the world within the film is known as 'diegetic'. Typically this consists of dialogue and sounds emanating from action within the shot, including background or ambient noise. Non-diegetic sound has a source

outside the film's narrative. Most obviously this includes incidental music but it also refers to voice overs. Non-diegetic sound is added at the editing stage and can hold great importance for the edited images. However, diegetic sound may also be modified or added during editing, for instance, the sound of a car crash. Two films whose narratives revolve around suspected manipulation of sound are *The Conversation* (Coppola, 1974) and *Blow Out* (De Palma, 1981).

Sound can also be used to help hold together edited shots, which are rarely continuous; they often hide an ellipsis, a period of time which is omitted from the film. It is, for instance, unlikely that a film would cover in real time someone leaving a house to get into a car. Parts of this action would be excluded, and continuous sound can help provide a smooth join between the discontinuous shots.

Sound effects

The use of sound effects is common in films; such effects usually function as diegetic sound in that they appear to originate from elements within the film, even though such sound is often added during postproduction. Sounds can be regarded as signs that produce meanings, just as visual elements are signs. The sound of a creaking door or the gradual approach of footsteps can create suspense and fear of the unknown just as can low key lighting. We wonder what is opening the door and fear its entry into the space of the film. We wonder whose footsteps we hear and what their arrival will bring.

Ambient sound

Ambient sound is also recorded at the end of filming in a location (referred to as 'atmos', i.e. atmosphere): it is what is heard when there is no dialogue or move-ment. This background sound, known as a 'buzz track' or 'wild sound', can be added at the editing stage if it is judged that there is too much silence or if there is a sound discontinuity that needs to be smoothed over. A lack of sound can be just as noticeable as the presence of sound, and it is rare that we experience complete silence in a film. Just as the speed of editing in films has increased over time, resulting in shorter takes and thus more shots, so too the amount of sound experi-enced in films has also increased, and audio content has increased in complexity.

Music

A soundtrack is usually essential for a film; it creates mood and strengthens meaning. A classic example of incidental music supplementing visual content while also creating meaning is the series of short, sharp, high-pitched screeching sounds produced by violins in *Psycho*. It is not an easy sound to listen to. It is of high volume and high frequency, and is discordant: it puts us on edge and makes us feel uncomfortable. When the film begins with this sound, accompanying the title sequence of light and dark lines slicing the screen horizontally, expectations

are immediately set up. Famously the music returns during the shower scene when Marion Crane is repeatedly stabbed. The music itself is sharp and stabbing and provides at least as much meaning as the shots it accompanies. To grasp the importance of music, one may try imagining the *Psycho* music being replaced with the theme tune from *Star Wars*. What effect would it have upon the visual content? It would seem inappropriate and would undermine the importance of what we see on the screen.

The soundtrack for *Trainspotting* is atypical. A film's music is usually not noticed; it is incidental, and supports the narrative by reinforcing the intended meaning. We are often not conscious of its presence. *Trainspotting* places the music up front alongside the visual content. The soundtrack consists of popular contemporary tracks from the mid-1990s and is no doubt as much to do with targeting an audience as with supporting the narrative. Not all music in *Trainspotting* is non-diegetic, however. There are a couple of scenes set in clubs and the accompanying music is diegetic because it originates from the club locations.

However, not all films have an accompanying music soundtrack. *The Blair Witch Project* contains no music to supplement its narrative and for good reason. The film is supposed to be documentary footage, roughly edited together having been found several years later, which records 'real' events. The addition of music, even if appropriate to the building of suspense, would have ruined the basis of the narrative, that the events witnessed really happened. We become so accustomed to the lack of non-diegetic music that the addition of abstract sounds during the end credits may seem odd.

Voice overs

Voice overs are added at the postproduction stage and are typically used to anchor the meanings in a film and give guidance to the audience. *Trainspotting* and *Lock, Stock and Two Smoking Barrels* both use voice overs at the beginning, the former to set the scene and raise issues for the film to deal with, the latter to introduce characters and indicate their possible roles in the film. Films such as *Blade Runner* and *Double Indemnity* (1944) use voice overs throughout as a way of supplementing what we learn from the images and dialogue while also providing insights into the main characters.

Parallel and contrapuntal sound

Usually the sound we hear in a film directly accompanies what we see on the screen; it is appropriate sound, it is the sound we expect. The music in *Trainspotting* matches what we see in the film and seems relevant to the characters, their lifestyles, and the pace of the film. In other words, the music works in parallel with the visual content of the film. However, this is not always the case. In both *A Clockwork Orange* (1971) and *Goodfellas*, horrific acts of violence are accompanied by bright, happy, energetic music rather than the sinister, threatening

incidental music we may expect. This is an example of contrapuntal sound. The sound works against what we see on the screen. In these particular cases the effect is to emphasize the characters' casual, sometimes gleeful attitude to violence while also shocking the viewer.

Sound bridges

The editing of a film normally ensures that sounds coincide with the shots they relate to. However, postproduction audio mixing can place a sound earlier or later than the image to which it relates. This device is used fairly often for linking two scenes together. We may be watching the end of one scene when we hear dialogue from the scene which we cut to a moment later. Similarly, we may cut to a shot from the next scene while still hearing dialogue from the preceding scene. In both cases we are prepared for the scene to follow. This technique, often used as a variation on the convention of a fade to indicate the ending or beginning of a scene, is known as a sound bridge. It can help smooth over the edit point between two shots.

Formalism and realism

Two perspectives that are closely linked to the topic of film form are formalism and realism. Each has a particular view of what film should be for and how it can achieve its purpose. Formalism began to take on coherence in the 1920s in the Soviet Union, and its two key theorists were Sergei Eisenstein and Rudolf Arnheim. The theorization behind realism gained strength during the 1930s and its later proponents included André Bazin and Siegfried Kracauer. Although the debate between these perspectives may not have really taken off until the 1930s, there has always been a division in the ways in which the medium has been used. Between 1895 and 1901 the films of the Lumière brothers aimed to record scenes from everyday life, while Méliès used film as an expressive medium that centred on the importance of *mise en scène* in the construction of fantasy.

Formalism emphasizes film's potential as an expressive medium. The available film techniques are of central importance – use of camera, lighting, editing. For the formalists, film should not merely record and imitate what is before the camera, but should produce its own meanings. Primary importance is attached to the filmic process, and it is suggested that film can never fully record reality anyway, if only because it is two-dimensional compared to reality's three dimensions.

We have already looked at examples which can be described as formalist in the work of Eisenstein and Hitchcock. The Odessa Steps sequence from *Battleship Potemkin* consists of montage editing. Eisenstein was not content to merely show us what happened on the Odessa Steps; instead he expressed the meaning of the events through the choice of shot content and the way he edited the shots together. He produced meaning from a dialectical process between shots, by

producing associations from shots, by using symbolic shots, all of which requires the viewer to make sense of what is seen, to think through a sequence. Eisenstein wrote of the editing of shots: '[t]he juxtaposition of these partial details in a given montage construction calls to life and forces into the light that general quality in which each detail has participated and which binds together all the details into a whole' (Eisenstein, 1942, p. 11).

The shower scene from *Psycho* uses a formalist strategy of montage editing. The scene is not shot and edited in a continuous, linear style. The meaning and effect come both from the content of shots, namely a knife flashing across the screen at different angles towards Marion Crane, and from the editing of the shots, which produces a series of short shots that juxtapose the knife and Marion with their different directions of movement. Further examples of formalism are to be found in German Expressionism. Films such as *The Cabinet of Dr Caligari* (1920) are non-realist: the expressive nature and meaning of these films tend to rely upon the *mise en scène*, on the selection and arrangement of elements within shots. It will be noticed that the formalist approach to film-making necessarily emphasizes the importance of the director as someone who intervenes in the film-making process. In other words, a film is a vehicle for personal expression.

Realism, by contrast, emphasizes film as a medium for directly recording what the camera 'sees'. Film techniques are important, but not for producing meaning within the film. The function of the camera is to record what is in front of it and to allow the content to speak for itself for the audience to draw their own conclusions. Bazin believed realist cinema was a more democratic form of film in that it did not manipulate the audience. The use of deep focus allows the audience to clearly perceive a number of elements within a shot instead of being guided towards a particular element. The use of long takes reduces the need for intervention by the director in the construction of the film. Less editing means less fragmentation of time and space. Film is seen as having the potential to reveal the world to audiences. 'For the first time, between the originating object and its reproduction there intervenes only the instrumentality of a nonliving agent. For the first time, the image of the world is formed automatically, without the creative intervention of man' (Bazin, 1967, p. 13).

This Bazin quote comes from an essay entitled 'Ontology of the Photographic Image'. Ontology is central to any kind of realism, concerned as it is with the 'reality status' of objects and representations. Is a documentary more 'real' than a Hollywood film? Can any film be 'real'? What does 'real' mean'? These are not idle questions: from personal experience we can affirm that many people (in response to a direct question) think of soap operas as 'real'. The ontological question is in turn linked to the matter of epistemology, which is about the meaning of 'knowledge'. How do we know what we know? Again, this question is much deeper and more far-reaching than it may appear: do I 'know' something because I have experienced it (empirically), because I have sensory (phenomenological) information about it, or because I believe what I have read or heard…or seen in a film or on TV?

Exercise 8.4

Consider the Iraq War and the subsequent events. How do you know what you know about it? What are the sources of your knowledge? How confident are you that your knowledge is 'true'?

The use of film as a means of addressing ('real') social issues gained impetus in the 1930s with the growth of documentary film-making and the 'realist' films of Jean Renoir. Renoir's films tended to deal with social issues and used deep focus and long takes as a way of reducing directorial intervention. A film such as *La Grande Illusion* (1937) typifies Renoir's concern with themes of class inequalities and the futility of war. John Grierson, who spearheaded British documentary film-making, was similarly concerned with revealing social issues in 1930s Britain. However, it must be noted that the use of realist film techniques does not necessarily imply social issue films. Orson Welles, for example, is well known for his use of long takes and deep focus but produced films as entertainment, and while *Citizen Kane* contains realist techniques, it also extensively uses formalist devices such as expressive lighting and unusual camera angles.

The concept of realism remains problematic. If long takes result in greater realism, then presumably one continuous take with no editing would be the ideal, yet this has rarely been tried. Even with such an approach, there is still directorial intervention in terms of decisions about when the take begins and ends. Similarly, although deep focus means the audience is not guided towards a particular element, choices are still made about what is in the shot and how it is composed. Add to this the fact that realist films often make very effective use of music, as in the case of *Bicycle Thieves* (1948), and the case for a realist aesthetic looks untenable. This is not to say that there is no place for realist techniques in film, but it does indicate the limits that exist for realism. What audiences regard as 'realistic' also changes over time and varies from culture to culture.

CASE STUDY: THE TITANIC NARRATIVES

The question was posed at the beginning of this chapter of how several film versions of the Titanic story could have been made, each different from the others. Having looked at the language of film and how film techniques, film form and narrative interlink, we are now in a position to look again at this question. We have noted that form is the result of the interaction between content and style, and is determined by the narrative and the way in which it is presented to us. This is what gives a film its shape.

Let us consider two of the Titanic films, *A Night to Remember* (1958) and *Titanic* (1997), both of which deal with the Titanic story from before passengers board the ship until after the sinking when some passengers are rescued. *Titanic*

also includes contemporary footage dealing with underwater exploration of the sunken ship and with the recollections of one of the surviving passengers.

The contemporary footage immediately results in a difference between the two films' methods of narration. *Titanic* is told using flashbacks. The exploration of the sunken ship results in Rose, a survivor of the disaster, contacting the research team, and this in turn creates the possibility of the story being told through her recollections. *A Night to Remember* does not give us a personalized account of the Titanic; it uses objective rather than subjective narration (see pp. 205–6 below), although both films use omniscient narration too. We are aware of events happening to different people in different locations.

A Night to Remember uses documentary footage of the Titanic being launched and its voyage at sea at several points as a way of establishing context and atmosphere and to provide a degree of authenticity. *Titanic* makes little use of documentary footage. *A Night to Remember* gives what appears to be a more straightforward account of the ship's voyage, while *Titanic* is very consciously telling the story in a fictionalized way. *A Night to Remember* does not have the embellishments of *Titanic*. The latter film spends a long time introducing and developing characters; the iceberg is not hit until more than ninety minutes into the film, compared with *A Night to Remember*, in which the iceberg intervenes after half an hour.

Both films have characters for us to follow, both films have elements of romance, and both contain class as an issue; however, each film deals with this content in a very different way. The characters in *A Night to Remember* are not developed far – it is the events that we really follow – whereas in *Titanic* the events are subservient to the characters (and to spectacle). *Titanic* conforms to Propp's observations on character types: Jack as the hero, Cal as the villain and Rose as the princess (see p. 201). Hence we can see that the same essential story is constructed and told in very different ways.

The same can also be noted for the film techniques used. While the *mise en scène* of some shots, essentially those establishing locations, is strikingly similar, the types of shots, use of camera and editing techniques are very different. *A Night to Remember* tends towards allowing meaning to emerge from the content of the shots (and is thus rooted firmly in the British 'realist' tradition), whereas *Titanic* goes further in producing meaning from the conscious use of camera and editing techniques such as close ups, crane shots, tracking and cross-cutting.

Finally, the eras in which the two films were made also account for some of their differences. *A Night to Remember*, made in 1958, is a black-and-white film and uses what now seem like primitive special effects and models. The *Titanic* of 1997 employs complex and convincing models and special effects, heavily based on digital technology and computer-generated images. We have the same story, but visually it is told very differently in each film. Thus we can see how a film's form emerges from the way its narrative is structured and presented through the language specific to film.

END OF CASE STUDY

CONCLUSION

As human beings we can't stop communicating, whether it be through conversation, non-verbal communication, writing, music or films, and all these different forms of interaction have their own languages. Much of our interaction is the transmission and reception of information and opinions as a necessary, as well as desired, aspect of everyday life. Communication within our societies often consists of stories, narratives, covering real and fictitious events. For over one hundred years film has been communicating narratives through the use of moving images employing techniques that are uniquely suited to its particular form. However, these techniques have never been static. As technology changes and as societies develop so new techniques become available and appropriate. From the small number of examples referred to in this chapter it should already be clear that many different types of film are possible. New films are always being made, and audiences never seem to tire of watching them because the permutations within and between narratives and film techniques are endless, which should ensure continuing innovation and originality. The language of film can be used in many different ways, some of which are explored in the rest of this book.

SUMMARY

↪ There is more than one way to tell a story – a range of possibilities exist and choices have to be made.

↪ A film's form is the result of a multitude of variables, which are themselves the result of decisions taken by those involved in the film's production.

↪ Decisions are taken as to how the narrative is to be structured and how it will be narrated.

↪ The content of each shot requires careful consideration, the result of which is the shot's *mise en scène*.

↪ The techniques used to film each shot need much thought in terms of camera movement, angle and shot size.

↪ The editing together of shots and the use of sound also play a vital part in the construction of a film's form as they produce, enhance and communicate meanings vital to the film's story.

REFERENCES

Bazin, A. (1967), *What is Cinema?*, vol. 1, Berkeley and Los Angeles, CA: University of California Press.
Cook, P. (ed.) (2007), *The Cinema Book*, 3rd edn, London: BFI.
Eisenstein, S. (1942), *The Film Sense*, New York: Harcourt Brace and Co.
Maltby, R. (2003), *Hollywood Cinema*, 2nd edn, Oxford: Blackwell.
Monaco, J. (2000), *How to Read a Film*, 2nd edn, Oxford: Oxford University Press.

FURTHER READING

Bordwell, D. and Thompson, K. (2004), *Film Art: An Introduction*, 7th edn, New York: McGraw-Hill.

A thorough guide to how film, as a particular form, communicates meanings.

Burch, N. (1973), *Theory of Film Practice*, London: Secker & Warburg.

Analysis of how the techniques used in film-making help create particular meanings as part of a language system.

Cowie, P. (1973), *The Cinema of Orson Welles*, New York: Da Capo Press.

Provides useful insights into his style and techniques.

Dix, A. (2008), *Beginning Film Studies*, Manchester: Manchester University Press.

A comprehensive introductory book covering elements of production.

Fabe, M. (2004), *Closely Watched Films*, Berkeley and Los Angeles: University of California Press.

Useful textual analysis of films.

Giannetti, L. (2007), *Understanding Movies*, Boston: Allyn & Bacon.

An accessible book taking a formalist approach that investigates how film techniques create meaning.

Lacey, N. (2004), *Introduction to Film*, New York: Palgrave Macmillan.

A concise, accessible book with useful analyses of films.

Phillips, W. H. (2009), *Film: An Introduction*, New York: Palgrave Macmillan.

Comprehensive text covering the analysis of films and identification of how they communicate with audiences.

Sterritt, D. (1993), *The Films of Alfred Hitchcock*, Cambridge: Cambridge University Press.

Provides useful insights into his style and techniques.

FURTHER VIEWING

A Personal Journey with Martin Scorsese through American Cinema (BFI, 1995)
 A fascinating insight into the techniques of many of the USA's best-known genre films. BFI, 21 Stephen Street , London W1T 1LN
Close-up on Battleship Potemkin by Roger Corman (BBC2, 1995)
 Excellent, accessible textual analysis of Eisensteins's Odessa Steps sequence. BBC Active, BBC Television Centre, Wood Lane, W12 7RJ
Reputations: Alfred Hitchcock (BBC2, 1999)
 A broad-ranging documentary about Hitchcock, his films and his techniques. BBC Active, BBC Television Centre, Wood Lane, W12 7RJ

Visions of Light (The American Film Institute, 1992)
> A well-made documentary about the role of the cinamatographer. American Film Institute, 2021 N. Western Avenue, Los Angeles, CA 90027-1657

Without Walls: J'accuse Citizen Kane (Channel 4, 1992)
> An interesting textual analysis and critique of *Citizen Kane* by Robert McKee. Channel 4, 124 Horseferry Road, London SW1P 2TX

Chapter 9

Film form and narrative

By the 1920s, particular conventions had become well established for making films. Mainstream techniques such as the organization of time and space through 'invisible' continuity editing and the verisimilitude resulting from particular uses of *mise en scène* and from cause-and-effect structures and character motivation began to dominate film-making, as exemplified by the output of Hollywood. In this chapter we shall examine the principal ways in which these and other practices contributed to what Noël Burch has called the 'Institutional Mode of Representation', though the more commonly used term is 'Classical Hollywood Narrative' (see Bordwell, Staiger and Thompson, 1985). This chapter will also discuss the development of alternative narrative forms. Using the ideas of Peter Wollen in particular, we shall describe alternative techniques such as non-linear narratives, lack of character identification, and the attack on conventional forms of pleasure represented by counter-cinema.

//

Mainstream narrative and film form

Narratives are central to our existence. Not only can our individual lives be seen as stories, but much of our time is spent telling people stories or informing them of things that have happened. Stories consist of people and events, actions, occurrences. Narratives can be defined as 'chains of events'. They contain actions and events that are linked together and which usually revolve around people – the characters within the story.

We shall be dealing here with narrative fiction. Although documentary films also usually contain narratives and are often structured in similar ways, these are briefly considered elsewhere (see Chapter 5). Our concern in this first part of the chapter will be the Classical Hollywood Narrative (which has already been signposted particularly in Chapters 1 and 8).

Structure

Narratives are about things happening, usually about people doing things. We may follow a narrative because the events interest us or because we can relate to the characters. However, if we are to clearly understand the content of a film narrative or fully comprehend the meanings intended by the film-maker, the narrative needs to be structured appropriately.

Cause and effect

Most narratives are what we can call linear narratives. They move forward in a straight line from beginning to end. The events in such a narrative are linked together via a cause-and-effect relationship. An event takes place which causes an effect upon something else, thus resulting in a new situation; in turn this new situation has an effect upon other elements within the narrative, again resulting in further change. So taken for granted is this basic narrative requirement that we usually do not think about its function. But consider what would happen to a narrative without this cause-effect process: it would stop; the story would remain static. We would have what is called 'dead time'.

Another way of viewing progression within narratives is as a dialectical process. Dialectics, from Plato to Hegel and Marx, is a method for explaining and creating change. It can be summed up by the idea of a thesis which is challenged by an antithesis (an opposite or opposing position); the result of this conflict of ideas or situations is the synthesis, a new concept or situation. The cause-and-effect structure of narrative works in a similar way, leading us from beginning to end via events, and these events take place within time and space. They occur in particular locations for a certain duration.

The centrality of cause and effect, of change, can easily be identified by look-ing at the opening scene of *Scream* (1996). Casey is spending a quiet evening

alone at home. It is unlikely that we would sit through the whole film if that situation remained unchanged, and of course it does change. Casey's quiet evening is interrupted by the phone ringing. She answers the phone. A threat is made. This results in a new situation: Casey is scared. The cause-and-effect process is under way. Her fears are then realized by the attack that takes place in her garden: yet another situation. This in turn leads to further actions: attempts to find the attacker, further attacks.

The logical way in which this cause-and-effect process develops is not usually questioned by the viewer, but a different arrangement of elements, a different ordering of events, would soon result in an incomprehensible storyline. If *Scream* began with the attack in Casey's garden and then cut to her having a quiet evening alone we would soon be confused, or would at the very least be expecting a very different type of film.

Chronology

Narratives thus tend to develop in a linear way, and this, crucially, tends to give us a chronological ordering of events. Events unravel in a logical manner over an ordered period of time. Time is a crucial ingredient in film narratives, not only because the medium itself consists of moving images which give films their duration, but also because the relationships between events and characters only become meaningful as they develop over a period of time.

The events in *Scream* are presented chronologically. The story's progression takes place from beginning to end through time in a linear manner. We can easily make sense of the film. This is how most film narratives are structured. However, Quentin Tarantino's *Pulp Fiction* (1994) interrupts this chronological structure and gives us a non-linear narrative. The usual chronological development of narrative is disrupted. *Pulp Fiction* begins and ends with a scene that is split in two and which chronologically occurs half way through the story. The film opens with Honey Bunny and Pumpkin conversing in a café. We learn that they have previously carried out armed robberies. The film ends with a continuation of this scene in which the couple carry out an armed robbery of the café which is interrupted by Vincent and Jules. In the body of the film the chronological beginning and end of the story are brought together. A young Butch is given a watch that belonged to his father and an older Butch then wins his fight and settles a score with Marsellus. As this latter scene is presented in the film it appears as a flash-forward to the future.

We can speculate about why Tarantino chose to reorder the narrative sequences. Certainly it forces us to think more deeply about what we are watching and possibly engages us more fully with the narrative. We are encouraged to be active viewers; we have to question what we see. Or perhaps it was a homage to Stanley Kubrick's *The Killing* (1956), one of a number of films which had already experimented with narrative chronology.

Other recent films such as *Memento* (Nolan, 2000) and the aptly named *Irreversible* (Noë, 2002) have also encouraged a more radical engagement with the film's time structure: in both these films, though for quite different reasons, the plot's events occur in reverse chronological order.

Flashbacks

A common method of interrupting chronology is through flashbacks. The flow of the story might be interrupted with references to things that have happened in the past. We are taken out of the present of the narrative. Interruptions of narratives, such as those caused by flashbacks, are usually explained and justified so that they do not necessarily disrupt the narrative; indeed they can clarify it. *Citizen Kane* (1941) tells the story of a powerful newspaper proprietor, Charles Foster Kane. The film begins with Kane's death, followed by journalists looking at newsreel footage of Kane's life. This is followed by the journalists planning to investigate the life of the recently deceased Kane. This is the 'present' of the narrative and we follow one journalist's investigations and interviews with people who knew Kane. However, the interviews consist of reminiscences, which means that much of the film's narrative consists of flashbacks. In this instance the film's initial situation is Kane's death and the short documentary about his life. The disruption comes with the journalists' mission to find out who the real Kane was and, most importantly, why the last word he spoke was 'Rosebud'. The implication of course is that if the journalists want to know, then so do we. Resolution is achieved when we, the viewers, find out the secret of 'Rosebud', which is revealed to us in the present but not to the journalists. The flashbacks have served to tell us about Kane's life and what lay behind the secret of 'Rosebud'.

Story, plot and screen duration

The temporal nature of narratives – how they are placed in time – is further elaborated by Bordwell and Thompson. They clarify the difference, with regard to time, between a film narrative's story and its plot. They define the story as all the events that we see and hear, plus all those that we infer or assume to have occurred, whereas the plot is the film's actual presentation (which includes the style) of certain events in the narrative.

We can clearly illustrate the difference between story and plot by looking at *High Noon* (1952). Plot time begins at 10.30 a.m. when news breaks that Frank Miller, who was imprisoned five years before by Marshall Will Kane, is due in town with the rest of his gang on the noonday train to seek vengeance. Plot time ends at noon with the shoot-out. In other words plot time is ninety minutes. However, story time is over five years, as the film refers to Miller's imprisonment by Kane, though we do not see this. The film is interesting for a further reason. Films usually compress time. A film usually has between 90 and 120 minutes to

deal with events often lasting at least several days. *High Noon* is an exception, as it comes close to presenting the plot in real time: screen duration is eighty minutes compared to the plot time of ninety minutes. Time is clearly integral to the film as we get several glimpses of clocks to remind us of the approach of noon as a method for building suspense. *Rope* (1948) goes one step further by presenting the plot in real time in just one location. The film appears to be one continuous shot (see p. 173 above).

Exercise 9.1

For any three films of your choice, compare the story time and the plot time. How are they related in each of the films?

It is also the case that time can be expanded in a film. *The Untouchables* (1987) contains a shoot-out scene on the steps of a station, part of which is shot in slow motion. The sequence lasts two minutes, whereas the fast-moving events would probably have lasted less than half that time. The expansion of time emphasizes the speed of the action by only making it comprehensible when it is slowed down. The sequence is also a homage to Eisenstein's *Battleship Potemkin* (1925) and the famous Odessa Steps sequence in which time is also expanded. The attack by the Tsar's troops on the citizens of Odessa is illustrated from various perspectives and points of view; events happening simultaneously are shown to us one after another. The effect is to create a stronger impression of slaughter and savagery. The importance behind these observations is the realization of how time is managed within narratives, how it is manipulated and rearranged in films.

Plot is more than story information, however. The style of a film (the *mise en scène*, editing, cinematography and sound) works ceaselessly to provide the viewer with other information, for example about character, about relationships, about mood. Thus the plot of *Pulp Fiction* informs us at one point that Jules accidentally shoots a captive while talking in the car, then argues with Vincent. This is part of the storyline. But it is the style's contribution to the plot that makes us party to the absurdly matter-of-fact tone of Jules and Vincent's conversation and the (comically) brain-splattered interior of the car. In *Citizen Kane*, when Kane and Susan talk/argue in Xanadu, plot information includes style: the expressionist lighting, the framing and camera angles accentuate Kane's power and Susan's powerlessness. This difference between story and plot information can be shown in Table 9.1.

Beginnings, middles and ends

The beginning of *Scream* and the film's subsequent events also serve to illustrate another key aspect of narrative theory. Tzvetan Todorov regarded narratives as typically consisting of three different stages. A narrative usually begins with an

Table 9.1 Story and plot information

Type	Order	Result
Story	Explicitly presented events rearranged into chronological sequence	Inferred events built into the sequence of explicitly presented events
Plot	Explicitly presented events, not necessarily in chronological sequence	Added stylistic/non-diegetic material

equilibrium, a state of harmony or balance in which the audience is introduced to key characters and locations. We get to know characters and perhaps identify with them. The next phase of the narrative sees a disruption of the initial equilibrium as a problem is introduced. This is one way in which the audience can be 'hooked' into the storyline. It is intended that we will want to follow the key characters through the story until they have solved the problem. This brings us to the third stage of a narrative: a new equilibrium is achieved, the problem is resolved, harmony and balance are restored. Traditionally this equates with a happy ending, with closure as the story is brought to an end. We can note that this also fits neatly with the cause-and-effect nature of a typical narrative which we identified earlier in this chapter.

Analysis of *Scream* confirms Todorov's model as appropriate to this particular narrative. The equilibrium is Casey intending to have a pleasant evening at home, a situation with which we can probably identify. The disruption is clearly the phone call followed by the attack. Casey has a problem and soon her friends have one too. The narrative is driven by the attempts to identify the killer, with a few more attacks along the way to add greater urgency. The new equilibrium, or restoration of harmony, is achieved with the unmasking of the source of the attacks. The problem is solved; a resolution is obtained. The narrative essentially conforms to Todorov's model, as do most film narratives. Closure is provided.

Open and closed narratives

However, while we may experience *Scream* as a complete narrative with closure, there have of course been a *Scream 2* (1998) and a *Scream 3* (2000). This obviously places a question mark over the degree of closure in the first film. The financial attraction of sequels is obvious, but the potential for a sequel is unknown until the degree of popularity of the initial film is established. It is a risky strategy to make a film with an obviously open ending which may prove unsatisfactory. For example when John Sayles' *Limbo* (1999) ends with a fade to white and no evident narrative closure, there have often been loud groans from the audience!

In reality, film-makers are now adept at making films that appear closed but hold the possibility of continuation. Nor is this a recent strategy. *Star Wars* (1977) is one instalment in a six-part story. No doubt George Lucas perceived this

particular section of the story as having the best chance of success. As a film it stands on its own as a complete story. However, as we now know, it is the fourth of six episodes; in other words, it is also an open-ended narrative. In this respect it is not such a typical narrative.

Being just a part of a larger narrative also explains why the beginning of *Star Wars* is at variance with the conventions of film narratives. As we have seen, an equilibrium is normally found at the beginning of a narrative, yet *Star Wars* begins *in medias res* (a Latin expression which means 'in the middle of things'), with action, with a battle in space, which visually strikes the viewer as a disruption. The only thing that would stop us defining it as a disruption is the fact that we have no knowledge of what came before and therefore do not know what could have been disrupted. We now know that *Star Wars* begins this way because it is a continuation of episode three. No doubt another good reason for beginning *Star Wars* this way is that it immediately launches us into the action, which is one of the key elements of its narrative. We have virtually no time to consider the narrative itself. Events move quickly and conflict is everywhere. Thomas Schatz summed up *Star Wars* and the film trend that followed as 'plot-driven, increasingly visceral, kinetic and fast paced, increasingly reliant on special effects, increasingly "fantastic"' (Schatz, 1993, p. 23).

Single- and multi-strand narratives

If the essential storyline of *Star Wars* moves rapidly from point A to point B, the same cannot be said of all film narratives. While most films contain one main storyline, *Do the Right Thing* (1989) can be described as a multi-strand narrative. There are several storylines running throughout the film which occasionally cross paths with one another. In many respects *Do the Right Thing* is like a soap opera narrative; it is even left open-ended. Although Mookie, played by Spike Lee, may be the central character, at least twelve other characters who regularly crop up have key roles within their own storylines, as well as within the narrative as a whole. They raise various issues and present a range of messages on race, parenthood, family, unemployment, enterprise and gender. It is a different type of film in both its narrative structure and the imaginative film techniques used. However, it is far from being an 'alternative' film; it still provides a coherent and entertaining narrative, albeit with political messages that often challenge mainstream beliefs.

Crash (Haggis, 2004) covers two days in Los Angeles, following the lives of twelve people and focusing on how their paths intersect. Similarly to *Do the Right Thing*, this multi-strand narrative reveals the racism within different ethnic groups and exposes how deep-seated racial stereotyping is. The film cleverly complicates the characters and presents them as complex and unpredictable. We see the characters exhibit both desirable and undesirable behaviour, resulting in them being far more believable than the protagonists in many films which use more simplistic representations.

Characters and actions

While the events within a narrative may well catch our attention, action on its own is unlikely to be enough to carry us all the way through a film. The number of films based primarily on action has increased in recent years, but characters are usually required to involve us fully in a film. This is partly because most actions are initiated by characters anyway, but also because as human beings we tend to link into a film much more easily through the representation of other human beings within a narrative.

Characters as protagonists

Almost invariably it is the main characters who are the protagonists in a film. They are the people within the story who cause things to happen. Exceptions are films where the driving force is a natural disaster that causes events. Yet even in such films individual human agency is usually woven into the narrative. In *Twister* (1996) it is tornadoes that provide the disruption. However, while on one level the equilibrium is a community before it is hit by a tornado, on another level the equilibrium is the lead character intending to settle down with his girlfriend. For the communities the arrival of the tornadoes is the disruption, while for the lead character the disruption is him being drawn back into 'tornado chasing' with his old friends, which poses a problem for his relationship. For the communities the new equilibrium is provided by the departure of the tornadoes, while for the lead character the new equilibrium is him agreeing to leave his fiancée and return to his previous lover, who is a kindred spirit, a fellow tornado chaser. This provides resolution, closure and a happy ending.

Motivated characters

For a film to involve the audience fully it will normally need to deal with the lives of individuals. As individuals in a relatively individualistic society, this is what we are likely to relate to. What we really follow in *Twister* is the lead character and his associates. They are motivated; they want encounters with tornadoes. This in turn makes them protagonists in that their motivations lead them to make things happen through the decisions they take. It is intended that we will identify with their desire for adventure and follow them through their dangerous adventures.

Exercise 9.2

For any three films you have seen recently, examine the motivations of the central characters. How do their drives and desires make the narrative go forward?

Character functions

Vladimir Propp has provided an interesting analysis of the kinds of characters contained by certain kinds of narratives. He analysed hundreds of Russian folk stories and identified eight main types of characters in terms of what their functions were within the narrative: the hero, the villain, the donor, the helper, the princess, the princess's father, the dispatcher and the false hero. While we need to be careful in judging the relevance of such analysis because of cultural and historical differences, the research having been undertaken in the Soviet Union in the 1920s, Propp's conclusions can be seen to be useful, even though he was only looking at a particular type of narrative. 'Proppian' analyses have been carried out, for example, on Hitchcock's *North By Northwest* (1959) and on the James Bond films, and a film-friendly model has been developed by ex-scriptwriter Christopher Vogler (1992).

A cursory glance at *Star Wars* soon reveals how the first five of Propp's character functions or types are appropriate. The hero is Luke Skywalker, the villain is Darth Vader, the donor is Obi Wan Kenobi, who gives Luke the 'force'; the helper is Han Solo, and the princess is Leia. Princess Leia is not of course the typical helpless princess of fairytales; she could not afford to be in a 1977 film, given the changes in gender values that had occurred as a result of the feminist movement. However, if we take account of changes in gender representation by broadening out the categories of hero and princess to encompass heroines and 'princes', Propp's model is still surprisingly appropriate.

Star Wars provides clear examples of the roles of characters and actions within a film. This is especially the case with Luke Skywalker. When we first meet him he is living with relatives, helping run a mundane business buying, selling and repairing robots. Luke is restless; he is in his teens, he wants to break away, to be independent, to prove himself a man and to have adventures (and is therefore also an ideal identification figure, especially for adolescent males). In other words, he is already motivated but needs a definite purpose, a clear goal. This is provided by the discovery that Princess Leia has been caught and is seeking help. Luke requests the help of the wise old Obi Wan Kenobi ('wisdom' being a stereotypically foreign concept), who aids his rites of passage in this story, seeing Luke safely on his way from boyhood to manhood. Luke is the protagonist, the main character who has a purpose. However, on its own this is not enough for an interesting story. An antagonist is needed, someone who opposes Luke's intentions. Once we have met the evil Darth Vader and the Empire, we are well placed to take the side of Luke against the villain. We identify with Luke and his mission to see good triumph over evil.

Good versus evil implies conflict, and this is a regular feature of *Star Wars*. The conflict drives the narrative forward, as it does in many classical narratives. Princess Leia is rescued but her planet is still threatened with destruction. Finally our hero saves the planet by destroying Darth Vader's (and the Empire's) base. The hero is rewarded with the princess. Happy ending.

Exercise 9.3

Consider any film with an antihero (a hero with negative characteristics).
Does this have an effect on the other character functions in that film?

Some aspects of style

Narratives can be considered in terms of content and structure. They consist
of events which are organized in a particular way. The process of presenting a
narrative is called narration, and the way in which a narrative is presented can
be identified as its style. The principal components of film style (*mise en scène*,
cinematography, editing and sound) have been described in Chapter 8 above and
much of their relevance to narrative has been considered; here we shall briefly
consider how a few particular aspects of style contribute to mainstream narrative.

Voice over

We experience a film's narrative largely through what we see characters doing
and what dialogue we hear from them. Other audio-visual elements such as
written text and music are used to add meaning to the film. Usually these forms
of communication are sufficient to produce a coherent narrative and create the
desired effect. However, another method for helping to deliver the narrative is
voice-over narration, which tends to be used for two reasons. First, it may be
used to reinforce the account of an 'omniscient' narrator. Second, it may serve to
provide a personal interpretation of narrative events.

Voice-over narration was particularly common in crime/detective films and
films noirs of the 1940s. The voice-over narration supplements what we see and
hear. We get a personal point of view of the events, though not usually a visual
point of view. An example of this technique can be found in *Double Indemnity*
(1944), in which the narration is built into the actual narrative. Walter Neff
records his confession and explanation of a murder he has become involved in.
The narration supposedly comes from the recording we see him begin to make
at the start of the film. The voice over then accompanies the story of how Neff
became embroiled in helping to murder Phyllis Dietrichson's husband in order
to make a life insurance claim. The story could have been told without voice-
over narration but then we would not have had such a personal interpretation of
events.

Blade Runner (1982) also uses a voice over. The voice-over narration is
supplied by Deckard, the main character. Deckard has supposedly retired as a
cop whose job was to kill rogue replicants, cyborgs built to perform human tasks.
He is forced back into his old job to eradicate some new and dangerous replicants.
The narration takes us through his thoughts and retells the story. *Blade Runner*

is an interesting example because Ridley Scott later released *Blade Runner: The Director's Cut* (1991), in which the voice over had been removed. The effect of this is to distance us from Deckard, making it easier for us to see things from the perspectives of other characters in the film. Without voice-over narration we are required to think more about what we see and hear. Things are not explained so clearly, and the viewer has to be more active.

However, we are most likely to come across voice-over narration in documentary narratives. A documentary usually aims to investigate a particular subject and to reveal information. Although interviews may be used, it is often the case that not all the required information is revealed through the shots and dialogue. A voice over may be added to supplement the 'raw' information. Examples of this practice are to be found in the classic documentaries produced by John Grierson in the 1930s and 1940s. He saw documentaries as having a potentially democratizing effect through their educational value and ability to expose social inequalities. In one way or another the documentaries he produced tended to deal with the living and working conditions of the British working class, among the most famous films being Cavalcanti's *Coalface* (1935) and *Night Mail* (1936). Voice-over narration was used to provide greater detail and to guide the audience towards a particular interpretation, and such techniques have since been and remain very common in TV documentaries.

Restricted and unrestricted narration

Other choices also need to be made about how narratives are to be presented. The narrative information given to us can be restricted or unrestricted (the latter is also sometimes called 'omniscient' narration; see p. 265 for discussion of the 'classic realist text'). Each method can be used to powerful effect. As Warren Buckland notes: 'in restricted narration, the spectator only knows as much as one character, resulting in mystery. In omniscient narration, the spectator knows more than the characters, resulting in suspense' (1998, p. 34). Although restricted narration links the narrative to one character, it is not necessarily from the character's perspective. This form of narration can create mystery because we are unaware of what is happening elsewhere. We are left guessing; we do not know everything. At the end of *Scream*, it appears that the two murderers, Stewart and Billy, have been killed and we begin to relax as the threat seems to be over, but we and Sydney are shocked by the sudden appearance of Randy in a close up shot of Sydney. Again we relax, only to be startled twice more by Billy suddenly coming to life – an effect we may see as comic, but only after we have recovered from the shock. We are as surprised as Sydney because the presentation of the narrative has not prepared us for these interventions; information has been withheld and restricted.

Unrestricted narration, on the other hand, links the viewer to several characters and locations. We move from one to another. We can see how characters

and events may coincide and have an effect upon each other; the viewer is in a privileged position. This form of narration is very capable of creating suspense because we may see what is about to happen while the characters may not. Towards the end of *Psycho* (1960) we are aware that Norman has put his mother in the fruit cellar. Lila, sister of the murdered Marion, has made her way to the house to question Norman's mother. She believes Norman's mother is harmless; the spectator has been led to believe she is a murderer. We are aware of something Lila does not know. We follow Lila around the house and it seems that she has managed to avoid the fruit cellar. However, she finds it by accident when she has to hide from Norman. Hitchcock continues to tease us by having Lila begin to walk down the steps to the cellar, only to stop and turn around, then finally continue down to the cellar. This creates suspense. We foresee two situations coinciding and feel like telling her to turn around and escape. While restricted narration is more likely to be used for shock, unrestricted narration is ideal for suspense – as Hitchcock himself knew very well. In a famous interview with French director François Truffaut, Hitchcock explained it thus:

> We are now having a very innocent little chat. Let us suppose that there is a bomb beneath this table between us. Nothing happens, and then all of a sudden, 'Boom!' There is an explosion. The public is *surprised*, but prior to this surprise, it has seen an absolutely ordinary scene, of no special consequence. Now, let us take a *suspense* situation. The bomb is underneath the table and the public *knows* it, probably because they have seen the anarchist place it there. The public *is aware* that the bomb is going to explode at one o'clock and there is a clock in the décor. The public can see that it is a quarter to one. In these conditions this same innocuous conversation becomes fascinating because the public is participating in the scene. The audience is longing to warn the characters on the screen: 'You shouldn't be talking about such trivial matters. There's a bomb beneath you and it's about to explode!'
>
> In the first case we have given the public fifteen seconds of *surprise* at the moment of the explosion. In the second case we have provided them with fifteen minutes of *suspense*. The conclusion is that whenever possible the public must be informed.
>
> (Truffaut, 1978, pp. 79–80, original emphasis)

A good example in which this principle is illustrated graphically is when three bombs are planted and we anxiously wait for them to explode in Gillo Pontecorvo's *Battle of Algiers* (1966).

In reality, films often mix restricted with unrestricted narration, depending on the scene and on the requirements of the narrative. *Star Wars* generally uses unrestricted narration but occasionally we receive restricted narration, as in the final battle scene when we share Luke Skywalker's point of view during his

attempt to blow up the Death Star, and do not realize that he is being backed up by Han Solo in the Millennium Falcon.

Objective and subjective narration

Narrative information can also be presented subjectively or objectively. Subjective narration tells the story from a character's point of view; this is not necessarily the character's optical point of view but may be his/her mental perception of events. An example occurs in *The Cabinet of Dr Caligari* (1920). The narrative is presented as known by Francis. The film tells his story, of how Dr Caligari hypnotizes his accomplice Cesare to commit murders. Francis intends to expose what Caligari is doing. He tracks Caligari, who goes into hiding in a lunatic asylum. However, by the end of the film we return to objective narration and learn that Francis is an inmate of the asylum and Caligari is his doctor.

Battleship Potemkin provides a very objective narrative. We do not get close to any of the characters. We do not see things from their perspectives, although we do see a range of characters as part of the events that are shown to us. The film is a fictionalized account of a sailors' mutiny against the Russian Tsar's regime and the support given to the sailors by the townsfolk of Odessa. The film's narrative has no individual protagonists as such, preferring to present the events as the result of political developments within society. The film provides an overview of this particular incident from 1905 rather than a character's personalized account.

Many films mix objective with subjective narration. For instance, in *Citizen Kane*, the narration from the beginning of the film to the start of the journalists' investigations is objective. We observe events. However, when the characters interviewed provide us with their flashbacks, we initially experience subjective narration, although the flashbacks too eventually resort to objective narration. Thus within a particular flashback, events may be shown or described which the flashback's 'narrator' could not have seen or experienced. For example, at one point during the account of Susan's disastrous singing career, an apparent crane shot (which is in fact a cleverly edited fabrication) takes us from Susan on stage up to beneath the roof to show two stage hands silently expressing their disgust: these two characters would have been invisible to anyone else.

Subjective and objective narration are often combined with restricted and unrestricted narration. Close analysis is sometimes required to identify which is being used. A voice over might give us a subjective viewpoint of events from a character's perspective, or it could be an objective description of events that is not personalized. It also needs to be remembered that using restricted narration which shows us events linked to one particular character is not necessarily subjective. We may not see events from the character's perspective. Similarly, unrestricted narration which presents events in relation to several characters is not necessarily objective, as the presentation of various events and characters may be retold from a very personal point of view.

///

Alternative narratives and film form

The vast majority of films, whether, British, Brazilian, Japanese or from the USA, have been structured around the kind of mainstream narrative described above. Such narratives tell stories about characters who are 'believable' (either because they are 'realistic' or because they correspond to accepted genre stereotypes) as they experience a series of events within a relatively coherent time and space. It may be worth repeating that such films, as part of the commercial film industry, are made with profit in mind: the aim is to make money. As is stressed elsewhere, this also tends to mean that such films are likely to belong to a genre and to contain stars, as both these factors tend to help in targeting a large audience.

Throughout most of cinema's history, though, some film-makers have refused this mode of film-making and have experimented with other kinds of narratives; indeed some have refused narrative altogether. Among famous examples of narratives being constructed quite differently from the dominant model outlined above were the Soviet Montage films and Surrealist films of the 1920s, which have been considered in Chapters 4 and 5 above.

A more recent example is provided by *Memento* (2000), which has a non-linear narrative. The alternative structure is justified by the story itself, which focuses on Leonard, who has short-term memory loss. He tries to find out who killed his wife, a mission made more difficult by his inability to remember facts that he uncovers. He therefore has to constantly make notes to remind himself of what he has discovered and the film constantly flashes backwards from his present as he tries to place his memories into a meaningful context.

A further note on 'independent films'

'Independent' is a term which has often been applied particularly to US films since the 1960s, as in 'American Independents'. But what does 'independent' mean in the cinema? We may recall that the early years of US film-making were dominated by the Motion Picture Patents Company, and it was only when the MPPC's activities were judged illegal in 1915 that other struggling companies became successful. These fledgling companies included Warner Brothers and Paramount, who were at the time the 'independents' of US cinema.

Some fifty years later, as the studio system had to find ways to adapt to the 1948 anti-trust legislation, changing lifestyles and television competition, increasing numbers of films were produced by 'independent' companies: companies set up, sometimes by maverick film-makers, for the production of a single film; such companies hired facilities from the studios but were otherwise financially independent. However, as successful production companies were established, and as the restriction on vertical integration was eroded during the Reagan years, powerful commercial concerns came to dominate all sectors of the industry, most

noticeably distribution (see pp. 150–3 above). It is thus very debatable whether the films of Tarantino and Jarmusch, for example, can really be called 'independent'; *Pulp Fiction*, for all its innovation, was co-financed by Miramax, as was Jarmusch's *Dead Man* (1995).

Perhaps the only productions which can be considered 'independent' are those dependent neither on Hollywood or multinational conglomerate finance nor on state sponsorship. Truly independent films would thus not be purely commercially driven, and would be produced for aesthetic or political reasons. The style and content of such films would challenge mainstream conventions and ideologies. Truly independent cinema stands apart from popular or commercial mainstream film and is generally considered to be marginalized, alternative or oppositional.

Though films which refuse the dominant rules of story-telling form a tiny percentage of all films ever made, they have been (and continue to be) an important part of film history and culture. Why is this?

Form and ideology

Films have a deep sensory appeal and have often been compared with dreams. It is this unconscious aspect of the film experience which has provoked much suspicion and criticism of classical narrative film form – and which has also inspired the use of film as propaganda. In this section we shall look at some of the criticisms levelled at mainstream narrative entertainment films and at some examples of alternative film forms: films which demonstrate a refusal of the kind of narrative described thus far in this chapter.

The appeal to the unconscious was an important part, for example, of the Surrealist project, in film and in other art forms. Here we shall be concerned mostly with the attacks on mainstream narrative coming from a more political critique which was first mounted in the 1970s; we shall also briefly consider the contributions made by 'art cinema'.

Since Brecht and Eisenstein, it has been argued that film, theatre and indeed written narratives in Western cultures have been constructed in such a way as to seduce the reader/spectator into accepting the dominant ideologies of the age. Among these have been assumptions about heterosexual, monogamous relationships within 'nuclear' family units which, so the argument goes, are designed to reproduce the class, gender and race relations suitable for capitalist exploitation. If poor, downtrodden spectators 'buy into' a social system which actually oppresses them and keeps them poor and enslaved, it is in large part because they unconsciously absorb messages about 'how society has to be' which are disguised as innocent entertainment. Millions of words have been printed arguing about how exactly this happens (and a few more are printed in Chapter 12, in which we shall consider ideology in slightly more detail), but there is a persistent belief, shared here, that this is indeed the job that ideology does through the media representations which surround us.

Yet this is not necessarily a new idea; and it has long circulated among the more 'progressive' writers and directors in Hollywood itself. *Sullivan's Travels* (Sturges, 1941) concerns itself with the heartfelt desire of a successful director of escapist entertainment films to make a documentary about his experiment of living with the poor. An early exchange with the director's bosses as the director insists on pursuing his project in the face of his bosses' incomprehension can stand in for capitalist neglect of suffering in general – and for an endorsement of 'entertainment':

Sullivan:	I want this picture to be a commentary on modern conditions, stark realism, the problems that confront the average man.
executive:	But with a little sex in it.
Sullivan:	A little, but I don't want to stress it. I want this picture to be a document. I want to hold a mirror up to life. I want this to be a picture of dignity, a true canvas of the suffering of humanity.
executive:	But with a little sex in it.
Sullivan:	With a little sex in it.
executive:	What about a nice musical?

The director goes off on his philanthropic mission to understand poverty, but, after a series of misfortunes which surely should not happen to a successful director, ends up wrongly convicted in a Deep South prison. The key moment in the film arrives when together with his fellow prisoners, as part of a merciful outing to a film show organized by a local (black) church, he finds himself watching a *Tom and Jerry* cartoon. At first he is dismissive and finds it beneath him, but soon he finds himself giving in and laughing (perhaps rather too hysterically?) along with the other convicts. The message is that there is nothing wrong with providing innocent (?) entertainment for those whose lives are hard. When Sullivan is eventually (miraculously of course) released he accepts that his vocation is to make innocuous entertainment films and not hard-hitting documentaries. The putative title of his film about poverty is *Oh Brother Where Art Thou?*

Exercise 9.4

If possible, watch and discuss *Oh Brother Where Art Thou?* (Coen brothers, 2000). Compare the 'message' of the Coens' film with that of *Sullivan's Travels*.

The very form of narrative as exemplified by Hollywood came under attack in a 1970s argument between Guy Hennebelle and James Monaco over whether it was possible to make responsible films about political subjects within a conventional narrative format. While Hennebelle argued that films such as those of Constantin Costa-Gavras (*Z*, 1969; *State of Siege*, 1973; *Missing*, 1982) would be consumed principally as thrillers and that their political 'message' would

therefore be lost, Monaco argued that the narrative 'hook' was essential to get audiences to see the films in the first place: as George Bernard Shaw pointed out, if there is a pill to be swallowed, it is best that it be sugar-coated. The debate was not so much about the 'obviously' progressive/anti-establishment values and beliefs promoted in films such as *The China Syndrome* (Bridges, 1978) and *Hidden Agenda* (Loach, 1990), but rather about whether the use of mainstream narrative techniques somehow neutralized the political effectiveness of such films.

Godard and counter-cinema

While there was no shortage of critics and theorists engaging in these arguments, a number of film-makers – predictably outside Hollywood – put theory into practice and made films which deliberately rejected conventional narrative forms. Among these was Jean-Luc Godard (see also pp. 81–3), particularly in the films he made between 1967 and 1972.

In an influential article written in 1972, Peter Wollen advanced the term counter-cinema to describe Godard's (and others') anti-narrative films. He organized the differences between conventional narrative film and counter-cinema into seven oppositions.

1 Narrative transitivity versus narrative intransitivity: conventional narrative has a coherent plot with events following one another in a cause-and-effect structure – this will serve as a definition of 'transitivity'. In counter-cinema, events do not follow each other in a logical cause-and-effect structure; there is likely to be digression and (deliberate) incoherence. *Pulp Fiction* is not an example of counter-cinema because despite Tarantino's games with chronology, the film is still composed of large narratively coherent chunks, which have only to be placed in the correct order for the puzzle to be solved. In Jean-Marie Straub and Danièle Huillet's *Not Reconciled* (*Nicht versöhnt*, 1965), on the other hand, the action takes place in at least three historical periods (corresponding to a character's youth, middle age and old age); yet it is extremely difficult to work out 'what is going on' as jumps in time are not signalled as they usually are by fades, by character motivation or cinematography (a zoom in to a face may usually signal a memory flashback, for example). In addition, no attempt is made to provide an illusion of passage of time by showing younger or older characters or by evoking a historical period: characters tend to look the same and to speak in the same way whether they are twenty or seventy years old! Needless to say, part of the aim here is to force the spectator to actively work out what is happening. The same 'active spectatorship' is necessary for such Godard films as *Weekend* (1967), *Wind from the East* (*Vent d'est*, 1971) and *One Plus One/Sympathy for the Devil* (1969); in the last of these, shots of a

Rolling Stones recording studio session are intercut with scenes exploring themes such as black power and feminism.

2 Identification versus estrangement: characters in mainstream narratives are generally constructed, made up, costumed and filmed in such a way as to encourage audience identification. Such characters may 'represent' social groups or positions, and they will often act naturalistically, or at least in a way we would expect according, say, to the genre. The spectator is also likely to be drawn into a conventional narrative to identify with events and situations: part of the 'reality effect' of film. By contrast, counter-cinema rejects such identification; the work of 'drawing in' and identification of conventional narrative are seen as central to the passing of ideologies referred to above. Instead, characters are often fragmented; no attempt is made to make them 'believable'; the same actor may play more than one role (this was a common practice in Brecht's theatre). Actors may look/stare at the camera – this has been called the 'fourth look' – perhaps while they and the spectator listen to a speech by another character, highlighting their 'role' in the film and breaking any identificatory spell. *Weekend* contains many such moments. Finally, voices may not match characters; sometimes it is difficult to work out 'who' is speaking. Marguerite Duras' *India Song* (1975) contains plenty of dialogue, but none of it is synchronized; again, the spectator needs to work hard to make meaning.

An important way in which most mainstream films bind in the viewer and encourage identification is through continuity editing and especially through shot/reverse shot sequences (see Chapter 8 above). These are also commonly refused in films such as *Weekend* and *Sympathy for the Devil*. Completely different editing patterns are used, and the long take or shot-sequence (a shot lasting ten to twenty minutes) is common.

3 Transparency versus foregrounding: just as in most films characters are constructed so as to seem 'believable', the overall *mise en scène* is likely to conceal the artifice of film-making and to promote the illusion. An ever greater degree of 'realism' is demanded (not least by audiences) in the representation of fights, bodily mutilations and transformations, accidents, blood, etc., not to mention the assumed verisimilitude of the film's settings. In just the same way as with acting and character, counter-cinema refuses such illusionism and is not afraid to declare 'this is a film'. Props and settings may not seem 'realistic', and cameras, sound booms and other film-making equipment (and personnel) may be part of the film itself. In Godard's *Vent d'est* and *Sympathy for the Devil*, characters who are meant to be tortured or beaten up have red paint thrown at them. When a character in *Weekend* is murdered, a dead fish is shown in a puddle of red paint. *Vent d'est* contains a sequence in which the production personnel hold a chaotic meeting about how to proceed

with the film. In this and a wider variety of films, the use of freeze frames, direct address to camera, hand-held camera and jump cuts and other discontinuities draws attention to the film's status as film and helps to break the habitual mainstream narrative illusion. Again, though, it is a matter of degree: if such techniques are used superficially (as a way of 'showing off' or as a kind of director 'signature'), they cannot be said to be counter-cinematic.

This strategy (again also frequently used in Brechtian theatre) also has literary roots: the Russian Formalists of the early twentieth century urged such foregrounding with the notion of 'making strange' (*ostranenie*). Since Brecht, such an anti-illusionist strategy has also been termed the 'alienation-effect' (*Verfremdungseffekt*). It distances the spectator, promoting contemplation and analysis rather than involvement and identification.

4 Single diegesis versus multiple diegesis: most film narratives take place in a single 'world': *Scream* and *Citizen Kane* both take place in and around the USA of the central characters. Sometimes, as in *The Wizard of Oz* or even *The Deerhunter*, two (or more) 'worlds' may be very different, but there is narrative motivation for movement between them: in *The Deerhunter* we spend the first hour of the film getting to know the main characters in a small industrial town, before being plunged into the Vietnam nightmare: this is clearly motivated, as we know three of the characters are about to leave for Vietnam. Some counter-cinema films, by contrast, move between narrative 'worlds' without apparent motivation: again the spectator must make sense of it. In *Weekend*, two central characters are on a journey through central France, but meet characters in nineteenth-century costume and become involved with a band of anarchist cannibals living in a forest. The existence of these different diegetic worlds is not motivated by events in the narrative.

5 Closure versus aperture: mainstream narrative films usually concern a relatively closed and self-contained world, and references to other worlds and texts are generally integrated into the narrative. The narrative closure of most films reinforces this sense of the film as a unity – a unity which some writers have called 'organic'. By contrast, counter-cinema's frequent references to other films/texts does not seek to integrate such references into an 'organic' whole, but indulges in the references for their own sake or just to make a point. Thus many Godard films are full of cinematic, cultural and literary references or 'quotes'. We shall return to this aspect of counter-cinema when we discuss postmodernism in Chapter 12.

6 Pleasure versus unpleasure: though it may seem strange (even incomprehensible?), this is a crucial aspect of counter-cinema and of critical discussion of entertainment films. According to the counter-cinema argument, the pleasures of mainstream entertainment films seduce

the spectator into a state of passive receptivity so that ideologically reactionary/conservative 'messages' are allowed free passage. Some critics and film-makers have insisted on the need to dismantle this kind of pleasure, and have called openly for its destruction:

> It is said that analysing pleasure, or beauty, destroys it. That is the intention of this article. The satisfaction and the reinforcement of the ego that represent the high point of film history hitherto must be attacked. Not in favour of a reconstructed new pleasure, which cannot exist in the abstract, nor of intellectualised unpleasure, but to make way for a total negation of the ease and plenitude of the narrative fiction film.
>
> (Laura Mulvey, in Nichols, 1985, p. 306)

While the political and ideological analysis of such theorists and filmmakers has been sound enough, they have ultimately perhaps overestimated the number of people prepared to see films which require hard work. A sequence in *Weekend* consists of a single eight-minute tracking shot showing a (non-'realistic') traffic jam with horns blowing throughout (Fig. 9.1); a single shot in Godard's *Tout va bien* (1972) tracks repeatedly to and fro past the many checkouts of a hypermarket to portray a slowly escalating disturbance in the aisles. Such writers and film-makers have no doubt also tended to underestimate the human need for 'pleasure'; following George Bernard Shaw, even Brecht recognized the strategic importance of providing pleasure for the

Figure 9.1 An everyday traffic jam in Godard's *Weekend* (*Weekend*, 1967, dir Jean-Luc Godard/© Copernic/Comacico/Lira/Ascot/The Kobal Collection)

audience: 'Erst kommt das Fressen, dann kommt die Moral' [loosely translated, 'eating comes ahead of morality']. How effective can counter-cinema and oppositional films be if most people do not want to see them?

The whole issue of how pleasure is produced and why we sometimes experience pleasure (and sometimes not) is a complex one which will be considered further in Chapter 12 below.

7 Fiction versus 'reality': it can be argued that all films, including documentaries, are 'fiction'. Since it is impossible to 'show reality' on film, the aim of counter-cinema has been to force the audience to confront reality: the reality of the film-making, the reality of the viewing experience, each spectator's own social and individual reality. Such is the aim of all the strategies outlined above. Films such as Godard's *Vent d'est* and *Struggle in Italy* (*Lotte in Italia*, 1969) and the early films of the American Jon Jost (for example, *Speaking Directly*, 1974) feature a direct address and implication of the spectator which systematically refuse the usual fictionalizing pleasures of the cinema.

Alternative form and art cinema

After his French New Wave films of the 1960s, Godard gained fame and noto-riety with his Maoist/Marxist-Leninist-inspired 'difficult' period of 1968–72, corresponding to the 'counter-cinema' described above. He was not alone in his politicized rejection of the status quo, but not all film-makers were so dogmatic in their politics. A contrast is provided, for example, by the work of Marguerite Duras, a French writer who turned to film-making in 1971 and proceeded to make some twenty films (see p. 302). While her films conform to a number of aspects of counter-cinema (especially the refusal of identification and of simple narrative structure), her motivation was less a political or ideological programme than simple disgust with the illusionism of conventional film form. More recently, Derek Jarman took the counter-cinema oppositions to the limit with *Blue* (1993), a meditation on life, death, AIDS and art conducted through an otherwise image-less blue screen: meaning is here almost entirely carried by the voice over and music soundtrack.

In some ways almost all 'art' cinema can be seen as more or less rejecting Hollywood's narrative conventions, sometimes in the pursuit of more indigenous story-telling forms. 'Art' films, where they use narratives at all, typically do not contain fully developed 'characters' in the classical sense, and the cause-and-effect chain is often weak or non-existent. The distinction needs to be made, though, between those film-makers who are clearly critical of conventional narrative forms and those whose motivation is some version of personal creativity. While directors such as Godard, Duras and Jarman and also avant-garde structuralist-materialist film-makers such as Michael Snow and Peter Gidal clearly rejected

conventional forms as inadequate (if not downright oppressive), others such as Raul Ruiz and Peter Greenaway have been less obviously political in their playful experiments with narrative forms. The case of film-makers working outside the so-called 'developed countries' and the major film-producing centres (such as Ousmane Sembene, Med Hondo and others) has already been considered in Chapter 4.

What became known as New German Cinema often achieved an effective combination of experimental style and political content. As a loosely delineated movement it lasted from the late 1960s to the 1980s and included directors such as Wim Wenders, Rainer Werner Fassbinder and Werner Herzog. The films were frequently critical of German society, exposing contemporary problems, as in Fassbinder's *Fear Eats the Soul* (1974). In this respect they served a similar function to British Social Realism in the early 1960s, whilst also experimenting with a looseness of style sometimes found in the French New wave of the same era.

While (well-known) directors like Godard, Straub and Fassbinder pursued their political agendas in the glare of critical scrutiny, the 1970s also saw an explosion of film-making in Western Europe by relatively unknown individuals and collectives who were equally committed to political change and to re-educating the spectator. Many of these films became 'unfashionable' over the Thatcherite years (1979–94) and some people now treat them as a kind of political freak show. Nevertheless film-makers like Werner Schroeter, Marc Karlin, the Berwick Street Collective, the Newsreel Collective and Laura Mulvey herself (*Penthesilea*, 1974; *Riddles of the Sphinx*, 1977) (to name but a few) contributed an important chapter to the evolution of film form.

Screenwriting and narratives

> Within the safety and isolation of a darkened theater or in the privacy or comfort of one's own home it is possible to leave the real world behind or at a safe distance and experience emotions, thoughts, feelings, and adventures that would not be encountered in everyday life. In watching a movie or television show, we can experience the love, the hate, the fear, the passion, the excitement, or the humor that elevates our lives, but in a safe, controlled setting.
>
> (Hauge, 1988, p. 3)

Michael Hauge goes on to emphasize that '(t)he screenwriter must elicit emotion in the person who reads the screenplay' (1989, p. 3), a reminder perhaps that without a screenplay there is no film. Just as a film is a particular form of communication, so a screenplay is a particular form of written narrative. The term 'screenplay' is specific to film, as opposed to 'script', which can apply to

film or television. At the beginning of this chapter we noted that by the 1920s particular conventions had become established for films telling narratives. Similarly conventions have evolved for the writing of screenplays, although there was a loosening of these unwritten rules in the 1960s, as there was for film techniques.

The classic three act structure was developed by Aristotle and at its most basic level can be equated with beginning, middle and end. However, just how valid such a structure is for film has been questioned. As a percentage of total screen time Act one tends to be approximately twenty-five per cent, Act two fifty per cent and Act three twenty-five per cent. One page of a screenplay lasts about one minute. Act two is therefore likely to have a duration of one hour. Acts are traditionally identified as ending with a major event so it can be seen that one hour is a substantial period of time without a major event. Kristen Thompson has suggested that in reality films tend to have four acts, which she identifies as set up, complicating action, development, and climax. Even Syd Field, a respected screenplay theorist who focuses on a three act structure, has referred to Act two as having a 'middle', in other words more than one part.

Syd Field identifies Act one as the set up. The main characters are established and the hero is given a motivation that is supplied by the 'inciting incident', an event that turns the established situation upside down. This event frequently happens about ten minutes into a film and hooks us into the narrative. We have become acquainted with the main characters and want to see how the hero will resolve the problem that has been introduced.

The hero, the protagonist who is now in conflict with the antagonist who caused the problem, starts on her/his quest to resolve the disruption to the previous equilibrium. By the end of Act one the protagonist typically encounters a major obstacle, a reversal of momentum, a turning point which requires her/him to take a different approach in Act two. This complication brings Act one to a close. Assuming the context of a two-hour film, within this Act there are likely to have been between ten and fifteen scenes, each scene leading up to a minor event.

Act two typically has between twenty and thirty scenes and consists of further complications, both major and minor, identified by Syd Field as 'turning points'. The conflict between the main character and her/his opponent increases, building tension, drawing upon the sympathy we have for the hero. Each scene reveals more about the hero and moves the story forward until we reach a crisis point at the end of Act two.

Act three requires the hero to take radical action to overcome the mounting obstacles in her/his way if s/he is to restore the balance that existed at the beginning. Act three moves towards the climax in which the hero faces a final showdown which will result in success or failure. We normally expect success, we get what we want, a happy ending. All that remains is for the loose ends to be tied up, for unanswered questions to be settled, which completes the resolution.

The vast majority of screenplays get nowhere near to being filmed. Success comes from a mix of creativity and technique plus luck and timing. Just as a film may be described as having effective *mise en scène*, stunning cinematography or powerful editing, so a screenplay can be described as engrossing, moving, well paced.

At the heart of the story are the main characters, whom we follow as they pass through various events, act in particular ways and communicate through their dialogue. Memorable characters have depth; they are 'rounded'. In other words they are well developed and believable, which tends to mean they are also unpredictable, flawed and psychologically complex. This applies to the antagonist as well as the protagonist and having a villain who knows the hero's weaknesses is an effective way to create tension. The relationship between hero and villain is of vital importance.

Secondary characters are likely to be 'flat', underdeveloped, predictable, stereotypical, and psychologically simple. They aren't as essential to the story as the primary characters so don't need to stand out; they don't carry the story. The primary characters are likely to be on a personal journey throughout the story. It is to be expected that they will change in some ways. It is important that there is a character arc, a transition in who they are from beginning to end.

The story itself can also aim for depth, not just in the themes, values and issues it may contain but also in how it is structured. As well as the primary storyline, there may also be subplots, secondary stories that underpin the key events. Subplots may involve the main characters or only characters linked to them. Depth can also be added to dialogue and actions through the creation of subtexts, other meanings that lie behind apparent meanings. What we see and hear can be taken at face value or it can be that there are hidden meanings, ulterior motives.

As indicated earlier, screenwriting is a particular form which requires particular formats, skills and approaches. Syd Field advises that you should know your ending before you start. Robert McKee suggests that the aim should be to give the audience what it wants but not the way it expects it. It's probably fair to say that luck is also a factor in whether or not a screenplay becomes successful. As the successful screenwriter William Goldman wrote, '(n)obody knows anything' (1985, p. 39), by which he meant that studio executives who commission a screenwriter and proceed with producing a film never know if it will be successful until it has been released. Previews and reviews may go well but they don't guarantee box-office takings. Timing and marketing are also central ingredients.

The Player (1992), a satire on Hollywood, gives a harsh but reportedly realistic insight into the movie industry. The film begins with a Hollywood hopeful pitching ideas and moves forward into further cynicism with a screenwriter taking extreme action after his pitch is rejected. If there is a lot of luck that accompanies skill for a screenwriter to be successful, it is also the case that there are routines that accompany the business. The whole process of commissioning

has several stages and for the successful screenwriter, at one stage or another, completion of the following is likely to be crucial:

 i) logline (a one-sentence description of the story),
 ii) synopsis (a one-paragraph description of the story),
 iii) step outline (a one-sentence description of each scene),
 iv) treatment (a one-paragraph description of each scene).

CONCLUSION

It can certainly be argued that the distinctions drawn here between Classical Hollywood Narrative and alternative forms are less clear than they once were. According to Richard Maltby, following the collapse of the classical Hollywood studio system and the need for innovation during the spread of television in the 1950s, the following two decades (from 1960 to 1980) saw a considerable loosening of the Classical Narrative conventions as they have been outlined in the above pages, a loosening which was hastened by the lifting of many censorship restrictions and by growing social liberalization. It is interesting to note, however, that Maltby (1995, pp. 221–8) also notes evidence of a return to classical Hollywood storytelling in 1980 (his example is *Ordinary People*), and links this to a return to more conservative family and other ideologies, also evidenced by the political regimes in Britain and the USA during that decade. If the narrative landscape of commercial films has evolved since the 1980s, perhaps incorporating and neutralizing some aspects of the previously revolutionary counter-cinema, it is perhaps time to introduce the notion of the postmodern ... but we shall have to wait until Chapter 12 to do so.

Exercise 9.5

Try applying the counter-cinema definitions to a recent commercial film. If the film seems to fit in with some counter-cinema criteria, how would you explain this?

Finally it is worth stressing that counter-cinema films were (on the whole) not made as part of some cruel, perverse joke. Many counter-cinema films are rich, dense texts which can reward the work necessary in watching and studying them. But such films are rarely 'entertaining'.

SUMMARY

↝ Whatever the exact structure, style or content of a mainstream narrative, particular film techniques tend to be used in order that the narrative may be presented coherently, so that the audience does not have to work too hard to understand.

↩ These techniques were consolidated with the rise of the Hollywood studio system: continuity editing ensures that the narrative is easily understandable by arranging shots in a certain order, and appropriate use of shot sizes guides the viewer through the narrative.

↩ These film techniques, together with the narrative techniques we have been looking at, gave rise to Classical Hollywood Narrative.

↩ Alternative narratives and styles have rejected the classical narrative model.

↩ These alternative modes of film-making have often been politically motivated and have rejected ideologies associated with 'entertainment'.

↩ Peter Wollen's idea of 'counter-cinema' provides a useful way of analysing oppositional film-making strategies.

REFERENCES

Buckland, W. (1998), *Teach Yourself Film Studies*, London: Hodder Headline.

Goldman, W. (1985), *Adventures in the Screen Trade*, London: Macdonald & Co.

Hauge, M. (1988), *Writing Screenplays that Sell*, London: Elm Tree Books.

Maltby, R. (1995), *Hollywood Cinema: An Introduction*, 1st edn, Oxford: Blackwell.

Nichols, B. (ed.) (1976), *Movies and Methods*, Berkeley, CA: University of California Press.

Nichols, B. (ed.) (1985), *Movies and Methods II*, Berkeley, CA: University of California Press.

Schatz, T. (1993), 'The New Hollywood', in J. Collins, H. Radner and A. Preacher Collins (eds), *Film Theory Goes to the Movies*, London and New York: Routledge.

Truffaut, F. (1978), *Hitchcock*, London: Paladin.

Vogler, C. (1992), *The Writer's Journey*, London: Boxtree Books.

Wollen, P. (1972), 'Godard and Counter-cinema: Vent d'Est', originally in *Afterimage*, no. 4, Autumn; reprinted in Peter Wollen (1982).

Wollen, P. (1982), *Readings and Writings*, London: Verso.

FURTHER READING

Barker, M. (1989), *Comics: Ideology, Power and the Critics*, Manchester: Manchester University Press.

An excellent examination of the role of ideology; also contains a very useful account of Vladimir Propp's work on character and narrative functions.

Bordwell, D. and Thompson, K. (2003), *Film Art: An Introduction*, 7th edn, New York: McGraw-Hill.

A very good thorough book with excellent use of film stills.

Bordwell, D., Staiger, D. and Thompson, K. (1985), *The Classical Hollywood Cinema: Film Style and Mode of Production to 1960*, London: Routledge & Kegan Paul.

A very detailed examination of Hollywood, the film industry and film style.

Burch, N. (1973), *Theory of Film Practice*, London: Secker & Warburg/BFI.

Though a little thin on the practical side of film-making, this book was highly influential in 1970s Film Studies.

Comolli, J. L. and Narboni, J. (1976), 'Cinema/Ideology/Criticism', in B. Nichols (ed.), *Movies and Methods*, Berkeley, CA: University of California Press.

A crucial article in the development of ideology-critique theory.

Cook, P. (ed.) (2007), *The Cinema Book*, 3rd edn, London: BFI.

Thorough and wide-ranging, if challenging in places.

Field, S. (2005), *Screenplay: The Foundations of Screenwriting*, New York: Delta.

How to write a screenplay.

Hennebelle, G. (1974), 'Z-Movies, or What hath Costa-Gavras Wrought?', in *Cineaste*, vol. 6, no. 2, pp. 28–31.

Together with the Monaco piece below, part of a typical polemic from the 1970s: can thrillers and other mainstream narrative films be politically effective? Hennebelle says *no*.

Maltby, R. (2003), *Hollywood Cinema: An Introduction*, 2nd edn, Oxford: Blackwell.

A useful book on the relationship between Hollywood, its films and its audiences.

McKee, R. (1999), *Story*, London: Methuen Publishing.

Successful screenwriting, from one of the gurus of the trade.

Monaco, J. (1976), 'The Costa-Gavras Syndrome', in *Cineaste*, vol. 7, no. 2, pp. 18–22.

Together with the Hennebelle piece above, part of a typical polemic from the 1970s: can thrillers and other mainstream narrative films be politically effective? Monaco says *yes*.

Mulvey, L. (1975), 'Visual Pleasure and Narrative Cinema', originally in *Screen*, vol. 16, no. 3, Autumn; reprinted in Bill Nichols (1985).

Perhaps the most referenced single film-theoretical article ever written. You have to read it to know what the fuss was about.

Neale, S. and Smith, M. (eds) (1997), *Contemporary Hollywood Cinema*, London: Routledge.

A useful book on more recent Hollywood.

Nichols, B. (ed.) (1976), *Movies and Methods*, Berkeley, CA: University of California Press.

Nichols, B. (ed.) (1985), *Movies and Methods II*, Berkeley, CA: University of California Press.

Both the Nichols volumes contain many crucial articles from the history of film theory which any serious film student should read.

Schatz, T. (1981), *Hollywood Genres: Formulas, Filmmaking and the Studio System*, New York: Random House.

Schatz was one of the most knowledgeable and painstaking writers about Hollywood.

Thompson, K. (1999), *Storytelling in the New Hollywood*, Massachusetts: Harvard University Press.

New modes of film storytelling: how have they changed?

Vogler, C. (1992), *The Writer's Journey*, London: Boxtree Books.

An interesting more recent version of Vladimir Propp's typology of character and narrative functions.

Walsh, M. (1981), *The Brechtian Aspect of Radical Cinema*, London: BFI.

A clear exposition of the importance of questions of film form to political film analysis.

Wollen, P. (1969, 1972, 1987), *Signs and Meaning in the Cinema*, London: Secker & Warburg (also London: BFI, 1997).

Historically important accounts of the ways in which semiology and auteur ideas were incorporated into British film theory.

FURTHER VIEWING

A Personal Journey with Martin Scorsese through American Cinema (BFI, 1995)
A fascinating insight into the techniques of many of the USA's best known genre films. BFI, 21 Stephen Street, London W1T 1LN

Late Review: Robert McKee (BBC, 1989)
Documentary about Robert McKee's method for teaching screenwriting. BBC Active, BBC Television Centre, Wood Lane, W12 7RJ

The South Bank Show: William Goldman (ITV, 2009)
Fascinating interview with one of Hollywood's most successful screenwriters who has written extensively about his craft. ITV plc. 200 Grays Inn Road, London WC1X 8HF

Visions of Light (The American Film Institute, 1992)
A well-made documentary about the role of the cinematographer. American Film Institute, 2021 N. Western Avenue, Los Angeles, CA 90027-1657

Chapter **10**

Film technology

In this chapter we shall focus on the ways in which film as a specific form of communication requires technology. In Chapter 1 on early cinema, we examined the emergence of photography, the development of the zoetrope and its provision of the first moving images. Here we shall trace the main developments in film technology over the last century, focusing on the camera, sound, colour, deep field photography, projection technologies and computer and digital technologies.

Technology, industry and audience

In some senses, the history of film is a hundred-year tale of innovation as film-makers attempted to translate stories into moving images. Film has always relied upon technology; as a form of art, it is one of the most technological. Arguably,

cinema is technology and thus examining technology is crucial to understanding film itself. Technological developments have affected film-making in two ways: film-makers have utilized new technologies to make films, and films have consequently increasingly reflected on the consequences of the use of such technology. As media guru Marshall McLuhan (1974) put it, 'the medium is the message'.

It is not our intention, however, to present technological developments as a simple or uninterrupted linear progression. As will be seen, improved film technology was not always welcomed initially or used immediately upon its emergence. Indeed, in many cases, the technology already existed some years (even decades) prior to its widespread adoption. The explanation behind this delay can partly be explained by the studios' assessment that the initial expense was too great and too risky and would disrupt the financial status quo.

The adoption of new processes closely mirrored their context. The initial financial risks of investing in new technology were later justified by potentially greater losses in revenue by not doing so. Thus, rather than being led by the new technology itself, the film industry reacted to social, economic and cultural factors (usually declining audiences) by utilizing new processes. In this way, it sought to regenerate itself and to present cinema as a 'novel' experience. As in any industry, complacency could lead to stagnation. Furthermore, just as the studios had specialized in particular genres or sets of genres in an attempt to attract customer brand loyalty through product differentiation (see Chapter 2), the adoption of new technologies led to each studio attempting to outdo its rivals in the bid for a greater market share.

The camera

The camera is the device with which the cinematographer captures a series of progressive images on a strip of film. Early pioneers in cinematography struggled with the problem of capturing clear, sharp moving images and were indebted to a combination of three constituent technologies, two of which were not particularly new. Lens manufacture, for example, had already become a healthy industry in the years since 1827 when photography was invented.

The technology for rapidly repeated exposure of a light-sensitive emulsion to light admitted through an aperture had also existed for some time: all that was needed was a motor designed to turn at the appropriate speed which triggered repeated opening and closing of the aperture, initially sixteen or eighteen times per second (twenty-four after the coming of sound in 1927–9), to take this number of photographs each second. It was a relatively simple matter to adapt the kind of mechanism used in a sewing machine, which had been invented in the 1840s.

The last piece of the technological jigsaw to be developed was the flexible celluloid emulsion-coated strip which could weave its way through the motor

without breaking. Early experiments such as those of Eadweard Muybridge and Jules Marey (who were interested in studying movement rather than inventing film) in the 1880s had generally been carried out with non-flexible plates, but in 1888/9 George Eastman developed the first flexible film, made first of paper, then celluloid. He christened this 'Kodak'.

Over a century later it is too easy to forget how established much of the early technology was to become. Although the Lumière camera-projector was hand-cranked (and so could be used in the most remote locations with no need for electricity), basic camera technology had changed little a century later; the four-sprocket 35mm film developed by Edison has remained standard and the earliest films can easily be shown on the most modern film projectors.

Initially, cameras were static, and most movement was restricted to panning and tilting from a fixed tripod. There were early experiments such as placing the camera on a boat or a train; the Lumière brothers and D. W. Griffith moved their cameras, but to a limited extent. The cinematographer of F. W. Murnau's *The Last Laugh* (*Der letzte Mann*, 1924), Karl Freund, however, was the first to move the camera backwards and forwards, up and down and side to side, to great dramatic effect. The style of German Expressionism (of which Murnau was an exponent) gradually found its way into US film.

The introduction of sound, however, introduced particular problems for camera movement. Omni-directional microphones often picked up the sound of the noisy camera. As a result, cameras were encased within soundproofed, static 'iceboxes', which limited movement, allowing only 30-degree tilts and pans.

During the 1930s, dubbing or post-synchronization released the camera from its icebox. Camera mobility was further facilitated by the invention of the blimp – a lightweight, soundproof casing that muffled the whirr of the camera's motor. Tracking was made easier by the introduction of a wide range of camera supports, manoeuvrable dollies and boom cranes. It is alleged that the first actual crane shot was developed for Paul Fejos' *Broadway* in 1929, but perhaps its finest moment came in *Gone with the Wind* (1939) when the camera tracks Scarlett O'Hara walking among the Civil War casualties at the railroad station.

Crane shots give a remarkable scope of choices to the film-maker; s/he can follow an actor up a flight of stairs; pass over crowds of people and focus on a single person; track an individual from a distance; move over obstacles; move off from heights and into space or provide an aerial view of a scene.

In 1922 and 1923 respectively, 9.5mm cameras and 16mm film stock (in contrast to the professional 35mm) were introduced, which meant smaller and lighter cameras and less expensive filming. Cameras became (just about) light enough to be hand-held, significantly assisting the development of documentary film. During the 1940s, a new generation of documentary film-makers became increasingly dissatisfied with the sedate tripod-restricted techniques of established documentary, and encased the camera in lighter metal to

make it more portable. In 1960, André Coutant used a prototype of a silent-running, hand-held 16mm camera to make Jean Rouch's *Chronicle of a Summer* (*Chronique d'un été*); the new camera was marketed as the Éclair in 1962. This allowed film-makers to move into areas once too restrictive for filming and allowed close tracking of movement. Hand-held camera movement produces an unsteadiness which can be used for a variety of effects, such as 'realism', immediacy or grittiness, as it can represent a character's point of view or emphasize the camera operator's situation amidst the action.

The introduction of the steadicam by Garrett Brown in 1973 allowed for hand-held-style shots combined with smooth movement. Rather than using dolly track to produce smooth camera movement, the camera was strapped to its operator by means of a hydraulic brace incorporating a series of shock absorbers. This removed the shakes and bumps that accompanied footage recorded by a hand-held camera, allowing free movement over rough terrain or where track could not be laid, for example on steps. Steadicam was used to follow Sylvester Stallone running up the steps of the Philadelphia Museum of Art in *Rocky* (1976). Its most notable user was Stanley Kubrick, who used it for various sequences in *The Shining* (1980). It was also used in *Goodfellas* (1990) to follow Henry Hill (Ray Liotta) as he enters a nightclub via its rear entrance.

The advance of digital cameras has now made moviemaking more accessible and cheaper. Digital 'film' is much cheaper to shoot, and the new technology allows the film-maker to capture much more footage than do conventional film and cameras. Furthermore, digital cameras allow the operator to do much more with much less training. As Jean-Pierre Geuens pointed out:

> The exposure can be immediately adjusted to any light level,
> brightening up even the darkest areas. The colors can be programmed
> to match whatever light sources are being used or can be extravagantly
> tweaked for all sorts of expressionistic effects. Tone, grain, contrast, and
> density can be altered to provide a specific look. Shutter adjustments
> can be refined to produce stunning visual effects in any movement.
> Fades and dissolves can be adjusted on the spot for maximum impact.
> A black-and-white look can be substituted for color at any time,
> and different composition ratios are equally available at a moment's
> notice. Other filters of less appeal stand ready to implement yet other
> transformations of the image.
>
> (Geuens, 2002, pp. 19–20)

According to Mark Cousins, digital film has a double benefit. 'The digitisation of the film process is not only changing the techniques of cinema, but protecting films against decay' (Cousins, 2005, p. 67). In 2000 Clint Eastwood's *Space Cowboys* became the first US film to be shot in high definition (HD), a new class of high-resolution digital format which combines with Dolby Digital Surround Sound to create image and sound of exceptional quality.

Exercise 10.1

Look at sequences from *Rocky, The Shining* and/or *Breaking the Waves* (1996) and any other films of your choice. Try to identify the types of camera movement used.

Advances in camera mobility seem to have been derived principally from aesthetic rather than commercial choices, the impetus being from the individual film-maker who desired to create a certain effect. Indeed, where camera mobility conflicted with commercial considerations like the introduction of sound, it was readily discarded as sound film was seen to be a greater crowd puller than camera movement.

//////////

Sound

The transition from silent to sound film was not a harmonious one. Experiments with sound began with the birth of motion pictures itself and between 1900 and 1925 sound systems proliferated. The studios, however, were unwilling to invest the sums needed to convert to sound production and they did not want to tamper with a profitable business. Initially, it was feared that conversion to sound might herald the collapse of the film industry itself. New sound studios would have to be constructed, cinemas would have to be wired for sound, a huge back cata-logue of silent films would become redundant, the foreign market would collapse as easily translated titles would have to be dubbed and stars would need to be retrained. Sound was also vigorously opposed by film theorists and directors such as Münsterberg, Arnheim, Chaplin and Kurosawa, who felt that cinema might be permanently hindered by the public's fascination with a passing fad.

Two studios, however, perceived the situation somewhat differently, acknowl-edging that sound enhanced the film-viewing experience, but that full-scale pit orchestras and Wurlitzer organs were too expensive. After the First World War, the search for a cheap but effective way of recording film sound intensified. Fox Film Corporation began developing their own sound system – Movietone – believing that the introduction of sound in their studios and cinemas would allow them to compete with the pit orchestras of their rivals. At the same time, Warners acquired a sophisticated sound-on-disc system called Vitaphone. In 1926 they presented *Don Juan* in Vitaphone followed by *The Jazz Singer* in 1927, heralding the intro-duction of sound in terms of music and effects. Just prior to *The Jazz Singer*, Fox had presented *Sunrise* (1927) using their competing system, Movietone.

This sound technology, however, was only single-track, meaning that it was not possible to have both soundtrack music and dialogue at the same time. Audiences, therefore, still had to wait for speech, as the dialogue-only sections of the film

were still communicated by titles. Warners, though, shrewdly allowed some of Jolson's ad-libbed dialogue to remain in the finished film and audiences were amazed not only by the singing and dancing Jolson, but also by his informal and spontaneous speech. At one point, he tells the audience, 'You ain't heard nothing yet'. *The Jazz Singer* was an international success grossing over $3.5m. This was followed by the release of *The Lights of New York* – the first completely sound commercial film – in 1928.

The popular success of these films showed that sound attracted large audiences and, therefore, could not be ignored. In a bid to catch up with Fox and Warners, the other studios rapidly converted to sound production. In part, the impetus was economic. Audiences had been declining since 1926, 1927 had been a bad year for the US film industry (with the exception of Warners) and the forecast for the following year was worse. The public seemed to be bored by formulaic production methods and heavily promoted stars. In addition, cinema was facing competition from the wider availability of cars and radios. Following the Wall Street Crash of 1929, the United States was thrown into an economic depression which further affected the film industry, and sound was the new attraction to lure audiences back into the cinemas. By 1932, silent films had been largely forgotten and 'talkies' helped to distract audiences from the harsh realities of everyday life. The major US studios were also keen to extend their grip over the film industry abroad and so began converting European cinemas to sound in order to capitalize on sound's popularity. The UK, in particular, became the major foreign market for US sound films.

The effect of sound on the film industry was radical. The camera's mobility became restricted as it now had to be enclosed in a soundproof booth, actors were grouped around concealed microphones, and close ups and complex editing were all but abandoned. Many silent film stars lost their jobs as their voices were not adequate and they were replaced by a new wave of Broadway actors, accompanied by scriptwriters who could write dialogue – the 1952 musical comedy *Singin' in the Rain* addressed exactly this subject. Sound led to the creation of new genres and the decline of old ones. The comedies of the Marx brothers and W.C. Fields replaced those of Charlie Chaplin and Buster Keaton. Musicals, in particular, benefited immensely from the developments in sound technology. Initially, musicals were little more than unsophisticated, photographed versions of Broadway productions, but they developed so quickly that by 1933 they had become a major US genre. The acoustic interiors of cinemas were transformed from concert halls to spaces with fewer echoes, thus increasing the comprehensibility of the dialogue. By the mid-1930s, soundtrack dubbing (whereby other soundtrack elements like music and sound effects would automatically be lower in volume under the recorded dialogue) and post-synchronization (post-recording sound, particularly dialogue, after the film has been shot and edited so that the new sound is synchronized with the on-screen images) had been perfected. This allowed film-makers to include overlapping lines, off-screen dialogue and

voice-over narratives. Films could now be dubbed into foreign languages easily, which meant that US films could be enjoyed around the globe.

Initially, the soundtrack was recorded on discs that were synchronized with the film, but this proved to be unreliable and gave way to the optical recording of sound onto the film stock itself. By the 1950s this was in turn replaced by sound recorded on magnetic tape and played back in optical stereophony to accompany the new widescreen formats (see below). Indeed, it was the arrival of these formats that led to the almost total conversion from optical to magnetic sound recording. In the following decade more improvements such as the Dolby System were developed; this reduced background noise, producing better fidelity for the soundtrack. Sound designer Walter Murch pioneered the use of sound technology to revolutionize film soundtracks in such a way that music and other sound effects combined with visual images to produce a harmonious whole. Using multi-track sound, Murch filled the cinema with noise, for example the synthesized whirr of the helicopter blades in *Apocalypse Now*. Such techniques, though taken for granted today, were innovative at that time.

Originally stereophonic, Dolby has now become Surround Sound, filling cinemas with sound effects and music from speakers located both to the side and to the rear of the audience. During the 1980s two rival systems were introduced: George Lucas' THX Sound System, premiered with his *Return of the Jedi* in 1983, and Digital Theatre Systems, which is by far the more popular format. In 2000 sound was being digitized, which has made postproduction simpler and more flexible while giving greater clarity, resonance, range and fidelity inside the cinema. Although some films are still released with only an analogue soundtrack, more and more are released for digital audio systems.

In the early days of film sound, dialogue and singing were privileged, but newer sound technology allows the recording of multi-track sound, of complex layers on the same soundtrack. Now, sound, music and dialogue can co-exist, lending a heightened 'realism' and greater emotional power.

Exercise 10.2

Discuss how far technological advances have contributed to the success of the film industry.

//////////////

Colour

Again, as was the case with sound, colour technology was experimented with from the earliest days of the cinema (Méliès hand-tinted his films), but was rarely used because of technical difficulties, the time-consuming nature of hand-colouring and the expense involved. Even the commercial success of Technicolor's first two-strip feature, *The Toll of the Sea* (1922), did not lead to a

major conversion to colour production; nor did use of improved Technicolor in films like *On with the Show* and *Gold Diggers of Broadway* (both 1929). By 1932 production of Technicolor films had all but stopped as audiences were unsatisfied with the two-colour process, but in 1934 Technicolor bounced back with Rouben Mamoulian's *Becky Sharp*, using a three-strip of cyan, magenta and yellow. Its commercial success led to the release of further three-colour films culminating in *Gone with the Wind* (1939) and The *Wizard of Oz* (1939), the latter of which dramatically highlights the transition from black and white to colour as Dorothy enters the fantastic land of Oz.

Earlier, in 1937, Walt Disney had released *Snow White and the Seven Dwarfs* – the first animated colour feature film. The commercial viability of colour had been established, but its rise was interrupted by the onset of the Second World War.

Film-makers began to use colour widely during the 1950s for two main reasons. First, the newly developed Eastmancolor was both cheaper and more convenient and had successfully challenged Technicolor's monopoly. By 1953, it had replaced Technicolor as the most widely used colour film stock. Second, the increased competition from television is the primary explanation for the US film industry's speedy shift from black-and-white to colour production between 1952 and 1954. The major studios attempted to respond to the advent of television, which had enticed 30 per cent of the cinemagoing audience away from the big screen, by singling out and highlighting film's advantages over black-and-white television: size (see below) and colour. In 1947 approximately 12 per cent of the US film industry's films were in colour, but by 1954 this had increased to over 50 per cent. Nonetheless, by the end of the 1950s 50 per cent of US films were still in black and white, which was only abandoned when television converted to colour in the 1960s.

Although colour had become the norm for high-budget productions, low-budget films, particularly the independent science fiction and horror B-movies of the 1950s, tended to remain in black and white primarily as a result of commercial considerations. Since the 1950s, colour cinematography has vastly improved in subtlety and sophistication and today the overwhelming majority of mainstream commercial films are in colour. Those that remain in black and white are so either for financial reasons (e.g. independent films like *Clerks*, 1993) or for aesthetic ones (e.g. *Schindler's List*, 1993). Such aesthetic choices are also often linked to 'diegetic motivation': the choice between black and white and colour can be explained in terms of the narrative. The black-and-white *vérité*-style footage in *The Blair Witch Project* can be 'explained' as student research material.

Deep field photography

Just as there was for sound and colour technologies, there was a gap between the technological possibility of deep field photography and its acceptance and use. Deep field photography had always been possible in sunlight and even the Lumière brothers

had used it, but US cinematographers resisted departures from the established style of soft tonal qualities and shallow depth of field. The emergence of deep focus cinematography as an acknowledged visual style is usually dated to Gregg Toland's cinematography for *Citizen Kane* (1941), but Jean Renoir had employed deep focus in the late 1930s (*La Grande Illusion*, 1937; *Rules of the Game* (*La Règle du jeu*), 1938), as had John Ford in *Stagecoach* (1939). But it was *Citizen Kane* that introduced the technique to the wider public (see also Chapter 8 on the language of film). Deep field cinematography simultaneously keeps all planes of an image – foreground, middleground and background – in equally sharp focus, giving the viewer the whole scene without guiding his/her attention. In contrast, shallow focus guides the audience's viewing by emphasizing a single plane of the image, usually the action, behind or in front of which everything else is blurred.

The emergence of deep field photography can be traced to two main considerations. The first factor in the use of deep focus was the rise in photojournalism and the social realist and documentary film movements of the 1930s. Influenced by these movements, film-makers increasingly made an aesthetic decision to replicate the perspective and realism of this photographic style. The second factor was the availability of new film-making equipment. From the mid-1930s to 1939, improved carbon arc lights replaced the silent Mazda incandescent tungsten lamps (another side-effect of the coming of sound), and faster film stock (which was more sensitive to light), enhanced emulsion types and new lens coatings allowed light to be used more efficiently, leading to more effective screen illumination, image contrast and sharpness of focus. These technological developments enable a fast shutter speed to be combined with a small aperture, which results in deep focus. Although the use of deep focus seems to derive from an aesthetic choice based on the accessibility of new technology, an economic dimension on the part of the studios can also be observed as they strove to improve their market position by developing a new look for their films.

Projection technologies

Since the earliest days of film, film entrepreneurs have struggled with different ways of exhibiting films. Projection refers to the process whereby photographed images are projected on a screen (and thus enlarged) so that their rapid consecutive appearance creates the illusion of movement through persistence of vision (and/or via the phi-phenomenon). It was the Lumière brothers – whose ownership of a factory manufacturing photographic materials was no doubt a great help – who developed the projection system which immediately spread all over the world. The remarkable feature of the system was its simplicity and compactness: the same basic hand-cranked motor served to operate both the camera and the projector, which formed a portable unit. The same system could also be adapted for developing and printing the film.

In the first year of their operations, the Lumière brothers trained several dozen camera operators/projectionists, who promptly travelled to all parts of the world, where they filmed the early 'actualities', developed and printed the film themselves, and often projected the results for the amazed locals. During the silent era films were filmed and projected at the rate of 16–20 frames per second (fps), the speed being variable as the motor was at first cranked by hand. With the advent of sound and the need for standardization to enable sound–image synchronization, a common speed of 24 fps was agreed on (and for films converted to video this has become 25 fps for the PAL system and 29.97 fps for the NTSC system). This is why characters in silent films screened at 24 or 25 fps seem to move so quickly!

For the remainder of this chapter, we will concentrate on the film industry's response to declining audience trends from the 1950s onwards, which led it to release new films in new formats and to introduce new projection and viewing technologies, the most significant being widescreen, 3D, IMAX/OMNIMAX and digital projection.

Widescreen

Widescreen refers to any film screening for which the ratio of the width of the projected image to its height (called the aspect ratio) is greater than 4:3 or 1.33:1 – the standard ratio used in the industry from silent film until the early 1950s, also called the Academy format. During the 1920s there were experiments with several different widescreen systems in the USA, such as Magnascope, Fox Grandeur, Vitascope and 70mm Wide Film, but these processes were expensive and did not provide high quality pictures. Meanwhile, in France, *Napoléon* (1927) was screened using 'Polyvision', whereby three projectors showed a triptych of images across three screens to create a panoramic shot. This process was improved in 1952 when Cinerama (based on Gance's Polyvision) introduced a curved screen, stereophonic sound and three projectors. The screen went beyond the field of vision, which is about 160 degrees, giving the illusion that the audience was actually 'in' the film. In the following year, Twentieth Century Fox brought out *The Robe* using its cheaper widescreen alternative, CinemaScope, which required only a single camera with a special anamorphic lens (again such lenses had already been made in the nineteenth century) that squeezed an image onto standard 35mm stock, which was then stretched back to its original format during projection. Screens were double the width of the normal screen and slightly curved to give the illusion of depth. CinemaScope was so successful (by 1955 more than 20,000 cinemas around the world had installed it) that foreign companies copied the system, using similar names – Franscope (France), Ultrascope (Italy), Agascope (Sweden), Sovscope (USSR) and Tohoscope (Japan).

Paramount responded by introducing its own process, VistaVision, and this was soon joined by Todd-AO. From 1960 onwards, however, Robert Gottschalk's

Panavision gradually superseded all of these widescreen processes, so that it is now almost the only process used in 35mm widescreen filming.

Despite its expense and difficulty of use, the studios were keen to invest in widescreen during the 1950s because audiences, unable to resist the allure of television, were declining: cinema attendance dropped from 90m per week in 1948 to 51m in 1952. It has also been argued that during the postwar period, audiences had a greater choice of leisure activities and many were now moving to the newly established suburbs, away from city-centre cinemas. As a result, films had to engage their audiences in a more spectacular fashion. The 1950s widescreen, employing a ratio of at least 1.66:1, provided a visual experience that television could not emulate, and this was exploited by film-makers. The new, altered screen formats led to a dramatic change in *mise en scène* as directors began to use horizontal space much as depth of field was explored during the 1940s. Editing became secondary to shooting long, uninterrupted scenes, as each frame was now wide enough to display a close up, a medium shot and a wide angle simultaneously. The viewer was involved in the space of the film and brought closer to the action with a greater immediacy than ever before. Particular genres, such as historical or epic dramas (*The Ten Commandments*, 1956) and Westerns (*The Searchers*, 1956) became natural choices for the widescreen format. Indeed, the post-studio system's taste for the blockbuster was facilitated by the new technology (see Chapter 2 on US cinema).

3D

3D, whereby the three-dimensional illusion of depth is created by making the foreground stand out in relation to the other planes of the image, was experimented with as early as the 1920s. It did not take off, however, until the 1950s, when the US film industry used the technology as a further ploy to draw audiences away from their TV sets and back into the cinemas. In 1952, 3D projection called Natural Vision was introduced with Arch Obeler's *Bwana Devil*, and 69 Natural Vision films were made by the end of the following year. Other studios released 3D productions and soon more technical innovations were pioneered: Vistarama, Superscope, Naturama, AromaRama and Smell-O-Vision. These processes, however, were flawed, expensive and failed to attract a lasting audience. They were novelties that were deemed not to be worth the expense and they died out after a few years. During the 1960s, the main advance was the new optical system, Panavision, which allowed 35mm film to be enlarged to 70mm width without the need or expense of wide film production.

IMAX and OMNIMAX

The above widescreen processes have, however, been improved upon and surpassed by the advent of IMAX 3D technology, which premiered in 1970 in Japan, and the first IMAX cinema opened at Ontario Place's Cinesphere in

Toronto the following year. 'IMAX' stands for 'image maximization' or 'maximum image', as it fills the field of human vision by producing an image as large as 20 metres high and 26 metres wide. IMAX uses a 15-perforation/70mm film format, which is not only supposedly the largest in the world, but is also ten times bigger than that of conventional 35mm film. The size and scale produce extraordinary clarity and sharpness. A six-channel Surround Sound soundtrack is synchronized with the film, and the audience sits on a series of elevated rows at a 30–45 degree gradient and so feels immersed in the picture. Since 1996 approximately 200 IMAX cinemas have opened world-wide, including the BFI cinema at Waterloo, London.

Reflecting the 1950s, IMAX technology can project films in both 2D and 3D. The spectator wears a special headset with left and right liquid-crystal lenses and a 'personal sound environment' that encases the six-channel soundtrack. OMNIMAX (or IMAX DOME) uses the same system, but with a fisheye lens for projecting a 165-degree image on a giant dome screen surrounding the viewer with high-fidelity sound, thus increasing the spectator's feeling of immersion. IMAX technology has not, however, spread throughout the industry. Films must be specially shot and are shown in purpose-built cinemas. The system's use of 3D is still some distance from 'realism' and the screen at times proves to be too large for comfortable viewing. The first feature length IMAX 3D film was *Polar Express* (2004), a children's Christmas story. Frequent movement towards the camera and scenes of falling snow are well suited to 3D, creating a visually engrossing experience. The relatively simple storyline ensures that the emphasis on vision does not detract from our understanding of the narrative.

Digital projection

In the summer of 1999, *The Phantom Menace* was the first film to be screened in the United States using digital projection equipment. Computers, microchips and liquid-crystal displays replaced the traditional projector and reels of film. Where traditional analogue projection uses a signal corresponding to the original light and sound waves of the subject, digital projection converts the image and sound into an electronic coding through a binary series of zeroes and ones. In 2000, *Toy Story 2* was the first film screened in the UK using digital projection. As Michael Atkinson stated, it was 'the first time in the history of the 104-year-old medium that a movie made its way from conception to execution to projection without ever involving a single foot of film' (2000, p. 9). Atkinson does not make the point, however, that arguably the medium itself is no longer 'film' per se as it no longer always uses film. Digital projection hints at the end of the traditional pattern of film production and distribution that has been the norm for over a century. No longer will image and sound need to be captured on moving reels of negative film that are then developed, cut and spliced together,

and transported to cinemas to be projected by bright light onto giant white screens. Instead, digital films can be beamed directly via satellite from studio to exhibitor with no loss in quality. At present, film distribution is vastly expensive and hence a whole industry has grown around it. Hundreds, if not thousands, of copies of films are distributed around the world at a cost of £3m for a global release. Since the advent of digital technology, however, such inconvenience and expense may become redundant. Digital projection may soon become the norm. As we noted in Chapter 6, it is predicted that by 2012 60 per cent of UK screens will be digitized.

The advent of digital projection has also meant that older technologies can be revived. Although 3D never disappeared, being part of the IMAX experience, its two-projector set-up was too costly for normal cinemas, but digital projectors make it affordable for the first time. Now a single digital projector can run at a higher frame rate and show both left eye and right eye images. RealD is the world's most widely used 3D projection system. Bulky and expensive eye glasses are no longer required and it claims to provide a fully immersive, yet ultra-realistic, cinematic experience. *Avatar* (2009) kick-started the roll-out of RealD and a slew of 3D films using this format were released in 2009/10. By 2012, analysts forecast, 20 per cent of UK screens will be 3D enabled.

Meanwhile, new interactive and multiplatform-viewing digital experiences are rapidly changing, particularly in an environment increasingly dominated by YouTube, iPods and iPhones. These may have an impact on DVD sales and box office takings in the future, but at the moment they seem to complement the traditional cinema experience (as shown in Chapter 11, UK cinema admissions in 2009 reached 2002 levels, matching a figure not seen since 1971), providing new sources of revenue. For those who do view films in new multiplatform environments, film viewing is perhaps becoming a less or different social experience, producing viewing flexibility albeit coupled with viewing quality issues. Such platforms as YouTube may be seen as a democratizing influence and/or simply another marketing tool.

Computer and digital technology

Unlike most of the technologies considered in this chapter, computer and digital processes are relatively new developments. But as for the other technologies, their adoption by the film industry has involved a combination of commercial and aesthetic considerations. Digital technologies have provided the means for creating new and different special effects images through computer generated imagery (CGI) (it should be noted that the initials are also used to refer to 'computer graphic interface' or to 'computer gateway interface'). They have made production and postproduction techniques more efficient. They have allowed the creation of new types of entertainment product, such as video and

computer games, theme rides and virtual reality (VR) experiences. And finally, they have provided new avenues for distribution: CD-ROM, the internet, satellite and cable, and DVDs.

Special effects

The desire to create artificial yet plausible worlds for their films has occupied film-makers since the beginning. This led to photorealism, the attempt to produce images of photographic appearance and quality. Méliès developed 'trick film' or special effects for his films during the first years of cinema, but though special effects were attempted, often they were not very photorealistic. Even sixty years on during the 1950s, for example, the science fiction genre, which relied heavily on special effects to create its extra-terrestrial props and settings, was relegated to B-movie status because of the poor quality of these effects. It was not until 1968 that Stanley Kubrick was able to create a 'virtual reality', and in doing so he revolutionized the genre and the use of special effects. His *2001: A Space Odyssey* was the product of innovative use of sophisticated technology such as blue screen photography, travelling mattes, scale models and front and rear projection. Kubrick set new standards and it was almost a decade before anyone attempted to emulate him.

George Lucas' *Star Wars* used computer-co-ordinated camera movement ('Dykstraflex') to produce a seamless fusion of special effects and live-action footage. By the end of the 1970s film had integrated special effects, which had originally begun as mere spectacle, as central to both narrative and *mise en scène*.

> ### Exercise 10.3
>
> Do technologies that result in films achieving greater 'realism' reduce the need for the audience to use its imagination, thereby resulting in less involvement in the production of meaning?

CGI

It was not until the 1980s, however, that computer technology had advanced sufficiently to allow film-makers to incorporate wholly computer-generated imagery into their films. Disney's *Tron* (1982) was the first film to combine live-action footage with 3D CGI, which took up a total of five minutes of screen time. The film both used and reflected upon this use of CGI, as its protagonist was a computer whizz-kid trapped inside his computer. Although the film's *mise en scène* was relatively primitive and based on limited technology, it had a profound effect on film-making, in particular in the science fiction genre.

In 1984, *The Last Starfighter* incorporated twenty-seven minutes of CGI. From the late 1980s onwards, computer and digital processes then developed

with amazing rapidity, reflecting the growth of and advances in the high-tech industries. Almost annually a new technique was, and still is, introduced into film-making. These developments can only be described as a 'digital revolution'.

In 1989, a vastly improved CG effect known as morphing appeared in James Cameron's *The Abyss* in the form of a fluid 3D seawater creature, known as a 'pseudopod', capable of mimicking any organic or artificial form in its surroundings. At that time, morphing was an experimental process and the creature only appeared in the film's climax.

In 1991, however, Cameron advanced this technique to an entirely new level of impressiveness in his sequel to *Terminator* (1984), *T2: Judgement Day* (1991). In *T2*, Cameron introduced the T1000 cyborg – a humanoid android capable of morphing into almost any animate or inanimate thing – as a central plot device. Not only did the T1000 appear throughout the film, but the quality of its morphing was also extremely sophisticated. The integration of the special effects with the actors was almost seamless and the film has been seen as 'groundbreaking in its digital special effects, in particular the sophistication and photorealistic quality' of its imagery (Michael Allen, 1999, p. 63).

Throughout the 1990s, many films incorporated CGI into their narratives; often the special effects themselves became the main feature. In 1993 Steven Spielberg's *Jurassic Park* created the first CG dinosaurs and the following year *The Mask* employed some of the same tools to produce effects that had previously only been seen in animation. CGI is also used in postproduction to add colour, to remove support wires used for stunts, to insert images or to integrate separate photographic images into a film. This is known as electronic compositing – the manipulation of film images. *Forrest Gump* (1994), for example, uses computer and digital technology to place its eponymous hero in a variety of historical settings with a range of historical characters. Since then, CGI has made unlikely, and probably unobserved, appearances in many films, such as *Elizabeth* and *Waking Ned Devine* (both 1998). Perhaps the high point of digital and computer technologies during the twentieth century came with *Titanic* (1997) and *The Matrix* (1999). In the former, the entire ship is resurrected from the seabed and brought back to life, whereas in the latter, the protagonist, Neo (Keanu Reeves), is seen to walk up walls, hover through the air and dodge missiles in 'a breathtaking mode of temporal mangling known as "bullet time"' (Bennun, 1999, p. 29).

'Bullet time' is the appearance of people or objects being suspended or moving slowly in mid-air while the camera seems to track around them to give different visual perspectives. The effect is achieved by placing a large number of still or movie cameras in an arc around the subject, then operating them at exactly or almost the same time. The almost simultaneous shots from each camera are then edited together and synchronized using computer technology to create the impression of a camera tracking round the subject while it is suspended, or moving slowly, in mid-air.

Pixar

Animation in particular has benefited from the advances in computer and digital technology as the new processes are less expensive, speedier and more versatile than traditional methods. In 1986, Pixar released its first fully realized digitally animated short film, *Luxo Jr.* The landmark in digital animation, however, arrived in 1995 when Disney's *Toy Story* was the first ever feature-length film to rely exclusively on 3D CGI. Using Pixar technology, *Toy Story* was made entirely on computer with not one single frame being shot using conventional methods. Nonetheless, the film still preserved the tempo and illusion of camera movement and sophisticated live action. Since then several other fully digitally animated films have been produced (*Antz* and *A Bug's Life*, both 1998, *Toy Story 2*, 2000 *WALL-E*, 2008), and *Up* (2009) amazing critics and audiences alike with their advances in animation.

While it is the product of an aesthetic choice, the use of CGI also reflects one of the US film industry's long-held concerns – economy. The use of digital and computer processes is sometimes cheaper than building an entirely new set or filming on location. In *Fight Club* (1999), for example, budget restrictions determined that CGI would be more cost-effective than building a giant kitchen for one particular sequence. In other films like *In the Line of Fire* (1993), *Forrest Gump* and *Titanic*, CGI was also used to generate large crowd scenes using only a small number of real extras who were duplicated and multiplied, saving money in wages and crowd control. Such technology is thus increasingly used as one of the ways in which production costs can be minimized. At the same time, films using these special effects have been immensely popular with audiences, and therefore some commentators see a link between the use of such technology and maximizing a film's revenues and argue that elaborate special effects are so bankable that rather than being used to tell a narrative, new films are written around them. Many of the films mentioned above have been high earners, suggesting a link between sophisticated special effects and box-office figures.

Exercise 10.4

Look at any film which relies on CGI (e.g. *Gladiator, Lord of the Rings, Titanic, Independence Day*). Are the effects achieved 'photorealistic'? Can you see a difference between the real actors and props and the special effects; do they blend together seamlessly or is there a noticeable difference?

Tech noir

Just as advanced technologies have emerged for creating improved special effects, the very films that have used them to greatest effect have also reflected on the

Figure 10.1 *Metropolis*: futuristic technology (*Metropolis*, 1927, Dir Fritz Lang, Factory ©
Paramount Pictures)

potential of technology. Science fiction films in particular have tended to reflect
on the latest technological developments and on possible future technologies.
Space travel was the subject of Georges Méliès' *Journey to the Moon* (1898), while
Fritz Lang's *Metropolis* (1926) (Fig. 10.1) envisaged a future set in the year 2000.
The future and space and time travel have continued to fascinate film-makers
ever since. In the 1950s, the classic sci fi 'B-movies' meditated on atomic and
nuclear technology, particularly on the effects of radioactivity. In 1968, Kubrick's
2001: A Space Odyssey (its title a homage to *Metropolis*) examined the implica-
tions of computer malfunction (in this case the computer is called HAL, which
some have read as standing for IBM – think about it) at a time when computers
were still confined to the military-industrial complex.

The revolution in computerization since the 1970s, however, has led to the
emergence of an entirely new subgenre: 'tech noir'. Building on Kubrick's *2001*,
tech noir began to emerge in the 1970s and 1980s. While reflecting on the impli-
cations of technology and manifesting a fascination with high-tech industry,
computer technology, artificial intelligence, genetic engineering and virtual real-
ity, it projected a dystopian, pessimistic view of the future. Films of this genre
include *THX 1138* (1970), *Westworld* (1973), *Logan's Run* (1976), *Blade Runner*,
Terminator and *T2*. Kathryn Bigelow's *Strange Days* (1995), using the device
of VR, was a sophisticated self-reflexive study of voyeurism, spectatorship, the

psychic dangers of vicarious entertainment and the nature of the cinematic medium itself. Other films which have examined the implications of VR are *The Lawnmower Man* (1992), *eXistenZ* (1999) and *The Matrix* (1999).

CONCLUSION

In a famous essay in 1949, André Bazin characterized the advance of film technology as an inevitable and graceful progression towards greater screen realism. In doing so, however, he ignored the socio-economic context in which each development was grounded. Up to that point, the prime impetus behind each major technological innovation had been commercial rather than aesthetic, as enterprising studio heads recognized new technology as a means to maximize profits while simultaneously distinguishing their product from the competition. Computer and digital technologies have advanced further than any other innovation considered in this chapter over the past twenty years. If they continue to progress at this rate, the age of complete 'realism', with CG images more realistic and more 'real' than the world we inhabit, may soon be achieved. Will this signal the end of traditional actors and settings? *Casper* (1993) featured the first CG talking lead figure while the *Lord of the Rings* trilogy depicted another CG character in Gollum. While in Casper the character was merely a friendly ghost, the huge leaps in computer and digital technology suggest that it may be the beginning of a new trend. Eventually, special effects technology will be able to replace live actors with resurrected dead stars, while any setting will be creatable within a computer. Although current technologies may point to such developments in the future, will they manage to achieve the level of 'realism' that many demand?

Exercise 10.5

Take each of the six new technologies outlined in this chapter. Find out who introduced them; what was their reason for doing so? Who was responsible for their adoption? Was it the studios, individual film-makers or outside companies? Consider how far they were introduced for commercial or for aesthetic reasons.

SUMMARY

↦ Technological developments have affected film-making in two ways: film-makers have utilized new technologies to make films, and, as a result, films increasingly reflect on the consequences of the use of such technology.

↦ The adoption of new technology was and is not a simple or uninterrupted linear progression.

→ Developments in film technology were not always welcomed initially or used immediately upon their emergence. In many cases, the technology already existed some years (even decades) prior to its widespread adoption.

→ The adoption of new processes closely mirrors their context.

→ The main technological developments have been: camera mobility, sound, deep field photography, colour, projection technologies (widescreen, 3D, IMAX/OMNIMAX and digital) and computer and digital technologies.

REFERENCES

Allen, M. (1999), 'Technology', in P. Cook and M. Bernink (eds), *The Cinema Book*, 2nd edn, London: BFI, pp. 45–64.

Atkinson, M. (2000), 'Cinema's Secret History', *The Guardian Guide*, 1 January, pp. 4–9.

Bazin, A. (1967), 'The Myth of Total Cinema', in *What is Cinema?*, vol. 1 (transl. H. Gray), Berkeley: University of California Press.

Bennun, D. (1999), 'One Day Soon, All Actors may be Made This Way', *The Observer Magazine*, 12 December, pp. 24–30.

Cousins, M. (2005), 'Widescreen', *Prospect*, 67.

Geuens, J. P. (2002), 'The Digital World Picture', *Film Quarterly*, 55: 4, 16–27, Summer.

McLuhan, M. (1974), *Understanding Media: The Extensions of Man*, London: Abacus.

FURTHER READING

Cook, D. A. (1996), *A History of Narrative Film*, 3rd edn, New York and London: W.W. Norton & Co.

A voluminous but magesterial and exhaustive account of film globally.

Hill, J. and Gibson, P. C. (eds) (1998), *The Oxford Guide to Film Studies*, Oxford: Oxford University Press.

A very useful anthology with chapters specifically focusing on film technologies.

Konigsberg, I. (1997), *The Complete Film Dictionary*, 2nd edn, London: Bloomsbury.

A very handy encyclopaedia of film terms and terminology.

Maltby, R. (2003), *Hollywood Cinema: An Introduction*, 2nd edn, Oxford: Blackwell.

A dense but classic text.

Monaco, J. (2000), *How to Read a Film*, 3rd edn, Oxford: Oxford University Press.

A definitive text for all film studies students.

Parkinson, D. (1995), *History of Film*, London: Thames & Hudson.

Brief but illuminating history of film.

Thompson, K. and Bordwell, D. (2009), *Film History*, 3rd edn, New York: McGraw-Hill (Chapter 1).

A key book from two leading film studies scholars.

FURTHER VIEWING

We have refrained from naming any specific titles here, but any *Making Of...* (e.g. *The Making of The Mummy*) documentary will provide useful and interesting information regarding developing and new technologies in cinema.

Part **3**

Movies and audiences

Chapter 11

Cinema, audiences and society

The relationship between films and their viewers is central to Film Studies. '[I]t is through the existence of an audience that film acquires social and cultural importance' (Jostein Gripsrud, quoted in Hill and Church Gibson, 1999, p. 203). It is precisely because of this powerful relationship that the film industry has been subject to censorship and regulation from its earliest days. Similarly, there has been an interest in the impact that a film has upon its audience from the turn of the twentieth century onwards, as well as in who constitutes that audience. The study of these matters falls into two main areas: audience research and spectatorship. In this chapter, we shall be considering the 'audience' rather than 'spectatorship' (the academic study of how individual viewers/subjects relate to and decode film texts), which is examined in Chapter 12.

This chapter is divided into two parts. In the first section, 'Film Consumption', we will examine contemporary film demand and consumption in the UK, encouraging the reader to reflect on her/his own viewing habits. In the process, both the commercial and cultural significance of film consumption will be considered. Film consumption includes not only cinemagoing, but also video, television, DVD and other situations of film viewing. In the second section we will consider how regulation and censorship have affected both producers and audiences and

impacted upon the relationship between them, particularly in imposing limitations. As we shall see, the history of both topics – audiences and censorship/regulation – follows a similar pattern, as both have fluctuated and changed according to political, social, economic and cultural circumstances.

Film consumption

We know that people watch films and that films have audiences. An audience is essential to the continuing production of films, as that is where profits are made and initial investments are recouped. But what is an audience and what do we actually know about audiences? First, a warning: the concept of the audience is slippery, shapeless, evasive, and rather hard to define, but we can distinguish the audience from the spectator. Where the spectator is an individual, the audience is a collection of individuals transformed by a shared experience; where the spectator is constituted by psychological and textual relations, the audience is organized around categories of ethnicity, class, gender, age, education, and so on. Furthermore, the audience is a construct and can never be understood in a 'pure', unadulterated form. The ideological perspective of those who are looking for the audience – film producers, marketers and distributors, pressure groups or governmental agencies – shapes their particular conception of the audience.

When seeking to understand the audience, we have to consider who watches films and how, when and where they are watched. How many people watched the film and what did they do afterwards? What role do films play in our lives? How do we actually watch them and with whom? How do we use and talk about our film experiences? We cannot treat the audience as a single, monolithic, undifferentiated mass. Rather, we must understand that the audience is heterogeneous and can contain many people from various groups, that different films are enjoyed and hated by different people at different times, and further that films are watched in widely differing circumstances: in cinemas, at home on the TV, video or DVD, over the internet, on aeroplanes, with friends, or alone, and so on. Our enjoyment of a film will also vary according to mood, different social occasions, whether we are alone or with others, and whoever is watching with us. Perhaps the best way to understand what we mean by the audience is to be aware of your own responses and behaviour when engaged in the social practice and cultural phenomenon of cinema.

Constructing audiences

Although the concept of the audience is difficult to pin down accurately, a great deal of what is called quantitative research has been devoted to doing just that. The first audience research was prompted by fears about the social effects of

cinema's huge popularity, particularly with youngsters. And there has long been an interest in audience composition, particularly for early audiences. Studio executives pay large sums to audience research groups to measure the success of their films and to provide 'what people want'. The commercial and competitive nature of the US and other film industries has ensured a constant flow of research about numbers of viewers, information about who they are and what they make of what they see (and hear). Furthermore, the film industry has always sought to relate cinema audiences to wider society and its tastes and composition. Audiences have thus been categorized in two ways:

- ↔ demographics, which segments social groups according to class, gender, age, family, nation, and ethnicity, education, religion, political allegiance, region, urban/rural background etc.;
- ↔ psychographics, whereby the consumer is categorized in terms of needs and desires (e.g. those who aspire to a richer lifestyle or those who want to make the world a better place).

Film producers, distributors and exhibitors (who are often ultimately part of the same company) have attempted to construct audiences from the very beginnings of the film industry. As we have seen in the section on distribution in Chapter 6, once a film is finished it becomes a product that needs to be sold. An audience is targeted, selected and constructed; today this has become an industry in its own right. Profiling, market research, advertising, tracking and psychological testing are all used to construct an audience, and vast sums of money are spent doing this.

Understanding audiences

Academics, governmental agencies and pressure groups, while interested in the audience, are particularly concerned with the effects of film consumption and the uses to which it is put, and a range of theories have been developed which seek to explain these processes. Some of these models are looked at in Chapter 12 on spectatorship; however, below we list those that have sought to understand how audiences read and use films.

- ↔ Opinion leaders and two-step flow: early research suggested that audiences were neither passive nor uniform. While audiences did accept media messages, they were also as likely to be influenced by their own situations or others' opinions as by the content of a film text. It was shown that opinion leaders played a key role in affecting individual views (see Lazarsfeld, Berelson and Gaudet, 1944).
- ↔ Selective influence: this research indicated that the effects of films were neither direct nor uniform. Further, audiences' selection of films was typically based on their social category (e.g. class, age, gender), their individual psychology and social relationships, which were more

influential on their opinions than the media. The research indicated that to maximize profit, films should be targeted towards specific groups.

↝ Modelling: this research suggested that audiences may gradually emulate behaviour that was clearly rewarded and appealing, which in turn could be reinforced by frequent observation of such behaviour or by discovering that it actually produced results. This approach is evident in the concern over cinematic and 'designer' violence.

↝ Media consumption within a particular social environment explores who controls the viewing and how people actually watch and talk about their experiences. This presumes an active viewer watching in specific social circumstances and sharing audio-visual experiences in an equally social context (see Morley, 1986).

↝ Historical reception studies: Reception Theory looks at audiences as individuals who actively make sense of media texts. Stuart Hall, head of the Centre for Contemporary Cultural Studies in Birmingham, suggested that how we decode information contained in the text will depend on our background and factors like class, ethnicity, gender, age, status, job, region, religion, experience and beliefs. These factors will influence our response regardless of what a producer may have encoded within a film. In analysing encoding and decoding in media texts, Stuart Hall, using a Cultural Studies approach, noted that while a text may have a preferred reading encoded within it, this is not always accepted. Rather, there are three types of audience response: dominant readings in which the audience accepts the preferred reading; negotiated readings in which the audience generally agrees with dominant values, but may disagree with certain aspects; and oppositional readings in which the audience rejects dominant values (see Hall, Hobson, Lowe and Willis, 1980; Morley, 1980). Umberto Eco (1981) has gone further in claiming that all media texts, including films, can also be aberrantly decoded. Historical reception studies analyse the varying responses of audiences to certain films at specific historical moments, taking into account social history, audience composition, reviews, commentary, fandom, star images, tie-ins, scandal and any other events/publicity that impact on the reception of a film (see Staiger, 1992). A good example of such an approach is Staiger's own 'Taboos and totems: cultural meanings of *The Silence of the Lambs*', in Collins, Radner and Collins, 1993.

A brief history of UK cinemagoing

In seventy years, UK cinema attendance has changed dramatically (see Table 11.1). The peak point of cinema attendance was 1946 when there were 1,635 million admissions, representing 31.5m people going once a week. By 1984, however, cinema attendance had sunk to a postwar low of 54m (over 70 per cent of the population had not been to see a film once that year!).

Table 11.1 UK cinema admissions 1933–2009

Year	Admissions (millions)
1933	903.00
1934	950.00
1935	912.33
1936	917.00
1937	946.00
1938	987.00
1939	990.00
1940	1,027.00
1941	1,309.00
1942	1,494.00
1943	1,541.00
1944	1,575.00
1945	1,585.00
1946	1,635.00
1947	1,462.00
1948	1,514.00
1949	1,430.00
1950	1,395.80
1951	1,365.00
1952	1,312.10
1953	1,284.50
1954	1,275.80
1955	1,181.80
1956	1,100.80
1957	915.20
1958	754.70
1959	581.00
1960	500.80
1961	449.10
1962	395.00
1963	357.20
1964	342.80
1965	326.60
1966	288.80
1967	264.80
1968	237.30
1969	214.90
1970	193.00

(Continued)

Table 11.1 (*Contd*)

1971	176.00
1972	156.60
1973	134.20
1974	138.50
1975	116.30
1976	103.90
1977	103.50
1978	126.10
1979	111.90
1980	101.00
1981	86.00
1982	64.00
1983	65.70
1984	54.00
1985	72.00
1986	75.50
1987	78.50
1988	84.00
1989	94.50
1990	97.37
1991	100.29
1992	103.64
1993	114.36
1994	123.53
1995	114.56
1996	123.80
1997	139.30
1998	135.50
1999	139.75
2000	142.5
2001	155.9
2002	175.9
2003	167.2
2004	171.2
2005	164.6
2006	156.6
2007	162.5
2008	164.2
2009	173.5

Source: Screen Digest/Screen Finance/BFI/Nielsen EDI.

What happened over these years to change a nation's leisure habits? Those who went to the cinema in 1946 were mostly working-class, urban and young and lived near to local cinemas. Young children grew up going to the cinema, particularly on Saturday mornings, encouraged by their relatives. By the mid-1950s, however, the growth of the suburbs took people away from local cinemas and their extended families. Furthermore, a growth in leisure time and greater disposable income meant that people had a far greater range of consumer products to distract them. Inner-city cinemas closed down and failed to relocate to the new housing estates. Meanwhile, though the young working classes were still the main consumers of films, they were also absorbed in other activities like music, dressing up and drinking, which grew out of a distinctive youth culture. Although television appeared in the 1950s, it was at first restricted to the middle classes (who had never constituted a significant part of cinema audiences) and did not have a major impact until the early 1960s with the advent of ITV and (later) colour. Thereafter, the home became the focus of leisure activity. By 1984, then, most people in the UK preferred to watch films at home. As we have seen in our section on exhibition, dingy cinemas, poor audio-visual quality and high ticket prices kept potential cinemagoers at home and the average Briton visited the cinema only once a year. By this time, cinema had also ceased to be a primarily working-class activity.

Video, pay TV, DVD

The advent of video in the mid-1970s revolutionized access to films and may also have kept cinemagoers at home. Rather than depending on the local cinema or BBC and ITV, people could choose a wide range of films to be viewed in the comfort of their own homes. Video viewing was suited to family life as it was cheaper than multiple cinema tickets, parking/public transport and the obligatory refreshments, and could cater for the whole family's tastes and preferences. Video also compensated for the lack of choice at the cinema and provided for niche or culturally specific tastes. Furthermore, video gave greater power to the consumer to choose when, where and how to watch – a trend that could only increase with the expansion of pay TV services, particularly BSkyB and digital TV, which now allow the viewer to select from a range of films on offer, and DVD, which has pretty much replaced video. According to Mark Cousins, DVDs 'have become the fastest growing entertainment technology of all time' (Cousins, 2005, p. 67). By 2008, certainly if the UK is anything to go by, DVD was the second most popular way, after the cinema, in which people preferred to see a film.

It will be interesting to see how these developments affect cinema attendance over the coming years, especially as the relationship between video/DVD and a decline in cinema attendance is not as straightforward as it appears. Cinema attendance began to rise in 1985 – reaching 75m compared to 54m the previous

year – just when video ownership was reaching its peak. VCR and DVD player ownership, therefore, may actually indicate a resurgence of interest in the cinema, not least because those who own VCRs and DVD players are also most likely to attend the cinema. Certainly, research shows that the cinema is still the preferred venue for watching films and cinema admissions and box-office revenues in the UK are both rising as a result. It appears then that 'cinema remains the loss leading window that creates value for film for the studios post its theatrical market release' (McDonnell, 2009, p. 9).

Multiplexes and multi-screens

When the first UK multiplex opened in Milton Keynes in 1985, it was during what was labelled 'British Film Year'. Since then cinemagoing has changed irrevocably and cinema attendance has risen, seemingly as a direct result of the increase in the number of cinema screens. In 2002 cinema attendance peaked at 175.9m, a figure not reached since 1971. Although Britain has nearly as many screens as in 1960, attendance has dropped by 75 per cent. The average person in the UK now goes to the cinema about 2.3 times per year in comparison to 9.6 visits per year in 1960. In contrast, the average person in the USA attends the cinema more than five times a year and the United States is described as having the world's most developed cinema market.

Cinemagoing has witnessed a shift in class allegiances, becoming more of a middle-class than working-class activity. In the UK those aged between 15 and 24 were the most regular cinemagoers in 1998, followed closely by 25–34 year olds and then 7–14 year olds, a total of 24.33m people (see Table 11.2). Research has shown that the 15–24 age group has the most time and money to go to the cinema and they will be deliberately targeted by film-makers, distributors and exhibitors. Interestingly, the largest demographic group – 35+ (representing 30.15m people, well over half the population) – visits the cinema the least, as their time and disposable income may be decreased as a result of other responsibilities. Since the rise of the multiplex the audience has become more family-centred since such cinemas are conveniently located (a short drive from most homes) and are near to shopping and other leisure facilities. In terms of viewing broken down by gender, the figures are almost identical.

Why do we watch?

The type of film available to us is determined by a number of factors: where we live, how much we can afford to spend, what is on TV, whether we have pay TV, a VCR or DVD player, and what is available at that particular time. In rural areas there are less cinemas than in urban areas. Similarly, in larger cities there is a greater choice of cinemas, including more repertory/arthouse cinemas. Cinemagoing tends to be greater in areas where there are many screens offering a

Table 11.2 Frequency of cinemagoing 2001–6

% Age Group	2001	2002	2003	2004	2005	2006
Cinemagoers (attend ever)						
7–14	92	94	94	92	96	96
15–24	96	97	96	90	96	96
25–34	92	92	93	84	91	92
35+	73	74	74	61	77	74
Frequent cinemagoers (attend more than once a month)						
7–14	31	32	33	39	39	36
15–24	50	50	52	53	53	46
25–34	29	35	33	34	34	36
35+	15	17	14	16	16	16
Male	25	27	25	27	27	26
Female	24	25	24	26	26	25

Source: CAA cinema and video audience research.

wide choice of films than in locations with a limited selection. The quality of the cinema experience, its proximity to other attractions, easy access and parking are all other reasons why people go to the cinema. However, increased ticket prices and the cost of food, popcorn, etc. have begun to undermine the perception that cinema is cheap.

Some of the main reasons for going to the cinema are that it provides the best setting for viewing films, access to new films while they are still 'fresh', and a pleasurable, undemanding and cheap chance for going out. On the other hand, improved home viewing technology, greater access to films through film channels and DVD hire, and shorter post-cinema release times have lessened the appeal of going to the cinema, making watching at home seem cheaper, easier and more comfortable and relaxing than going to the cinema. Cinemagoing competes against other forms of leisure; for some people it does not have the convenience of watching at home, while for others it is not as social or exciting as going out for a drink, to a party or a club, or eating out. It has a low priority as it is seen to be continuously available, low-key and neither routine nor special enough to make it first option. Cinemagoing, therefore, is increasingly combined with other leisure activities as one part of a larger night out. However, there are occasionally 'must-see' films which transform cinemagoing into a leisure activity in its own right.

The most intensive periods for watching films in the UK are the Christmas and summer holidays, the peak leisure times when both TV and cinema audiences are at their highest. Weekends usually generate the most DVD rentals.

Choosing films

According to the Film Policy Review Group (FPRG, 1998), 'Film is regarded [by the audience] as the most complete story-telling medium; watching an enjoyable film is still one of the most satisfying, absorbing and appealing forms of entertainment'; but how do audiences decide what films to see?

A survey of UK cinemagoing habits conducted by the FRPG in the 1990s showed that cinemagoers were rather cautious when choosing films, tending to avoid those they might not like. As there is a large choice of films which spectators know they should enjoy, there was only limited interest in taking risks by exploring films beyond the mainstream, and a tendency to stick with 'their kind of film'.

The study found that in general terms, younger (18–30) C1C2 audiences prefer more mainstream, big-budget, star-studded action films with impressive special effects rather than gritty realism, small-scale and low-budget 'message' films, which are perceived as 'depressing'. Older audiences, on the other hand, like subtlety; men prefer action films while women prefer human interest stories. C2s favour easy-watching escapist films while BC1s want to be challenged more. Older and more educated Bs like realistic films about characters and settings they can identify with and period films, classics and films about social issues.

Beyond these broad tastes, mood, occasion and company can also have an impact, and we are likely to be influenced by the presence of a favourite star or director, the plot, special effects or music. Our choices are also influenced by how and by whom the film has been recommended. Despite the vast sums of money spent on marketing films, word of mouth is a particularly important factor in choosing a film, though reviewing and criticism clearly also play a part. Specific choices and judgements are made on the basis of a wide variety of evidence, such as genre, title, poster, stars, director and publicity.

Exercise 11.1

Think about your own film-watching behaviour: when do you go to the cinema and why? When do you watch films on TV and when do you rent DVDs? Also, consider occasions when you have watched films other than on TV or at the cinema.

Regulation and censorship

Censorship – erasing or blocking parts of or whole publications, correspondence or theatrical performances – has a long history stretching back to ancient times. Every society has had customs, taboos or laws by which speech, play, dress, religious observance and sexual expression were regulated, and laws have evolved

concerned with restricting the expression, publication and dissemination of information, particularly in wartime.

Public complaints often accompanied the emergent medium in the 1890s, but it was not until the expansion of permanent cinemas from 1905 onwards that public and governmental interest took hold and censorship was enforced. Initially it was the responsibility of the police and the local authorities, using the existing laws and powers covering places of entertainment, to censor films. But as film developed into a global phenomenon, film-makers had difficulty dealing with the variable standards applied from one country to another and sometimes within their own country too. In response, each country's film industry usually set up its own voluntary censorship organization with which film producers were expected to co-operate. In most European countries censorship remained a local police responsibility for far longer than in the UK or the USA. In countries with totalitarian or autocratic governments, however, there has been central government control of all films, as was the case in Nazi Germany and the Soviet Union. Government censorship still occurs today, for example in several Middle Eastern countries. Singapore only relaxed its censorship laws in 2004.

Censorship bodies usually develop guidelines about what is prohibited in films, and these have changed over time according to changing circumstances. In particular, public attitudes have changed, and more explicitly violent and sexual representations are tolerated now than in the past. As the power of religious bodies has declined, religion and morality do not appear to be subjects for censorship.

Exercise 11.2

As a member of an audience, how far do you feel that an external body has the right to censor and regulate what you see? In what situations are censorship and regulation not only necessary, but also desirable?

CASE STUDY

Censorship in the United Kingdom

At present, film and DVD are regulated (and in some cases censored) by the British Board of Film Classification (BBFC) – an independent, non-governmental body, funded by charging for the service it provides to the film industry. Although the BBFC gives the certificate for a film, any local authority has statutory power to overrule its decisions. Local authorities generally accept the Board's decisions, except on rare occasions such as when Westminster Council, for example, refused to allow the screening of *Crash* (1996) in its cinemas, or when Camden showed *The Texas Chainsaw Massacre* (1974) without approaching the Board. Several local authorities also banned the screening of *Monty Python's Life of Brian* (1979) on grounds of blasphemy, with the result that in 1979/80 one could see the film

in Leeds but not in Harrogate. All films normally require a certificate, which must be clearly displayed in advertising, at the cinema entrance and on the screen immediately before the film is shown. Local authorities can, however, allow an uncertificated film to be screened, but face the possibility of legal action, for example under the Obscene Publications Act. Cinemas have to be licensed before they can screen films and are thus unlikely to risk losing an exhibition licence by screening a film which a local authority is likely to object to.

Initially, it was the responsibility of local authorities to censor films, but this led to confusion as widely differing standards were applied. Among the first councils to ban a film outright was London County Council, which took objection in 1910 to a film of the recently contested world heavyweight boxing championship, in which a white man had been beaten by a black opponent (see Richards, 1997, p. 167). In 1912 the British Board of Film Censors was established by the film industry to provide uniform national standards of censorship. The Board has never had a written code of practice although it has published its classification guidelines. The history of regulation and censorship shows, however, that the Board's standards have changed as society has changed. In 1913, there were two certificates: 'U' (universal) and 'A' (more suitable for adults). In 1916, BBFC President T. P. O'Connor compiled a list of forty-three rules that covered censorship. At that time, Britain was involved in the First World War and Russia was close to a revolution. These concerns were reflected in his guidelines that films should not depict 'realistic horrors of warfare' or 'relations of capital and labour'. The rules also exhibited a fear of immorality, particularly sex, and outlawed items such as 'nudity' and 'indelicate sexual situations'. The rules governing cinema were strict at this time, not least because the audience was perceived by the very paternalistic and morally old-fashioned Board as an immature, working-class mass, susceptible to corrupting influences. A notable example of censorship after the war was the banning of the Soviet film, *Battleship Potemkin* (Eisenstein, 1925), in 1926 because of its violent and revolutionary aspects. These were seen as particularly relevant in Britain at that time as the General Strike held the possibility of striking workers overthrowing the government.

Between the two world wars, the BBFC was mainly concerned with horror and gangster films and those that dealt with sexuality. In 1932 the category 'H' was introduced to indicate potential unsuitability for children. By 1951, the emergence of the 'teenager' as an economic force and a major part of cinema audiences, coupled with fears of teenage gangs and crimes, prompted the introduction of a new category: 'X' excluded children under 16. *Rebel without a Cause* (1955) was heavily cut so that it could be screened, and *The Wild One* (1954) was banned altogether, as it was seen as a threat to traditional family values. Over the next two decades, partly in response to growing numbers of serious 'adult' films with sexual themes from mainland Europe, the Board were obliged to accept directorial intention and artistic merit as valid criteria; the standards changed once again partly also to incorporate teenagers' specific concerns: 'X' was raised from

16 to 18, 'A' allowed the admission of 5 year olds whether accompanied or not, 'AA' allowed in those aged 14–17 if accompanied by an adult, and 'U' was wholly suitable for children of all ages.

In 1982 these categories were again changed when the BBFC modified its classifications to correspond with the US system: 'A' became 'PG', 'AA' became '15', 'X' became '18', and a new category of 'R18' for material of a sexually explicit nature was introduced. The category of '12' was added in 1989 to bridge the gap between 'PG' and '15' and the category of 'UC' (particularly suitable for children) existed solely for video and DVD until 2009 when it was dropped. Reflecting concerns over the rise of so-called 'video nasties', in 1984 the Video Recordings Act was passed and a year later the BBFC was empowered to classify all videos for sale and rental. The Board changed its named to the British Board of Film Classification to reflect its new role. In 1994 the Criminal Justice and Public Order Amendment to the Video Recordings Act of 1994 required the BBFC to consider if a video and DVD can cause 'harm to potential viewers' or 'harm to society through the viewers' behaviour' in its treatment of 'criminal behaviour', 'illegal drugs', 'violent behaviour and incidents', 'horrific behaviour and incidents' and 'human sexual activity'. The standards applied to videos and DVDs have always been much stricter, as access to them is much easier than to a cinema, which is required to operate an age bar and can lose its licence for not doing so. The Board's video and DVD classification also has more direct legal force.

The BBFC only censors/cuts about 1–2 per cent of the films submitted for classification. Past BBFC President (1997–2002) Andreas Whittam Smith recognized that cutting is not easy to do without the audience realizing that the film has been censored: 'I originally thought "Oh well, if there's a problem, we can cut our way out of it." That's not really an option. Anything good is too intricately made to cut' (quoted in Pendreigh, 1999, p. 7).

In terms of classification the BBFC has three main areas of concern: language, sex and violence. It must also apply legislation to films, DVDs and videos before they can be classified, and its guidelines have changed as new laws have been passed. These include the Cinematograph Films (Animals) Act 1937, the Protection of Children Act 1978, the Obscene Publications Act 1959 and 1964, the Race Relations Act 1976, Blasphemy, the Hypnotism Act 1954 and the Human Rights Act 1988. Now, the BBFC also has to take into account the right to free expression under the European Convention of Human Rights.

Changing times: the 1990s

As a sign of changing times, the BBFC has passed uncut several films which have featured explicit sex scenes that seem to have crossed over the line of what was previously thought in good taste, particularly *Romance* (1999) and *Idiots* (1999); but *Happiness* (1998), *American Pie* (1999) and *There's Something About Mary* (1998) have also tested the boundaries. Furthermore, the Board has classified

films that had caused controversy on their original release in the 1970s. *Straw Dogs* (1971) and *The Exorcist* (1973) received video classifications for the first time; *The Texas Chainsaw Massacre* and *A Clockwork Orange* (1971) – the latter withdrawn by Stanley Kubrick himself – were both passed for cinema screening, while *The Driller Killer* (1979), demon of the 'video nasties' hysteria of the 1980s, was passed and screened after the distributing company itself made cuts. In 1998, the proportion of '18' films dropped to 16 per cent and cuts were required in only fourteen films, 3.6 per cent of the total. Both statistics represent the lowest recorded proportions on record. In 2000, following a six-month consultation period involving the public, the BBFC relaxed its guidelines, saying that it would 'only rarely' cut explicit sex scenes, thus reflecting a mood that the public would rather make up its own mind about what was acceptable. An example of this new policy was *Nine Songs* (2004), which featured some quite explicitly sexual scenes. Indeed, since 2000, the number of films cut has never exceeded 3.5 per cent of the works submitted for classification. Does this indicate that the BBFC is becoming more liberal in its decisions, reflecting contemporary circumstances, or that film-makers are treating adult subject matter in what some may consider to be a more responsible and socially acceptable fashion?

Exercise 11.3

In *Ali G: Da Video*, Ali G expressed the opinion that if his video did not receive the '18' certificate then he would be in grave danger of losing his street credibility. How far are we guided by a film's classification? Would you watch or ignore a film because of its classification?

END OF CASE STUDY
::::::::::::::::::::::::::

::::::::::::::::::::::::
CASE STUDY

Censorship in the USA

In the United States, the Constitution and the First Amendment, which guarantees free speech, protect film. However, individual states can censor films if they are 'obscene' and classify them if it is felt they may harm children. Initially, the National Board of Censorship was set up in 1909 to pass films as suitable for exhibition, whether censored or uncut. Unlike the BBFC it did not classify films as suitable for particular audiences. In 1922, however, following growing public concern about film content and some US film industry scandals, the US film industry set up the Motion Picture Producers and Distributors of America (MPPDA),[1] headed by Will Hays. The MPPDA administered a 'voluntary' code of self-regulation in both preproduction and postproduction, which became known as the 'Production Code' or the 'Hays Code'.

The Production Code

In 1930 a more formal set of rules called the Motion Picture Production Code was introduced into the US film industry but this was not enforced until 1934. During those four years, censorship was lenient and film-makers took full advantage, with the result that sex and violence routinely found their way onto the screen. In 1934, however, the studios were under intense pressure to 'clean up' or face government legislation and they agreed to self-regulation through the Code. The studios were feeling the effects of the Great Depression and radio's growing popularity. In an attempt to appease religious groups engaged in box-office boycotts and to ward off the possibility of costly governmental censorship, the MPPDA instead amended the 1930 Code 'to give it coercive power over member producers'. The amendments were formally adopted on 12 July 1934. Self-regulation was quickly and generally accepted for three reasons: its standards were uniform and national, it saved the studios huge editing and distribution costs and the resulting 'wholesome family pictures' were extremely profitable, and the advent of the enforcement of the Code coincided with the US film industry's rapid return to financial prosperity. Any infraction, however small, was punished by a $25,000 fine. The Code attempted to tie film production to a 'Judaeo-Christian' standard of morality by instituting the following guidelines: the sympathy of the audience should never be drawn to the side of crime, wrongdoing, evil or sin; excessive and lustful kissing and embracing and suggestive gestures and postures and explicit nudity were unacceptable; and swearing, such as the use of 'Damn', 'God' and 'Hell', was unacceptable.

HUAC and the 1950s

The 1950s were a fascinating decade in US film history. In addition to the Production Code, a number of political, economic, cultural and social factors coincided to produce an almost unprecedented situation of self-regulation and self-censorship. In 1947 and later in 1951, the House Un-American Activities Committee (HUAC) began to investigate possible communist influence in the motion picture industry. The Committee was motivated by the number of communists employed by the US film industry, and to ensure publicity for itself it called the most popular film stars of the day to testify in Washington. The refusal of a group of directors and writers, known as 'the Hollywood Ten', to co-operate with HUAC produced panic within the film industry. In the new Cold War climate communism was unpatriotic and tantamount to treason and any director, writer or actor found to have such sympathies would suffer a boycott of his/her films by religious and other right-wing groups. Faced with potential commercial failure, the US film industry's investors on Wall Street pressured the industry to fire such individuals, producing an unofficial blacklist from November 1947 onwards. The Motion Picture Association of America (formerly the MPPDA

until 1945), rather than the government, imposed the blacklist. Anyone caught refusing to testify before HUAC was blacklisted, which meant a loss of work and usually led to social ostracism. Effectively, the US film industry purged itself of some of its most talented individuals, as those who were blacklisted fled or were forced to work under pseudonyms such as Dalton Trumbo. The blacklist did not ease up until 1960, but many careers had been destroyed by then.

The studios were afraid to produce any film that could be interpreted as communist or even left-wing; this led to a decline in serious-issue and social comment films. There was a fear of anything too new or too different, as uncertainty and apprehension fuelled by the Cold War, the atom bomb and the political tirades of Senator McCarthy characterized the 1950s. With a few exceptions, it was a time of safe, uncontroversial, bland and timid movies. In particular, two genres thrived: the anti-communist film, which lauded the US authorities, in particular the FBI (*My Son John*, 1952; *I Was a Communist for the FBI*, 1951), and the science fiction B-movie. Where the former genre was quite clearly pro-US in its sensibilities, the sci fi genre allowed for more ambiguity. Submerged in metaphors and analogies, these films dealt with themes such as atomic radiation (*The Day the Earth Stood Still*, 1951), usually signified by shrinking/growing humans (*The Incredible Shrinking Man*, 1957) or by creatures exaggerated to gargantuan proportions (*Them!*, 1954), and communist invasion depicted by alien attack (*Invasion of the Body Snatchers*, 1956; *Invaders from Mars*, *War of the Worlds*, both 1953). It was not until 1960 that public hysteria regarding communism had declined sufficiently to allow the film industry to return to its pre-1950 days.

The Production Code was formally dropped in 1968 (although in practice it had been liberalizing since the early 1960s and Kubrick had tested it with *Lolita* in 1961), as it was recognized that cultural values had changed from those of the 1930s. The MPAA abandoned censorship altogether and instituted an advisory rating system instead. The Code and Ratings Administration (renamed the Classification and Ratings Administration in 1977) replaced the Production Code, introducing four categories: 'G' (General), 'M' (Mature), 'R' (Restricted) and 'X' (no under-18s permitted). *Midnight Cowboy* (1969) was the first major US film to carry an X certificate and to win Oscars nonetheless. These categories were eventually replaced by the following, which are still in current use: 'G' (General), 'PG' (Parental Guidance), 'PG-13' (Parental Guidance although some material may not be suitable for under-13s), 'R' (Restricted) and 'NC-17' (No-one under 17). Recently, power has been devolved to the local level and the central body only classifies films with respect to their content as suitable for various age groups. Since the MPAA dropped its censoring function, it is sometimes argued that there is no censorship in the USA, only classification. But how far is this the case given that film-makers work within the framework of an advisory system? Particular classifications still have potential commercial advantages

over others; for example, the under-17 audience is crucial to box-office success while the 'NC-17' rating is dreaded, as some cinemas refuse to screen such films, TV networks won't carry their trailers and print ads are hard to place. This means that film-makers will act as self-censors in order to conform to a specific audience rating. Furthermore, some contracts oblige the production of films for distributors that are not above the 'R' rating. As a mark of this, only a handful of controversial films have been awarded 'NC-17', including *The Cook, the Thief, His Wife and Her Lover* (1989) and *Henry: Portrait of a Serial Killer* (1986). *American Psycho* (2000) initially received the 'NC-17' rating, but eight minutes of a sex scene were cut to appease market forces and its final rating was 'R'. Likewise, *Zack and Miri Make a Porno* (2008) was rated R for strong crude sexual content including dialogue, graphic nudity and pervasive strong language. Three versions were originally rated NC-17 for some graphic sexuality but the first two were edited voluntarily and the last was successfully appealed.

We could say that the US system represents a form of preproduction self-censorship, rather than the external censorship of the UK where cuts occur in postproduction. A surface comparison between the two countries suggests that it is easier to see how censorship and regulation affect film producers in the USA than in the UK.

Exercise 11.4

Using any national cinema of your choice, investigate how far film censorship and regulation have influenced film content at one specific point in history. You may wish to compare this with another national cinema at the same moment, or compare it with another moment from the same national cinema.

END OF CASE STUDY

CONCLUSION

The topics of audiences and censorship and regulation are similar in several respects. They both help to shape film content in one form or another. Film producers, particularly in mainstream cinema, are concerned to understand their audiences in order to provide them with what they want or like. Similarly, censors, classifiers and regulators wish to protect film audiences from what they see as the harmful effects of particular film messages, but at the same time they are willing to account for the audience's attitudes, beliefs and values. Approaches to both the audience and censorship have changed over the course of the first hundred years of film history as the understanding of them has shifted according to changing circumstances. What was felt to be dangerous and how it affected

those who watched it at the beginning of the twentieth century is very different in the twenty-first century. Although we do not know exactly where audience research and attitudes towards censorship are moving, we can be certain that they will develop and shift over the next 100 years.

SUMMARY

↪ The concept of the audience is difficult to define and has changed over time, but it is essential to both the film industry and Film Studies, and can be distinguished from spectatorship.

↪ Audiences are not passive or uniform; rather, they are constituted by a number of factors and exist in very different circumstances.

↪ Film consumption is also influenced by a number of factors. In the UK it declined after the Second World War and then recovered dramatically in the mid-1980s.

↪ Regulation of film content and censorship have changed according to different social circumstances and have affected film content.

↪ The BBFC operates an external postproduction classifying service for the UK film industry, while in the United States censorship and regulation have been voluntarily adopted by film producers themselves.

REFERENCES

Collins, J., Radner, H. and Collins, A. P. (eds) (1993), *Film Theory Goes to the Movies*, London and New York: Routledge.

Cousins, M. (2005), 'Widescreen', *Prospect*, 67.

Eco, U. (1981), *The Role of the Reader*, London: Hutchinson.

Film Policy Review Group (1998), *A Bigger Picture: The Report of the Film Policy Review Group*, London: Department for Culture, Media and Sport.

Gripsrud, J. (1999), 'Film Audiences', in J. Hill and P. C. Gibson (eds), *The Oxford Guide to Film Studies*, Oxford: Oxford University Press, pp. 202–11.

Hall, S., Hobson, D., Lowe, A. and Willis, P. (eds) (1980), *Culture, Media, Language*, London: Hutchinson.

Lazarsfeld, P., Berelson, B. and Gaudet, H. (1944), *The People's Choice: How the Voter Makes up his Mind in a Presidential Campaign*, 2nd edn, New York: Columbia University Press.

McDonnell, P. (2009), 'Cinema's Premiere Spot Pays Off', *Cinema Business*, 53: 9.

Morley, D. (1980), *The Nationwide Audience*, London: BFI.

Morley, D. (1986), *Family Television*, London: Comedia.

Pendreigh, B. (1999), 'Everything was in Place for a Clampdown on Sex and Violence. So Where Is It?', *The Guardian*, 30 April 1999: 6–7.

Richards, J. (1997), 'British Film Censorship', in R. Murphy (ed.), *The British Cinema Book*, London: BFI, pp. 167–77.

Staiger, J. (1992), *Interpreting Films: Studies in the Historical Reception of American Cinema*, Princeton: Princeton University Press.

FURTHER READING

Barker, M. (ed.) (1994), *The Video Nasties*, London: Pluto Press.

A selection of essays on the so-called 'video nasties' that were banned until the 1990s.

Black, G. (1998a), *The Catholic Crusade Against the Movies, 1940–1975*, New York: Cambridge University Press.

A history of influential Hollywood films and censorship from 1940 to 1975, providing a detailed account of film making in Hollywood's golden era.

Black, G. (1998b), *Hollywood Censored: Morality Codes, Catholics and the Movies*, New York: Cambridge University Press.

Focuses on the role censorship played in the construction and production of Hollywood films, demonstrating the extent to which censors were responsible for the images on the screen.

Couvares, F. G. (ed.) (2006), *Movie Censorship and American Culture*, 2nd edn, Amherst: University of Massachusetts Press.

A selection of essays exploring the role of censorship in the US film industry.

Doherty, T. (1999), *Pre-Code Hollywood: Sex, Immorality, and Insurrection in American Cinema, 1930–1934*, New York: Columbia University Press.

A look at the pre-Code era in Hollywood, when it seemed that almost anything was game.

Hodgkiss, R. (1999), *Media Effects and Censorship*, London: Film Education.

A useful introductory pamphlet available from http://www.filmeducation.org.

Jacobs, L. (1991), *The Wages of Sin: Censorship and the Fallen Woman Film 1928–1942*, Madison, WI: University of Wisconsin Press.

Focussing on the 'fallen woman' in film, the book explores Hollywood's system of self-censorship and the evolution of the rules governing representations of sexuality.

Lyons, C. (1997), *The New Censors: Movies and the Culture Wars*, Philadelphia: Temple University Press.

Discusses the different ways that films can be censored in the post-Code era.

Matthews, T. D. (1994), *Censored. What They Didn't Allow You to See and Why: The Story of Film Censorship in Britain*, London: Chatto & Windus.

A look at film censorship in Britain.

Wollen, T. (1988), *Film and Audiences*, London: Film Education.

A useful introductory pamphlet available from http://www.filmeducation.org.

FURTHER VIEWING

Film Industry Pack

Interactive DVD ROM and documentary programmes aimed at teachers. Available at http://www.filmeducation.org

NOTE

[1] This is the name given for the MPPDA by the majority of sources. Thompson and Bordwell's *Film History* (1994), however, refers to the Motion Picture Producers and Distributors Association.

Chapter 12

Meaning and spectatorship

In this chapter we shall examine the major critical approaches towards under-
standing film. We shall try to understand the complex relationships between film
as text, cinema as institution, and the spectator. This will involve considering the
chequered history of theories about how individual spectators 'read' films.

It is important to note straight away that we shall not be considering the
'audience' here (see Chapter 11). You will often hear the term 'audience response'
used apparently to refer to the way individuals react to or 'read' a film. This
is, though, perhaps a little misleading since the principal aim of such studies/
research (which is often commissioned by production companies or other media
organizations for economic reasons) is usually to establish statistical informa-
tion about audiences which can be used to change the ending of a film prior to

general release or to try to predict what kind of film is likely to be a hit next Christmas. By contrast, spectatorship studies refer to the more academic study of how individual viewers (or subjects as they/we are sometimes called) relate to and decode film texts.

This involves theorizing the spectator and the nature of the viewing experience. Who or what is a spectator? What does watching a film involve? Are there different ways of watching a film? How do we create meanings when we watch a film? These are actually difficult and complex questions which also depend on first defining what we mean by a 'film text'; fortunately much of this task has been achieved, and Chapters 8 and 9 have been devoted to establishing this. We have seen how a film text can be defined in terms of the use of *mise en scène*, cinematography, sound and editing to produce a more or less narrative audio-visual representation.

Watching a film

Before the Copernican revolution in the sixteenth century, it was obvious to everyone that the Earth was flat. When the Lumière brothers first projected a film of a train arriving at a station in 1895, it was obvious to many spectators that a train was about to mow them down: there was reportedly panic in the room.

Anything which seems obvious needs to be approached with care. The act of watching a film can never be 'just entertainment'; there is always important social, ideological and psychological work being done. We need to keep asking the questions: who is this spectator who is watching? What goes on during the viewing experience? How exactly do we watch a film?

Theories of spectatorship have made use of concepts drawn from a number of areas, some of which may at first sight seem a little far-fetched; nevertheless this has enabled a great deal of important and interesting work to be done, and in the latter part of the twentieth century these ideas of how we watch films were very influential – though they were certainly contested. In the following pages we shall be looking very briefly at how psychoanalytic theory, semiology, structuralism, the concept of ideology and more recently cognitive approaches have contributed to spectatorship theory. But first let us take a look at the early days.

Early models

There were some early pioneers of writing on film spectatorship, among them Hugo Münsterberg and Rudolf Arnheim. Although the theories advanced by such theorists have been largely ignored (partly because they wrote only about pre-sound film and partly because in most cases film was not their principal

concern), they have recently been rediscovered and reread: see pp. 186–7 on formalism and realism. Their impact on approaches to spectatorship studies, however, was for much of the last century far less significant than that of more sociological approaches addressed to the larger concern with audiences for mass culture.

'Effects' approaches

Since the early days of film and of mass media, there has been a strong assumption that media have an 'effect' on the spectator; this assumption has been most noticeable in the various moral panics which punctuated the twentieth century, most obviously the early anxiety about film itself, the debate around the so-called 'video nasties' in the 1980s and the more general concern about representations of violence (see Martin Barker's *A Haunt of Fears* and *The Video Nasties*); among the more high-profile films which have run into trouble have been *Peeping Tom* (Powell, 1960), *Straw Dogs* (Peckinpah, 1971), *A Clockwork Orange* (Kubrick, 1971) and *Natural Born Killers* (Stone, 1994).

The mechanisms by which films/media may have an effect, however, have been far from clear, and a number of explanations have been used. An early model was the hypodermic syringe model, so called because of the strength of the underlying idea: the media get under the skin and 'inject' values and beliefs into the spectator. Yet this model did not begin to explain how this could happen.

A more elaborate (sociological) approach was provided by Katz and Lazarsfeld in the 1940s; they argued that according to the two-step flow model it was only certain individuals (called 'opinion leaders') whose learning or world-view was affected by the media, and these opinion leaders then passed on this 'effect' to their less active peer groups.

Central to subsequent developments in 'effects' theory are theories of psychoanalysis and ideology (see below), but one other model should be mentioned here. The idea of the classic realist text was applied to films (first by Colin MacCabe in *Screen*); according to this idea, all narrative films (which means virtually all films that 99 per cent of the public go to see) are structured in such a way (through a hierarchy of discourses) as to provide a secure position of knowledge for the spectator: stylistic codes involving editing, camerawork, *mise en scène* and sound are used to place the spectator in an unthreatening position of virtual power. According to this model, the spectator position itself can be seen simply as a textual effect: the range of meanings which it is possible for any spectator to produce is severely limited by the narrative and stylistic form.

Uses and gratifications

It was largely as a reaction against the pessimism of such models (called deterministic because they seemed to allow no freedom of interpretation and saw

meaning as largely pre-determined within an ideological system) that the uses and gratifications approach developed in the 1970s. Here there was a greater stress on the more or less conscious uses which individuals make of the media and on the kinds of pleasures which can gratify a variety of needs. Thus watching a soap opera such as *Eastenders*, for example, can be an exciting addition to a boring everyday routine, it can be an escape from the problems of one's own everyday life, it can enable a lonely person to feel part of something, it can enliven conversation with friends or colleagues the following day (did you see...?). Media users can then be described as belonging to interpretive communities: groups who use a particular programme in a similar way. Uses and gratifications work in the 1970s and 1980s focused predominantly on TV audiences and how/why viewers watch: see especially the work of David Morley and Ann Gray.

Cultural studies

If uses and gratifications approaches were not so evident in Film Studies, this was due partly to the continuing sway of so-called 'screen theory', but also to the emergence in the 1980s of Cultural Studies, an approach which sought to transform 'screen theory' in combining it with more sociological methods, for example those emerging from the work of the Centre for Contemporary Cultural Studies in Birmingham. The first issue of the journal *Cultural Studies* in 1987 thus carried the following statement:

> *Cultural Studies* will publish articles on those practices, texts and cultural domains within which the various social groups that constitute a late capitalist society negotiate patterns of power and meaning.
> It will engage with the interplay between the personal and the political, between strategies of domination and resistance, between meaning systems and social systems.

In the 1990s, the study of meaning-making in films was much influenced by this approach, as indeed it continues to be. Film is seen as one (changing) medium among many, consumed/used in a variety of social contexts, so that how meanings are produced will depend on the individual and on her/his social history as well as on the specific film text. This is exemplified in practice by Reception Studies in which, using methods very similar to those utilized by Morley and Gray in their studies of TV audiences, interviews and focus groups are used to study the complexity of individual meaning production in a determinate social context.

This discussion has perhaps taken us a little away from this chapter's focus on individual spectatorship. Let us return to some areas which have been influential in theorizing the individual spectator's relation to film.

//

Psychoanalytic models of the viewer and of the viewing activity

Since the time of Sigmund Freud (1856–1939), the relevance of psychoanalytic theory to many other disciplines (and indeed its very validity) has been hotly contested. While Film Studies has been no exception, we propose here to accept (one hopes not too controversially) that the unconscious exists, that we as human beings ('subjects') are by definition largely unaware of much that happens in our unconscious minds, and that it can be fruitful to analyse what 'hidden' mechanisms are at work in films.

The typical film-watching experience (and this is still so well into the twenty-first century) takes place in the dark. While some viewers do occasionally indulge in conversation, mobile phone-calls, texting, popcorn-eating and other sensuous activities during a film, the typical relationship with what unfolds on the screen remains of a rather special kind (see John Ellis, 1982). It is not for nothing that Hollywood has been called the Dream Factory. The 'effect' of relatively large moving images, usually involving human figures, since 1929 usually with sound, since the 1950s usually in colour, and more recently often with Dolby/stereophonic sound and a widescreen format, can be seen as dreamlike. Indeed, it is interesting that the drive of this ever-growing 'reality-effect' is precisely to encourage the spectator to 'believe in' the illusion being presented on the screen – though we should also note the 'distracted mode of viewing' or 'back-seat viewing' theorized by Christine Geraghty (1997, p. 155).

It is not possible to consider the details of Freudian theory here, but we can outline some of the main ways in which psychoanalytic ideas have been used in studying film. The first two of these are of less theoretical importance than the last three.

Film-makers and psychoanalysis

A perhaps surprisingly large number of films have been 'touched' by psychoanalytic ideas; these can be identified principally in three historical periods. First, some European 'art' and avant-garde films of the 1920s and 1930s were made within or influenced by the Surrealist movement, for which techniques for exposing the unconscious directly in art were central. The most important films – which are still remarkable to behold – were *The Andalusian Dog* (*Un chien andalou*, Luis Buñuel and Salvador Dali, 1929) and *L'Age d'or* (Buñuel, 1930). It is interesting that Quentin Tarantino, a self-taught 'film freak', named his one-time production company (notably for *Pulp Fiction*) 'Large Door': a clear homage to the 1930 Buñuel film.

A further group of films influenced by psychoanalytic theory emerged in the 1970s and 1980s, this time mostly in Britain and North America. This time

the influence was more explicitly theoretical, and these avant-garde films tried to work against dominant models of narrative, identification and spectatorship (see p. 146). Among these many films were *Riddles of the Sphinx* (Laura Mulvey, 1977), *Thriller* (Sally Potter, 1979), and the films of Jackie Raynal. These films reached only small audiences of intellectuals and political activists and required very specific watching skills!

A third group of films, however, was very much part of the Hollywood production of the 1940s and 1950s. This was a period when Freudian psychoanalysis became popular and indeed fashionable in the United States, and a number of studio personnel and film-makers saw the potential of drawing on such ideas. Several films worked directly with (popularized and simplified) psychoanalytic notions such as repression, neurosis, mother-fixations, split personalities or the Oedipus complex. These films included *The Secret Behind the Door* (Lang, 1948), *The Cobweb* (Minnelli, 1955), *Shock Corridor* (Fuller, 1963) and *Marnie* (Hitchcock, 1964). Many other films of the period (particularly those of Alfred Hitchcock, for example), though they did not deal explicitly with such issues, lent themselves to analysis in psychoanalytic terms.

The 'nosographic' approach

There has been some writing which attempts more or less to psychoanalyse a film director; the director's films can be treated as 'symptoms' which can be used to analyse, for example, the director's repressed sexuality or mother-fixation. Such an approach has been used, for instance, in writing about Alfred Hitchcock and about Howard Hawks. You will often find this attitude underlying film reviews and biographies, but it has not generally been considered a very useful approach in academic work.

'Apparatus theory'

As we have already hinted, it is possible to see the mechanism of watching a film (at least at a cinema) as somehow dreamlike, engaging unconscious processes. Indeed, the illusory nature of film viewing was foreshadowed over two thousand years ago by the Greek philosopher Plato in a 'thought experiment' which is now referred to as 'Plato's cave'.

Plato imagined a situation in which spectators (who can be taken to represent humanity in general) sit in an enclosure facing a wall and in front of another wall which it is impossible for them to climb; what is behind this wall is unknown to them, indeed, they are basically unaware that there is anything behind the wall (see Fig. 12.1). On the wall/screen in front of them the spectators see shadowy images, which are in fact the shadows projected by figures moving and dancing in front of a fire behind/above the spectators: a scene to which they have no access and of which they have no knowledge.

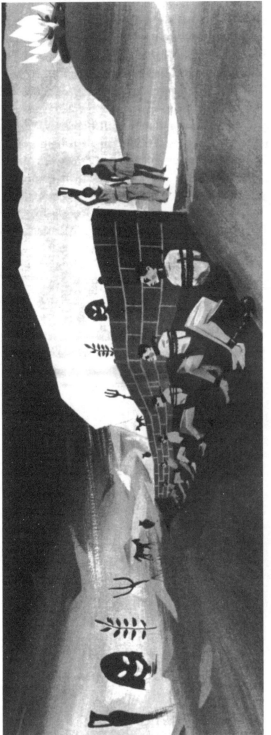

Figure 12.1 Plato's cave (François Millepierres, *Platon – La République VII et VIII*, collection Traductions Hatier, © HATIER, Paris 1966)

3

Plato's imagination seems to have provided a remarkable premonition of cinema: spectators in an auditorium watch images projected from behind them by a mechanism which is startlingly similar to the figures moving in front of a fire in Plato's cave. Most importantly, the watchers of film seem to ignore (we refer to it as a 'suspension of disbelief') the projection mechanism which creates the illusion. This supports the idea that film-viewing is largely unconscious, and is also linked to ideas about how ideology operates; we shall return to this later in this chapter.

The 'cinematic apparatus' thus puts individual watchers in a position of specularity, where the drive to look or watch (the clinical word for this is scopophilia) is satisfied. But of course this is not the end of the story.

What does 'looking' mean?

It is significant that in the cinema this drive to look remains largely private: although there may be hundreds of spectators looking at the same screen, each individual ('subject') sits in the dark and enjoys an intimate scopophilic relationship with the screen.

A significant step in the use of psychoanalytic theory in Film Studies was taken in 1975 when Laura Mulvey used the ideas of Jacques Lacan (an influential analyst who effectively rewrote Freud for the late twentieth century) to argue that in the classical Hollywood narrative the spectator is constructed as male. Over most of

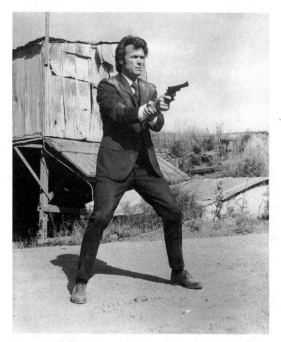

Figure 12.2 Dirty Harry Callaghan: whose identification figure? (*Dirty Harry*, 1971, actor Clint Eastwood, dir Don Siegel/© Warner Bros/The Kobal Collection)

the history of Hollywood films the 'hero' or central character has usually been male, and female characters have been there principally to be looked at or to be saved. This was of course a reflection of gender power relations common in Western (and other) societies; but it was also, Mulvey argued, a product of complex (male) fears revolving around castration anxiety (again we must stress that these fears and anxieties are profoundly unconscious). As a result, male characters – from John Wayne's cowboys and heroic soldiers to Dirty Harry (Fig. 12.2) and Rambo – were typically active, investigative narrative agents inviting identification, while female figures in film – from Marlene Dietrich in von Sternberg's 1930s films to Marilyn Monroe (Fig. 12.3) and Brigitte Bardot – were often fetishized as objects of a male gaze. We need only think of macho heroes saving swooning virginal damsels or of half-dressed women displaying themselves for the spectator to see which films Mulvey was concerned with.

Mulvey's original ground-breaking work generated much intense debate and writing. She herself and many others have modified and extended her ideas; others have argued against such a psychoanalytic approach (see pp. 267–8).

Two related areas of enquiry in relation to the 'male spectator' are of interest. First, since the 1970s films have increasingly featured central female

Figure 12.3 Monroe in *Gentlemen Prefer Blondes*: who is she performing for? (*Gentlemen Prefer Blondes*, 1953, actor Marilyn Monroe, dir Howard Hawks/© Twentieth Century Fox/ The Kobal Collection)

characters, from *Alien* (Scott, 1979) to *Blue Steel* (Bigelow, 1990) to *Thelma and Louise* (Scott, 1991) and *Kill Bill* (Tarantino, 2003, 2004). Second, many women writers have questioned the validity of the 'male spectator' position outlined by Mulvey, arguing that there are pleasures and other ways of looking available to women; and indeed there have (again since around 1980) been more and more films which also seem to offer the male body (for example, Sylvester Stallone/Rambo, Arnold Schwarzenegger, Brad Pitt) as an object of desire. Nevertheless, it may be argued that for every *Thelma and Louise* or *Desperately Seeking Susan* there are still more *Die Hard*s and *Lethal Weapon*s, and that even where the male body is offered for spectacle it generally retains narrative control.

Exercise 12.1

Arrange yourselves into groups in which each member has seen the same (recent) film. Discuss to what extent the film addresses the spectator as 'male' (or female?). Discuss the presence (or absence) of active/central female characters. Is it possible for female spectators to identify with male characters (and vice versa)? Are male characters there 'to be looked at'?

Psychoanalytic theory has also been used (again controversially) to explain the way in which spectators are drawn into shot/reverse shot editing, to analyse ideas of acting 'performance' in relation to the 'performance' of gender roles, to analyse virtually every aspect of cinematic pleasure. If psychoanalytic approaches to film are still often rejected and ridiculed, a good reference point may be the world-famous film made by one of Britain's finest directors which explicitly dealt with the more disturbing links between voyeurism and film: *Peeping Tom* (1960) was immediately banned for over twenty years and Michael Powell never made another film.

Exercise 12.2

Discuss the 'difficulty' of psychoanalytic approaches. Is it more likely that such approaches are 'wrong' or that (because they deal with unconscious processes) they are threatening (to individuals and to the social status quo)?

Analysis of individual films

The most important and productive use of psychoanalytic theory has been in the analysis of individual films and the ways in which they prompt the production of meaning. This has often meant the application of fairly standard psychoanalytic concepts, but these have been adapted to gain insight into specific films.

The so-called Oedipus complex is one example. According to classical Freudian theory, in order to become fully socialized (heterosexual) adults, male and female infants have to (eventually) renounce their primary love-object (their opposite-sex parent) and accept that another man or another woman will do instead. To over-simplify, the boy typically 'feels' a sexual attachment to his mother, would like to eliminate/kill his father who is his rival, but has to 'learn' the difficult lesson that the father-figure represents 'the Law' and that he cannot himself take the father-figure position unless he accepts symbolic 'castration' and submits to the 'Law of the Father'. He must (symbolically) lose his masculinity (by submitting to a father-figure) so that he can in turn wield the phallus (and the patriarchal power that goes with it) himself. A similar (but different) journey awaits the infant girl. This 'Oedipal journey' results in adulthood.

The Oedipal journey can be found in many narratives, filmic and non-filmic. For example, in *North By Northwest*, Roger Thornhill's perilous journey can be shown to follow an Oedipal model very closely. He begins the film attached to his mother, struggles with (symbolic) father figures throughout the film, and reaches sexual maturity at the end of the film when he is saved from death by the forces of law and order and a new Mrs Thornhill takes the place of the mother in his life. Many (some have argued all) films contain traces of such an Oedipal journey, and of course, the more such ideas have passed into critical circulation, the more film-makers have begun to deliberately play with and subvert generic expectations to do with the 'hero's journey' (*Back to the Future*, 1985; *Last Action Hero*, 1993).

Exercises 12.3

1 List some films you have seen which contain traces of such an Oedipal journey.
2 In a recent film of your choice containing a central male character, discuss his 'journey'. What Oedipal elements can you find?
3 Choose a recent film with a central female character. How does her narrative 'journey' compare with that of a typical male central character?

Semiological ways of describing a film

Both spoken and written languages are made up of signs. The social science of linguistics developed in the late nineteenth century as a means of studying language systems. Methods were developed for studying the sounds (phonetics) of a language, its grammar, its vocabulary, its historical development, and its relation to other languages. What was new was the systematic nature of the subject, which many writers treated as a kind of science.

But if language is a system of signs, then what about painting? What about photography? And what about film? It became clear in the second half of the nineteenth century that all cultural products are made up of signs, and indeed that we are surrounded by various kinds of signs in everyday life. Charles Sanders Peirce (pronounced 'purse'), for example, was among the first to analyse such everyday signs; from him we have the division of all signs into three types:

- ↔ iconic: signs which (in some respects at least) look like the things they refer to, in other words they are 'motivated': for example, some road signs, some 'male' and 'female' toilet signs, figurative painting, and of course photographs.
- ↔ indexical: signs which have some causal link with what they signify: for example, a weather-vane indicating wind direction, a footprint, smoke signifying fire.
- ↔ symbolic: signs which are arbitrary: this means that there is no apparent causal link between the sign and what it refers to. Examples include Morse code and, of course, words and the letters/sounds of which they are made. 'D-o-g' and 'c-h-i-e-n' both refer to (more or less) the same thing, but the choice of letters/sounds for each word seems arbitrary.

Peirce is seen as the founder of semiotics, which is really the American word for what is called semiology in Europe. The beginnings of the latter were developed by Ferdinand de Saussure, a Swiss professor of linguistics, in the late nineteenth century. There is sometimes some confusion because Peirce and Saussure worked independently and sometimes used the same words to mean slightly different things.

It is to Saussure that we largely owe a different model of signification:

- ↔ signifier: that which signifies: the word, the letters on a page, an image, a sound.
- ↔ signified: that to which the signifier refers: the idea of 'a dog' perhaps, or something more precise like the idea of 'a rotweiler'.
- ↔ sign: the combination of the signifier and the signified. Saussure nicely compared these two 'sides' of the sign to the two sides of a sheet of paper: both necessary for the sheet to exist, but impossible to separate. The sign has a *referent*, the thing it refers to.

Together with this vocabulary of signification, a bundle of other terms entered the cultural analyst's vocabulary. Thus *denotation* refers to what is signified (this is a picture of a woman washing black dye out of her blonde hair), while *connotation* is about what is *suggested* (she may be changing her identity; she is not what she seems; at this point we have not yet seen her face; the binary opposites black and white also have connotations). Denotation corresponds to *first order signification*, while connotation, which also depends on expressive

elements such as *mise en scène*, camera angle and lighting for example, is *second order signification*. Indeed connotations are intimately tied up with culturally specific *myths* and *ideologies*, and the latter comprise the level of *third order signification*.

It should be noted that semiology approaches texts from the position of a 'spectator' and not from a production perspective. The *cultural codes* through which we make meaning from a film need to be kept distinct from the *technical codes* which operate in film production, though in practice there is some overlap between the two. Thus while it is common to discuss/analyse films in terms of technical terms such as high angle, low key lighting or shot sizes for example, other terms used in semiological analysis, such as the orders of signification introduced above, would have no place in film production vocabulary.

When analysing images and films we can also think in terms of primary and secondary codes. Primary codes are the basic conventions we use: for example in many languages text is read from top to bottom and left to right; we tend to concentrate our attention on the centre of an image. Secondary codes are 'codes within codes' and relate to particular forms and types of communication. Genres thus consist of secondary codes, particular uses of images, sounds and text, in particular films and TV programmes.

In the second half of the twentieth century semiology came to be closely associated with structuralism, a method of study with the following principles:

- ↪ Structuralists were concerned with the text (film, novel, advertisement, painting, and so on) and not with the author or the audience.
- ↪ The approach was non-normative: this means that it made no attempt to evaluate or judge whether texts or artworks were 'good' or not. Studying beer-mats could be seen as just as useful as studying Picasso's paintings.
- ↪ Meanings were seen as produced by particular sign systems interacting with their context.
- ↪ Structuralists saw their work as systematic and as more 'scientific' or 'objective' than more traditional approaches to the study of culture.

The 1960s and 1970s saw the most intensive attempts to apply the methods of semiology to film (and to television). It is only possible to mention two aspects of the mountain of study, but among the chief figures were Roland Barthes, Raymond Bellour, Christian Metz and Peter Wollen.

One kind of work concerned analysis of how signification is coded in individual frames or shots in particular film texts. In this respect film analysis was quite similar to structuralist-semiological analysis of other products; for example, Roland Barthes gained public prominence with a series of semiological meditations on things like the Citroën Déesse car and the face of Greta Garbo. In films, the focus came to be on how elements of the image such as iconography, *mise en scène*, camera and lighting 'make meaning'. The low key shadowy lighting and strange camera angles of film noir help to signify a threatening and uneasy atmosphere;

the use of red colour in *Marnie* (blood, a bouquet of flowers) is clearly used to signal the central character's mental fragility. An iconography including crucifixes, garlic, knives and tombstones can be used to analyse the horror genre. It is worth remembering that much everyday reviewing and critical writing on films has now absorbed semiological assumptions; indeed, students generally already 'think semiologically'. Here it is simply a matter of making the origins of such thinking explicit.

The second application of semiology was more ambitious. One of the main questions which concerned such theorists was whether and how film could be described as a 'language' – indeed, one of the unresolved questions remained whether linguistics is a branch of semiology or whether semiology is a kind of linguistics. By the 1960s it had already become common to speak of close ups, camera angles and different kinds of editing as part of the 'language' of film (as we have done at some points in this book), but what interested Christian Metz in particular was whether it was possible to see these and other elements as part of a more systematic 'grammar', to see film as a language system. In keeping with the structuralist principles listed above, Metz used *Adieu Philippine* (a relatively obscure film directed by Jacques Rozier in 1960) to develop a typology or grammar (which he called a *syntagmatique*) which attempted to show all the different types of shot combinations which could be used in a narrative film. The terms syntagm and syntagmatic entered the critical vocabulary, and referred to any fragment of a text (in the case of film, frame, shot, scene or sequence) and how such elements were linked together to form a narrative. At the same time, any element in a text could also be seen as a paradigm or as paradigmatic, in which case the emphasis was on how the element (the high angle for the shot of the village about to be attacked in Hitchcock's *The Birds*, for example) was chosen in preference to other alternatives. The effectiveness of such paradigmatic choice could then be checked against other possible options (in this case a low angle shot) using a commutation test (see also p. 344).

Metz's work gave rise to much further research and debate which eventually cast doubt on the validity of seeing film in such rigid 'grammatical' terms, but his work remains an excellent example of the strengths (and weaknesses) of the structuralist-semiological approach.

Structuralist approaches to narrative

We have already referred in the chapter on film form and narrative to models of narrative developed by Vladimir Propp and by Tzvetan Todorov. As they deal principally with the structure of the narrative, and tend to ignore the 'content' and themes (what the story is 'about'), such approaches are often described as structuralist. This also means that the intentions and indeed the importance of the author/*auteur* are marginalized: we shall look in the next chapter at the 'death

of the author'. At this point we shall deal briefly with two other structuralist approaches to narrative which have been influential.

Lévi-Strauss and binary oppositions

Though anthropologist Claude Lévi-Strauss did not work on or write about film, his studies of myth and meaning-making in a variety of cultures have been widely used in narrative studies. Lévi-Strauss proposed that myths (and by extension narratives) are structured around binary oppositions which are significant for the particular society or culture. While Lévi-Strauss studied oppositions such as light and dark, sun and moon and raw and cooked in South American and other cultures, his ideas and analysis can readily be applied to films and other media/cultural artefacts.

In a Western such as Clint Eastwood's *Pale Rider* (1985), for instance, significant binary oppositions include the following:

law	disorder
knowledge	lack of knowledge
male	female
individual	town/community
civilization	wilderness

These binary oppositions interact and change in the course of the narrative; more interestingly, comparison of how similar oppositions work in other Westerns tells us how narrative themes change from film to film, from one historical period to another. This is a way of looking, for example, at the role of the individual hero central to most Westerns: why did audiences want John Wayne in the 1930s and 1940s but go for Clint Eastwood in the 1970s and 1980s?

Exercise 12.4

1 Choose two films of the same genre and map out their binary oppositions. How do the oppositions develop and interact in the films? What are the differences?
2 Are such binary oppositions so easy to detect in more recent films (since 1990, say)? What does this tell you about the narratives of more recent films? How is this linked to genre?

Roland Barthes and narrative codes

A second approach which has been called structuralist is that developed by Roland Barthes, a French writer and cultural theorist who wrote widely from the 1950s until his death in 1980. Once again (though Barthes did also write about

film) some of his influential ideas originally concerned narrative in literature, but have been extensively applied to film.

In a book entitled *S/Z*, Barthes outlined the workings of five narrative codes; while some of the names he chose are Greek and may be difficult, he also sensibly provided abbreviations (see Table 12.1). It is possible to see how Barthes' codes are relevant to a number of preceding chapters: we have already considered the nature of narrative cause and effect (which involves the hermeneutic code), the nature of plot and story events (which refer to the proairetic code) and character (semic code); the binary oppositions of Lévi-Strauss are clearly ideal for Barthes' symbolic code. The cultural code focuses on knowledge which a viewer brings to a film: the colour red may signify danger, passion or 'stop'; the Big Mac conversation in *Pulp Fiction* depends on audience knowledge of hamburgers (and of McDonald's!); it can even be argued that we use the cultural code to recognize that a close up signifies intensity or attention to detail.

Detailed analysis of a single film using Barthes' codes is a long and exhausting procedure – see *Jump Cut* no. 12/13 (Dec 1976) for a very difficult but fascinating analysis of Jean Renoir's *The Rules of the Game* (*La Règle du jeu*, 1939). If we limit ourselves to a single sequence or to the start of a film, though, we can learn a great deal about the narrative organization of the film and about how a viewer decodes that narrative.

Table 12.1 Roland Barthes' narrative codes

Code	Abbreviated	What the code organizes
1. Hermeneutic	HER	Code of puzzles, enigmas and mysteries; 'what happens next?'; 'how will this end?'; clues (which may be misleading) are provided, resolutions are delayed; this code draws the reader/spectator through the narrative
2. Semic	SEM	Code of character construction: characters are built up through iconography, gesture and speech and usually establish apparent individuality
3. Proairetic	ACT	Code of actions (hence ACT) related to recognizable behaviour; this code operates retrospectively as actions can be seen to have been organized into sequences
4. Cultural	REF	Code of references (hence REF) to bodies of knowledge outside the text, e.g. accents, knowledge about particular places, parody of other texts/films
5. Symbolic	SYM	Code of broad themes and motifs often structured in oppositions (cf. Lévi-Strauss), for example light/dark, good/evil, male/female; patterns of symbolic meanings run through the text

CASE STUDY

Barthes' codes and the opening six minutes of *Scream*

The credit sequence of any film already activates the codes and influences the viewer's understanding of the narrative, and *Scream* is no exception. The lurid lettering of the title, the scream, metallic (knife) sounds and heartbeat on the soundtrack instantly appeal to cultural knowledge of the horror genre [REF code]. We may also (unconsciously?) register the colours used in the title lettering: red, white and blue: the colours of the US flag…[REF and SYM codes]. As with most titles, there are also immediate questions: Who will scream? Why? [HER code]; here an additional question may be 'Is that really the end of the credits?'!

After the sound of the phone ringing bridges from the title to the start of the narrative proper, and the camera pans as Casey picks up the receiver and answers the call (Fig. 12.4), many viewers would recognize Drew Barrymore [REF]. The SEM code also immediately comes into action as we begin to build an idea of the character: her appearance, clothing (chunky-but-tight-fitting white sweater) and manner tell us she is young, blonde, attractive, confident in her surroundings, perhaps friendly. The SEM code, however, also enables us to begin to imagine the man who is calling: initially polite, pleasant…but perhaps already just a little unsettling. Why is he calling? What does he want? Is it important? These are all HER code questions.

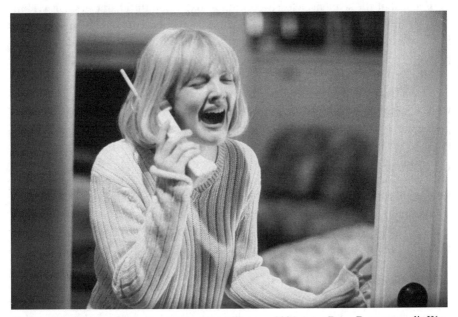

Figure 12.4 Scream: Casey answers the phone (*Scream*, 1996, actor Drew Barrymore, dir Wes Craven/© Miramax/The Kobal Collection)

After another phone call (which involves the SEM code to continue to establish the caller as threatening), the camera zooms in to and lingers for a moment on the window…we (more or less unconsciously) recognize this as significant [REF] and continue to wonder what will happen next [HER]. The extreme long shot of the house which follows acts partly as a delayed establishing shot but also confirms [REF] a sense of unease familiar to horror fans.

Casey lights the gas and starts to prepare some popcorn. The REF code is activated as this evokes film-viewing, and it is clear from what she says during her third conversation with the mystery caller that she is a 'normal' horror-film fan: this could be you! Here there are also shifts involving both SEM and HER: she is (implausibly?) friendly and even flirtatious with the caller, and the viewer surely wonders what her changed manner will lead to. Casey walks through from the kitchen to the living room while she discusses horror films with the caller; she turns off a light as she does so; the camerawork here subtly reinforces the dialogue, which is about *Halloween* and the Freddy films [REF].

An important HER moment occurs as the caller says 'I want to know who I'm looking at': the threat is clear and is immediately underlined by a subtle zoom towards Casey [REF perhaps] and the sound of dogs barking, accompanied by threatening music. Another important HER element throughout this opening sequence is the state of the popcorn: the repeated cutaways to the popcorn getting hotter and hotter and about to burst clearly parallel [SYM] the overall tension of the sequence. It is significant that she is just about to turn off the gas when the killer calls one more time and things become really nasty.

The rest of the sequence clearly continues to develop the characters [SEM] but also clarifies the ACT code: a young woman is harassed on the phone, then she and her boyfriend are murdered by an unknown killer. While the ACT code could in principle be reduced to smaller actions (she picks up the phone, she smiles…), it is usually used to split up a narrative into larger chunks (phone harassment; murder).

The REF code is also rampant throughout the whole sequence: Casey plays with a large carving knife as she happily talks to her killer about *Halloween*, preparing the viewer for the knowing self-reflexive 'quiz' which the killer imposes on her. The REF code here is clearly complicated by the many overt ('postmodern') references to the film's own genre, for example 'You should never say "who's there", don't you watch scary movies?'. A further indicator of the REF code is the TV set (switched on but imageless…) which is often (and very deliberately) placed in the background in many shots.

The SYM code tends to operate over an entire film. In *Scream*, one significant symbolic opposition seems to be light and dark: Casey gradually turns off most of the lights as she is increasingly terrorized and ends up hiding behind the TV set, and this can perhaps be linked to her own blondeness and white jumper (the killer taunts her with 'blondie'). A broader symbolic opposition may be peace/stability and mayhem, a staple of the slasher subgenre. Visibility and invisibility are also an important symbolic opposition; the killer wants to know who he is looking at;

his taunting of Casey ('can you see me?') is subtle because he can only ask the question because he knows/can see where she is…and of course for the spectator everything on the screen is visible.

END OF CASE STUDY

Ideology and postmodernism

3

What is Ideology?

We have already come across the idea that films have an ideological function. But what is this stuff called ideology? When the word was first introduced by Antoine Destutt Tracey in 1812 in the aftermath of the French Revolution, it referred to 'the study of ideas'. Before long, however (in Destutt Tracey's own lifetime – he was imprisoned for his writing), it became clear that those in power generally did not like the 'ideas' underlying their power being analysed. Given the different interests of the power 'élite' and of those being oppressed by that power (the working class), it is not surprising that the definition of ideology has been a theoretical battleground ever since. In the process, 'ideology' has come to refer not so much to the study of ideas as to the 'ideas' themselves.

Exercise 12.5

Working individually, read through the following list of possible 'definitions' (courtesy of Terry Eagleton) of ideology. Select three which seem most 'correct' to you.

Then, in pairs, select three definitions on which you agree. Finally, in groups of 4–6, compare choices; each group must (through reasoned discussion, seduction, haranguing or bribery) come up with a shortlist of three preferred 'definitions'. In class discussion you will see if there is any consensus. Your teacher may also contribute her/his preferred definitions.

(a) the process of production of meanings, signs and values in social life
(b) the body of ideas characteristic of a particular social group or class
(c) ideas which help to legitimate a dominant political power
(d) false ideas which help to legitimate a dominant political power
(e) systematically distorted communication
(f) forms of thought motivated by social interests
(g) socially necessary illusion
(h) the medium in which conscious social actors make sense of their world
(i) action-oriented sets of beliefs
(j) the indispensable medium in which individuals live out their relations to a social structure

Much of the development in theories of ideology in the nineteenth century was influenced by Karl Marx, whose aim was the overthrow of capitalism and the establishment of a socialist society governed by the people. Considering the anti-democratic interests of capitalism, it is not surprising that throughout most of the twentieth century, 'ideology' was seen (in Europe and North America at least) as a fanatical or fundamentalist set of ideas (a grotesque caricature of Destutt Tracey's original definition of the term). So the official view was that the Soviet bloc, as well as China, Cuba and other regimes, were in the grip of 'ideology', whereas the liberal democracies of most of Western Europe and North America were (and are) ruled by rational 'common sense', free of ideology.

This last view was ridiculed and exposed as itself ideological by political theorists, particularly in the 1960s and 1970s. It has become clear that many 'common-sense' beliefs and assumptions are profoundly ideological, from the once-commonplace racist beliefs about white supremacy over 'savages' to the old chestnut of 'women drivers' (and the ideological function of racist and chauvinist jokes is of course far from negligible). As we have already noted, it is wise to suspect the 'obvious'.

The tradition of Marxist writing on ideology was continued by Antonio Gramsci, Georg Lukacs, and Herbert Marcuse, Theodor Adorno and Max Horkheimer of the Frankfurt School, among many others. Throughout the middle of the twentieth century, theories of ideology were developed which, it must be said, had little effect on film theory at the time.

This changed with the advent of Jacques Lacan and Louis Althusser. While Lacan developed a complex – some would say incomprehensible – psychoanalytic reworking of Freud, Althusser sought to marry Marxism and psychoanalysis. The result was a particularly complex theory according to which ideology is seen as unconscious, as an imaginary relation to real conditions of social existence.

All representations (whether part of the mass media, 'art' or personal communication) are thus ideological: they carry ideological 'messages' which overwhelmingly reinforce the status quo. The individual subject has some limited 'choice' (insofar that s/he may have come to oppose dominant ideologies) to decode representations 'oppositionally', but the emphasis of the Althusser model of ideology is on the fundamentally conservative nature of most media representations as carriers of dominant ideology.

The immediate effect of the work of Lacan and Althusser in the 1960s and 1970s – and we need to remember that several years passed before their writing was translated into English – was a massive reassessment and revaluing of Marxist theory, together with a wealth of related writing on film, particularly in the journal *Screen*.

Much of the theoretical writing of the 1970s has (some would say unjustly) now joined flared trousers, platform heels and Slade as a 'fashion casualty' of that time. It is possible, though, to see the subsequent marginalization and dismissal of Marxist theory (and of film theory built on Marxism and/or psychoanalysis)

as part of a backlash which itself can only be described as ideological – a backlash which gained much strength from the 'end of socialism' rhetoric associated with the fall of the Berlin Wall in 1989 and the dissolution of the Soviet Union in 1991.

Postmodernism and postmodernity

There is no space here to consider the postmodern in detail. Even the (obvious?) idea that it follows the modern (see p. 331) has been disputed, and much of the writing of postmodern theorists is notoriously hard to understand.

The distinction between postmodernism and postmodernity needs to be made, however. Postmodernism refers to art (painting, architecture, films, writing) which is part of an explicit rejection of or alternative to modernism; there have been few (if any – *Blade Runner* may be a candidate) 'postmodernist' films – as a label the term has more readily been attached to architecture, paintings and literature, increasingly since the 1970s. On the other hand, postmodernity is a term used to describe the culture which Western societies increasingly live in, and the word 'postmodern' can thus be applied to films, TV and other aspects of contemporary life independently of the label attached to the particular product.

The following (see also p. 333 below) are some of the characteristics associated with postmodern culture. Film titles are included where they show signs of the particular characteristic.

1 Loss of faith in the so-called grand narratives of human progress (including Marxism, Darwinian evolution, Freudianism, feminism, perhaps even rationality and science).
2 A loss/lack of a sense of history (*Absolute Beginners*, 1986; *Shakespeare in Love*, 1998; *Plunkett and MacLeane*, 1999; *Moulin Rouge!*, 2001).
3 Borrowing of fragments from other texts (including paintings, film, etc.) and using them with no reference to their original context (bricolage); this is closely linked to the idea of intertextuality, which is about references to other texts/paintings/films (*Orlando, Pulp Fiction*; use of famous paintings in posters, for example the Mona Lisa smoking a joint).
4 Pastiche and playfulness: 'Modernist' texts often had/have a serious purpose and often use(d) parody to satirize or attack a person or an institution. Postmodern pastiche does not have any serious target but tends to imitate and play with past texts/forms just for the fun of it (*Austin Powers: International Man of Mystery*, 1997; *Austin Powers: The Spy Who Shagged Me*, 1999).
5 Irony and knowingness are closely linked to most of the above (*Orlando*).
6 *Hybridity*: the mixing of genres (see also pp. 32 and 332), from *Star Wars* and the *Scream* series to *The Sixth Sense* (1999).
7 Divorcement of the image from reality: it has been increasingly argued since Baudrillard that (in Western cultures) we are losing touch with

reality (whatever that is) and that electronic images (TV, video and now the internet) have become the new reality: a simulacrum of reality (a simulacrum is an image which cannot ultimately be linked to a specific referent or object being represented). In David Cronenberg's *Videodrome* (1982), a character called Brian O'Blivion says as much:

> The battle for the mind of North America will be fought in the video arena – the Videodrome. The television screen is the retina of the mind's eye. Therefore the television screen is part of the physical structure of the brain. Therefore whatever appears on the television screen emerges as raw experience for those who watch it. Therefore television is reality and reality is less than television.

While the narrative of *Videodrome* is explicitly about television, other more recent films such as *eXistenZ* (Cronenberg, 1999), *Vanilla Sky* (Crowe, 2001) and *The Matrix* have begun to play explicitly with notions of 'reality' and philosophical issues of 'radical doubt', building on such earlier alternative-reality films as *Total Recall* (Verhoeven, 1990).

8 Fragmentation of the individual subject: while until (roughly) the 1970s/1980s most individuals (again, it has to be stressed that this applies to Western cultures) saw themselves as unitary, coherent subjects, the trend is now to a more fragmented subjectivity (matching an increasingly fragmented society) in which individuals have a different personality for each day of the week.

9 'The end of ideology': Francis Fukuyama infamously suggested in the aftermath of the events of 1989 that the 'victory' of Western liberal democracy and the fall of the Soviet regime effectively signalled the end of history.

Exercise 12.6

In small groups and then as a whole group, discuss the ways in which some recent films may be described as 'postmodern'.

Of course it is possible to argue that some of the above strategies are not new, but the last three points in particular (whether we want to accept them or not) seem to signal quite a radical shift in the way many people see films, and, indeed, the world.

Indeed, such aspects of the postmodern can also be seen as part of poststructuralism which, naturally enough, followed the structuralist impulse of the 1960s and 1970s. If structuralism did have a tendency to study a cultural product in isolation, and was often open to the charge of ignoring the social context in which such products were produced and consumed, it is also fair to say that much structuralist analysis has always been acutely aware of the limits of its methodology:

Barthes' *S/Z*, which furnished the narrative codes (see Table 12.1) which have been much used in film analysis, was itself marked by a poststructuralism which insisted that there was no single meaning, no way of simply stating how any spectator or reader would decode a text.

If the text was central to the structuralist approach, it is the very idea of a 'text' which has been deconstructed in poststructuralism. If *The Matrix*, say, is an audio-visual text, it is also part of a larger 'text' which would have to include the previous biographies and work of the film-makers, their financial and artistic relationship with the backers of the film (including the distributors, Warners), the production process itself, and indeed the biographies and social positioning of all of its spectators. In poststructuralism and for Cultural Studies, the 'text' becomes global: the whole of the world and of reality becomes a 'text'.

Yet if poststructuralism has been intent on deconstructing cultural artefacts and analysing their relation to the societies which produce and consume them, it could not have done so without the tools and the vocabulary provided by structuralism. It can be argued that the vocabularies of semiology, structuralism and psychoanalysis remain vital to understanding how films 'work'.

Cognitive approaches

Since around 1990 a number of writers (principally North American and most notably David Bordwell and Noël Carroll) have contested the apparent dominance of so-called 'Screen theory' (named after the British film journal), of which semiology, psychoanalysis and ideology were important components. Indeed, the hostility of many of the critiques of 1970s theory has led some to refer to the new approaches as 'anti-theory'. The title of the book edited by Bordwell and Carroll, *Post Theory* (1996), is itself provocative.

Nevertheless it would be quite wrong to say that the new 'post-theory' approach has no theoretical foundations. While rejecting much 'established' screen theory and its post-structuralist developments, such writers favour an approach based on Cultural Studies, reader response and cognitive theories. Cognitive theory (or 'cognitive science') aims at detailed (scientific) explanation of the links between perception (of film images and sounds, among other things) and the emotions produced. This approach is partly based on sciences of (visual) perception and Darwinian adaptation and evolution.

The old (and admittedly poorly understood) 'persistence of vision' explanation for how films produce an illusion of movement has thus been discarded in favour of the 'phi-phenomenon'. While the former attributed the illusion to an automatic mechanism beyond the viewer's control, the latter stresses the active nature of the work done by the brain in 'filling in the gaps' between the film's frames (Maltby, 1995, p. 490). The assumption tends to be that perception and cognition

are universally 'hard-wired' processes practiced by all humans, in contrast to the orthodox or neo-Marxist view that such processes are historically and culturally determined.

Not that cognitivism should be seen as a unified approach, however, as Carroll himself notes:

> Cognitivism is not a unified theory, not only because the theoretical domains cognitivists explore differ, but because cognitive film theorists, like cognitive psychologists, may disagree about which proposals – of the competing cognitivist proposals – best suit the data. So, once cognitivists stop arguing with psychoanalysts, they will have to argue with each other. And this is why it is a mistake to imagine that cognitivism is a single, unified theory. It is a stance.
>
> (Bordwell and Carroll, 1996, p. 62)

The stances of cognitive film theorists tend to involve either a complete rejection of both psychoanalytic and semiological models in the case of the North American writers, or some concern to take account of semiological and linguistic models, as in European cognitivism (see for example Michel Colin or Roger Odin).

If both the *Screen*-derived and cognitivist approaches claim to provide more accurate explanations of how individual spectators create meaning from films, the single central thing which separates the two camps seems to be an insistence on or an indifference to the role of our old friend the unconscious. Cognitive approaches would appear to take film decoding as something which happens naturally and needs no theorizing; we understand a film 'just by looking – *sans* any process of decoding, inference, or reading' (Carroll, 1988, p. 132). Such an approach is evident in writing about film such as Andrew Klevan's (1999) *Disclosure of the Everyday: Undramatic Achievement in Narrative Film*, which continues an interpretative tradition going back to Vincent Perkins and before him F. R. Leavis which seems to equate filmic images with 'reality'.

According to Carroll, '[t]he mere plausibility of a cognitivist theory gives it a special advantage over psychoanalytic theories of the same phenomenon...[W]here we have a convincing cognitivist account, there is no point whatsoever in looking any further for a psychoanalytic account' (Bordwell and Carroll, 1996, p. 65). On the other hand, as we have already seen, this kind of assertion seems to deny the possibility that the plausible (or obvious) may be 'wrong' and that a psychoanalytic approach may be necessary to expose why perception works as it does.

//

New forms of spectatorship

New film-making and screening technologies are bound to entail new relationships between spectator and film text. Some of these have been suggested in Chapters 6 and 10 above, but it may be worth considering some other changes

in spectatorship which will no doubt emerge in the next decade or two – indeed such is the speed with which new technologies are now developed and marketed that textbook sections such as this one risk being out of date in no time at all.

Film projectionists (of whom there are surprisingly many) will no doubt mourn the eventual disappearance of celluloid and of 'film' in the physical sense. Film projection is a technical skill requiring considerable training and expertise. With the advent of digital technologies, however, it is most likely that screenings in cinemas will increasingly depend only on someone capable of pressing the right buttons.

How will this affect cinema spectatorship? Superficially, perhaps very little at first. The spectator's relation to the screen will remain much as it is now. The ritual of watching a film in a cinema may remain relatively unchanged. But there are at least five further aspects of the new digital technologies which are likely to have far-reaching effects on spectatorship.

For the first of these, we do not need to leave the cinema. With increasing use of CGI in films, the screen image loses its 'depth' and becomes 'flatter', a less effective simulation of three-dimensional space. What will be the implications for feeling 'part of the action'? How will this affect identification with character or action? Will films come to resemble TV or computer games?

Second, and remaining in the cinema, the very nature of characters and the actors/stars who play them is likely to change radically. Already, characters have been entirely computer-generated: in *Titanic*, the crowd seeing off the voyage is a computer figment; in *Eyes Wide Shut*, the version distributed in the USA features a group of computer-generated characters walking in front of an orgy scene which would have been unacceptable for the rating which the distributors wanted. In this and an increasing number of instances the images of people which are shown on the screen have no referent; this is not a picture of a real person (which of course has serious effects on the kind of semiological analysis that is possible!). Again, this is likely to have implications for how we think about identification with characters, or with actors or stars. It is likely that in the future there will be cyberstars (or 'synthespians') who have no material existence. Existing stars may also sell the rights to their images to computer-imaging companies so that their (computerized) images can be recycled in future films. As Barbara Creed points out (2000), as Arnold Schwarzenegger was fond of saying, 'I'll be back!'

The other likely effects on film spectatorship move us out of the cinema and into the domain of private viewing. While around 1980 (in the UK) widespread access to VCRs and videotape revolutionized private film viewing (not least for academics and teachers!), the effect of DVD, following that of CDs in audio, may well be even more radical. Not only do DVDs usually come complete with additional 'documentary' material about the making of the film, profiles of actors and creative technicians, etc. and 'directors' cuts' (that for *The Wicker Man* (Hardy, 1973) is particularly interesting), but the facility of being able to drop into the film at almost any point (and indeed of watching scenes in any order) further weakens the incentive to watch the whole film. The development

of so-called interactive technology also means that spectators will soon be able to choose which narrative (for a named film) they wish to follow…

Indeed this has already happened. After *Timecode* was released in 2000, the director Mike Figgis 'toured' and 'performed' his own projections of the film. The images of *Timecode* remained unchanged in each 'performance': the entire film consists of what happens in front of each of four cameras, each image track occupying a quarter of the screen. There is no editing. The spectator is free to give attention to each of the image tracks as s/he wishes. The point of the 'live' screenings was to vary the prominence given to the *sound* accompanying each of the image tracks: the spectator's attention could then be manipulated (or not?) by privileging the sound associated with each image track: for example a psychotherapy session, a secret phone call to a lover, a sex scene, the sound of passing cars. The sound mix is essential to the attention the spectator gives to each of the image tracks (though of course one can deliberately look for clues in the soundless images), and crucially also to the spectator's understanding of the narrative. Interestingly, one DVD version of *Timecode* allows the (home) viewer to manipulate the sound levels for her/himself.

Fourthly, the above developments will, of course, also be transferable to film viewing on the internet. Here, in addition to the DVD options, there are likely soon to be sophisticated databases linked to individual films. At the time of writing, prototype internet programmes exist which allow DVD viewing on part of the screen, and simultaneous analysis on other parts of the screen. For example, it is possible, at a click of the proverbial button, to identify all cuts or shots for a sequence or for the entire film and to generate sample frames from the shots. It is possible to summon texts from a database of reviews and articles in which sections dealing with particular aspects of the film (for example, the central character, lighting, *mise en scène*) have been highlighted; a click on the highlighted section can then call up the sequence referred to. Some films in production are already having all technical information about shooting automatically stored on computer. Internet sites (and perhaps DVDs) will thus contain shot-by-shot catalogues of shot sizes, camera angles, lighting and various aspects of *mise en scène*, in addition to dialogue and other script details.

Finally, the alternatives to immersion in a film in a big-screen auditorium have now been joined by the possibility of watching a film on an iPod or a mobile telephone. Aside from the points discussed above relating to viewing context and the manipulation of the film itself, the issue of *scale* is here pushed to the limit. Quite apart from the kind of attention which can (or needs to) be given to such a small image, there are interesting questions about the *kinds* of films which may best lend themselves to such viewing. It is doubtful whether wide-screen epics or rapidly edited action sequences, for example, can be fully appreciated on such a screen, compared with a screen 100,000 times the size at a large cinema. It will perhaps not be long before films are visually designed with mobile phone viewers in mind: intimate dramas with plenty of close ups may become a favoured genre…

CONCLUSION

With such wide-ranging changes in strategies of spectatorship, it is likely that theories of spectatorship will also need to change. It will be for a new generation of film spectator-theorists to develop appropriate models. These will no doubt need to draw on much of the theoretical legacy outlined above...but the recipe will be different.

SUMMARY

↪ Spectatorship refers to the individual spectator, while 'Audience Studies' refers to social groups of spectators.

↪ Over the course of the twentieth century, 'effects' studies gave way to uses and gratifications and Cultural Studies approaches.

↪ Alternatively, the spectator's position can be seen as an effect of the text itself.

↪ Psychoanalytic models of the spectator have been influential since the 1970s, but have recently come under attack, particularly from a cognitivist perspective.

↪ Semiology/semiotics (the study of sign systems) and structuralism have provided important tools for textual analysis of films.

↪ The concept of ideology has been at the centre of arguments over how films produce meaning in relation to individual spectators/subjects.

↪ The idea of the postmodern has led to suggestions that we have reached the end of history and of ideology.

REFERENCES

Bordwell, D. and Carroll, N. (eds) (1996), *Post Theory*, Madison, WI: University of Wisconsin Press.

Carroll, N. (1988), *Philosophical Problems of Classical Film Theory*, Princeton, NJ: Princeton University Press.

Creed, B. (2000), 'The Cyberstar: Digital Pleasures and the End of the Unconscious', *Screen*, vol. 41, no. 1, Spring.

Creed, B. (1987), *Cultural Studies*, vol. 1, no. 1.

Geraghty, C. (1997), 'Women and Sixties British Cinema', in R. Murphy (ed.), *The British Cinema Book*, London: BFI.

Klevan, A. (1999), *Disclosure of the Everyday: Undramatic Achievement in Narrative Film*, Trowbridge: Flicks Books.

Maltby, R. (1995), *Hollywood Cinema*, 1st edn, Oxford: Blackwell.

FURTHER READING

It is not possible here to give a full sense of the amount of detailed analysis which has been carried out on individual films from a psychoanalytic perspective

(or indeed from many other theoretical perspectives). There is a vast iceberg of theoretical literature just waiting for the unsuspecting student…Some of the texts suggested here are perhaps more 'difficult' than many of those listed in other chapters.

Andrew, D. (1976), *The Major Film Theories*, Oxford: Oxford University Press (Part 3).

A clearly structured, accessibly written summary of types of film theories.

Barker, M. (1984a), *A Haunt of Fears*, London: Pluto Press.

Barker, M. (ed.) (1984b), *The Video Nasties*, London: Pluto Press.

Both these Barker books are excellent in their use of ideas of ideology to analyse moral panics.

Barker, M. (with Austin, T.) (2000), *From Antz to Titanic*, London: Pluto Press.

An excellent book if used for in-depth study: contains detailed analysis of key scenes from a range of mainstream films, with clear explanations of how the analysis works. Recommended for the serious student.

Barthes, R. (1973), *Mythologies* (transl. A. Lavers), London: Paladin.

Some fine examples of early applied semiology as Barthes 'reads' some everyday artefacts of his time.

Barthes, R. (1974), *S/Z* (transl. R. Miller), New York: Hill & Wang.

A challenging but fascinating demonstration of Barthes' narrative codes.

Braudy, L. and Cohen, M. (eds) (1999), *Film Theory and Criticism: Introductory Readings*, 5th edn, Oxford: Oxford University Press.

An essential compendium of important film-theoretical writing.

Buckland, W. (2000), *The Cognitive Semiotics of Film*, Cambridge: Cambridge University Press.

A good thoughtful introduction to cognitive film studies and a useful situation of its opposition to some other approaches such as the psychoanalytic.

Cook, P. (ed.) (2007), *The Cinema Book*, 2nd edn, London: BFI.

A good thorough introduction; good if at times challenging on film theory.

Ellis, J. (1982), *Visible Fictions*, London: Routledge & Kegan Paul.

Though there is no index, a stimulating examination of the relationship between film texts and their production and exhibition contexts.

Gray, A. (1987), 'Reading the audience', *Screen*, vol. 28, no. 3, Summer.

A good example of early Reception Studies.

Hill, J. and Gibson, P. C. (eds) (1998), *The Oxford Guide to Film Studies*, Oxford: Oxford University Press (Chapters 6–11).

A useful, fairly thorough summary of topics covered in this chapter.

Manovich, L. (2002), 'Old Media as New Media', in D. Harries (ed.), *The New Media Book*, London: BFI.

A good, stimulating discussion of the tensions between celluloid and digital film production.

Mayne, J. (1993), *Cinema and Spectatorship*, London: Routledge.

A good collection of theoretical texts about spectatorship, largely from a psychoanalytic perspective.

Morley, D. (1980), *The Nationwide Audience*, London: BFI TV Monograph.

Morley, D. (1986), *Family Television*, London: Comedia.

Both Morley books are good examples of early Uses and Gratifications work in Reception Studies.

Stam, R. (2000), *Film Theory: An Introduction*, Oxford: Blackwell.

A good sound introduction.

Wollen, P. (1969, 1972, 1987), *Signs and Meaning in the Cinema*, London: Secker & Warburg (new edn, London: BFI, 1997).

An important book from the 1970s which exemplifies the way in which semiology and auteur studies influenced one particular strand of British film-theoretical writing.

FURTHER VIEWING

The Philosopher's Magazine: http://www.philosophersnet.com/games/matrix_start.htm (for a stimulating philosophical exercise on *The Matrix*)

Chapter **13**

Authorship

> [T]he cinema is the work of a single man, the director... A film is what
> you write on the screen.
>
> (Orson Welles, quoted in Wollen, 1969, p. 26)

This chapter will examine the role of the director in relation to the complex
structure of finance, production, genre and stars. In particular, it will look at the
influence of the *Cahiers du cinéma* articles in which Jean-Luc Godard, François
Truffaut and others developed their 'politique des auteurs' and the subsequent
application of these ideas to Hollywood cinema.

As we have seen, film-making is almost always a complex team activity, and
the idea of authorship may seem a strange one to use in such a collaborative
medium. Nevertheless, as we shall see below, the idea of the author has been
crucial to much thinking about film for at least the past four decades. But what
is an author?

Some general reflections on authorship

In common usage the idea of an author seems unproblematic: it is the person who writes; usually the word is used to refer to the writer of a published work, be it a book, an article or a letter. Yet even this is perhaps not as straightforward as it may seem. Many books are listed under the person who has 'edited' a series of chapters or articles by different writers; clearly the writers of the separate chapters/articles are the collective authors, but the person credited for the book is the 'editor', who may have written just a short introduction.

Then there is the problem of copying and plagiarism – an important area for any student or writer to negotiate. If for the purposes of this chapter in this book I copy or rely heavily on someone else's book/text, then can I be said to be the 'author' of the chapter? If a student copies large chunks from, say, Bordwell and Thompson's *Film Art* in an essay, who is really the 'author' of the essay? Such plagiarism and stealing of other peoples' ideas and words have of course long been a subject of dispute: two quite different sorts of examples would be the controversy about 'was Shakespeare really the author of the plays that are attributed to him?' and the increasing numbers of long (and expensive) court cases (for example, that involving Bruce Springsteen) fought over alleged theft/plagiarism of relatively obscure fragments of music. Indeed, with the popularization of rap and sampling techniques since the 1980s, and with the increasing availability of written text, recorded sound and moving images through the internet since the 1990s, another kind of major threat to common-sense ideas of authorship (and of course to the idea of copyright) has emerged. Of what, for example, is rapper Will Smith the 'author'? It is also to be noted, of course, that plagiarism in examination work is often punished with a 'Fail' grade.

The idea of the writer/painter/artist as gifted creator/'author' of his/her work of art is in fact a comparatively recent one in the history of humanity. Though the names of a number of artists and writers have of course been recorded over the centuries, the idea of the 'gifted artist' as 'author' of her/his (historically usually 'his') work really dates from the Renaissance of the fifteenth and sixteenth centuries: before then the ultimate 'creator', or the source of inspiration, was most often seen as God (or some equivalent). Painters, sculptors and writers were principally seen as craftsmen.

Though it comes at the end of a (very) long history of ideas about writing/literature, the idea that Mary Shelley was the author of *Frankenstein*, Dickens of *David Copperfield* and Brett Easton Lewis of *American Psycho* can now be taken for granted. By extension, it is fair to see Leonard Cohen as the 'author' of 'The Future', John Lennon of 'Imagine'.

These examples, however, begin to illustrate another kind of difficulty with the idea of an author. While obviously some authors/artists have created their work in private and with the aim of expressing their creativity (Rubens and Gauguin

in painting perhaps, Virginia Woolf and Salman Rushdie in literature, to take a few random examples), this has certainly not been the norm. Most painting and sculpture before and after the Renaissance was commissioned either by the Church or by wealthy patrons – the 'artist' was thus basically doing a job for someone. Much music was also written/composed in the same way, and indeed many post-Renaissance composers, Mozart and Wagner among them, continued to rely on commissions and patronage to earn a living.

With the development of capitalism in the eighteenth and nineteenth centuries (and of course throughout the twentieth), a new kind of market was created, works of art became commodities, and the artist/author's name became a label which could be used to sell the product: a painting, a book, a theatre production. The idea of the author as gifted creative individual is thus (in the grand scheme of things) a relatively recent development which fits perfectly into the dominant capitalist culture which has developed most particularly in Europe and North America over the last two centuries.

Possible 'authors' in film

All of this is relevant to film because cinema was born at the end of the nineteenth century into a set of developed capitalist economies in France, Britain and the United States. The new medium (see Chapter 1 for more detail) was almost immediately developed along capitalist lines as a commodified entertainment.

The initial attraction of film was as a novelty, and film-makers (the distinction between director, producer, company, etc. only becomes useful after about 1907 with the development of the first film studios in North America) and exhibitors were not slow to exploit the entertainment and exploitative possibilities of the new medium. Nickelodeons in the USA between 1905 and 1915 ran continuous programmes, typically from 8 o'clock in the morning until midnight; programmes were often sensationalist and were advertised stridently. The emphasis was thus on the experience and the novelty – in much the same way that Virtual Reality arcades, computer games and indeed perhaps still the circus are advertised/consumed today – and the idea that individuals/artists could produce films was at first nowhere in sight.

Film companies

If anything gained fame/notoriety during this period, it was the film company (for example Edison, Vitagraph, Biograph), which would typically be the only 'credit' attached to the film. Indeed, until around 1910 the upstart film shows were not 'respectable' entertainment at all, and many of those appearing in the films were actors who could not secure work on the more legitimate stage. There was thus a certain stigma attached to acting in films, and indeed film producers

were at first reluctant to publicize nascent 'stars' since this would lead to claims for higher wages.

Actors

The first credits for individual actors began to appear in 1910, and this has been seen as arguably the first step towards recognizing authorial agency in film. Perhaps it is not surprising that actors were thus recognized before directors, since they are the most publicly visible personnel in film-making.

But can an actor be seen as the 'author' of a film? If actors could then be seen by audiences as a film's most significant individuals – as of course they often still are – which other persons may be candidates for the 'authorship' of a film?

Exercise 13.1

List the major roles which have to be fulfilled by individuals in the making of a film. For each one, note in what ways that individual could be considered as the 'author' of the film. It may help to think about specific examples which could support your choices.

The earliest films (for example, those credited to Georges Méliès, Edwin S. Porter, R. W. Paul) were made by very small groups of people: in the Lumière tradition at least, the principal task was simply to operate the camera. While individuals continued to experiment (increasingly in other countries further and further away from France and the USA), a significant event was the setting up of Thomas Ince's New York Picture Company studios in California and the development of production control and scientific management practices aimed at the efficient production of films (see Chapter 2). The important innovation at Ince's studios was the division of film-making labour into specific tasks – tasks which had been roughly developed previously but which had never been so clearly defined within an industrial and management structure. While the size of Hollywood studios increased a hundredfold over the coming half-century, Ince inaugurated working methods which, though they evolved with time, were to become the bedrock of the US film industry.

The principal personnel in film-making in the studio system – apart from the actors of course – became the studio head, the producer, the scriptwriter(s), the director, the cinematographer, the camera operator and the editor. Even in the studio set-up some of these functions were sometimes combined, and perhaps the most interesting contested task in the present context is that of the editor.

Although it will become clear (if it is not already) which of these roles can best be and most usually is called 'authorial', a limited case (usually based on the evidence of relatively few films) can be made for some of the others.

Moguls

It could, for example, be argued that studio production heads ('moguls') such as Irving Thalberg (at Loew's-MGM between 1924 and 1936) and David O. Selznick (who worked at RKO and MGM between 1931 and 1936) stamped a recognizable 'identity' or 'look' on nearly all films produced in their studios during that particular period and so should be given (at least joint) 'author' status. It is reported that Thalberg in particular read all scripts, saw the rushes of all films, and oversaw the production of Universal and MGM films to an unprecedented degree. In common with other producers, Thalberg and Selznick also controlled the editing of most films (except those entrusted to the most experienced directors or those who dug their heels in and refused studio 'interference'). Thalberg's reputation is thus typified by his sacking Erich von Stroheim before the editing stage when, already a respected director, the latter had run massively over budget on the production of *Foolish Wives* in 1922. Selznick was also famed for the hundreds of memos he would send during the production of a single film.

While the term 'mogul' is commonly used for influential company heads of the heyday of industrial capitalism (there were also 'oil moguls' and so on), a new generation of rich and successful directors emerged from the 1970s onwards whose own production companies, while quite different from the classically-managed production lines of the studios, can be seen as reflecting the film-making preferences of their respective 'star producers'. Is Steven Spielberg's hand not visible, for example, in *Twister* (de Bont, 1996), *Deep Impact* (Leder, 1998) and *Jurassic Park III* (Johnston, 2001)? Is George Lucas' fondness for escapist adventure not reflected in the Lucasfilm-produced *Indiana Jones and the Last Crusade* (Spielberg, 1989)? Indeed the well-cultivated 'star' status of Quentin Tarantino has ensured that a film such as *True Romance* (Tony Scott, 1993) is often referred to as a 'Tarantino film'.

Scriptwriters/screenwriters

An obvious case could also be made for the authorial status of many scriptwriters. This is not only because scriptwriters actually write and are thus more easily thought of as 'authors', but also because scripts sometimes 'make' films. Among scriptwriters whose work has most often been seen as crucial to a film are Dalton Trumbo (*Spartacus* and *Exodus*, both 1960) and T. E. B. Clarke, who wrote the scripts for many of the Ealing comedies. Another interesting case is Ruth Prawer Jhabvala, part of the Merchant–Ivory–Jhabvala 'authorial' team: an unusual case of joint 'authorship' being proclaimed through the triple-barrelled label attached to such films as *A Room with a View* (1985) and *Howards End* (1991). Richard Curtis' writing of *Four Weddings and a Funeral* (1994) and *Notting Hill* (1999) shows considerable 'authorial' continuity. The list could go on, and would include Aaron Sorkin, who has marked himself out

with a distinctive style in his scriptwriting work for film and television, from *The American President* (1995) through to *Charlie Wilson's War* (2007) with TV series in between: *Sports Night* (1998–2000), *West Wing* (1999–2006), *Studio 60 on the Sunset Strip* (2006–7). His characters' dialogue is often fast-paced with quick, witty exchanges that often challenge the viewer, not only with the need to concentrate on what is said but also to identify the historical, cultural, political and generally academic references that frequently emerge. Lead characters tend to be intelligent and knowledgeable, perhaps with the implicit expectation that the same is expected of the viewer. Sorkin's writing style has become identified with director Thomas Schlamme's camera style. Their television collaborations have matched Sorkin's characters' frequently long monologues and dialogues with Schlamme's long tracking shots, sometimes referred to as 'walk and talk' shots.

Authors of 'source' books

The 'quality' adaptations of the Merchant–Ivory–Jhabvala team also remind us that the author of the original written text can be given some author-status in a film's very title in an effort to boost its cultural prestige: thus *Bram Stoker's Dracula* (Coppola, 1992), *Mary Shelley's Frankenstein* (Branagh, 1994) and *William Shakespeare's Romeo and Juliet* (Luhrmann, 1996).

Cinematographers

Perhaps less obviously, the cinematographer and photographer (in early films these functions were often combined by one person) have also sometimes been hailed as 'authors', as having the greatest influence on how a film turns out. Thus most famously, Gregg Toland's work on *Citizen Kane* has often been seen as more significant than Orson Welles' well-publicized direction (though it is true that Welles also co-scripted and starred in the film). The deep field photography, allied to the lighting systems and the camera angles and framing, were highly innovative at that time and, perhaps rather belatedly, Toland's is now being seen as the determining contribution.

Another interesting example from film history is the camerawork of Karl Freund, whose experiments with 'das entfesselte Kamera' (the 'unchained' camera) in films such as *The Last Laugh* (*Der letzte Mann*) in 1924 were a revolutionary liberation of the camera from its previously ponderous movements. Thus, another arguably 'authorial' contribution. Many more recent films have also boasted the services of celebrated photographers: for example, Raoul Coutard worked consistently with Jean-Luc Godard between 1959 and 1967; Sven Nykvist was closely associated with Ingmar Bergman before going on to work with a number of other well-known directors. And although 'author' status never came his way, Billy Bitzer was the expert camera operator with whom D.W. Griffith (see below) made almost all 'his' films.

Editors

Before we move to the role in film-making which has most consistently been associated with authorship, we should note the crucial role of the editor. While Alfred Hitchcock and John Ford, for example, insisted on tight control of the editing in 'their' films, countless other films have been edited, in effect, by studio personnel, by professional editing staff who would have been virtually unknown to those actually shooting the footage on set or out on location, or to the audience. Sometimes – indeed, more often than not in the major studios of the 1930s, for example – editing was personally supervised according to a strict set of guide-lines by the producer and/or the studio head. Though the editor is not normally thought of as an author, then, it is nevertheless clear that the overall look/shape of a film depends enormously on the editing.

Interesting case studies are provided by *Performance* (Cammell and Roeg, 1970) and *Blade Runner*. Warner Brothers executives hated *Performance* so much (Richard Schickel's review in *Time*: 'the most disgusting, the most completely worthless film I have seen') that they tried to have it drastically re-edited, to the dismay of Cammell and Roeg. Only under pressure from Cammell did they agree for re-editing to be done by Frank Mazzola, to whom Cammell gives much of the credit for the eventual version. *Performance* was then deliberately released in the USA in the 'dead' month of August 1970 and sank without trace; in Britain it was released in January 1971, received good reviews and became a cult classic. The editing of *Blade Runner* was delayed by endless controversy and argument especially among Ridley Scott (the director), Hampton Fancher and David Peoples (the scriptwriters), Michael Deeley (the producer) and the representatives of the financing companies (see Sammon, 1996). The film was first released in 1982 having been edited by Terry Rawlings, not without pres-sure and interference from Tandem, the 'completion bond guarantor' company. It was not until 1992 that Ridley Scott was able to re-edit the film and change the soundtrack, and *Blade Runner: The Director's Cut* was released.

More extreme cases of editor-authorship are of course provided in cases where films depend largely or entirely on archive/found footage. A famous example of this was the case of the Soviet film-maker Esfir Shub, several of whose films, including *Fall of the Romanov Dynasty* (1927), were composed entirely of such pre-shot archive film. Apart from the (often unknown) camera operators who had shot the original material, therefore, she was the sole 'author' of her films. Interestingly, however, the Soviet film administrators Sovkino refused to recognize Shub's right as author.

The director as 'author'

This brings us, finally, to the person most commonly accorded film 'author' status: the director. In the remainder of this chapter we shall trace the way in

which the idea of directorial authorship developed, and particularly the debate which followed a series of articles about the auteur in the French journal *Cahiers du cinéma* and which had a widespread effect on theories of authorship.

It is not generally wise to overvalue the importance of single individuals. Whatever influence the individual has and whatever the 'effect' on history, the individual must always be seen in a historical, social and economic context. As we have noted, the idea of the gifted creative artist is historically a relatively recent one, and the concept indeed needs to be seen in the context of the Renaissance, of a gradual retreat from religious explanations of human agency, and of a slowly developing capitalist society.

D. W. Griffith as auteur

Nevertheless, the contribution of David Wark Griffith to film history was an important one. If he was in some way a 'genius', this was because his talents were ideally suited to the early industrial context of film-making: the early studio system which provided a tight production structure but in which innovation (especially technical) was vital and would benefit all concerned: the audience with the excitement of a developing entertainment/art form, the studio bosses/owners with increasing profits, and film-making employees with new technical and aesthetic challenges. For some, of course, this meant fame, and D. W. Griffith became famous.

Griffith's innovative career is also considered elsewhere in this volume; the relevant point here is his development of the role of the director as person in overall charge of shooting a film. At the time of Griffith's debut in film-making in 1908 – he had drifted into the film industry when his career as a theatre actor failed to blossom – the directorial function was in its infancy; since the advent of cinema in 1895 the person who 'made' the film had been the camera operator. At the turn of the century, of course, editing was also quite rudimentary and consisted of the sequencing of 'tableaux', sometimes into a narrative progression, sometimes not. Although by 1906, following Edwin S. Porter's *The Great Train Robbery*, intercutting between scenes was being developed (in the USA and elsewhere), when Griffith began his career in 1908 editing was in its infancy. The camera remained static. The camera operator was concerned with light levels, with the distance of the camera from the actants/subject (framing) and indeed often with organizing what was happening in front of the camera (the *mise en scène*).

Griffith was instrumental in changing this. Though constrained in the 450 films which he made between 1908 and 1913 by Biograph's insistence on one-reelers and the studio's reluctance to venture into 'serious'/'artistic' subjects, Griffith was nevertheless responsible for much innovative work on film language (see p. 16) and was the first to establish a reputation as director which rivalled those of emergent stars of the day such as Theda Bara, Douglas Fairbanks and Mary

Pickford. Indeed, he was the first director to accord himself authorial status by placing his directorial credit before the names of well-known stars. Related to this, it is not insignificant that he took his own writing talents seriously: he soon began composing his own (sometimes rather pompous) inter-titles and placed his own logo on each inter-title for all to see.

Griffith's status as star director enabled him to put pressure on Biograph to let him make longer and more ambitious films (*Enoch Arden* and *Judith of Bethulia*) but he was unhappy with the company's marketing of these films, which did not help them to be successful. In 1913 Griffith left Biograph and was able to complete two ambitious projects, *Birth of a Nation* (1915) and *Intolerance* (1916), both considered to be major landmarks of film art. After some financial hiccups, together with Charlie Chaplin, Douglas Fairbanks and Mary Pickford he set up United Artists in 1919 and immediately directed *Broken Blossoms*, his last major film.

Griffith was thus the first high-profile director who could be accorded 'author' status. If there have been many other directors since then who may be considered 'authors', the story has become complicated by an important distinction which can be seen to have some roots in the Griffith case: this is the distinction between 'art cinema' and the commercial or mainstream cinema of (initially) Hollywood.

Art cinema

Outside and in parallel with the industry of commercial cinema, art cinema has always been concerned less with entertainment and more with artistic experimentation and expression. Art cinema (like its cousins avant-garde and independent cinema) has been closely linked with the idea of film as an expression of the vision of an individual director-artist. Working outside industrial structures, some directors have made films entirely alone: Steve Dwoskin, for example, made films in the 1970s partly as social commentary but also as intensely personal (and political) documents. At the same time and into the 1980s, structural-materialist avant-garde artists such as Peter Gidal, Peter Kubelka and Michael Snow produced experimental films which explored the possibilities of the film medium: 'images' were created on film not only by unconventional combinations of lighting, camera movements and angles, but by physical manipulation of the celluloid: film was scratched, deliberately scorched, treated with acid, mould was allowed to grow on the celluloid surface, and so on. It is easy to see the self-expression and products of such film-makers in the same way as those of, say, the painter-artist.

Other directors have worked more or less professionally with other film personnel: with recognized camera operators, actors etc. Nevertheless such directors maintain(ed) a good deal of control over the production process and over the final product, and so their films have been recognized as expressions

of their artistic sensibility. Carl Dreyer, for example, famously insisted on total control over all aspects of production in the relatively few feature-length films he completed (six between 1928 and 1964, an average of six years for each feature film). Though (most) other 'art' directors had a more complicated relation to the broader film industry, we are used to talk of 'an Ingmar Bergman film' or 'the latest Jarmusch'.

There is an interesting commentary on 'authorial' control at the end of *Speaking Directly* (Jon Jost, 1974) in which Jost, a steadfastly outspoken and independent film-maker, painstakingly thanks all those involved in making his (very cheap) film. He lays out and describes all the equipment he has used, explains where he borrowed each item from, thanks the spectator for watching, but also explains that to credit everyone involved in the film would involve thanking the people who physically developed his film stock, the mine workers who obtained the minerals necessary for the film emulsion, and so on.

There have been and are many such film 'authors'. One further interesting case was Marguerite Duras, a French writer and film-maker who died in 1996 as author of much literature and of over twenty films. One of her avowed reasons for making films was a strong hatred for the limitations and conservatism of conventional film story-telling, and almost all her films (for example, *India Song*, 1974; *Le Camion*, 1977; *Les Enfants*, 1985) were thus refusals of the conventional treatment of time, character and space. While following a very personal agenda both in terms of the films' subject matter and in her filming methods, the thing to stress in the case of Duras is the collaborative nature of the work; perhaps a kind of seduction in which the directness and the honesty of a charismatic artist, though often 'difficult' to deal with, generally produced a closeness and a sense of shared purpose in all those involved.

The media 'fame' of a film-maker (and here we effectively return to Griffith) may, as in the case of Duras, be related to her/his other work, for example, as a writer, or to a flair for self-publicity (no doubt true of Griffith but also, for instance, of Orson Welles). The artistic aura of others such as Ingmar Bergman, Carl Dreyer or Stanley Kubrick has been at least partly due to their perceived mysteriousness and lack of self-publicity in the rarity of interviews, for example.

The 'author' and the Hollywood studio system

We thus return to the world of commercial/entertainment cinema with its publicity and its marketing: an 'image industry' in that it produces filmic images, but also in the sense that it produces 'star images', usually of star actors but also sometimes of directors (think of Quentin Tarantino).

As we have seen, then, film production in the Hollywood studio system which dominated world cinema from the 1920s until around 1950 was a highly organized and collaborative enterprise, and we have also remarked that it might

even be possible to see a studio head of production such as Irving Thalberg as having the greatest personal influence on any particular MGM film of the time. Since the studio system became a more or less universal organizational model throughout the world, considerable influence thus also fell, for example, to Michael Balcon at Ealing Studios and to the 1930s producers at the massive 'Bollywood' studios in Mumbai in India.

If, since Griffith, the director could therefore sometimes be seen as imposing his/her ideas on a project, as definitively shaping a film to an 'authorial' purpose, it has also been clear that the studio system with its rigid divisions of labour made this very difficult. Thus though the quality of the films would also have been a factor, while some directors became known either partly because of a previous acting career (Charlie Chaplin), through doggedly insisting on greater control (John Ford, Alfred Hitchcock) or largely through self-publicity (Orson Welles), the fame of the great majority of directors ended with seeing their name in the credits; the film was a Warner Brothers gangster film or a Universal horror film. It is largely with retrospect that names such as Todd Browning, James Whale, Mervyn Le Roy, Lloyd Bacon and hundreds of others are now well known to film historians, and that many directors of Hollywood and elsewhere have become 'authors'. How and why did this happen?

Cahiers du cinéma, the 'politique des auteurs' and auteur theory

The seeds for a reappraisal of the director's role were sown in an article written in 1948 by Alexandre Astruc for *Cahiers du cinéma* entitled 'The Birth of a New Avant-garde: la caméra-stylo [camera-pen]'. This established the idea that film-making was analogous to writing, so it was not long before filmic equivalents for the literary author were sought. The moment which sparked a major shift in assessment of a director's contribution to the film-text was an article by François Truffaut entitled 'A certain tendency of the French cinema', which appeared in *Cahiers du cinéma* no. 31 in January 1954.

The position advanced in the Truffaut article and in subsequent pieces in the same journal by Jean-Luc Godard, Jacques Rivette, Claude Chabrol and Éric Rohmer became known as the 'politique des auteurs'. It is often wrongly called the 'auteur theory', which as we shall see below was principally the responsibility of the US writer Andrew Sarris. The French writers' texts were put forward as a polemic, as an argument intended to provoke debate and change, not as a 'theory'.

The starting-point of this polemic was the cinematic unimaginativeness of the French cinema of the time as perceived by Truffaut and his young colleagues. Theirs was a thirst for a cinema which would innovate and explore the cinematographic possibilities of the medium, and for them the model of such experimentation was to be found in Hollywood films. The love of Hollywood films as a form of cinematic art, itself a view perhaps peculiar to French *cinéphiles* (lovers of film),

was, however, also linked to growing suspicion about the relative values of 'high art' and popular or mass culture: the traditional dismissal of the latter (as trivial and unworthy of serious critical attention) at the expense of the former (as uplifting, concerned with 'serious' matters). While the exporting of American culture (particularly after the Second World War) can certainly be seen and denounced as cultural imperialism, here the French writers' focus was on the democratizing and aesthetic possibilities of popular cinema; a reappraisal of the artistic merits of a popular form was begun in reaction against the widespread class-snobbery of 'high art'.

This led the *Cahiers* group to examine the films made by a particular director to try to find common themes or signs of a characteristic film-making style. Feeling confident that they could indeed find, for example, common themes and preoccupations in many of John Ford's films, and a coherent characteristic use of *mise en scène* in the work of Vincente Minnelli, they boldly argued what had not been argued before: that many directors (in Hollywood but also by extension elsewhere), despite working in a 'scientific management' industrial system, nevertheless managed to shape 'their' films so that the films which they had directed had something in common; the director's 'style' or world-view was a kind of 'authorial' signature linking her/his films. While not denying that any film was subject to many other influences, the *Cahiers* group asserted that the director was an auteur – or, failing this, a *metteur en scène*. The distinction was between those directors (auteurs) whose films showed a more or less consistent set of themes or preoccupations which was developed through many or all of their films in a coherent, individual way, and those directors whose 'authorship' was detectable principally at a stylistic level but whose films lacked a coherent 'world-view': these were the *metteurs en scène*.

Many of the films of Douglas Sirk, for example (and especially *All I Desire*, 1953; *Magnificent Obsession*, 1954; *All that Heaven Allows*, 1956 and *Written on the Wind*, 1957), consistently explore family and gender relations in middle-class America; Sirk's use of the melodrama/'women's weepie' genre is now widely agreed to have enabled a biting critique of American society which would probably not have been possible in other genres of the time. Many of John Ford's films (most of which were Westerns or war films) explore the place of a certain kind of masculinity in American culture. This means that Sirk and Ford have been seen as auteurs.

▮▮▮▮▮▮▮▮▮▮▮▮▮▮▮▮▮▮▮▮▮▮
CASE STUDY

Alfred Hitchcock

The British director Alfred Hitchcock made some fifty-seven films in a career spanning over fifty years; his first film as director was *The Pleasure Garden* (1925) and his last was *Family Plot* (1976), completed at the age of 76.

Having established himself as a 'master of suspense' in Britain by 1938, and at a peak in terms of reputation, Hitchcock then gave in to the lure of Hollywood. After some hits and some misses in the 1940s, he entered his most successful phase working at Warner Brothers, Paramount and Universal. His films during this period included *Strangers on a Train* (1951), *I Confess* (1953), *Dial M for Murder* (1954), *Rear Window* (1954), *The Trouble with Harry* (1955), *The Man Who Knew Too Much* (1956), *Vertigo* (1958), *North by Northwest* (1959), *Psycho* (1960), *The Birds* (1963), *Marnie* (1964) and *Torn Curtain* (1966).

Among the themes which have excited the attention of film critics and theorists are guilt and religion, knowledge, looking and voyeurism, and obsessive/troubled relationships between men and women, and particularly their mothers – a potent brew!

If it is possible to play the amateur psychologist (see p. 268) and point to Hitchcock's strict Catholic upbringing and to his troubled relationship with his own mother, these are not the main aims of the auteur theorist. The important point in establishing Hitchcock's status as auteur is to analyse and chart how the above themes run through many of his films.

Thus, for example, the theme of guilt is evident as early as *The Tenant* (1926) and *Blackmail* (1929). The latter is usually described as the first British sound film; it also involves some rudimentary special effects (quite innovative at the time) which helped Hitchcock to develop the pursuit scenes which were to mark a number of his later films.

'Guilt' here is much more than the common plot device of 'is he guilty?' or 'will her guilt be discovered?'. Many of Hitchcock's films are complex examinations of the very idea of 'guilt', whether 'real' or imagined. The religious (Catholic) dimension of feelings of guilt is explicitly explored, for example, in such films as *I Confess*, but is never far below the surface, for instance in *Strangers on a Train* and *Vertigo*.

Many of Hitchcock's films are concerned with investigation, thus with watching and spying and the relation between knowledge, looking and voyeurism. In *Rear Window* the central character is played by James Stewart; the fact that he is hardly referred to by name may indicate his status as an 'everyman' voyeur. Confined to his room with a broken leg, he indulges his investigative drive (he is a photographer/reporter) by watching his neighbours, eventually through binoculars and then using a telephoto lens. The viewer thus shares his observation of several minor narratives; these include a lonely woman who almost attempts suicide after failing to meet a man through a lonely-hearts agency, and a couple of newlyweds on honeymoon.

He begins to suspect foul play in an apartment facing his own across the courtyard, but is unable to convince his police friend to take it seriously. Instead, his (female) nurse and his girlfriend (played by Grace Kelly) become his accomplices and do his legwork. When his girlfriend risks her own safety by entering the suspected murderer's flat to find evidence, she is discovered by the killer.

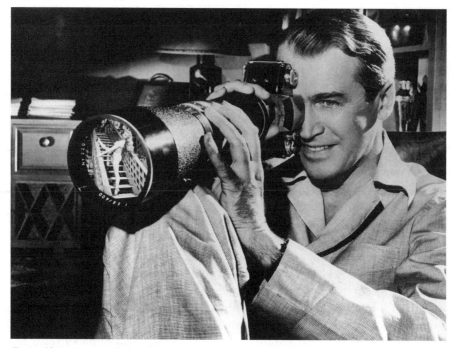

Figure 13.1 Are we all voyeurs? *Rear Window* (*Rear Window*, 1954, actor James Stewart, dir Alfred Hitchcock/© Paramount/The Kobal Collection)

He hastens to Stewart's apartment to kill him, but the latter outwits the killer (by blinding him with flashbulbs). Though he breaks his other leg in the ensuing fight, Stewart solves the case and the killer is caught. The last shot of the film seems to tell us that our voyeur has decided to give up spying on the neighbours: he is resting, asleep at the open window. But this is how the film began…

Attached to the convenient hook of a murder mystery, *Rear Window* is in fact itself a complex investigation of the act of looking and its pleasures. Through manipulation of point of view and through editing, the spectator is obliged to (at least partly) identify with the central character's peeping tom activities (see Fig. 13.1). The critique of cinematic voyeurism may be less radical and more playful than in *Peeping Tom* (Powell, 1960), but *Rear Window* is more about looking than it is about a simple detective story.

Other Hitchcock films which involve explicit themes of looking/voyeurism would have to include Norman Bates watching Marion Crane through a hidden spyhole in *Psycho*, Scottie's obsession with recreating an image of Madeleine in *Vertigo*, and themes of spying and performance in *North by Northwest*.

The third important theme in Hitchcock's films is the often troubled relationship of a central (usually male) character with women, and particularly with an (often strange) mother. Among early examples would be the threatening mother-figure in *The Man Who Knew Too Much* (1934) (and in Hitchcock's own

1956 remake). The theme is taken up in earnest in the American films between 1951 and the late 1960s. In *Strangers on a Train* Bruno (Tony Curtis) has a very odd relationship with his mother. The spy-thriller plot involving smuggled microfilm in *North By Northwest* is a good example of a 'McGuffin', a plot red herring; the central theme and subject of the film is the working through of Roger Thornhill's (Cary Grant's) Oedipal relationship with his mother. Norman Bates (Anthony Perkins) in *Psycho* of course has the unhealthiest relationship of all with his mother. The mother-figures in *The Birds* and *Marnie* (the latter the mother of a female character) are also constructed as disturbing figures.

END OF CASE STUDY

Effects of the *politique*

The discovery of common strands – both thematic and stylistic – in a director's work is rather more complex than it may seem here. In the 1970s and beyond, psychoanalytic theory and semiology were used to carry out many detailed analyses of the work of Hitchcock and many other directors (see Further Reading for this chapter and for Chapter 12) and to explore their contributions as auteurs.

By contrast, other directors were praised for their mastery of the filmic art of storytelling, but were seen to lack the thematic coherence of the auteur. A good example would be William Wyler, whose exploration of the social problems exposed by soldiers returning from the Second World War in *The Best Years of Our Lives* (1946) was seen as a masterpiece of *mise en scène*, but whose other better-known work included films from a number of quite different genres: the dangerous-female melodrama *Jezebel* (1938), the in-praise-of-British-war-spirit *Mrs Miniver* (1942), the Western *The Big Country* (1958), the Roman epic *Ben Hur* (1959), and a musical: *Funny Girl* (1968). Directors such as Wyler, Minnelli, Michael Curtiz and John Huston could then be seen as expert technicians, in contrast to the auteurs who succeeded, against the industrial odds, in expressing something of their own sensibility, and were therefore closer relations to the more obvious 'authors' of the art cinema.

While the *Cahiers* polemic of course shocked the French cinematic Establishment, the *politique* had important effects on film-making itself as well as on ideas of authorship in film theory. We have already looked at the French New Wave in Chapter 4; here we can note that the *Cahiers* articles were instrumental in launching the film-making careers of several of the journal's writers, most importantly those of Truffaut, Godard, Chabrol, Rohmer and Rivette.

The effect on thinking about film was less immediate but no less profound. While *Cahiers du cinéma* continued to examine the films of Ford, Minnelli, Hitchcock, Huston and many others, and engaged in a debate with the rival left-wing journal *Positif* about the value of the *politique des auteurs*, theorists elsewhere and particularly in Britain and North America digested the work.

An important factor in the 'migration' and assimilation of 'theory' in other countries/intellectual cultures has always been availability of texts in translated form. While the internet is clearly able to drastically reduce the time needed for a text to become available in translation, the 'history of theory' has been much shaped by this factor in the past. Thus the *Cahiers* articles which appeared in the early 1950s were only published in English in the mid-1960s. While theoretical arguments continued (and have not ended) over the exact extent to which a Hollywood director could be considered an auteur, the study of directors became intellectually acceptable, indeed fashionable.

The *auteur* concept in Britain

The auteur concept was taken up in different ways in Britain and in the USA. British films have often been described in terms of their more 'realist' traditions and indeed a preference for 'uncinematic' cinema; there is a long history of disparagement of British cinema (rather like its cricket team really…). One quote may stand in for many others: 'I do not think the British are temperamentally equipped to make the best use of the movie camera' (Ray, 1976, p. 144).

Put another way, British cinema had, since the documentary influence of Flaherty and Grierson in the 1920s and 1930s, been generally less concerned with 'film as art' than with film as some kind of reflection of/commentary on the reality of social life. This persistent tradition was evident in initial reactions – in both film-making and film criticism – to the *Cahiers* polemic. While much British film production continued to seek to inflect Hollywood's commercial working practices with a particularly British (or rather English) sensibility, the direction taken by 'independent' film-making was much more concerned with 'social realism' and less concerned with authorial investigation of film as 'art'. The key moments of British cinema of the late 1950s and early 1960s were thus the 'Free Cinema' of Lindsay Anderson, Karel Reisz and Tony Richardson, and the British New Wave which explored naturalist 'kitchen sink' realism (see Chapter 3 above).

British film criticism and theory, though also heavily influenced by the documentary/realist tradition, did begin to address the issue of authorship, and three journals were central to this critical debate. *Sight and Sound*, originally founded in 1932, had during the 1950s come to concentrate on art cinema and the aesthetic, and thus on the art film director as an art auteur; the journal was on the whole hostile at the time to the idea of treating Hollywood directors as auteurs. A rival journal, *Movie*, though quintessentially British, was, as its name implies, more favourable to American films and between its beginning in 1962 and well into the 1970s developed its own brand of auteurist criticism, exemplified in the work of Victor Perkins.

The third and 'youngest' journal, *Screen*, though it only began in 1971, became the leading British film theory journal of the 1970s and 1980s (in a history of the politics of the editorial policies of film journals, *Screen* would

merit several chapters). As part of this development it increasingly promoted and engaged with French film theory and was instrumental in the evolution of a British strain of 'structuralist auteur criticism' (also heavily influenced by Marxist and psychoanalytic theory) which sought to extend French auteur analysis through structuralist analysis of film-texts, exemplified by the work of Peter Wollen on Hitchcock, Godard and others (see Chapter 9). It is interesting that while this kind of 'cine-structuralism' sought to unearth previously undiscovered themes common to particular directors through structuralist methods derived from Claude Lévi-Strauss, Vladimir Propp and others, it also (sometimes explicitly, sometimes implicitly) stressed 'the death of the author': the 'author' was an 'effect of the text'; the 'author' 'Hitchcock' (in inverted commas) was to be found in the text; the simpler words Alfred Hitchcock were reserved for the real flesh-and-blood person, whose actual role in creating a particular film would remain complex and obscure – as originally explored by Michel Foucault in 'What is an Author?' (see Further Reading below). These assaults on the concept of authorship are discussed further below.

The 'auteur theory'

By comparison with the sometimes obscurely theoretical turn of events in film culture in Britain, the influence of the *Cahiers politique* in the United States was no less important. It was writer/critic Andrew Sarris who, between 1962 and 1968, elaborated the 'auteur theory' which has so often been confused with the original *politique*. His championing of the auteur idea involved a rejection of the then-dominant 'social realism' writing of most US critics, and was related to the growing availability of (old) films on television (and subsequently on video and DVD). This increased availability of previously dismissed films for a wider audience (including film critics and theorists) facilitated a reappraisal of those films and their directors.

Having dispensed with the finer points of the *Cahiers* argument, Sarris proceeded to elaborate his criteria for a 'pantheon' – amounting to a kind of league table of directors, placing most known directors in one of several categories:

> I am now prepared to stake my critical reputation, such as it is, on the proposition that Alfred Hitchcock is artistically superior to Robert Bresson by every criterion of excellence, and, further, that, film for film, director by director, the American cinema has been consistently superior to that of the rest of the world from 1915 through 1962. Consequently, I now regard the auteur theory primarily as a critical device for recording the history of the American cinema, the only cinema in the world worth exploring in depth beneath the frosting of a few great directors at the top.
>
> (Sarris, 1962/3, pp. 5–6)

It is to be noted that there is in Sarris' categories a strong evaluative sense (some directors are great, some others are better than the rest) which is almost completely absent from the more structuralist British approach and which runs counter to the polemical thrust of the original *Cahiers* writers, whose principal aim was the critical rehabilitation of Hollywood directors as a species.

Poststructuralism and recent developments

Subsequent poststructuralist and postmodern theoretical developments (see Chapter 12) have posed further difficult questions about the concept of authorship. Is the 'author' the real person called Quentin Tarantino, is it an effect of the film-text (the 'Quentin Tarantino' of *Pulp Fiction*, say), or is it something that lives in the reader/viewer's head? Indeed, after Roland Barthes, are we not all 'authors' who 'write' our own films in our heads as we watch them? And apart from the theoretical argument, the advent of video and DVD means that it is now possible (for some spectators) to control the experience of film viewing in strange new ways: 'interactive' DVD systems promise to enable viewers to literally construct their own narratives from, say, an image/sound bank labelled 'Pulp Fiction'.

Computer programmes have also been developed to aid in a kind of statistical analysis which may always have been possible but which would until recently have been all too tedious. Any given film can now be subjected to an analysis which informs us, say, of the percentage of close up shots or low angle shots or of the average shot duration when the central character is (or is not) on screen. It is therefore possible to track a particular director's films and to build a profile of the director's stylistic preferences and the way they have perhaps evolved. Indeed it is possible to compare films with the same cinematographer in this way, which may give support to an argument about any particular person's 'author' status. Warren Buckland is among those who have begun to work in this field – in his case looking initially at the *Jurassic Park* series and Steven Spielberg's œuvre. There is a suggestion that *Poltergeist* (1982), credited to Tobe Hooper as director, may have Spielberg's statistical fingerprints on it.

At the same time, the distinction between 'art' and commercial/entertainment films has, since the late 1950s and the start of the auteur debate, become increasingly blurred as mainstream films continue to adopt formal strategies which were once seen as avant-gardist and 'arty' (see p. 217). Whether it is Ford or Hitchcock, Tarantino or Lynch, Jarman or Duras, the idea of the director as the most significant creative influence on a film has passed into everyday mythology; while some would have gone to see *Eyes Wide Shut* when it first came out for the sex, some for the stars and some more problematically for the genre, few would have been unaware of Kubrick's reputation as a director – or at least of his recent death.

Indeed, the increased celebrity status of many 'Hollywood' directors can, as we have already suggested, be dated to the breakdown of the classic Hollywood studio system in the 1950s and the threat to cinemagoing posed by television and other social/demographic changes which affected choice of leisure activities. The fame and quasi-'art cinema' author-status of the 'movie brats' such as Scorsese, Spielberg and Coppola who emerged between 1971 and 1974 (and of more recent 'name' directors) are largely due to the lack of permanence/stability in contemporary studio and industrial structures. Most particularly, it is now the director who has taken over many of the functions previously carried out by the producer and which arguably made the latter something of an 'author'. While producers of the 1930s and 1940s would typically find story material, see it developed into a screenplay, do the casting and oversee production and postproduction/editing, the producer since the 1960s has increasingly become 'an agent, a packager, a promoter, or a financial man' (Pandro Berman, producer at RKO and MGM, quoted in Kent, 1991, p. 182).

CONCLUSION

Finally and in summary: should the student of film accept the idea of director as 'author'? The answer seems to be no and yes. In stressing the terms film industry, show business and dream factory, Richard Maltby has asserted that 'authorship remains an inadequate explanation of how movies work' (1995, p. 33). Yet by analysing ways in which individual directors were/are able to produce a stylistic or thematic 'signature' in 'their' films, the auteur concept has reasserted the possibility of individual agency in the context of the corporate capitalism of the studio system of the mid- and late twentieth century.

As a postscript to this chapter, and echoing earlier remarks about other sources of 'authorship' in film, we should perhaps note that the very concept of director has been called into question by recent films. For example, Daniel Myrick and Eduardo Sanchez were credited as directors, screenwriters and editors for *The Blair Witch Project*. Yet almost all the footage for the film was shot without the directors present. Given the proliferation of public access programmes and channels on TV (particularly in the USA), are the days of the director as currently defined numbered? Just as rappers deliberately sample other texts and DJs such as Carl Cox attain star status by sampling and mixing music 'authored' by music artists, are films also becoming just another source for postmodern recycling?

The distinction between different types of film has also been further eroded by the ease with which any moving images can now be posted on the internet, anywhere from YouTube to one's own website. This not only (see p. 193 above) throws into question our definition of a film or a movie; it also in some ways returns us to the artisanal and experimental nature of film production over a

century ago. While the cameras and editing equipment were then radically different from the webcams and editing software of today, we now have a new generation of image producers – would they call themselves film-makers? – whose work is typically produced in almost complete isolation. There is no question about 'authorship' here (though it may be significant that many such films are to all intents and purposes anonymous), but the exhibition of David Firth's work (*Salad Fingers*, 2004), for example, raises many questions about the changing nature of film – and of its audience.

Exercises 13.2

1 Discuss the auteur status of any director of your choice; how does the director's contribution compare to the contributions of others (e.g. scriptwriter(s), cameraperson, editor) who work on a film?
2 Is the 'world-view' expressed in a film that of the director? Is it an important mark of 'authorship'?
3 Compare a recent/contemporary director (e.g. Tarantino, Cameron, Bigelow) with one from classic Hollywood cinema (e.g. Hitchcock, Ford, Curtiz). How has the 'authorial' role of the director changed?

SUMMARY

↔ The idea of individual authorship is a problem in a collaborative medium such as film-making.
↔ The idea of the talented author is itself historically specific.
↔ It is possible (particularly for pre–Second World War films) to argue authorship status for a number of film-making personnel such as camera operator, producer, studio head, etc.
↔ There are important differences between the director's role in Hollywood and other mainstream entertainment films on the one hand and 'art' films on the other.
↔ The idea of Hollywood director as author/auteur dates from arguments first presented in the French journal *Cahiers du cinéma* in the 1950s.
↔ A distinction can be made between Hollywood directors who are/were expert technicians ('*metteurs en scène*') and true 'auteurs' whose films can be seen to express some kind of 'artistic vision'.
↔ The idea of directorial authorship was taken up in different ways in Great Britain and the USA.
↔ The 'cult of the director' is flourishing as we enter the twenty-first century, but the reasons may be less to do with authorship than with brand-name marketing.
↔ This can be contrasted with the near-anonymity of the creators of 'films' which can be accessed only on the internet.

REFERENCES

Barthes, R. (1990), *S/Z* (transl. R. Miller), Oxford: Blackwell; first published in French in 1970.

Kent, N. (1991), *Naked Hollywood: Money, Power and the Movies*, London: BBC.

MacCabe, C. (1998), *Performance*, London: BFI Film Classics.

Maltby, R. (1995), *Hollywood Cinema*, 1st edn, Oxford: Blackwell.

Ray, S. (1976), *Our Films, Their Films*, Bombay: Orient Longman; reprinted by Hyperion Books, 1994.

Sammon, P. M. (1996), *Future Noir: The Making of Blade Runner*, New York: Harper.

Sarris, A. (1962/63), 'Notes on the Auteur Theory in 1962', in *Film Culture*, no. 27, Winter.

Wollen, P. (1969), *Study Guide No. 9: Orson Welles*, London: BFI Education Department; reprinted 1977.

FURTHER READING

Bordwell, D. and Thompson, K. (2003), *Film Art: An Introduction*, 7th edn, New York: McGraw-Hill.

A rigorous and thorough textbook, though from a US perspective which plays down the psychoanalytic, auteur and semiological approaches long favoured in Europe and the UK. Excellent use of a wide range of film stills.

Cook, P. (ed.) (2007), *The Cinema Book*, 3rd edn, London: BFI.

Good, thorough if occasionally challenging coverage.

Foucault, M. (1979), 'What is an Author?'; translated and reprinted in *Screen* vol. 20, no. 1.

High-level philosophical thinking for the more ambitious student.

Hill, J. and Gibson, P. C. (eds) (1998), *The Oxford Guide to Film Studies*, Oxford: Oxford University Press, pp. 310–26 (Part 2, Chapter 7).

A good summary of principal issues around authorship.

O'Pray, M. (1999), 'The Big Wig', in *Sight and Sound*, vol. 9, no. 10, pp. 20–2 (on Andy Warhol).

Truffaut, F. (1976), 'A Certain Tendency of the French Cinema' (1954), in B. Nichols (ed.), *Movies and Methods*, vol. 1, pp. 224–37.

The original article from which subsequent auteur study developed has been reprinted many times. Any serious student of film should read it.

Turner, G. (1999), 'Sharp Practice', in *Sight and Sound*, vol. 9, no. 7, pp. 24–6 (on Gregg Toland).

Sight and Sound has long been a good, 'respectable' film journal; since the 1970s, however, a number of more 'theoretical' (and difficult) journals began to appear. It is recommended that, where your own educational institution's resources allow it, you try to have a look at back numbers of some of the following British journals: *Screen*, *Framework*, *Film Form*, *Undercut* and *Block*. Among equally prestigious North American journals of the time were *Jump Cut*, *Wide Angle*, *Cineaste*, *Velvet Light Trap* and *Camera Obscura*. It should be noted that these theoretical film journals, almost without exception, assumed a Marxist, feminist, anti-establishment position.

FURTHER VIEWING

Hitchcock on Hitchcock (BBC2, 1999)
> Interesting insights given into the director's techniques. BBC Active, BBC Television Centre, Wood Lane, W12 7RJ

Reputations: Alfred Hitchcock (BBC2, 1999)
> A broad-ranging documentary about Hitchcock, his films and his techniques. BBC Active, BBC Television Centre, Wood Lane, W12 7RJ

Scene By Scene: David Lynch (BBC2, 2000)
> Informative textual analysis. BBC Active, BBC Television Centre, Wood Lane, W12 7RJ

Scene By Scene: Roman Polanski (BBC2, 2000)
> Informative textual analysis. BBC Active, BBC Television Centre, Wood Lane, W12 7RJ

Scene By Scene: Woody Allen (BBC2, 2000)
> Informative textual analysis. BBC Active, BBC Television Centre, Wood Lane, W12 7RJ

Chapter **14**

Genre

The use of genres within the film industry is so common that we usually do not question their function. We tend to use genre categorizations without being aware of them. DVD stores physically divide up space through classifying DVDs by genre, and film promotional campaigns, whether trailers in cinemas, adverts on television or posters on billboards, often explicitly refer to a film's genre and at least implicitly indicate what type of film it is. What we don't often think about is why films tend to be divided up into genres and how they can be identified as belonging to a particular genre. Nor do we tend to concern ourselves with how genre conventions structure films and how the industry and audiences use genres. This chapter looks at these issues and some of the debates surrounding the theory and practice of film genre. The ways in which genres change over time are identified along with an evaluation of the usefulness of genre studies.

//

Genre as repetition and difference

Genre is a French word meaning 'type', and film genres have existed since the early days of cinema. Films were frequently categorized as being crime, romance, comedy, fantasy or actuality. It is to be noted though that the descriptions given to particular types of films have frequently changed, along with the identification of new genres. Edwin Porter's *The Great Train Robbery* (1903) was initially described as a crime/chase movie but is now regarded as a Western. Similarly, Méliès' *Journey to the Moon* (1901) was referred to as fantasy whereas nowadays it would be identified as science fiction. Classification of films into genres helped the industry to organize production and marketing in terms of making use of available and suitable props, locations, actors and production staff, as well as promoting films as being of a particular type. Audiences in turn used the marketing descriptions of films as a guide to what to expect.

However, while the use of genre has a long history in film, it has a far longer general history which dates back to Ancient Greece, at which time Aristotle categorized theatre plays by type. Nowadays most cultural production, be it television, magazines, music, painting or literature, ends up being assigned to one genre or another. In all cases what makes a genre possible is the existence of common elements across a range of productions. In other words, it is the identification of repetition across a series of productions that results in them being described as being of a particular type. An important term in genre analysis is 'convention', meaning the way in which something is usually done. Because certain films tend to do things in particular ways, we recognize similarities between them and consequently describe them as belonging to a particular genre.

If repetition is a key requirement for the identification of a particular genre, then so too is difference. When watching a film we become aware not only of how it is similar to other films but also of how it differs. Genres exist not only because there is repetition across a number of films, but also because there are differences across a range of films. The demarcation of films by genre emphasizes the differences between these types.

The concept of difference has further significance for genre categorization. It was noted earlier that genres had importance for both industry and audience during the formative years of cinema, and this became even more the case as the industry established itself further, especially with the consolidation of the US film industry during the 1930s through the Hollywood studio system (see Chapter 2). The industry had become adept at demarcating the market, with accompanying benefits both for production and for targeting audiences through the use of genre conventions. However, the problem for the industry was that genre production could easily result in films that were repetitive, predictable and formulaic. Indeed,

the emergence of art cinema, which tends to consist of non-genre films, was seen by many as a reaction to the over-use of successful formulas by the industry which stifled creativity and experimentation in film. It was therefore imperative that difference be an ingredient within genres as well as between genres. Genre films had to be not just 'more of the same' but also 'something different'; they needed variation, innovation, flexibility and change, albeit within the general parameters of the genre.

Style often results in difference being created within a genre, but it can also result in difference between films of the same genre that are basically telling the same story. Many of the classic horror films from the 1930s, such as *Dracula* and *Frankenstein*, both from 1931, have been remade several times over but in different styles. The originals were no doubt frightening at the time of their release and visually their influence can be seen in later versions, but the originals now appear rather slow, theatrical, tame and uncontroversial. The remakes by Hammer Films essentially told the same story but were stylistically very different. *Dracula* (1958) updates the vampire tale for a new generation of cinemagoers in a new cultural context. The 'X' certificate rating enabled Hammer to go further in trying to shock, which they attempted to do through more violence and gore and greater emphasis on the sexual nature of Count Dracula's relationship with his female victims. The many horror films made by Hammer in effect established a subgenre of Hammer horror through considerable continuity in style, actors, themes and directors. More recent remakes of 1930s horror films have included *Bram Stoker's Dracula* (1992) and *Mary Shelley's Frankenstein* (1994), both of which tell more complex tales than had the earlier versions.

While remakes are fairly common, usually a significant period of time elapses before a film is reinterpreted, as with the above example. However, a notable exception is *Nikita* (1990). It is the story of a drug addict who shoots a policeman and is sentenced to death, but is pardoned so long as she agrees to become a government assassin. The film was directed by the French director Luc Besson. However, a Hollywood remake was released just three years later; *The Assassin* (1993) told almost exactly the same story, to the point where repetition becomes noticeable; stylistically, however, the two films are radically different despite having a common story and genre. Nikita is widely regarded as the 'better' of the two, perhaps because it not only tells an interesting story but also contains impressive direction of camera, lighting, music and acting. By contrast, *The Assassin* concentrates on telling the story as clearly as possible and thus perhaps loses some of the subtlety of the original while not being as visually memorable.

Another remake which differs stylistically from the original is *Shaft* (2000). The original *Shaft* of 1971, though belonging to the crime genre, carried the label 'blaxploitation'. It was made during the US era of Black Power politics

and the main black detective character was a break with stereotypes of blacks as subservient and second-class. The 2000 remake no longer needed to challenge such stereotypes in the same way and concentrated on being an action/crime film. With its big budget and well-known stars, the new version was a mainstream movie; the original was a cult film with a political message. Indeed, there have been so many re-makes of older TV shows in the past decade that one wonders if this constitutes a genre in itself!

Unsurprisingly Hollywood succeeded in combining repetition and difference in its films, at least to the point where audiences regularly returned to view genre films. A further way in which Hollywood has categorized films is through the use of stars as a means of identifying and targeting films and audiences (see Chapter 15). A film would be referred to as a John Wayne film rather than as a Western, a Marilyn Monroe film rather than a comedy/romance. In the contemporary US film industry, categorization has often come to include reference to the director (see Chapter 13 on authorship). We get a Scorsese film rather than a gangster movie, a George Lucas film rather than a science fiction film. However, the main problem with categorizing films by reference to individuals is that we are restricted to a particular era of films. With such a classification, we cannot trace changes over an extended period of time in the way we can with genre classification.

The ultimate effect of the repetition, common elements and conventions found within genres is to create particular repertoires of elements, a range of possibilities all of which in effect limit what is possible. The conventions of individual genres define the parameters within which a genre film will normally operate. The choices available within the Western genre would not normally include song and dance routines and slapstick comedy, and if we came across such a film it would probably be *Blazing Saddles* (1974) by Mel Brooks or the earlier *Cat Ballou* (1965), and would be referred to as a Western spoof or pastiche. Genre conventions are readily identified by audiences and are so well established that they can easily be used as comedic devices in spoofs, as perhaps best illustrated by *Scary Movie* (2000) and its sequels.

The use of a repertoire of elements ends up creating a self-contained world structured by genre conventions. For the duration of a film we experience a world defined and limited by these conventions. Consistency is essential if this 'genre world' is to be believable, so in effect genre films need to create realism within the confines of their conventions. The term verisimilitude describes the quality of being believable: the appearance of being real; plausibility. However, this believability is placed very much within a fictional world and is dependent upon maintaining consistency in the elements used in the genre film. Verisimilitude can be contrasted with realism, which is the representation of a reality, a world that recognizably exists outside the film itself. However, the concept of realism is problematic and there is often disagreement about its definition (see Chapter 8).

Exercise 14.1

With reference to your own favourite genre film, list its generic features and note how it differs from other films of the same genre. What do you find appealing about the film?

Film genre, image and sound

Genre categorization can also be problematic, however. On one level, understanding genres is simple; we can identify recurring elements with regard to narrative themes, characters, plots and visual content such as location, props and costume; sound can also be a recurring element, particularly in terms of music appropriate to a particular genre. However, we soon come up against the problem of films that don't quite fit a genre, films which seem to cover several genres and films that appear to be a particular style of a particular genre. Thus while we can refer to the Western genre or crime/detective genre, some films may be identified as spaghetti Westerns or film noir. Such films are often referred to as belonging to a subgenre, a genre within a genre, although in the case of film noir this is disputed by some who see it as a style of the crime/detective genre but think it sufficiently different to have its own genre, a point we will return to later in this chapter.

The most immediate way in which we identify a genre is usually by the visual elements in a film. The film's narrative may take a while to reveal the genre but the visual signification tends to be immediate. However, it is possible that sound could first indicate genre through theme music at the beginning of a film, and with comedy, romance and melodrama, the narrative, rather than the iconography, could well indicate the genre. The theme music of *Blade Runner* (1982) hints at the science fiction genre before we see any images; the music would seem out of place if used to introduce another genre. If used at the beginning of *Mamma Mia* (2008), the music would raise inappropriate expectations. Similarly, the placing of a spacecraft in *Mamma Mia* would undermine the expectations raised by the musical/comedy/romance genre.

Sound and image indicate genre through the use of signs. Signs represent and communicate particular meanings, and audio-visual content functions as signs. However, for a sign to be readily understood by an audience, it needs to be a part of a well-established system of communication, in effect, a part of a language system belonging to a genre. If the film-maker uses audio-visual signs appropriately, then an audience that is aware of the genre conventions will generally understand the intended meanings. Intended meanings are encoded into signs by the film-maker and the audience decodes the signs to reveal the meanings. It is the regular use over a period of time of particular signs that establishes them as conventions and builds up the language system for a particular genre.

Although we have identified the role that 'sound signs' have within genres, film tends to be primarily regarded as a visual medium, and so attention often concentrates on the visual signs found within genre films, a point elaborated on by Colin McArthur in his analysis of the gangster genre.

> The recurrent patterns of imagery can be usefully divided into three categories: those surrounding the physical presence, attributes and dress of the actors and the characters they play; those emanating from the milieux within which the characters operate; and those connected with the technology at the characters' disposal.
>
> (1972, p. 24)

The study of visual signs and their meanings is known as iconography, icons being visual representations. Icons, as visual signs, give away the genre of a film. Iconography is about the meanings carried by genre elements such as location, props and costumes.

This may sound very similar to *mise en scène*, as both are obviously concerned with what elements are placed within a shot. However, iconography refers to how location, props and costume produce meanings through the broad cultural agreement that exists about what these visual signs refer to – meaning is collectively determined. *Mise en scène* emphasizes the way in which the director produces meanings through the selection and arrangement of location, props and costume – meaning is more individually influenced. The contrast between iconography and *mise en scène* can be broadened out into the opposing perspectives of genre analysis and authorship, the former having been elaborated on by Jim Kitses and Will Wright among others, the latter theorized in the French journal *Cahiers du cinéma* in the 1950s. Genres are seen as relying upon a general understanding of the conventions used and the meanings they produce, whereas authorship focuses on the ways in which meanings originate with the director or possibly with a star or cinematographer. Similarly genres may be associated with restricting what is possible through their structuring tendencies – manifesting themselves, for instance, in the conventions of a Western – while authorship is seen as allowing personal creativity and vision; hence the existence of genre cinema and art cinema. However, as we saw in the last chapter, attempts have also been made to reconcile both perspectives, with directors being seen to manipulate genre parameters and use them creatively.

One of the richest genres for iconography is the Western, from obvious icons such as barren landscapes, horses and guns to the occasional appearance of wind-blown tumbleweed (Fig. 14.1). It would be misleading, however, to imagine that specific genres require specific visual elements, because iconography can be relatively flexible. As mentioned earlier, one distinctive type of Western is the spaghetti Western, so called because these productions were based in Italy as costs were lower than in the USA. Filming often took place in Spain, again for financial reasons, and this gave such Westerns a different look – the impressive mountainous scenery of

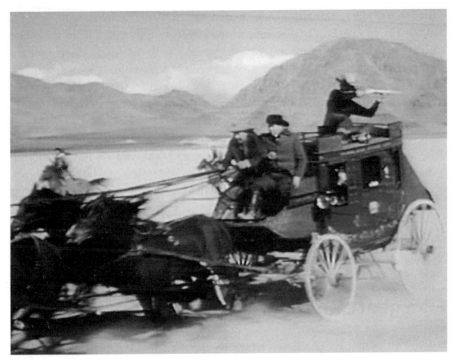

Figure 14.1 *Stagecoach*: Western location, props and costume (*Stagecoach*, 1939, Dir John Ford, John Wayne, Andy Devine, George Bancroft © United Artists)

many traditional US Westerns was often replaced by flat desert locations. Spaghetti Westerns, especially those directed by Sergio Leone (*The Good, the Bad and the Ugly*, 1966), were noticeably stylized in contrast to mainstream US Westerns. The use of extreme camera angles and of cutting from extreme long shots to extreme close ups, not necessarily for any obvious reason, gave such Westerns a different look compared with the US Western. However, the identification of visual stylistic differences highlights the limits of iconography in its ability to identify and explain visual content. Iconography cannot account for the use of camera or for editing, which also crucially shape a film visually. These film techniques are to be found across a range of genres and are not necessarily specific to one genre.

Exercise 14.2

Choose a suitable poster or DVD cover for a genre film and identify the possible meanings produced by the lighting, props, location and actors.

Film noir is strongly identifiable by its iconography; regardless of whether it is a genre, subgenre or style of the crime/detective genre, it is unusual in that its categorization was created by film theorists as a descriptive tool rather than by the industry as a marketing tool. The term was coined in 1946 by the French film

critic Nino Frank to describe a development in US films that had begun with *The Maltese Falcon* (1941). Visually, noir films, as you would expect from the name, are dark. Low key lighting is frequently used, with resulting silhouettes and shadows, and light is often fragmented through Venetian blinds with alternating black and white shafts of light splayed across walls and ceilings. An urban setting is the usual location, with the addition of rain to complete the forbidding picture. Cigarettes and glasses of whisky are common props. *Double Indemnity* (1944) uses such iconography extensively. It is a classic example of film noir, complete with deep shadows, strong contrasts between light and dark and gloomy, forbidding locations. However, it needs to be noted that the use of low key lighting has also been explained as necessary in order to hide the fact that set designs were often of low quality as a result of material constraints. Certainly film noir characteristics have persisted through stylistic variations, resulting in the label neo-noir being applied to films such as *The Long Goodbye* (1973) and *Chinatown* (1974), and the tech noir of *Blade Runner* (1982) and *The Matrix* (1999).

Film genre and narrative

However, film noir is more than just the iconography mentioned above. Its narratives contain particular themes, characters and plots, and these can indicate genre too. The seductress is a central character in film noir narratives; the *femme fatale* is a deadly woman whose function is to tempt the lead male into committing a heinous crime, usually a murder, from which she will benefit. However, the *femme fatale* is usually outwitted, caught and punished in some way. The male lead tends to be a world-weary, cynical loner, often the archetypal 'hard-boiled' detective alienated from the society he lives in, as in the Sam Spade and Philip Marlowe characters created by Dashiell Hammett and Raymond Chandler. A common sound convention of film noir is the use of voice-over narration as a reflection on what has taken place. In *Double Indemnity*, the male lead provides a commentary to explain events, delivered in a hard, emotionless voice.

Morbid themes are central to noir narratives: the cold-blooded planning of murders, detail being dwelt upon and a lack of remorse are common. Underlying the plot and themes lies a paranoid wariness, a distrust of other human beings. Deceit and double-crossing accompany the other narrative elements and visual signifiers. Why such narratives, themes and visual style should have appeared between 1941 (*The Maltese Falcon*) and 1958 (*Touch of Evil*) is an interesting question which has been analysed by Colin McArthur, among others. Genre analysis looks for explanations within the society in which the film was produced. Is it possible that noir films were an expression of unease about changes within US society, especially against the backdrop of the Second World War? Women had gained greater independence, they increasingly held a strong position in the job market and their lives were not necessarily dedicated just to home and family. From

a male perspective, this could have been seen as a challenge, as unsettling. US involvement in the war provided more space for women to take up employment as many males were called up, and the war itself raised dark issues, uncertainty and anxiety, all identified within film noir. The end of the Second World War was marked by the first use of an atom bomb, and the ensuing postwar angst about the possibility of global nuclear war also contributed to growing uncertainty and increased anxiety. It can therefore be seen that film noir provides a good illustration of how genre categorization is dependent upon more than visual conventions.

Thomas Schatz has written extensively on the importance of narrative in relation to genre categorization. He shifts attention away from iconography as the determining factor towards narrative themes, plots and characters. However, he goes further than many would by proposing that essentially there are only two categories of genres, 'genres of social integration and indeterminate space' and 'genres of social order and determinate space'. Schatz writes:

> Ultimately, genres of indeterminate, civilised space (musical, screwball comedy, social melodrama) and genres of determinate, contested space (Western, gangster, detective) might be distinguished according to their differing ritual functions. The former tend to celebrate the values of social integration, whereas the latter uphold the values of social order.
>
> (1981, p. 29)

According to Schatz, the genres of social order/determinate space include Westerns and gangster and detective films. Typically such films have a narrative that contains a male hero whose individual actions involve the use of violence to resolve conflicts within a society. A key theme in such films is lawlessness, and the problems developed within the narrative are ultimately resolved by the protagonist who creates or restores order by the end of the film. Such narratives also tend to take place within a clearly defined space or setting, necessitated by the narrative theme of gaining control over a particular community or locale. Iconography tends to be central to such narratives in that visual signifiers help define the contained world within which action takes place. A Western such as *Unforgiven* (1992) is set in a relatively lawless society, as exemplified by the cowboy who attacks and injures a prostitute but goes unpunished by the sheriff. Justice and order are restored by Clint Eastwood, who shoots him. *Star Wars* (1977) centres on the conflict created by Darth Vader and the Death Star, who are destroying whole civilizations. It takes Luke Skywalker and friends to restore order to the universe through the destruction of the Death Star. *Goodfellas* (1990), as a gangster film, is concerned with gangsters as a lawless element within US society and with conflict in the gangster community, in which order is achieved through violence. A degree of order is achieved at a societal level when Henry gives evidence against his former gangster partners, thus ensuring that justice is done.

Schatz's genres of social integration/indeterminate space encompass musicals, comedies and melodramas. In such films there is a strong likelihood of the lead

character being female, or the lead role may even be a collective position taken up by two or more characters rather than an individual male lead. The setting for the narrative tends to be stable and consensual as opposed to being based on conflict and opposition; thus the space within which the action takes place may not be clearly defined, because location is not necessarily a key issue. Similarly, iconography may be less important as the centrality of visual signifiers is displaced by an emphasis on emotions and ideological issues. The problems raised within the narrative are emotional and will generally be resolved through agreement or by co-operation rather than by physical and violent action. The key theme running through films belonging to this category is the peaceful resolution of conflict which results in the film's characters being integrated into a consensual community. Thus, in the musical *The Wizard of Oz* (1939), the temporarily wayward Dorothy is welcomed home by her family and community at the end of the film. The conflict in *Notting Hill* (1999) arises from the central characters' problematic relationship: Anna Scott is a wealthy US film star with a boyfriend; William Thacker is a bookshop owner struggling to make ends meet. Their emotional crises are resolved by the end of the film when Anna agrees to settle in England with William.

However, while such an approach is useful for concentrating attention on recurring themes, values and beliefs across several types of film, the two categories cannot always be clearly distinguished. *Alien* was a ground-breaking film in 1980 in terms of gender representation and complicated the idea of a genre of order by having a female lead in a science fiction film. Sigourney Weaver as Ripley is also attempting to preserve a 'community' in space, albeit through physical violence. The film is more than science fiction though, clearly encompassing horror with the inclusion of the alien as a monster. Horror films could generally be problematic for Schatz's categories; where, for instance, would you place a film such as *Scream* (1996)? While there is a violent resolution to the film and order is restored, key characters are female, relationships are an important theme and the community within which the narrative is set is generally integrated. It is of course also a self-aware, postmodern comedy. *Thelma and Louise* (1991) also seems to suit both categories. Although the film is about the establishment of order through the shooting of a rapist, the film has two heroes who are female, and emotions, along with relationships, are key themes.

Schatz's categories nevertheless provide a useful approach to studying genre and can perhaps be thought of in terms of genres of conflict, in which a resolution is provided through violent confrontation, and genres of consensus, in which a resolution is provided through emotional agreement, with the possibility existing of a cross-over between both categories.

Exercise 14.3

Choose one gangster film and one romance film. Note how far each film's narrative has developed before you can identify its genre and what narrative elements confirm that genre.

Film genre, industry and audience

Cinema, like all industries, is about the production of goods and services. The vast majority of films are produced as commodities to be consumed, for profit. Films are big business, subject to the 'laws' of commercial supply and demand. The industry will make films as long as people want them. As with other industries, profits are maximized through efficient production methods, accurately matching supply to demand, and effective marketing. From an industry perspective, genres have several uses which help fulfil these economic imperatives.

If genre films are particular types of film, it follows that such films require particular types of scripts, acting, locations, props and costumes, and often need specialist equipment and production staff for the actual shooting and editing. In effect, genre films lend themselves to specialization at all levels of the production process and this increases the likelihood of being able to maximize profits through the efficient use of existing resources. Genres are about standardization, an industrial practice. The film industry aims to identify successful formulas and recycle them, albeit in different guises.

Directors and stars will often work on particular types of film, and the industry will use the reputations and expectations attached to directors and stars to help market films and create demand (see Chapters 15 and 13 on stars and authorship). Genres enable the industry to divide up the range of films that can be made; the market is demarcated. Market research and the monitoring of audience trends inform the industry of what types of film are likely to do well at the box office; genres can therefore be targeted at the audience that exists for particular types of films.

The flip side of the industry using genres to target audiences is of course that the audience in turn uses genres to target particular films. Being able to identify the genre of a film enables a cinemagoer to determine whether s/he is likely to enjoy a film or not. This raises the question, however, of why audiences gain pleasure from genre films. Considering the predictable elements in genre films, we can assume there are certain narrative themes and visual elements that audiences are attracted to. This attraction can be analysed at a psychological level, at the level of subjectivity, while also being linked to the social world, the objective world of social relations, cultural values and ideology (see Chapter 12).

If we accept that there are certain attractions that draw audiences to see genre films, how is the attraction maintained over a sustained period of time? Pleasure is often gained through obtaining what we want and in the case of genre films, having one's expectations met results in pleasure. We get what we want and our knowledge of the genre's characteristics is confirmed. In other words, we seek repetition of a past pleasure; we will, to a degree, be able to predict what will happen, what characters will do. The use of recognizable character types and plots can also make a film easier to understand. However, as noted earlier, difference is also an integral part of genre production. The audience gains pleasure from the introduction of

variations on a theme and through identifying the ways in which conventions are reinterpreted and reinvented within the general parameters of the genre.

Though we should not ignore those films which, because of their non-adherence to generic conventions, cannot easily be categorized, it must be noted that non-genre films constitute a minority of films made and distributed and that, by and large, such films are not hugely popular.

Tom Ryall's (1978) approach to genre has de-emphasized the importance of identifying particular genre characteristics and has concentrated on the relationship between film, film-maker and audience and the role that all three areas have in the production of meaning, albeit within the general conventions of a genre. Although a film may be placed within a particular genre, the film-maker makes decisions about how to use the conventions, and ultimately the audience interprets the film for itself. Ryall also highlighted the importance of the production context of a genre film in terms of finance and ownership, which then needs to be placed in the overall social context of production and consumption. Thus for Ryall there are a number of variables such as film, film-maker, audience, studio, industry, economy and ideology, all of which need to be borne in mind when evaluating the function and effect of genres. In other words the genre conventions to be found in a film and how they are used are the result of a multiplicity of influences.

Steve Neale (1980) similarly focuses on industry, film and audience and their relation to genre, while also emphasizing the function of expectations, conventions, repetition and difference. However, Neale is not interested in the categorization of films as such and sees overlap and flexibility between genres as the predominant feature. He also sees the need for a psychoanalytic approach to genre study in order to identify the ways in which pleasure, identity and the relationship of the subject to society are reflected, reinforced or shaped in genre productions. Thus the determining potentials of the subconscious and of ideology are important in Neale's perspective, which takes account of audience desire and its origins in relation to the functions of genre films.

Film genre, society and history

The previous section raised the question of why audiences tend to be drawn to genre films, and also referred to the position of genres within the wider social context. In identifying the relationships between audiences, genre films and society, it is worth emphasizing that genre films, as cultural products, may very well carry the dominant ideologies of the societies in which they are produced. Given the economic imperatives of the industry, it is likely that cultural production will reflect societal values and beliefs. Moral issues are raised, questions are asked and answers given. We are invited to evaluate a character's actions and decisions, and imaginary solutions are offered to real problems within society.

Genre films, and the stories or myths they tell, can be regarded as a society or culture communicating with itself, reflecting on what it consists of, explaining the world to itself, perhaps learning about itself by retelling aspects of the culture's experiences. It could be claimed that such films are not 'reflections' of society but are particular perceptions of a society. How we see such films might ultimately be determined by whether or not recurring patterns and themes can be identified.

In the case studies from the science fiction genre that follow, we shall see how it is possible to claim that the themes addressed by genre films do deal with issues and values predominant within a culture. Perhaps the most important point to note is that although a genre remains recognizable over an extended period of time, the style and themes within that genre change, reflecting changing beliefs. The values that are prevalent within a society can be reproduced within the structures of meaning in a film.

CASE STUDY

Science fiction case studies

The science fiction genre rests upon what has become known as the 'what if?' question. We are encouraged to speculate about what life would be like if certain things happened, in other words, what our future would hold for us if our present world were radically transformed by the advance of science and technology or, of course, visitors from another planet. The science fiction genre enables contemporary issues relating to technological developments to be considered with regard to how they might change our future world. However, as we shall see, it can also be used to symbolize other concerns that are not related to scientific advances but which are very much to do with ideology.

Metropolis (Fritz Lang, Germany, 1926)

This German Expressionist film is set in the year 2000. The ruling class of Metropolis live above ground in luxury while the masses work below ground keeping the city functioning and their rulers living in luxury. The workers rebel and start destroying the machinery on which they work. Meanwhile a scientist is developing a robot that can do the jobs of the workers, and so the rulers are content to let the workers destroy the underground city. The film ends somewhat simplistically with both sides making peace, although what that peace involves is not really explained.

The early part of the twentieth century had seen social upheavals in Germany with continuing industrialization, high unemployment, an authoritarian government and defeat in the First World War. These issues were reflected in this film with its portrayal of an unjust, divided class society and a ruthless dictatorship.

Distrust of authority and its misuse are key themes throughout *Metropolis*. The huge technological advances being made at the time created uncertainty for many and did not augur well for the future, and a fear of the future was the result of these rapid changes. This film reflects those fears about the potential of technology, especially when it is in the hands of an authoritarian government.

Invasion of the Bodysnatchers (Don Siegel, USA, 1956)

The film is set in a small town and focuses on the local doctor and the events he is drawn into. Dr Miles Bennell is confronted with a lot of patients claiming that people close to them are exhibiting strange behaviour. Initially the widespread claims are dismissed as a form of 'mass hysteria'. However, after close friends confide in him he carries out further investigation and discovers that townspeople are being taken over by an extraterrestrial life form. Seeds from outer space have arrived on Earth and have developed into pods. They kill humans and take on their physical appearances; however, they can't imitate their personalities. Their aim is to take over the human race. Dr Bennell's claims are ignored and he is dismissed by locals as a lunatic; increasingly the locals are themselves the aliens he is warning against.

As with any film *Invasion of the Bodysnatchers* can be viewed as a self-contained story with no hidden meanings and no cultural links. However, this has been interpreted in two key ways that both resonate with the times in which the film was made. By the mid-1950s the world was consolidating into political spheres of influence after the turmoil of the Second World War was replaced by the 'cold war'. The Soviet Union represented communism and the USA represented capitalism. From a US perspective capitalism equated with freedom and communism equated with authoritarianism. Given this background it is easy to see *Invasion of the Bodysnatchers* as a film that warned of the dangers of communism as an alien power attempting to infiltrate and take over the USA from within. Furthermore this reading of the film also warned of the danger of ignoring those who attempted to bring such a threat to people's attention. However, the film has also been read from a liberal perspective that was critical of the anti-communist paranoia engineered by US senator Joseph McCarthy. McCarthy encouraged witch hunts against those who opposed his right-wing politics, resulting in many people, from actors to trade unionists, being black-listed, thus ending their careers. The illiberal conformism of McCarthyism can be likened to the single-minded, emotionless mission of the alien pods. Thus the film warned against the growing intolerance of the 1950s that encouraged people to reject those who protested.

2001: A Space Odyssey (Stanley Kubrick, UK, 1968)

2001 is a film that celebrates space, science and technology while also warning of what could happen if we lose control of such technology. In the central section

of the film, HAL, the spaceship's central computer, takes over control of the spaceship from the crew. The space technology ends up inadvertently enabling the surviving astronaut to gain an insight into the nature of existence after an encounter with a form of extra-terrestrial. The film, like its source book, speculates on the origins of life, the universe, and time and space. The film's slow pace and low-key action leaves filmic time and narrative space for the viewer to contemplate the issues raised within the film. Instead of following the film's narrative we are encouraged to engage with the events and themes. The film is a drama in that it places characters and relationships, even with a computer, at the centre of the narrative within a future world with technology at its heart.

The 1960s had seen successful missions into space and space travel was a strong contemporary issue. Space exploration was generally seen as a positive use of resources, but since humans had not yet landed on another planet, there were uncertainties about what was out there. The film deals with this fear of the unknown and warns of the danger of technology taking over. The film also coincided with the psychedelic era of the late 1960s and consciously used psychedelic imagery in some sequences.

Blade Runner (Ridley Scott, USA, 1982)

Blade Runner is set in Los Angeles in 2019. Replicants (robots/androids that look human but have superhuman abilities) have escaped and are to be hunted down by Deckard (Harrison Ford). There are points in the film when we are encouraged to wonder whether in fact the replicants are more humane than the humans. The replicants are denied the right to live as long as humans through a built-in life expectancy of four years; however, at the end of the film the last replicant, Roy, catches Deckard but saves his life just as his own is coming to an end.

Throughout the film this dystopian world always seems overcast and it is almost always raining. The film contains typical sci fi iconography but also has a dark, sombre urban setting with a strong use of low key lighting which is strongly reminiscent of film noir. The replicants are dangerous and are a product of scientific progress, much like the monster of *Frankenstein*; there are thus elements of the horror genre in *Blade Runner*, through the representation of the replicants as monstrous. The process of hunting down the replicants creates similarities with the crime/detective and action/adventure genres, and romance is provided by Deckard's relationship with the replicant Rachel.

In the early 1980s there was widespread concern over nuclear weapons and their continuing proliferation. The possibility of nuclear war raised the prospect of a 'nuclear winter' in which the skies would be darkened from the explosive fallout, resulting in continual darkness and rain. These concerns are mirrored through the location and lighting in *Blade Runner*. Debates had also developed about the nature of human subjectivity: what is it and where does it come from? The film investigates

the issue of identity – what does it mean to be human? Can a replicant be just as human as we are? This debate is given urgency in the film with the proposal that in 2019 it will be possible to construct cyborgs that appear to be human; scientific and technological advances since 1982 may well have reinforced such a view.

Cloverfield (Matt Reeves, USA, 2008)

We don't know exactly when the *Cloverfield* story is set but from the appearance of New York and its inhabitants we can assume it is in the near future. Despite the near contemporary events the film falls into the category of science fiction, as well as horror, because of its key premise of an attack on New York by monsters from another planet, with the implication that they have advanced forms of science enabling them to visit earth.

The film consists of point-of-view footage supposedly recorded on a digital camcorder. The main protagonists have attended a farewell party for a friend which was being filmed with the camcorder. During the party the building shakes and explosions are heard and it soon transpires that the city is being attacked by monsters. The rest of the film records the friends' attempts to escape the onslaught. The film ends with the protagonists dying but their camcorder surviving. It transpires that the recording has been found by the United States Department of Defense and has been kept as evidence of the attack.

There are obvious but noteworthy parallels to be drawn and questions to be asked in relation to this film. Visually scenes in *Cloverfield* bear remarkable similarities to the 9/11 attack on New York. The parallels aren't just to buildings collapsing, debris falling to the streets and panic-stricken people running in fear but also in the similarities between the shaky point of view camerawork in the film and the numerous amateur camcorder recordings from the actual 9/11 events. In other words, *Cloverfield* taps into fears and memories of a real attack from seven years before by al-Qaeda and places them at the heart of a fiction film. It could be argued of course that other films, such as *The War of the Worlds* (1953), have portrayed cities under attack. However, *Cloverfield* has New York as the city under attack; it could have been San Francisco, it could have been a worldwide attack, but New York was chosen. Placing the ubiquitous camcorder at the heart of the film is also an effective technique for linking into an aspect of the lifestyle of its target viewers who no doubt have access to such technology.

END OF CASE STUDY

From the above examples it can be seen that genres are flexible. While the iconography remains relatively similar, the narrative themes and styles can change over time as cultural values change and different ideological issues arise within society. However, it is perhaps important to recognize that genre films do not automatically reflect a society's dominant ideologies. It could be argued that genre films can challenge dominant ideas and question cultural values. Certainly,

such a view could be regarded as more positive and optimistic as it would imply that we are not helplessly tied into a society's belief system. Our conclusions as to whether cultural products such as genre films reflect, reinforce or challenge a society's values will no doubt depend on the examples used, the analytic methods employed and the perspective from which we approach genre study.

Exercise 14.4

Choose two films of the same genre that were made at least twenty years apart. Identify the similarities and the differences between the two films, and try to link these to their historical contexts.

Contemporary film genres and postmodernism

It will be noticed from the third example in the previous section, *Blade Runner*, that several genres have been identified in the film. Just as we have seen how genres are flexible as they change over time, it can perhaps also be claimed that flexibility and change can be introduced into genres by combining them. Although multi-genre films are nothing new (*Casablanca* embodies at least three), it has been claimed that more recent films aim increasingly consciously for genre cross-over. Rick Altman notes that

> Hollywood's early mixing of genres for publicity purposes was rudimentary at best, typically involving a small number of genres combined in an unspectacular and fairly traditional manner. Only rarely was attention drawn to disparities among the genres thus combined. Recent films, on the contrary, often use intertextual references and conscious highlighting of genre conventions to stress genre conflict.

(1999, p. 141)

This phenomenon has been identified as one aspect of what has been called the postmodern condition (see also pp. 283–5).

The term postmodernism begs an obvious question: what is modernism? Modernism is a term that has been used to describe developments in the arts and is one aspect of modernity. Modernity was built on the values of the eighteenth-century Enlightenment which foresaw a new age of science, reason, liberation, freedom and progress. The new outlook that emerged in the modern era was wide-ranging and encompassed the arts, science, philosophy, economics and politics. A strong element in this new outlook was the desire to explain the world, to provide answers.

From the perspective of film as cultural production, it is art that we are concerned with and modernist art became identified as such in the early twentieth century. Its initial theory and practice were based on progress and experimentation, which manifested themselves in film as well as other art forms. However, by the 1980s some cultural theorists were claiming that the spirit of experimentation and progress had come to a halt around the 1950s. The implication was that there was nowhere else to go with art, everything had been tried, that modernism had come to an end.

The era that has followed is often referred to as postmodern. Its general approach has been to reject the notion that explanations and answers can be universally applied to humanity or to this world. Everything is regarded as relative, there are no valid 'grand theories', nothing is certain, there are no absolute truths and, from the point of view of the production of meaning through iconography and signs, there are no fixed meanings. All we have are floating signifiers. From the perspective of art and film, the inevitable conclusion is that if there is no more space for progress, no new ground to break, then the only possibility is to reuse and recycle, perhaps in different combinations, what has gone before. This is what we quite often get in contemporary cinema.

Several key concepts and practices have emerged in contemporary cinema which could be described as postmodern. As mentioned earlier, genre cross-over, resulting in multi-genre films, is common. This practice of genre amalgamation results in a mixing together of already existing types and styles of films and opens up new possibilities. Meaning can be produced in different ways; different types of stories can be told, new combinations are possible. The mixing together of genres is often referred to as bricolage: elements from various film types can be selected and pieced together. Such films are hybrids; they are eclectic in that there is no specific set of conventions to shape the film; the film-maker picks and chooses from a range of available influences. Pastiche is the result of bringing together unusual influences and types of material that often draw on genres and styles from cinema's past; this technique is marked by its deliberate and self-conscious nature. The result is an intertextuality in which films interact with each other rather than with issues taken, in one form or another, from the world outside the film. This can lead to a somewhat self-contained world which may be entertaining and interesting but runs the risk of heavy reliance on irony and of having little that is of relevance to the viewer.

Whether films that use postmodern techniques are successful or not may still depend on how well the genres and styles are integrated into a coherent, unified piece of cinema. A film such as *From Dusk Till Dawn* (1996), which deliberately and noticeably joins two completely different genres together in the middle of the film, obviously runs the risk of losing the audience's involvement in the storyline. *Blade Runner*, on the other hand, integrates the different genres into the narrative, and visually the different genres are not too difficult to separate from each other. The latter film also deals with postmodernity in

relation to issues such as subjectivity, authenticity (the real versus the copy, human versus replicant) and the lack of answers or solutions; it is a fatalistic, dystopian film.

The Coen brothers are film-makers who regularly use postmodern techniques. Visually and thematically their films frequently employ some of the devices described above. *Barton Fink* (1991) contains the usual rich array of entertaining characters and dark humour associated with the Coens in a story set in 1930s Hollywood which follows several weeks in the life of a young scriptwriter. Thematically it is the film industry looking at itself, albeit via a comedy and across a time period of sixty years. *The Big Lebowski* (1998), another Coen brothers film, is again a successful comedy/thriller with an entertaining variety of characters. The most notable postmodern device is the use of occasional voice over narration provided by an observer of the events who talks like an old Western ranch hand, and when we eventually see him on the screen he matches our expectations with his cowboy attire. The laid-back cowboy drawl suits the film in many ways while visually being out of place; the borrowing of Western iconography ultimately probably works because of the comic nature of the film. The beginning of the film completely misleads the viewer as the camera tracks over a typically barren Western landscape, accompanied by some rolling tumbleweed that the camera follows, all of which is followed by the cowboy's introductory voice over.

The references to postmodernism here have emphasized the aesthetics of film with regard to genre; it is, however, also possible to place postmodern cinema in an economic context. A good example is *Star Wars*, which could justifiably be described as postmodern in that it is a pastiche of different genres, from science fiction and action/adventure through to elements of the Western, war movie and romance, with the consequent intertextuality. Thomas Schatz refers to *Star Wars*' 'radical amalgamation of genre conventions and its elaborate play of cinematic references' (Schatz, 1993, p. 23). The film has been a huge success for over twenty-five years in terms of entertainment and box-office takings. It could be argued that its success is partly due to the wide range of genres that it evokes, the effect being to broaden its audience appeal. In this respect, the application of postmodernism to film-making could have an economic imperative as well as an aesthetic purpose.

CONCLUSION

If one thing is certain about the film industry it is that genres will continue to structure what films consist of, motivate audiences to go to the cinema and guide what studios produce. Genres have existed since the early days of cinema and as the audience we tend to want to know what type of film we are dealing with, this also being the case with other media forms. Satellite television was quick to divide up its transmissions into 'genre' channels, one of the most successful

being 'films'. This has now developed further with channels that deal with specific genres such as science fiction. It may not be long before satellite television specializes further with subgenres. The loosening and fragmenting of genre boundaries have, in theory, opened up the possibilities for film productions and in the process have complicated genre study with the increasing tendency towards subgenres and the hybridity of genres.

SUMMARY

↪ The majority of films have been genre films and genre categorization has existed almost throughout cinema's history.
↪ Genres can be identified through visual content and narrative themes and it is the repetition of common elements across a number of films that makes categorization possible.
↪ Difference is also necessary in genre films to ensure innovation and novelty as well as predictability.
↪ Genre categorizations are not static, and themes and styles evolve to match social change.
↪ Genres are useful for the industry in targeting audiences, and for the audience in terms of being able to identify the types of films that will be liked.
↪ Genre study is useful in that it enables us to determine whether, and how, genre films reflect values, beliefs, issues and ideas that are prevalent within a society at any given moment.
↪ The study of genres enables us to identify the common elements in films belonging to a particular genre in terms of iconography, music and narrative themes, and to examine structures and variations that occur within and between genres.
↪ Genre study can highlight the ways in which common characteristics can appear in films of different genres, indicating that genres can overlap and can be combined.

REFERENCES

Altman, R. (1999), *Film/Genre*, London: BFI.
McArthur, C. (1972), *Underworld USA*, London: Secker & Warburg/BFI.
Neale, S. (1980), *Genre*, London: BFI.
Ryall, T. (1978), *Teachers Study Guide No. 2: The Gangster Film*, London: BFI Education.
Schatz, T. (1981), *Hollywood Genres*, New York: McGraw-Hill.
Schatz, T. (1993), 'The New Hollywood', in J. Collins, H. Radner and A. P. Collins (eds), *Film Theory Goes to the Movies*, London: Routledge.

FURTHER READING

Altman, R. (1999), *The American Film Musical*, Indiana: Indiana University Press.
Informative, analytical focus on the musical genre.

Buscombe, E. (ed.) (1988), *The BFI Companion to the Western*, London: André Deutsch Ltd.
Comprehensive coverage of the genre with excellent application of genre theory to the study of films.

Copjec, J. (1993), *Shades of Noir*, London: Verso.
Useful investigation of film noir and the debates surrounding the subgenre.

Donald, J. (ed.) (1989), *Fantasy and the Cinema*, London: BFI.
An accessible, informative text on this genre's application to films.

Kitses, J. (1969), *Horizons West*, London: Secker & Warburg/BFI.
Excellent book about Westerns and the genre's key directors.

Neale, S. (ed.) (2002), *Genre and Contemporary Hollywood*, London: BFI.
Comprehensive research and analysis of various genres.

Ryall, T. (1978), *Teachers Study Guide No. 2: The Gangster Film*, London: BFI Education.
Detailed application of theory to the analysis of the concept of genre.

Wright, W. (1975), *Sixguns and Society*, Berkeley, CA: University of California Press.
A structuralist approach to the study of the Western.

FURTHER VIEWING

A Personal Journey with Martin Scorsese through American Cinema (BFI, 1995)
A fascinating insight into the techniques of many of the USA's best known genre films. BFI, 21 Stephen Street, London W1T 1LN

Chapter 15
Stars

In this final chapter we shall examine the functions and meanings of stars within the film industry and Film Studies. Stars have not always been deemed essential to the production of films. It was not until the 1920s in the United States that the value of the star was widely acknowledged. Throughout the 1930s and 1940s US stars were placed at the centre of the film industry, but by the 1950s their role had changed somewhat. In recent times, certain star actors have held far greater power in the US film industry, and indeed in other film industries such as Hindi Indian cinema, particularly in terms of production. Similarly, stars have not always been seen as a particularly important part of Film Studies and star studies are still in a relatively early stage of development.

Early writing on stardom was little more than biography (of which there is still plenty being produced). Often such writing mythologized the stars, simply serving as a means to promote the star's image. In the 1950s and 1960s, stars were looked at as symbols of the larger society. It was not until the late 1970s that stars began to become a topic for film theorists when Richard Dyer suggested

that stars were economic elements within and manufactured by the US studio system and other film industries like Bollywood. Dyer has helped to direct attention towards the figure of the star not only within film, but also as part of a wider social context.

Thanks to Dyer, Christine Gledhill and others, it is now recognized that the star is more than just talent, beauty, glamour and charisma. There are at least five key elements to be considered when studying stars. These five elements – the star as a real person; the star as a form of economic capital or commodity; the star in performance, as someone who takes on roles and characters; the star as an image, a persona, a celebrity, and the star as a form of representation – will be examined in turn here. While we may tend to focus on the US film industry, if only because it was responsible for the primary model of film stardom, it is hoped that the reader will go beyond its boundaries to look at stars from other national cinemas.

//////////////////////////////////////

The real person

How much does the 'real' person behind the star really matter? When we watch a film we know that a real person called Keanu Reeves (if that is actually his real name) undoubtedly exists, but does it impact upon our understanding of the film? In some cases, where we know that the star uses a stage name (Winona Ryder/Horowitz), the gap between the real person and the star is evident. Sometimes films can confuse these identities. In two British films, *Final Cut* (1999) and *Love, Honour and Obey* (2000), the names of the actors were used, so Jude Law's character was called 'Jude', Sadie Frost's 'Sadie', and so on. The relationship between the real identity and the star can get more complicated, as in *Notting Hill* (1999) where Julia Roberts plays a film star called 'Anna Scott', or when a star plays another star's 'real' identity, for example, Jim Carrey as Andy Kaufman in *Man on the Moon* (2000). In *Last Action Hero* (1993) Arnold Schwarzenegger plays himself as well as a fictional character called Jack Slater. Do we get here a rare glimpse of the 'real' Roberts or Kaufman or Schwarzenegger or are we merely observing an image of the image that is Julia Roberts or Andy Kaufman or Arnold Schwarzenegger? In a class discussion, a student said that he could never look at Hugh Grant the same way again after the episode in the back of his Mercedes. In this case, the 'real' person has interfered with the viewer's reception of his character. However, Dyer would argue that the real identity of the star is inconsequential, for we only really know her/him through other media products (newspapers, TV, magazines, etc.), and that the rare insights into a star's character offer us nothing in the understanding of a film. Guest appearances by film stars on TV shows such as *Friends, Seinfeld, The Larry Sanders Show* and *Curb Your Enthusiasm* are regular occurrences. In some episodes they appear as themselves, as the 'real' person. Think about what this says about modern stars. Is there a

gap between their star image and the real person? Do we learn something about the real person or do such stars appear as we expect them to? The study of stars does not seek to discover the real/true person/identity behind the media facade, but rather attempts to analyse the function of the star within the film industry in particular, and the star's meaning and function in society in general. Like films, stars are perceived as texts that exist within particular socio-economic contexts and hence must be studied accordingly.

Economic capital/commodity

Film stars have not always been with us. Prior to 1910 in the USA, actors' names did not appear in film credits or publicity as it was felt that they might demand higher fees. Instead, the spectacle, technology and story of the film were promoted. It soon became clear, however, that films which named the 'featured players' were more successful with audiences, and during the period from 1915 to 1920 the importance of the actor was more widely appreciated. The Famous Players Company and the introduction of major theatrical actors into 'films d'art' began to focus attention on the body and life of the actor, changing the way that film actors were perceived. The print media also began to publicize the off-screen lives of these actors, transforming hitherto nameless screen bodies into actual film stars with names and identities that went beyond their on-screen roles. The presence of a particular star in a film helped to differentiate it from the competition, and soon the studio system in the USA had adopted the star. By the 1920s a fully formed star system had emerged.

As we have seen in the chapter on US Cinema, stars were considered central to the success of a film. We still often go to the cinema to see particular actors and actresses regardless of the films they are actually in. Some have become more popular than others, and a star name on the credits may become a guarantee of a degree of financial success (bankability). A star, therefore, is someone who contributes to a film's box-office success. Significantly, though, a star is someone who can do this over a number of films, rather than just one, as there have been many examples of what can be called 'one-hit wonders'.

Stars are part of the labour force that produces a film: the raw material from which films are made. The real person needs to be transformed into a star; hence the talent schools and dialogue coaches, beauticians, hairdressers and fitness instructors who serve to fashion the raw individual into a star image/product. The film industry perceived stars as a means of drawing audiences into the cinemas. Accordingly, stars were seen as a form of capital or commodity and the studios employed them on long-term and permanent contracts. Stars were tied to a particular studio, which then prepared them to fit the styles and genres of that studio. They had almost no say in which roles they were cast for or the films they would be in, and if they refused they could be suspended without pay.

Stars were contracted because they helped to target and attract a large audience for their films. Their performances contained a set of conventional elements such as standard gestural and behavioural patterns, which would be repeated over a number of films. Audiences then expected a certain type of performance and were able to predict what the star was most likely to do. Stars were also closely linked to genre, in particular through iconography, visual style and placement within the structure of the narrative. Humphrey Bogart, for example, symbolized the hard-boiled detective and lone alienated figure of film noir. Alternatively, the star was the basis for recognition by audiences through a readily identifiable image ('Humphrey Bogart in'). Often the stars were loaned out to other studios; for example, Vivien Leigh and Clark Gable were loaned to David O. Selznick for *Gone with the Wind* (1939), one of the most successful films in history. Since the audience expected a certain type of experience, film posters would create expectations by placing the star against a background of scenes from the film.

The studios deliberately used stars to increase demand for tickets. They often generated publicity around stars' off-screen lives which was designed to complement their onscreen images. The studios often packaged stars such as John Wayne, Marilyn Monroe, Clark Gable and Cary Grant as untouchable, mythic figures, identified by their typical screen roles, which were often in truth fairly superficial. This is what is known as the star's 'image', which we will look at in more detail below. Stars were also seen as an investment, a protection against possible loss of revenue. A poor story or a remake could be improved by the presence of one or more stars. In order to maximize the potential of a star, the studios constructed an image or persona for him/her: we can think of Bogart, who was often seen wearing a fedora hat and smoking a cigarette, or of Marilyn Monroe with her skirts blowing over an air vent.

Following the decline of the studio system, the power of star actors has increased massively with the ending of the restrictive contract system. Stars have effectively become free agents and talent agencies increasingly negotiate deals with studios on their behalf. Stars now have more power to select which films they appear in; indeed, they make fewer films than under the studio system. The increasing trend towards big-budget and star-studded features, as well as the increasing competition from the television and music industries, has facilitated 'star power'. Some stars have set up their own production companies and have used their economic power to control the films they appear in, often producing and directing themselves. However, this is not a new development. In 1910, Fox wooed Florence Lawrence away from the Biograph Studio by fulfilling her demands for a larger salary, a larger dressing room and a job for her boyfriend. In 1919 Charlie Chaplin, Mary Pickford and Douglas Fairbanks, together with D. W. Griffith, established United Artists so that they could exercise more control over their own careers. During the 1950s, Marilyn Monroe set up her own company in order to produce her own films.

It has been suggested that five or six key stars have now usurped the power of the studios, directors, producers and agents in the US film industry hierarchy; indeed, we now talk of 'star power'. Actor Nick Nolte has condemned this state of affairs: 'The star system sucks. The big studios have boiled Hollywood down to four male leads…it's not creative. They get the stars before they get a script' (quoted in Gibbons, 2000, p. 9). Director John Boorman further explains:

> Because films go out to hundreds of cinemas across America at the same time, they need very expensive advertising. This means the audience needs a recognition factor of a simple story and stars they can identify with. Films now have to succeed on that first all-important weekend and, because they can open a picture in that way, this has given a handful of stars enormous power. They choose the projects; they are the people in charge.
>
> <div align="right">(quoted in Dewe Matthews, 1999, p. 2)</div>

3

This power has translated into bigger fees per film, and many stars now have control not only over how a film is made, but also over how it is marketed. Stars can determine which films are made, they can demand script alterations, select their co-stars and even approve the final cut (known as the 'actor's cut'). Examples are Edward Norton and *American History X* (1998) and Mel Gibson and *Payback* (1999). Stars have become so powerful because studio executives believe that the right actors make the difference between success and failure. As films have become more expensive, studios, producers and financiers have increasingly relied upon star attraction to protect their investments. Since stars are now free to pick and choose projects and the major talent is spread fairly thinly, the power is in their hands. In an attempt to retain them, production companies strike deals as a means of rewarding their most valuable performers. The value of a star is now measured in terms of how much money her/his films make, particularly over the opening weekend. This is known as insurance value to the investor. Echoing the contracts of the studio system, the major studios attempt to 'buy' their own personal film stars, but despite their attempts, it seems to be a stars' industry. As producer Tim Bevan put it, '[y]ou can't expect somebody in the studio's position or in our position, who's being asked to put up $40–$50m, not to reduce their risks and look for an insurance policy, and in our business, the insurance policy is a star…at the end of the day, the stars have got a monopoly because there are so few of them' (quoted in Dewe Matthews, 1999, p. 2).

The history of stardom in India (in particular the Hindi cinema of Mumbai) parallels that of the US film industry. Star power grew bit by bit; initially stars were tied to studios with strict discipline and rigorous contracts, but this began to break down in the 1940s, with the result that today stars command even more power than their US counterparts. It is an entrenched axiom in Indian cinema that stars are an essential element in the success of any mainstream film. And since the 1960s an entire magazine industry has emerged which spreads lewd

these stars in many languages. An additional ingredient which spices ...od gossip is the dynastic nature of the Hindi film industry. The way ...ges of star actors and directors are continued from father to son (from A... ...to Abhishek Bachchan, from one Kapoor to another) has been far more pronounced in Bollywood than in the USA, and may owe something to a caste system which many Indians find an embarrassment.

Since the rise of the multiplex, video and DVD, it could be argued that the role of the star has changed yet again, that their role is simply to make money. Lately, however, there has been concern that stars are failing to fulfil their function and are no longer bankable. After the success of the $200m blockbuster *Titanic* (1997), its stars, Leonardo DiCaprio and Kate Winslet (see case study below), both appeared in box-office failures (*Celebrity*, 1998; *Hideous Kinky*, 1998). Big names are no guarantee of success.

Harrison Ford, Bruce Willis and Nicolas Cage have all suffered poor box-office returns. In contrast, films featuring unknowns can become massive hits, suggesting that audiences like to be surprised occasionally. There are ultimately no guarantees that the mere presence of a star will generate income. Nonetheless, the question is: do stars still constitute a form of capital, and if so, who owns them: the production companies, their agents or themselves?

Exercise 15.1

Compare and contrast a star from the studio system with one from the contemporary US film industry. What are the differences and what are the similarities in terms of their appeal, what they represent and how they have been presented to us?

Role, character and performance

In this section we will consider the following question: what specific meanings do stars bring with them to the roles they play? A key part of the star is her/his performance. Movement and expression within the *mise en scène* are ways in which actors 'signify' – convey or express meaning. The star, like the director, may be considered an 'auteur' in his/her performances in that s/he may bring qualities to a film independent of the script and generic conventions. This has increasingly become the case for Clint Eastwood. *From A Fistful of Dollars* (1964) to *Dirty Harry* (1971) to *Gran Torino* (2008), he has become known for playing men of few words who speak through their actions. He is typically an anti-hero, operating outside the law but ultimately ensuring that justice is done. His auteur status has been enhanced through his frequent role as a director, often of films which he also appears in. For the audience, interpreting a performance involves assessing how far the actor has 'become' the character, which may then

be discussed in terms of how far it was 'believable', 'truthful' or 'realistic'. A film is often a vehicle for the star, giving him/her the chance to demonstrate his/her unique qualities in a particular role, situation or context. An actor may on the one hand submerge his/her personality to create a character, or may let his/her own personality create the character. Acting ability, however, is not always a prerequisite for stardom. A common criticism levelled at Arnold Schwarzenegger (which is not shared by all critics) is that he can't act. Consider how many times you have seen a film and said the same thing about the main actors/actresses.

The star's ability to act or to play certain roles and characters gives a production value to the film-maker, who then knows what to expect from a certain star. The character may be adapted to fit the star, or the former's characteristics may happen to correspond to those of the star. Few of us really believe, however, that the star and the character being played are actually the same thing (although, as we have seen above, a character's name may accord with that of the star, causing some confusion). Richard Dyer has categorized three relational possibilities between the star and role/character. First, cases where the character makes 'selective use' of the star's persona; second, when the character and the star seem to be a 'perfect fit'; and third, when the star and character are mutually opposed or a 'problematic fit'.

As we can see, there is a relationship between the star and the role/character s/he is playing. A role is created for a star or a star is put into a particular role. Eventually, the star becomes associated with a particular type of role (e.g. James Bond and Sean Connery/Roger Moore/Pierce Brosnan/Daniel Craig). These recurring elements lend a measure of predictability to the film and go some way to fulfilling the audience's expectations. Think of Schwarzenegger, Clint Eastwood or Sharon Stone and certain roles/characters will spring to mind. There is a circular relationship between the star and her/his role within a particular genre. A star often emerges within a particular genre. Stars, therefore, can be productively studied with reference to genre.

Performance is an important part of stardom and can be broken down into two categories:

- → Impersonation: this type of acting/performance is usually associated with the theatre. The actor constructs a role using her/his imagination and specific skills and is judged on how successfully s/he submerges her/his 'real' personality by the number and scope of roles s/he adopts, and how far s/he is acknowledged as being psychologically realistic.
- → Personification: the US film industry more often utilizes this type of acting/performance. The actor plays a role that matches his/her physical appearance, what Dyer refers to as a 'perfect fit', and success is judged not by what s/he does (acting), but rather by what s/he 'is' (identity).

Since the early days of film, the role of the star has gradually changed as a result of considerable changes in acting styles. During the silent era, actors were not

required to speak while acting. The introduction of sound after 1926–7, however, meant that many silent actors lost their jobs and were replaced by East Coast theatre actors. Since the subsequent decline of the studio system from the late 1940s onwards it can be argued that actors have had more input into their roles as well, interpreting them with more individuality than was previously possible. Indeed, this is reflected in the arguable auteur status which international stars such as Marlene Dietrich, Gérard Depardieu, Jackie Chan, Raj Kapoor and Clint Eastwood (among others) have enjoyed.

In the USA, the mannered, heavily stylized enunciation of previous decades was gradually replaced by a more spontaneous, more naturalistic approach, as demonstrated by Marlon Brando, Rod Steiger, James Dean, Paul Newman, Geraldine Page and Joanne Woodward. They had trained at the Actors Studio, New York, which embraced the Stanislavsky technique, stressing emotional truth and realism in the performing arts. Stanislavsky's teachings were preached by Lee Strasberg and Elia Kazan and became known as 'Method Acting', or simply 'the Method'. The Method seeks to break down the distinction between the actor and the role (for more detail see Maltby, 1996) and is a more extreme and advanced form of personification whereby the actor physically embodies the role in appearance, gesture and movement. When Kazan's *On the Waterfront* (1955) won seven Oscars, including a Best Actor award for Brando, the Method had arrived in the USA and by the 1960s it had almost completely permeated the mainstream film industry.

As a result of these changes, some stars are now considered to be more believable, more 'real', and are more likely to be appreciated for their acting skills as their on-screen roles tend to have more depth. An actor committed to the Method is Robert De Niro, who researches the background of his character, seeks real-life models for the character he portrays and attempts to transform himself physically into the role he is playing. In *Raging Bull* (1980), for example, he gained a great deal of weight in order to physically personify an ageing and out-of-shape boxer, as well as turning in a savage performance as the same boxer in his fighting prime.

Appearing in the same role/character can lead to typecasting, and audiences may become bored with the constant repetition. For a star to survive s/he must be willing to adapt or change, and as a consequence stars, like genres, can change over time as the star moves over several genres. Bruce Willis, for example, has successfully broadened his appeal by making comedies as well as action/adventure films.

But does the star generate meaning through acting ability (i.e. voice and body) alone? One way of testing this is through what has been called the commutation test: this works by imagining swapping one actor for another in a particular role to see if this makes any difference for the spectator. Any changes point to what is unique about one actor compared with another. *Last Action Hero* explicitly and playfully invokes this notion when, in an alternative reality, Sylvester Stallone is imagined to be the star of *Terminator* rather than Arnold Schwarzenegger.

What is more, elsewhere we discuss how genre and authorship play an important role in signalling meaning for the spectator. In the 1920s, Soviet film theorist Lev Kuleshov intercut a shot of an expressionless actor with various objects. He argued that because the spectator then saw emotions in the actor's face (depending on whether the actor had been intercut with a bowl of soup or a young child, for example) this had to be a result of editing rather than of the actor's performance alone. To this it can be added that action as perceived is a product of camera angles and movement, lighting and music, as well as of voice and body. Is the actor/actress constrained by the director, genre and film technique, or will her/his performance transcend those boundaries? What factors determine how we read a performance?

3

> **Exercise 15.2**
>
> Discuss how far an actor's performance alone generates meaning. You may wish to consider the roles of the director and the casting director as well as the actor's acting ability.

///////////

Image

Although stars belong to the raw material from which films are made and are part of the labour force that produces a film, they are distinguished from the rest of the crew by their image. The image of a star is vitally important to the film industry, as the star is used to market and publicize a film as an enticement to come to the cinema. As the Film Policy Review Group notes, '[t]he presence of certain stars can endorse a film and provide clues about its likely nature and appeal and a favourite star is a defining factor in choice for some cinema goers'. The star image is constructed through promotion, marketing, advertising, publicity, film roles and characters and critical commentary on those roles. Today, the star is extensively promoted through the mass media in interviews, features, reviews, news and so on. Media promotion of the star plays upon a set of contradictions – stars are both ordinary and glamorous, they are like us and yet not like us, they are a real person and a mythical economic commodity. It is often claimed, therefore, that stars carry meaning in the persona – think of Jessica Alba – independently of the particular roles they may play.

Like genre, director and even special effects, stars are used to sell films and so the star's image dominates film posters and trailers and appears in hundreds of magazines and newspapers. Image gives the star extra value as it can attract investment, and signals to the audience and the exhibitor that this is a particular type of film. This is known as trademark value. Stars provide a sense of expectation for the audience and consequently they are used both by the industry to target audiences and by audiences to target the type of film

they wish to see. Thus stars are designed to conform to certain generic expectations just as films are, and we expect a certain type of performance from a particular star. Consequently, stars can play a part in the standardization of films just as genre categorization does, as they can carry particular roles with them from one film to another. It may be argued that popular audiences identify and value films according to their stars and star performances rather than their directors. The presence of certain stars gives us important clues to the nature of the film, and may suggest genre, narrative and mood before we have even seen the film.

But who exactly determines the star's image? Do we as the audience simply accept the image that is constructed for us by the star, the role and the publicity, or do we have a more active role in deciding upon the image? It can be argued that the meanings and responses generated by stars are much less fixed than film producers and casting directors may imagine and that the audience plays a more creative part in the process of star understanding. The sheer number of unofficial and fan-based websites for major film stars suggests that fan behaviour in responding to stars is outside the control of the film industry. On the other hand, while the expansion of the internet may have empowered many to create their own websites about their favourite actors and actresses, it has simultaneously fuelled the fetishization of stars created by the media in the first place.

Exercise 15.3

Consider your own behaviour as a 'fan'. How far are you responsible for constructing the image of your favourite star and how far is the distributor/marketer responsible?

Representation and meaning

Why are certain stars popular at certain times? It is hard to pinpoint exactly why an actor/actress becomes a star, but there can be a measure of luck in simply appearing in the right film at the right time. Stars are people the audience can identify with, relate to and admire. They allow us the vicarious pleasure of identification: they are there to do the things that we can never do and to live the lives we can never lead. As James Monaco has put it, '[s]tars were – and still are – the creation of the public: political and psychological models who demonstrate some quality that we collectively admire' (2000, p. 222). Furthermore, stars often settle ideological conflicts that cannot be resolved in real life, and these fantasy solutions serve to comfort the viewer. Indeed, audience identification with the hero/ine and audience and conflict resolution are both central aims of mainstream cinema.

Particular stars may also be the direct or indirect reflection of the needs, drives and dreams of their particular society. We can point to the success of Chuck Norris, Sylvester Stallone or Arnold Schwarzenegger, for example, during the Reagan years; their success has since declined as times have changed. According to the BBFC's report of 1998, there seems to have been a shift in what we watch. The action/adventure heroes of the 1980s and 1990s such as Seagal, Van Damme and Schwarzenegger had aged or fallen out of favour except on video and DVD. Film stars can participate in the spread of dominant ideological values by embodying or personifying the dominant ideology, and may be seen as role models – they represent beliefs and values which largely reflect those of their society. In looking at stars, we must consider representation in order to understand how stars generate significant meanings and responses and thus may embody various values and ideologies.

But can we simply say that stars are reflections of dominant social values? Although this is a common belief, current star studies reject this idea as simplistic: film stars can also participate in the alteration of ideological values. In Indian cinema, for example, stars often behave in a 'shocking' fashion (both on and off the screen) that would seem to undermine the rigid social patterns of Indian society. Thus Madhuri Dixit was one of seven actresses whose 'obscene' performances prompted an unsuccessful prosecution in India – which dragged on from 1996 until 2000 – for 'eroding the cultural fabric of the country'. Rather than simply suggesting that the star is a mere reflection of dominant social values, we can say that the star generates many meanings within a particular context.

Current star studies seek to analyse these meanings in relation to ideologies of class, race and gender. Typically, the female actor/body has been the focus of many star studies, including those of Marilyn Monroe, Greta Garbo, Shirley Temple, Jean Harlow, Rita Hayworth, Kim Novak, Judy Garland, Mae West, Bo Derek and Demi Moore in the west, and 'Fearless Nadia', Nargis Dutt and Smita Patil in the east. In many cases, it is argued that female stars are constructed to appeal to male desire (voyeurism and scopophilia), but such studies have been criticized for their assumption of a male spectator and masculine viewing position. What if the spectator is female and the observed a male? Stars has also been an increased interest in masculinity as viewed from both female and male perspectives. For example, what are we to make of the frequent close ups of the body of Brad Pitt within genres that primarily appeal to young males?

Using a semiological approach, Richard Dyer's influential work of the 1980s and 1990s has studied stars as texts, as bundles of analysable signs. According to Dyer, in any single instance, a star can signify a polysemy – a range of different possible meanings – which has been manufactured through four main types of media texts: promotion, publicity, film roles/characters and criticism/commentary on these roles. For Dyer, the presence of a star in more than one media text – intertextuality – is vital to studying stars. Indeed, a star must appear in a range of media texts; otherwise s/he is not truly a star. It is this intertextuality

that distinguishes the star from the non-star known only for one role (this is the case with many soap characters when we either forget or do not even know their real names). Today, US stars cut across far more media texts than they did in the days of the studio system. Will Smith, for example, started out as a rapper before starring in the TV sitcom *The Fresh Prince of Bel Air*. Since then he has continued with his musical career while starring in big-budget US blockbusters (see case study below). As we mentioned above, film stars regularly also make guest appearances on TV shows.

Central to understanding the star's representation and meaning is the audience. Frequently the audience is either omitted entirely from star studies (which tend to treat the star as a text) or presumed to be passive. Both approaches are inadequate and it is important to try to understand how audiences might read stars within specific historical and cultural settings. This move beyond simply considering the function of stars within particular film texts has been exemplified by Richard Dyer's *Heavenly Bodies*, an effective sequel to his own groundbreaking *Stars* (see Further Reading).

CASE STUDY

Kate Winslet

Co-star of *Titanic* (1997), Kate Winslet (see Fig. 15.1) was thrust into stardom; but what kind of a star is she? Many US stars of the studio period did not go by their original names: John Wayne was born Marion Morrison, Marilyn Monroe started life as Norma Jean Mortenson. Cary Grant's original name, Archibald Leach, was deliberately used for the Archie Leach character in the British comedy *A Fish Called Wanda* (1988) played by John Cleese, whose name would have been John Cheese if his father had not changed his own name before going

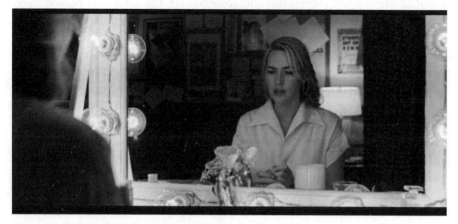

Figure 15.1　Kate Winslet: in some ways a star, in others not?

into the army in 1915. By contrast, recent stars have perhaps more often retained their own names, so the person who is 'Kate Winslet' is also called Kate Winslet.

Winslet acted in a number of TV and film roles before she was 20, including an episode of the BBC hospital soap *Casualty*. The breakthrough into major roles came with *Sense and Sensibility* (1995), *Jude* (1996) and *Hamlet* (1996); *Titanic* and record-breaking success beckoned. It is interesting that subsequent films such as *Hideous Kinky* (1998) and *Holy Smoke* (1999) have not been successful and have not enhanced Winslet's star status. Indeed, it was not until 2008/9 that Winslet received mainstream recognition, garnering a host of awards for her roles in *Revolutionary Road* (2008) and *The Reader* (2008). Why should this be?

At least four different kinds of factors may have contributed to Winslet's relative lack of prominence since the success of *Titanic*. First is her relative 'ordinariness': like Johnny Depp, say, she appears approachable. This in turn may be linked to her Englishness and to her apparent wariness of the US film industry: several of her films, from *Heavenly Creatures* (1994) to *The Holiday* (2006), have been at least partly British, often with French, Australian, or New Zealand/Aotearoa connections: *Holy Smoke* was directed by Jane Campion, the New Zealand/Aotearoa director who made *The Piano* (1993).

This lack of US exposure could also, of course, have been forced by a third factor: the relative weakness of her perceived celebrity image, which has a number of possible explanations which are likely to overlap. Is there something non-photogenic about Kate Winslet's appearance? Despite the success of *Titanic*, were there reservations about her acting in the film or about the meanings generated by her character and performance? Could it be that *Titanic* hit the jackpot despite its female lead and not because of her?

Or, finally, does Kate Winslet herself refuse to conform to the conventional star image, with its photo-opportunities, emphasis on image, glamour and gossip-fodder? Inconceivable though it may be to marketing executives, it may be that she is simply not interested in being the kind of star they have in mind. The characters she plays are often strong-willed, independent-minded free spirits; could it be that these qualities in a woman are still threatening to some?

END OF CASE STUDY

CASE STUDY

Will Smith

Willard Christopher Smith Jr was born in 1968 and grew up in middle-class West Philadelphia. He allegedly earned the nickname 'Prince' because of the way he could charm his way out of trouble, and began his career as the rapper 'Fresh Prince' performing with DJ Jazzy Jeff. He then went on to star in his own sitcom, *The Fresh Prince of Bel Air*, from 1991 to 1996. In this sitcom he played

himself in the title role of a streetwise and tough kid from West Philadelphia who is sent to live with his middle-class cousins in Bel Air.

Meanwhile, Will Smith appeared in the films *Where the Day Takes You* (1992), *Six Degrees of Separation* (1993), *Bad Boys* (1995) and *A Thin Line between Love and Hate* (1996), but it was not until the blockbuster *Independence Day* (1996) that he emerged as a leading US actor. Since then he has appeared in *Men in Black* (1997), *Enemy of the State* (1998), *Wild Wild West* (1999), *The Legend of Bagger Vance* and *Men in Black: Alien Attack* (both 2000), *Ali* (2001), *Bad Boys II* (2003), *I, Robot* (2004) and *Hitch* (2005). Although he has played a variety of roles and characters (confidence trickster, police officer, military captain, lawyer, Civil War hero and even a golf caddie), Smith seems to stick to certain genres. Using his comedic TV persona, Smith has appeared in films that integrate comedy with other genres such as action, thriller and science fiction. Across all of these roles, however, one can detect his trademark brashness.

As an important bankable commodity he now commands a fee of approximately $15m per film. What is more, Will Smith is seen as a good investment because he can also provide the soundtrack: on at least two of his films, *Men in Black* and *Wild Wild West*, he wrote and sang the title track.

Will Smith has entered a newer, arguably more mature phase of his career in which he has dropped the wisecracking/rapper persona in favour of a what might be perceived as a more Oscar-friendly seriousness as an actor, as witnessed in such films as *The Pursuit of Happyness* (2006), *I Am Legend* (2007) and *Seven Pounds* (2008). In *Hancock* (2008), he is self-reflexively and meta-critically playing off his previously 'bad boy' persona.

Why has Smith emerged as such a success? Certainly there has been a history of African American actors in the US film industry, such as Paul Robeson, Sidney Poitier (incidentally in *Six Degrees* Smith plays a man who pretends to be his son) and more recently Samuel L. Jackson and Denzel Washington. But Smith's success as a leading actor in the mid- to late 1990s may signal a transformation not only in the US film industry, but also in US society in general. As an African American, it is possible that Smith could only have reached this level of stardom within a more liberal and open-minded society, perhaps mirrored by the liberal Clinton Administration, than those presided over by Reagan and Bush. His gentler, more comedic persona has replaced the white, macho, patriotic action-adventure heroes of the late 1980s and early 1990s such as Schwarzenegger, Stallone and Van Damme. Perhaps Smith's stardom reflects a new era and a US society that is more pluralist and tolerant of ethnic minorities.

Unlike Winslet, Smith seems to conform to the conventional image of the star. As a musical and TV performer he fulfils Dyer's condition of intertextuality necessary for stardom, and he has continued to perform as a rapper, releasing a string of successful hits such as 'Will2K' and 'Summertime'. His various images as a successful rapper, TV performer and film star have overlapped to create a very marketable persona. Since some of these characteristics seem to have been

drawn from his real life, we may feel we are actually offered a glimpse of the 'real' Will Smith, particularly as we may have seen him before he emerged on the big screen. His cool rebellious character, as indicated through his dialogue, music and dress style, has an obvious appeal for a teenage audience that frequently has similar concerns, while his comedy and occasional moral messages perhaps attract an older audience too.

END OF CASE STUDY

CONCLUSION

Star study is a relatively new and complex part of Film Studies. In looking at the five components which make up the star – the real person, economic capital/commodity, performance, image/persona/celebrity and representation – we can say that the meanings and responses generated by stars are not stable or fixed. In recent years, for example, the phenomenon of stars and celebrities has changed particularly in the light of the pervasive nature of celebrity cultures and the proliferation of mobile phone cameras and video. What has been called 'celebrity culture' is much more in evidence, as is the advent of individuals being famous for nothing more than being famous. Arguably, though, such celebrities are still distinct from 'stars' who are defined by the specific medium in which they work (e.g. 'film stars') and are thus perceived to have some sort of talent.

Nonetheless, the study of stars, alongside genre and authorship, is not only productive when looking at the film industry, but also sheds light on our under-standing of film. Yet there is a possibility that stars will not always be with us. Things have shifted drastically since the days of Florence Lawrence the Biograph Girl; while a few stars may dominate the US film industry or Bollywood today, since the arrival of CGI we may no longer need stars in the conventional sense. Rather than investing in physical human labour, film executives may deem it cheaper and less complicated to resurrect dead stars or to create them entirely from scratch. During the production of *Gladiator* (Ridley Scott, 2000), for example, Oliver Reed died. CG depictions of his head were matted onto another actor's body. And some have argued that the best actor in the *Lord of the Rings* trilogy (2001, 2002, 2003) was the CG Gollum (voiced by Andy Serkis).

SUMMARY

↔ Star studies attempts to understand the function of the star in both film and society.
↔ It is important to understand the role of the audience when studying stars.
↔ The star is a real person, but how far does this matter?
↔ The star was and maybe still is deployed as a form of economic capital or commodity to increase the success of a film.

↔ The star is someone who takes on roles and characters and may often be judged by the quality of his/her acting.

↔ The star has an image, a persona and a celebrity which may be different from the real person and the role/character which is used to publicize a film.

↔ The 'value' of a star can be broken down into three categories: insurance value (for the investor), production value (for the producer) and trademark value (for the audience).

↔ The star also operates as a form of representation and produces meaning within a particular society.

REFERENCES

Dyer, R. (1986), *Heavenly Bodies: Film Stars and Society*, London: Macmillan.

Dyer, R. (1990), *Now You See It*, London: Routledge.

Dyer, R. (1998), *Stars*, new edn, London: BFI.

FPRG. (1998), *A Bigger Picture: The Report of the Film Policy Review Group*, London: Department of Culture, Media and Sport.

Gibbons, F. (2000), 'Stars Demanding Up To $30m a Film', *The Guardian*, 9.

Gledhill, C. (ed.) (1991), *Stardom: Industry of Desire*, London: Routledge.

Kruger, S. (1985), *Film and the Star System*, London: Film Education.

Maltby, R. (2003), *Hollywood Cinema: An Introduction*, 2nd edn, Oxford: Blackwell.

Matthews, T. D. (1999), 'They're Not Just Rich and Famous. They're in Charge', *The Guardian*, p. 2.

Monaco, J. (2000), *How to Read a Film: The Art, Technology, Language, History, and Theory of Film and Media*, 3rd edn, New York and Oxford: Oxford University Press.

Wise, D. (1999), 'Money for Nothing?', *Screen: The Observer*, pp. 6–7.

FURTHER READING

Basinger, J. (1994), *A Woman's View: How Hollywood Spoke to Women, 1930–1960*, London: Chatto & Windus.

An exhaustive analysis of the 'woman's picture', a Hollywood genre that flourished during the 1930s, 40s and 50s, including the roles female stars were expected to play, their clothes, social behaviour and the ideals of femininity which Hollywood projected.

Evans, J. and Hesmondhalgh, D. (eds) (2005), *Understanding Media: Inside Celebrity*, Maidenhead: The Open University Press.

A useful collection of essays exploring the changing notion of celebrity and stardom.

Fischer, L. and Landy, M. (2004), *Stars: The Film Reader*, London: Routledge.

A useful anthology of writing on stars and stardom in film and television.

Fouz-Hernández, S. (ed.) (2009), *Mysterious Skin: The Male Body in Contemporary Cinema*, London and New York: IB Tauris.

An anthology exploring masculinity, specifically the male body, across a range of national cinemas.

Macnab, G. (2000), *Searching for Stars: Rethinking British Cinema*, London: Cassell.

A focus on the British star system and how it has compared to its US counterpart.

McDonald, P. (2000), *The Star System*, London: Wallflower.

A short introductory text examining the developing and changing organization of the star system in the US film industry.

Stacey, J. (1994), *Star Gazing: Hollywood Cinema and Female Spectatorship*, London: Routledge.

Rejecting psychoanalytic theories of female spectatorship, Stacey explores how female viewers understood Hollywood stars in the 1940s and 1950s, including Doris Day, Joan Crawford, Betty Grable, Ava Gardner, Rita Hayworth and more.

Thompson, J. O. (1978), 'Screen Acting and the Commutation Test', *Screen*, vol. 19, no. 2.

Thompson's original essay explaining the commutation test.

Vincendeau, G. (1998), 'Brigitte Bardot', in J. Hill and P. C. Gibson (eds), *The Oxford Guide to Film Studies*, Oxford: Oxford University Press.

A short case study of one of France's best known film stars alongside a chapter on 'The Star system and Hollywood'.

FURTHER VIEWING

We have not identified any specific items here because there are many documentaries which explore the lives of individual stars, such as Gary Cooper, Marilyn Monroe, Humphrey Bogart and Sidney Poitier.

Glossary

180 degree rule ↔ the camera should normally stay on the same side of the line of action for successive shots. The imaginary line of action passes between characters or objects; if shots are taken from opposite sides of the line (this is called crossing the line) then the spatial relationship between the characters or objects is reversed.

30 degree rule ↔ if shot size and content remain similar for successive shots, then the camera should move position by at least 30 degrees; failure to do so results in a jump cut when the edited shots are viewed together.

abstract ↔ non-figurative. Abstract films do not contain representations of identifiable objects; they are likely to consist of colours, shapes and rhythms and to have no narrative.

alienation ↔ estrangement. Feeling distanced from something. Inability to feel as though one is a part of something. Some films are intended to alienate the spectator by preventing involvement in the film; the spectator is discouraged from identifying with the action in the film and is kept at a distance.

analogue film production ↔ the recorded material is analogous or similar to the actual subject matter filmed; film as a recording medium has the quality of being continuously variable in its ability to respond to variations in light intensity and colour (see digital film production).

aperture ↔ the hole through which light passes from the lens to the film. The size of the hole is varied by adjusting a diaphragm. A greater depth of field is obtained by using a small aperture, which in turn requires either greater illumination to ensure sufficient light reaches the film or a more efficient lens and faster film stock.

art director ↔ responsible for set design and costumes.

auteur ↔ a person, usually a director, who is credited with being responsible for the thematic and stylistic characteristics of a range of films.

avant-garde ↔ an advance beyond what has gone before. At the cutting edge of artistic experimentation. Avant-garde films use new techniques and ideas to produce alternatives to the mainstream.

back light ↔ a soft light placed behind and above or below an actor to produce a slight aura of light around the edge of the actor.

background light ↔ a light that is placed behind an actor and directed towards the background to create a sense of depth and distance between actor and background.

balanced lighting ↔ (see high key lighting).

best boy ↔ assists the gaffer.

bricolage ↔ the piecing together of a variety of different elements and influences. As a technique, this manifests itself in films as a mixing together of genres and styles (see postmodernism).

camera obscura ↔ literally means darkened room. An early form of the still image camera. It consists of an enclosed box with a pinhole on one side through which the light from an exterior object is projected onto the opposite interior face of the box.

capitalism ↔ the economic organization of society whereby the means of production are privately owned. The primary motive for producing goods and services is to make a profit. In theory, competition between producers should result in more choice and lower prices, but in practice competition is weakened through the trend towards concentration of ownership, leading to oligopolies and monopolistic trends (compare with communism).

chiaroscuro lighting ↔ (see low key lighting).

chromakey ↔ (colour separation overlay) An electronic technique that can be used in video production, where a chosen colour (usually a 'blue screen' background) can be ignored by the camera so that another image can be 'keyed' in to replace it. The video equivalent of a film matte.

cinematographer ↔ is responsible for deciding how the camera and lighting are to be used.

cinéma vérité ↔ literally means 'cinema truth'. A documentary style developed in France in the 1960s that made use of mobile, lightweight camera and sound equipment. The camera operator was seen as potentially part of the events being filmed through his/her interaction with, and influence upon, the participants.

close up ↔ when framing a human face, such a shot would range from just above the top of the head to just below the chin.

codes ↔ systems of audio and visual signs that enable communication to take place. Particular types of objects, shot sizes, camera angles, lighting, editing and music in films tend to produce particular meanings for those

who understand the codes. The codes are widely understood because they have become conventions.

cognitivism/cognitive theories ↔ as the name implies, this recent approach (which spread from North America in the 1990s) values conscious recognition and knowledge, and rejects many of the more complex psychoanalytic and structuralist assumptions of Screen Theory; most cognitive theory writers are intensely hostile to the notion of the unconscious. The links between perception (of films for example) and emotion are analysed using rational, scientific models.

communism ↔ the economic organization of society whereby the means of production are publicly owned. Goods are produced for need rather than profit. In theory, ownership and control are spread throughout society, but in practice power has tended to become concentrated in the hands of a small élite. Marx's analysis of capitalism led him to propose a communist form of society (compare with capitalism and see Marxism).

composition ↔ the arrangement of elements within a shot.

connotation ↔ the associated or implied meaning of an image, sound or word.

continuity editing ↔ the editing together of shots such that the action flows smoothly. Content, position and direction of movement are consistent between shots and the editing ensures that attention is not drawn to the construction of the film itself.

conventions ↔ the customary ways of doing things. Films normally use conventional methods for structuring and communicating their narratives, such as story resolution, the inclusion of certain objects and locations, and particular use of camera, sound, lighting and editing. Genres consist of conventions that have become established over time. Conventions result in codes, accepted ways of understanding and communicating meaning.

crane shot ↔ the camera is mounted on a crane, enabling it to move up and down, backwards, forwards and sideways.

cross-cutting ↔ editing together shots which alternate between action happening simultaneously in different locations.

cross-media ownership ↔ owning companies in different media industries. Makes synergy possible.

crossing the line ↔ (see 180 degree rule).

cut ↔ this has two related meanings: it describes the end of a filmed take (as when a director calls out 'cut!'). It also describes a simple transition between two shots which have been edited together.

cutaway shot ↔ a shot inserted between other shots in a scene which is not directly related to the scene.

deep focus ↔ everything within a shot is in focus, from foreground to background (compare with shallow focus).

denotation ↔ the direct and literal meaning of an image, sound or word.

depth of field ↔ the range within which objects in an image are in focus.

dialectics ↔ the process whereby ideas and situations are challenged and result in new ideas and situations. The initial concept is a thesis, which is challenged by an anti-thesis, which leads to a synthesis, the outcome of the conflict. Progress, in the real world or in a narrative, can be regarded as a dialectical process.

diegetic ↔ that which originates from within a film's narrative such as dialogue, sound effects and music played by a character (see non-diegetic).

digital film production ↔ the recorded material is an approximate but incomplete copy of the actual subject matter filmed because digital electronics does not have the quality of being continuously variable in its ability to respond to variations in light intensity and colour. The colour range of television and video technology is less than that of film, but digital equipment tends to be cheaper and more flexible than film equipment (see analogue film production).

direct cinema ↔ a documentary style developed in the USA in the 1960s reflecting the belief that the availability of mobile, lightweight camera and sound equipment made it possible to make documentaries that revealed social realities in a more truthful way as the filming of events did not need to be planned and was therefore more direct and unmediated. The camera operator does not play an active part in the events.

director ↔ responsible for the creative aspects of a film's production; determines how the narrative is to be translated onto film.

director of photography ↔ (see cinematographer).

dissolve ↔ a transition from one shot to another by fading out the first shot as the second shot fades in.

DVD ↔ digital versatile disc. A method of storing audio, video and computer data which is now replacing the use of magnetic tape.

dystopia ↔ a future world that would be an unpleasant place to live in; the opposite of a utopia.

editing ↔ selecting the required takes from the filmed shots, arranging them in the required order and joining them together.

ellipsis ↔ a narrative jump in time. The time not shown/described can be many years (the trick cut from childhood to adult life in *Citizen Kane*) or a second or less (the matched shots showing someone from either side of a door).

empiricism ↔ a view of knowledge which privileges direct experience. Empirical knowledge is based on personal experience (see epistemology).

epistemology ↔ the study of the meaning of knowledge. What does it mean to 'know' something? (see empiricism).

establishing shot ↔ a shot, usually at the beginning of a scene and often an extreme long shot, which provides a visual context within which action is to take place.

extreme close up ↔ a shot that provides detailed visual information. When framing a human face, such a shot would range from just below the top of the head to just above the chin.

extreme long shot ↔ a shot that provides context but little detail. When such a shot is centred on a person we may also see other people, objects and an indication of the location.

eye-line match ↔ when a character looks offscreen in one shot, we may expect the next shot to indicate what s/he is looking at. We would also expect the direction and level of the character's gaze to be consistent with what we see in the next shot.

fade ↔ a common device for indicating the end and beginning of a scene. The last shot of a scene may well fade to black and the beginning of the next scene fade from black into the first shot.

feature film ↔ the custom is that a film must run for seventy-five minutes for it to be classified as a feature film.

fetishism ↔ the displacement of sexual desire onto an object or body part which stands in for the disavowed object of desire. One argument in film theory has been about the extent to which representations of the female body, in so far as they focus on bits of the body rather than on the overall (female) character, reflect a fetishization of the female body which goes hand in hand with the active male hero who drives the narrative forward. The male character, so the classical psychoanalytic argument goes, is a figure for identification; the female body is an object of fetishistic scopophilia.

fill light ↔ a soft light that is placed on the opposite side of an actor to the key light with the function of reducing shadows by balancing out the overall level of lighting.

fly-on-the-wall ↔ a form of documentary in which the intention is that the camera records events without the participants being aware of its presence.

focal length ↔ the distance between the lens and the recording material, e.g. film in a film camera and a charge coupled device (CCD) in a video camera.

focus ↔ the degree of sharpness of an image.

form ↔ generally refers to the means by which communication takes place, as in media forms such as television, radio, newspapers, magazines and film which use particular methods for producing meanings. For film, form refers to the use of moving images and sound to communicate meanings that are shaped by a film's narrative and style. The narrative may be structured by a genre or may be relatively free of conventions. The style may consist of mainstream film techniques or may employ alternative techniques.

formalism ↔ emphasizes how film as a specific form of communication can be used to produce particular meanings. The formal properties of film mean that shot size, camera angle, lighting and editing all influence meaning. Formalism can be contrasted with realism.

framing ↔ relates to the edges of a shot and what is included and excluded.

front projection ↔ an improved version of rear projection. A filmed location is projected onto a half-silvered mirror set at an angle of 45 degrees in front of the camera and projected onto a screen behind the actors. The camera

records the action and the location through the mirror. Lighting is adjusted so that the projected images are not visible on the actors.

gaffer ↔ the chief electrician who is in charge of operating the lights.

graphic match ↔ two shots edited together which are visually similar.

hegemony ↔ it is argued that those with power (the ruling class or a political and economic élite) obtain support for their ideas, and can thus gain ideological dominance, through cultural influences rather than force. Although society consists of different social groups, it is run in the interests of a minority. The media, such as cinema, can promote values and beliefs that come to be seen as common sense, whereas in reality other alternative ideologies may well be at least as appropriate. It could be argued that Hollywood has hegemony over the international film industry with regard to the conventions used in film-making and in terms of the values and beliefs contained in such films.

high angle shot ↔ the camera is placed above the subject.

high concept movie ↔ a film that is based on a simple idea that is easily summarized, understood and marketed.

high key lighting ↔ lighting that avoids creating shadows by using two or more light sources on opposing sides of the subject.

horizontal integration ↔ a company specializing in one area of production buys up another company with similar interests. A film production company that takes over another production company expands horizontally.

hypodermic model ↔ an approach that believes the media are powerful and that they 'inject' meanings into the audience. Media texts such as films are seen as having an effect on a passive audience; the text is the stimulus and the audience responds (contrast with uses and gratifications model).

iconography ↔ the way in which visual signs and referents create meanings. Especially important in genre studies where the selection of particular locations, props and costumes is linked to conventions that are intended to communicate particular messages.

ideology ↔ a set of ideas, values and beliefs that are often taken for granted and go unchallenged through their being regarded as natural and true despite the fact that other alternative ideologies may exist. Dominant ideology is the general set of values and beliefs widely held throughout society and may be seen as helping to sustain particular power relations in that society.

institutional mode of representation ↔ the established way of showing things. By 1915, a broad range of conventions had become established for the production of films with reference to shot size and duration, camera angle and movement, lighting and editing, especially with regard to mainstream cinema.

intertextuality ↔ texts cease to exist as isolated texts and are linked to other texts through references and influences. Films increasingly make implicit and explicit references to other films (see postmodernism).

jump cut ↔ an edit between two shots which results in an abrupt and conspicuous change in the otherwise identical shot content (see 30 degree rule).

key grip ↪ in charge of the stage hands on a film set. Organizes the film set in terms of layout of equipment and set design.

key light ↪ the main source of illumination, usually a hard light, placed on the opposite side of an actor to the fill light.

lighting cameraperson ↪ (see cinematographer).

long shot ↪ when framing a person, such a shot would range from just above the head to just below the feet.

low angle shot ↪ the camera is placed below the subject.

low key lighting ↪ lighting that creates shadows by using one main light source, thus making the lighting unbalanced; there is a strong contrast between light and dark.

Marxism ↪ a wide-ranging body of thought based on the writings and activities of Karl Marx, a German philosopher (1818–93). Marx claimed that the bourgeoisie, who own the means of production, live off the profits of goods produced and sold, and promote an ideology that is intended to perpetuate its power and control. The proletariat (working class) sells its labour in order to survive. Marx's analysis of capitalism as an economic system revealed contradictions that inevitably resulted in periodic crises. He also highlighted the social injustice and exploitation inherent in a class system. Marx proposed a classless society in which the means of production are owned by all (see communism).

master shot ↪ a long take, usually a long shot, that generally covers all the action in a scene. It is usually intercut with mid shots and close ups.

match on action ↪ two shots of different sizes or angles that are edited together to provide continuous coverage of an action.

matte ↪ the combining of two different filmed images within one frame by masking out a part of one image and replacing it with another.

medium or mid shot ↪ when centred on a person, such a shot would range from just above the head to the waist.

mise en scène ↪ what is included in a shot. The selection and arrangement of elements in front of the camera, all of which are contained by the framing of a shot. Includes location, props, costumes, make up, acting and lighting.

modernism ↪ refers to developments in the arts at the beginning of the twentieth century that were epitomized by experimentation and innovation in cultural production. Film was a relatively late artistic form but modernist influences clearly emerged in the 1920s as a challenge to mainstream techniques.

montage ↪ literally (in French) means editing or piecing together various elements to make a complete artefact. A key technique of discontinuity editing. Consecutive shots are not continuous but are often juxtaposed so that meaning is created through the contrast between the different shots.

narrative ↪ the linking together of events that usually have cause and effect relationships in space and time.

naturalism ↪ an approach to film-making and art in general that aims to accurately reproduce surface appearances (compare with realism).

non-diegetic ↔ that which is added to a film and does not originate in the narrative, such as soundtrack music and credits (see diegetic).

Oedipus complex ↔ a concept central to Freudian psychoanalytic theory: child (unconsciously) desires/loves opposite-sex parent, has to learn that such love is 'impossible', and relinquishes the parental love-object to find a socially acceptable partner. For a boy, this means accepting the father-figure's prior claim to the maternal love-object and accepting the 'Law of the Father'. The traces of Oedipal attachments and anxieties are rarely fully resolved. Many (some say all) narratives are about the quest for or journey towards a new love object.

oligopoly ↔ a small number of companies control an industry, resulting in reduced competition, as is the case with the US film industry.

ontology ↔ the study of the reality status of an object or representation. How 'real' can an image (or a film) be?

pan shot ↔ a horizontal movement of the camera around its axis.

paradigm ↔ one of the range of possible elements that could be used in place of each other in a particular text. An appropriate sign is selected from the available set of choices in order to communicate a message. A concept used in semiology (see syntagm).

parody ↔ the imitation of someone else's work in a humorous or mocking way. The films of Mel Brooks are usually parodies.

pastiche ↔ the reuse of existing styles, often mixed together. Films may be identified as postmodern because of their recycling of previous film styles and influences (see postmodernism).

persistence of vision ↔ a phenomenon whereby the retina of the eye retains an image for a split second after it has disappeared until a new image appears. This explains the illusion of a continuous moving image produced by a film, even though the film consists of separate images each lasting one twenty-fourth of a second. This process is seen as automatic or 'passive' (see phi-phenomenon).

phallus/phallic ↔ these terms are central to Freudian (and Lacanian) psychoanalytic theory and have been much used in film theory. The 'phallus' is a symbolic representation of the penis, both in films (guns, knives, big cigars, thrusting engines, skyscrapers, big budgets) and in psychoanalytic accounts of patriarchy and the 'Law of the Father'.

phenomenology ↔ a strand of art reception theory which emphasizes 'knowledge' of the environment through direct sensual perception (see empiricism and epistemology).

phi-phenomenon ↔ the process by which the brain uses intermittent images (as in a film) to construct a represented simulation of movement. For the cognitivists, this is an 'active' process (see persistence of vision).

plot ↔ everything that is directly presented to us in a film. Style shapes the plot and the story may not be portrayed chronologically. Referred to as *syuzhet* by the formalists.

pluralism ↔ it is argued that power is distributed among a variety of social groups. Society is believed to be heterogeneous rather than homogeneous, and a pluralist conception of society emphasizes how the media, such as cinema, produce a diverse range of products to meet the interests of all social groups. Pluralism also identifies the need for a variety of political parties reflecting the interests of all social groups.

point of view shot ↔ a shot that represents the viewpoint of a character in a film. Most shots are taken from the point of view of an uninvolved observer. Optical point-of-view shots which show exactly what a character sees are relatively rare.

polysemy ↔ the quality of having many meanings. Although a film may have been made with a particular message in mind, different viewers will extract different meanings from it.

postmodernism ↔ whereas modernism was epitomized by experimentation and innovation in cultural production such as film-making, postmodernism emphasizes the reworking of existing ideas and styles as typified by the techniques of pastiche and intertextuality. The boundaries between different styles are also broken down through an eclectic approach that uses various influences embodied in the technique of bricolage.

poststructuralism ↔ an approach which stresses that although society contains structures within which meanings are produced and ideas are communicated, there is a multiplicity of structures resulting in a variety of values and beliefs being propagated. The power and constituting effects of these wide-ranging structures negate the concept of ideology as there are no sets of ideas as such. The meanings that can be extracted from a film are seen as more free-floating than they are using a structuralist approach.

post-synchronization ↔ adding sound (dialogue, music, sound effects) to a film after the shots have been edited together.

preferred readings model ↔ the producers of media texts, such as films, encode particular meanings into texts with the intention that the audience will decode the texts accurately and accept the meanings; in other words, media texts have preferred readings. However, while a viewer may make a dominant reading of the text that accepts the intended meaning, s/he could make an oppositional reading rejecting the intended meaning or a negotiated reading that only partially accepts the intended meaning.

producer ↔ responsible for the administrative aspects of a film's production such as getting financial backing for the film, booking locations and equipment, hiring actors and film crew.

psychoanalytic film theory ↔ the use of ideas derived from Freudian psychoanalytic theory to study how films (in general and in particular) interact with the unconscious mind. Films can be seen as potentially powerful in that they are generally viewed in the dark on a large screen that is usually placed above the spectator, all of which concentrates vision on overwhelming images. Such spectatorship has been compared to a dreamlike state.

realism ↔ emphasizes how film as a form of communication has unique properties that enable it to make an accurate recording of reality. The view that meaning is produced from the content that is filmed rather than from the film techniques that are used can be contrasted with formalism. Realism as a film style is usually associated with the recording of everyday situations, often dealing with social issues, and is often thought of in terms of whether a film accurately records or imitates what we identify as the real world. With regard to fiction, realism also refers to the degree to which a film conforms to our expectations in terms of surface appearance, character actions and narrative events (see verisimilitude and naturalism).

rear projection ↔ a filmed location is projected onto a screen behind the actors so that they appear to be in that location.

reception theory ↔ an approach to analysing the relationship between a media text, such as a film, and the audience which recognizes the possibility of different people interpreting and responding to texts in different ways. Cultural factors such as class, education, employment and ethnicity are seen as likely to influence how an individual responds to a text.

representation ↔ the process of showing something. The media represent aspects of the world, both fiction and non-fiction; however, when we use the media we experience things indirectly, second hand. Choices are made (consciously or unconsciously) as to how to represent things, which can result in controversy if social groups are represented positively or negatively compared to other social groups; hence frequent claims of bias or misrepresentation. There tend to be ways in which things are represented that have become established as dominant representations and could be regarded as reflecting dominant ideology. Stereotypes are often used in media representations. Representations tend to change over time; an example is the different ways in which the 'wild west' has been portrayed in Westerns over the past hundred years.

scopophilia ↔ pleasure, often sexual, gained by looking. While voyeurism refers to a hidden activity usually related to a particular object or sexual obsession, scopophilia is related to the general act of looking. With regard to cinema, feminist theorists have claimed that films tend to be made for the male viewer so that pleasure is gained either by looking at a female character who is there for the male's sexual gaze, or by identifying with an active male character who may well be the hero.

semiology/semiotics ↔ (The first word is used in Europe, the second in the USA). The study of signs. Analysing the audio-visual content of a film, in the context of cultural practices and social conventions, can reveal how meanings are produced and communicated.

sexuality ↔ the sexual desires people have and how they express themselves sexually. Linked to heterosexuality and homosexual/gay/lesbian issues.

shallow focus ↔ Only a small area on one plane of the image is in focus (compare with deep focus).

shot ↔ a continuous period of action filmed in a single take.

shot/reverse shot edit ↔ the editing together of two shots that provide different perspectives on action, most commonly a conversation between two people in which each shot shows a character talking or reveals the expression on the other's face. Such an edit provides visual information that clarifies the spatial and emotional relationship between the characters. Such edits must normally obey the 180 degree rule.

social realism ↔ a style of film-making that attempts to represent the typical everyday lives of most people in society. The subject matter is usually the working class and related social issues.

socialist realism ↔ a style of art and film-making that developed in the Soviet Union during the Stalinist era as a form of propaganda, with the purpose of promoting the interests of the supposedly socialist state.

stereotypes ↔ simplistic categorizations of social groups and ideas that are easily understood but usually inaccurate. A stereotype is the result of a regularly repeated representation. Early Westerns stereotyped Native Americans as barbaric, uncivilized and unjust.

story ↔ a chronological account of all events in a narrative, including the plot plus events that are inferred, hinted at or assumed. Referred to as *fabula* by the formalists.

structuralism ↔ an analytic approach which sees society as containing underlying structures. Language systems organize how meaning is produced and determine how it can be communicated. The various forms of communication carry the values and beliefs of a society. Language carries (usually dominant) ideology. Cultural products, such as films, can only be understood by reference to their relationships to the structures within which they are produced and consumed; meaning is shaped by the structures within which communication takes place (compare with poststructuralism).

style ↔ the particular way in which something is done. Different directors or film movements may use particular film techniques in certain ways. Film style can be analysed in terms of *mise en scène*, camerawork, editing and sound.

subject ↔ in film/media theory, this refers to the individual (viewer) and her/his analytic and social position.

synergy ↔ the use of various media interests to the mutual benefit of each area. Cross-media ownership makes synergy possible; a company could use its different media interests to make a film, promote it in its newspapers, screen it on its television channel and produce computer games based on the film.

syntagm ↔ the arrangement of chosen elements into an appropriate sequence to construct a particular text. The signs are organized into a suitable order to communicate a message. Depending on the object of analysis, a syntagm in a film may be the series of frames in a shot, the shots making up a sequence, or the sequences in the entire film text. A concept used in semiology (see paradigm).

take ↔ a filmed shot. It is common for several takes to be filmed of a shot.

tilt shot ↔ a vertical movement of the camera around its axis.

tracking shot ↔ the camera is mounted on wheels attached to a device called a dolly which runs on tracks, enabling it to move backwards, forwards and sideways.

unconscious ↔ the central idea in Freudian psychoanalytic theory: part of our mind is not directly accessible to us, and we are unaware of the deep-seated reasons for much of what we want, do or say, or indeed of many of the complex meanings that films hold for us. While much film theory has accepted this view, some recent writing has begun to reject the importance of the unconscious (see cognitivism).

uses and gratifications model ↔ an approach that sees the audience as powerful and as using the media to satisfy needs and wants. The audience is seen as active and may consume media texts such as films for various reasons and in a variety of different ways (contrast with hypodermic model).

verisimilitude ↔ believability or plausibility, often structured by particular conventions. Although we will not have experienced a future reality, we will happily accept the world presented in a science fiction film if it uses the expected conventions (see realism).

vertical integration ↔ a company specializing in one area of production, distribution or exhibition buys up another company with interests elsewhere in the chain of commercial activities. A film production company that buys into exhibition expands vertically.

voyeurism ↔ a perversion of scopophilia. The ('natural') drive to look becomes a desire to look secretly. It is possible to see film-watching (particularly in a dark cinema) as voyeuristic.

willing suspension of disbelief ↔ a phrase which describes a state of mind whereby although we know the events in a story aren't actually happening or the images on a screen are fictional, we voluntarily ignore our doubts about their authenticity, usually for the sake of entertainment.

wipe ↔ a shot transition (see also cut, fade and dissolve) in which one shot replaces another by spreading horizontally or vertically over the screen.

zoetrope ↔ a pre-cinematic device that creates the illusion of a moving image. It consists of a series of images, each slightly different from the preceding one, on the inside surface of a cylinder that has a thin vertical viewing slit between each image. When the cylinder is revolved and the viewer looks through the viewing slits, the images appear to create a continuously moving image.

zoom in/track out ↔ a complex use of the camera in which the camera tracks out as the lens zooms in, so that the framing remains the same but the centre of the image is magnified, resulting in a distortion of perspective. A track in/zoom out tracks in while zooming out so that perspective appears to stretch away.

Index

The following selective index contains entries only for those words, names and films which are more or less substantively discussed in the text, and does not have entries for those which are mentioned only in passing.